D0005858

The biographies of Copley and Stuart were based
on the shorter accounts contained in *America's Old Masters*

HISTORY OF
AMERICAN PAINTING
VOLUME ONE

First Flowers of Our Wilderness

THE COLONIAL PERIOD

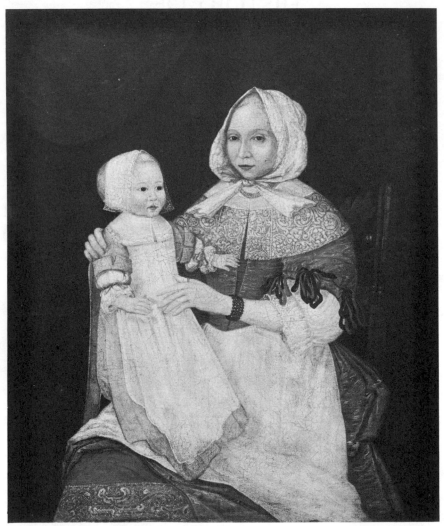

FREAKE LIMNER: *Mrs. Freake and Baby Mary* *Courtesy of the Worcester Art Museum*

HISTORY OF
AMERICAN PAINTING
VOLUME ONE

First Flowers of Our Wilderness
THE COLONIAL PERIOD

BY

JAMES THOMAS FLEXNER

DOVER PUBLICATIONS, INC.
NEW YORK

COPYRIGHT © 1947, 1969 BY JAMES THOMAS FLEXNER.
All rights reserved under
Pan American and International Copyright Conventions.

Published in Canada by General Publishing Company, Ltd.,
30 Lesmill Road, Don Mills, Toronto, Ontario.
Published in the United Kingdom by Constable and Company, Ltd.
10 Orange Street, London WC 2.

This Dover edition, first published in 1969, is an unabridged
republication, with minor corrections, of the work as published in
1947 by Houghton Mifflin Company. Grateful acknowledgment
is made to the magazines that first published certain chapters of
this book: *Antiques, The Art Bulletin,* and *The Magazine of Art.*
A new introduction has been specially written by the author for
this Dover edition. Also, two new illustrations have been added and
two others have been substituted for those of the original edition.

International Standard Book Number: 0-486-25707-X
Library of Congress Catalog Card Number: 68-8811

Manufactured in the United States of America

Dover Publications, Inc.
31 East 2nd Street
Mineola, New York 11501

To the memory of

Simon Flexner

(1863–1946)

Introduction
to the Dover Edition

WHEN IT originally saw the light in 1947, *First Flowers of Our Wilderness* was the only book that had ever existed exclusively concerned with the entire development of painting in Colonial America. Today, more than twenty years later, the volume still occupies the same unique position. No other publication of any sort discusses and illustrates so many artists and pictures of the period.

In paraphrasing the title, *First Flowers of Our Wilderness*, from *Fair Harvard*, the anthem of our *alma mater*, my Boston publishers and I meant the "flowers" to refer to the paintings discussed. Had we chosen to indicate the nature of the book itself, we could have called it *First Clearings in Our Wilderness*. For this was an effort to chart and expand the researches of a small group of earlier scholarly pioneers.

There existed at that time only widely scattered sources, a few of great value, others fragmentary but sound, and many the achievements of tenderfeet who should never have ventured into so tangled a forest. My first labor was to bring everything together so that I could discover what was known. Here and there (as in the field of seventeenth-century New England painting) an area proved to have been handsomely surveyed. But, since broad reaches were completely unexplored, I had upon occasion, to blaze what trails I could through absolutely virgin wilderness. Finally, I tried to map the whole country by combining details into general conclusions on the nature and progress of American painting in its first century.

During the more than twenty years since this volume was published, many of the clearings hacked out in *First Flowers* have been

enlarged and a few resurveyed. More biographical facts, more pictures have been added to the dossiers of various painters. However, I think it is accurate to say that in its larger geography the book has not been made out of date. No artists of importance who were unknown to me, no new schools or movements have been identified.

First Flowers has been extensively mined by later writers. Thus I have experienced both pride and irritation to see matters first stated in these pages become so built into the body of knowledge that their source has been forgotten. To take one example: having concluded that a group of artists working in the Hudson River Valley during the 1720's constituted the first recognizable school in American painting, I coined for the school, which had so often served New York's old Dutch families, the name "Patroon Painters." This name is now commonly considered traditional, like "Hudson River School" or "Ash Can School."

The most exciting development that has appeared in our knowledge of Colonial painting since this volume was published was, most fortunately, foreseen in Chapter Seven. Early American art had been in the 1940's hardly collected at all by museums, while historical societies and individuals then valued a canvas (if they valued it at all) as the effigy of some historical figure or ancestor. Thus, almost all the collecting and studying and photographing which had been done when I wrote *First Flowers* had been concerned with portraiture. Little else being known, the dictum was accepted that our early artists had limited their activity to this branch. On the basis of written records and and the sparse examples I could find, I argued that American Colonial artists had actually practiced "painting in all its branches." In the succeeding years, many Colonial paintings other than portraits have been brought to light.

There is one major dead spot in this book. On pages 299-302, I presented an argument to show that Robert Feke's presumptive birth at Oyster Bay had not been proved. This inspired Waldron Phoenix Belknap to find the needed proof, making aspects of my exposition no longer necessary.

All in all, as I survey the twenty years since *First Flowers* was published, I find a happy situation to report. Shortly after *First Flowers* appeared, there came a spate of excellent general histories of American paintings: by Oliver Larkin, by Edgar Preston Richardson; by Virgil Barker. And if there have been, more recently, no

impressive achievements of an equal scope, university history of art departments have entered a field which they formerly left to one side. As a result, there has been a great proliferation of the examination of individual pictures and the output of individual artists. Although these have not coalesced into any major new findings, the fact remains that the old wilderness is being, however slowly, charted from end to end.

Much more rapid has been the national increase in the interest in early American painting. When this volume first came out, there did not exist enough concern with the subject to keep my enthusiastic publishers, who lavishly anticipated a large sale, from experiencing a sharp disappointment. And canvases by American painters before Copley (even the best) were, when offered to museums (even for pittances) likely to be turned down with scorn. Now museums vie with collectors to procure the once despised pictures: prices can go into six figures. The paintings are being preserved and widely exhibited.

J. T. F.

New York City
1968

Acknowledgments

THIS BOOK was written on a Library of Congress Grant-in-Aid for Studies in the History of American Civilization.

I wish to thank the Frick Art Reference Library for placing its superb facilities at my disposal. Many other institutions, especially the Yale University Library, the Yale Art Gallery, the New-York Historical Society, the New York Public Library, the Boston Museum of Fine Arts, and the Metropolitan Museum of Art have been of great assistance.

My debt to the scholars who have gone before me will be manifest to anyone who examines the bibliography and source references that are appended to this book. The staffs of the museums which possess American Colonial pictures have been generous with their time and advice, while private owners, with exceptions made noteworthy by their rareness, have kindly permitted me to examine and reproduce their pictures. I wish to express my gratitude to the owners of the canvases here illustrated and discussed.

A list of individuals who have been of personal assistance to me would be a complete roster of students of American art; there is space here to mention only a few. My special thanks are due to Harry MacNeill Bland, Louise Burroughs, Thomas C. Cochran, Bartlett Cowdrey, Louisa Dresser, Esther Forbes, Harriette Merrifield Forbes, Lloyd Goodrich, John Davis Hatch, Jr., Hannah Johnson, Ethelwyn Manning, Hope Mathewson, Barbara Neville Parker, John Marshall Phillips, J. Hall Pleasants, Anna Wells Rutledge, William Sawitzky, Josephine Setze, and Donald A. Shelley. My wife, Agnes Halsey Jones, has assisted me in every phase of my study. Virginia Thomas Hammond helped most efficiently with the preparation of the manuscript.

J. T. F.

NEW YORK CITY
August 1, 1946

Foreword:

Briefing Our Journey

THIS BOOK, complete in itself, is the first of a series in which I hope
to show the relationships between life in America and the long
tradition of American painting. Although this labor offers fascinat-
ing discoveries not only about the artistic traditions of our people
but also about the meaning of our society as a whole, it has never
been undertaken as a detailed voyage of historical exploration.
Like Boone, when he reached an Allegheny peak and looked for
the first time over the rich bottomlands of Kentucky, we shall
clamber to a new vantage-point from which to survey our culture
and its development.

Beginning with the earliest canvases known to have been created
in British America, this book will examine the painting of the
Colonial period. We shall see reflected the exciting years during
which a few wilderness clearings grew to the strength and self-
consciousness that made a war of independence inevitable. The
war will bring an end to this part of our study. Although all
American painting, from the beginning to the present, is a con-
tinuous tapestry, the design traced here will be as complete
in itself as it is possible for any historical design to be. For
the Revolution marked as great a change in art as in politics.

This book is dedicated to the proposition that artists, one with
the rest of humanity, express the basic philosophical conceptions
of their place and time. Like plants, painters are rooted by the
falling of the seed into the soil of their own generation. The
dreams of the mystic, the revolts of the reformer, although more
exotic growths, suck their strength from the same subterranean
springs and minerals that nurture the ordinary harvest in its even

[xv]

rows. Individual genius makes an important contribution to the strength of an artist's vision, but personality never functions in a vacuum. The objects seen, the thoughts expressed, are all determined by the environment in which a painter functioned. Therefore it should be possible to explain early American pictures in terms of early American life, and to see the world of our forefathers through the pictures they left behind them.

Americans are so used to regarding books as their outstanding means of expression that most of them will be amazed to hear that painting flowered in their culture generations before literature. Washington Irving, whose earliest important work was published in 1809, is universally considered the first literary man of the United States. He was also the first American writer to achieve a reputation abroad. By the time he had written his *Knickerbocker History* and his *Sketch Book*, American painting had been on a professional basis for at least three-quarters of a century. Many artists had produced important pictures, and a half dozen of them were classed, in Europe as well as at home, among the leading painters of their time.

If we wish to make use of our ancestors' first esthetic strivings to gain an understanding of our cultural beginnings, we must lift our eyes from the words on paper where they have so long exclusively rested. We must examine the marks left by brushes on panel and canvas, for the Colonial pictures, sometimes beautiful, are always historical documents of the greatest importance. Through them we may gain a new insight into the fountainheads of our national life, and into the growth of a people who now face the responsibility of being perhaps the strongest nation in the world.

While axes still beat against the primeval trees of the New England coast, there appeared the first beautiful paintings we know to have been produced in America. Touching medieval portraits by the accomplished Freake Limner were created about 1674, when the earliest settlers of Boston were in their prime. From then on, there was always something doing in the fine arts. Poor work appeared more often than good, even as it does today, but during every generation a flash of lightning struck the wilderness, kindling a little blaze of strength or beauty. In the Hudson River Valley during the seventeen-twenties there emerged the first authentic school of American art, a complicated result of many painters working together that depicted a period of culture with

the sudden glow of a spotlight illuminating the heavens. That this school is known only to a handful of experts makes it no less significant to the story of our national life.

Such manifestations were naïve, folk melodies rather than symphonies. Yet the great personalities of American painting lurked not far behind. In the seventeen-forties, a mariner named Robert Feke appeared mysteriously, created for a decade shining visions of provincial grace, and then vanished without a trace.[1] After this meteor came the fixed stars. Benjamin West, who was to be considered by writers on both sides of the ocean the leading painter of his age, arose in rural Pennsylvania, became a professional during his early teens, and in his twenty-second year, already a famous man, departed for Europe where he was to be a creator of the neo-classical style that swept the Western world. Born in the same year as West, John Singleton Copley enjoyed at first an opposite career. He worked at Boston in the old American manner, making himself one of the greatest artists America has produced in any line of endeavor. His canvases give us a profound esthetic insight into American life more than a half century before literature reached an equivalent maturity. Our volume ends as Copley, now middle-aged, steps on shipboard to follow Benjamin West to London, a symbolic act that marks the close of American isolation in the fine arts.[2]

We should assume that our writers would for generations have been absorbed in the revealing story told by the pictures that arose from their own wilderness settlements and provincial cities. Actually the achievements of the painters of the Colonial period have been almost completely overlooked. The small band of devoted specialists who have for years been exhuming pictures and names and facts have generally been regarded as harmless eccentrics engaged in dusty antiquarianism.[3] Most writers on early America ignore painting; and when, out of a desire for logical completeness, an author does mention pictures, he is likely to satisfy himself with a few paragraphs full of inaccuracies, showing no understanding of America's earliest artistic monuments. We may examine the standard sources on our culture without discovering more than a hint of the existence of the rich mines of the American spirit which this volume will attempt to explore.[4]

In undertaking so vast a task as a social history of American

painting, the writer must limit his subject matter as best he can lest he spend his life in ever-widening labors and in the end have a more confused vision than when he started. In history, as in art, the man who tries to show everything shows nothing. I knew a composer once who resolved to express in a symphony the harmony of the universe. Nothing was to be slighted; all reality was to be caught in a continuous net of sound. He kept adding instruments until he needed not one symphony orchestra but two, and then three, and so on until no auditorium in the world was large enough to hold his musicians. Had not the pen dropped at last from his exhausted fingers, all the citizens of the world would have had to play his music, with no one left to stand at a distance and listen for the meaning of what he had written.

Since all aspects of Colonial living impinge on my subject, I have tried to make the focus of my camera as selective as I can. Painting being the center of my interest, I have kept it directly before my lens. Never allowed to register for its own sake, the background will be brought in only when it is part of the principal image. Architecture, sculpture, the purely decorative and the purely illustrative arts, as well as religious, economic, and political matters, these concern us here only when they explain painting or are explained by it. Yet painting was so much part of its environment that we shall find on our negative a likeness of American thought and life, taken from a specific angle, it is true, but nonetheless valid.

That the major energies of our Colonial artists were engrossed by portraits, although not to the extent always assumed, will give us a peculiarly direct insight into early American mores. Forced to please not only himself but also his sitters (to say nothing of their sisters and their cousins and their aunts), the portraitist is tied by a stout rope to the social demands of his generation. Although this often impedes the esthetic value of his work, it need not do so if artist and environment are perfectly in tune.

Even the most naturalistic creators of likenesses do not try to reproduce exactly the physical semblance of a man. Hardly a single face you see on the street or in your own drawing room could be found just as it is in a portrait of any time and school. Only once to this writer's knowledge has visual reality forced its way into portraits. In albums dating back to the beginnings of photography, we discover great-grandfather just as he was, the

mole on his cheek and his beard tobacco-stained. Grandfather's picture is very different: he looks rich and noble and honest and handsome and elegant. When photography was young, the camera had not yet been taught to lie. But human ingenuity was spurred to frenzy by the awfulness of truth. Filters were developed, fancy films, and methods of retouching. Now photographic portraits deviate from reality as much as painted ones.[5]

To see the physical peculiarities of our forefathers would have been interesting, but it is even more interesting to learn from old canvases how our forefathers wished to look. Each picture shows not only a person, but also his class and his generation. Portraits of a seventeenth-century merchant, a belle of the seventeen-forties, and revolutionaries like Samuel Adams reveal what American society demanded of its economic, social, and political leaders. The foibles of our ancestors, their dreams and their sexual symbols were given immortality by the painters, as well as their profound convictions concerning the individual's place in society.

General interest in early American painting has usually been confined to the single consideration, 'Was it *American*?' Various answers have been given and much hair has been pulled out in the resulting controversies, but the discussions tend to be conducted on a passionate plane of theory which ignores basic historic factors. Both sides have postulated that to be American a picture must be painted in a different manner from any European picture; the debate centers on whether it is possible to find profound deviations. If there are close resemblances, then the artist was by definition a craven imitator of foreign models.

Arguments conducted on this basis tell us more about the combatants than they do about early American art.[6] Like epaulettes on soldiers' shoulders and the exclusive-racial theories of the Nazis, they are symptoms of a malady; the aggressive nationalism that Samsonlike is pulling the temple of civilization down. Too often, the debaters substitute for the healthy patriotism that makes a man love his hearth and home the pathological narrowness of some village crackpot who, keeping his blinds down and his doors bolted, throws stones at his neighbors when they venture a friendly call. Soon, it is to be hoped, the attempt to impose on the worldwide development of art an irrelevant nationalistic pattern will seem as obsolete as does today that wrangling of Puritan divines about abstract states of the soul, which once created a tremendous

[xix]

pounding on the pulpits of the land and even called into play the whip and the gallows.

The most modern of intellectual regimens, science, has reached its contemporary pre-eminence partly because it is not infected with nationalist superstitions. The same men who attack painters because they received inspiration from abroad, would not think of attacking a physicist because he based his experiments on work done in other lands. A scientist would be regarded as an ass if he refused to employ a useful technique merely because it was developed in England or the USSR. A painter would be just as much of a fool. In art as in science, quality is not determined by the source of a man's inspiration, but by what he did with it.

The question 'Was early American art *American*?' has meaning outside the arenas of prejudice only if we rephrase it to read, 'Was early American art a valid expression of early American life?' This change of wording takes us into a different intellectual climate, substitutes historical facts for emotional imperatives. It becomes instantaneously clear that an art which expressed American life would deviate from European art only to the extent that American life itself deviated. The civilization of the New World has always been interwoven with that of the Old by a common heritage and a similar evolution toward not too different ends. Even American liberalism, often considered the most indigenous aspect of our thought, was part of a world current toward freedom. The spokesman for the revolutionary patriots, Thomas Paine, was an English radical who had reached these shores only two years before he wrote *Common Sense*.

Since American civilization did not work itself out in a test-tube separated by impermeable walls from the thought of Europe, American painters, if they were to be truly national, could not climb into a private test-tube of their own. To reflect national life, painting had to play its rôle on the vast stage of international history. Indeed, we shall discover that many characteristics of our art, which have been attacked as imitative because they were duplicated abroad, grew up independently and spontaneously on this side of the ocean. Similar condition inspired similar artistic inventions in both Europe and America.

As we attempt to clear the wilderness trail that leads to the first images that formed in the minds of our ancestors, let us, like any

backwoods hunter, be alert to the total environment through which we walk. That bird which rockets from a distant tree, that rustling in the leaves behind us, all the multiple movements of the forest must be scanned for meanings lest we be captured unawares by prejudice and misunderstanding.

Contents

List of Illustrations

[xxv]

[xxvii]

CHAPTER ONE

Lambs in a Large Place

IF WE WISH to track down the first esthetic products of our wilderness, we must undertake the labors of the pioneer. Deserting cozy hearths of complacent knowledge, we enter a forest of forgotten time. Landmarks are overgrown with the underbrush of centuries; fallen trees lie across our path. Like the explorers who plunged inland from the tidewater, we shall gain only glimpses of the fertile lands around us; it must wait for future generations to clear each field and trace to its source each rill. Yet we shall see much that is new and marvelous and strange. And before long, we shall emerge again into the cleared fields of better-documented history.

For our arduous journey, we must discard the paraphernalia that makes agreeable trips over more beaten paths. Most missed, perhaps, will be the delights of biography. Although the names of artists exist in old records, it is usually impossible to link them with specific canvases. The signatures that gleam so prettily on seventeenth-century American pictures have usually been added by the scalping redskins who lurk on the borders of the art market.

Since chance has preserved only a small and random selection of the paintings created during America's first years, the evidence is too sketchy to enable us to separate off groups of canvases as certainly the work of one man. Like archeologists dealing with some ancient civilization, we must write of early American painting largely in terms of the artifacts themselves. For it is better to take one certain step than a dozen through the blind underbrush of conjecture.[1]

The pioneers who first penetrated the American forests had to deal with superstitious as well as physical dangers. Our exploration, too, is menaced by myth. The Puritans and Cavaliers, shadowy in the abysm of time and yet so bright to the imagination,

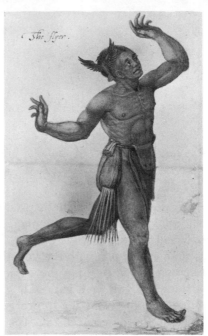

JOHN WHITE: *Indian Runner* Courtesy of the British Museum

seem to contemporary Americans hardly people at all: they are symbols of a great destiny. As symbols demands are made of them that would have puzzled and enraged and defeated them as men. Nationalistic thinking postulates that as they stepped on American soil they should have sloughed off the Old World as a snake sloughs off its skin. In their eagerness to have a unique culture appear to the very sound of keels scraping on sand, some modern writers have misunderstood the evidence, or, when too hard-headed for factual error, have denounced their ancestors in a wild fury for painting in a European manner.

If we wish in our imaginations really to sail those terrible seas with our forefathers, we must forget everything that has happened since the seventeenth century. As we stand on the bounding decks, we have not in our most mystical dreams foreseen that the continent toward which square sails are drawing us will become a populous and powerful nation. To us America is a daring financial speculation or, if we are religious exiles, a desperate expedient. Landing at last, we find ourselves in a world that is altogether strange. Gone are the tight European villages in their friendly fields. Here fallen trees, rank vines, uncurbed underbrush impede

[2]

the feet until it is only possible to move on little paths that are haunted by savages who, so our pastors tell us, are representatives on earth of the living Satan.

No evidence indicates that our ancestors attempted to preserve in paint their first settlements complete with primeval trees and lurking Indians. We would be fascinated by such pictures, but the pioneers could not have been. You would as soon expect the Arabs of the desert to build their courts around sand-boxes. Arabs desire above all things tinkling fountains to enable them to forget the parched reaches of the Sahara. The first Americans wanted to forget forest and savage; they wanted to imagine themselves at home.

Such representations of wilderness conditions as existed were made for consumption not locally but in Europe. The artist Jacques le Moyne accompanied Laudonnière to Florida in the fifteen-sixties, and in 1587 America had its first artist-governor: John White presided over Raleigh's colony at Roanoke, Virginia.

JACQUES LE MOYNE: *Enemy Town Burnt in a Night Raid*
Courtesy of the New York Public Library

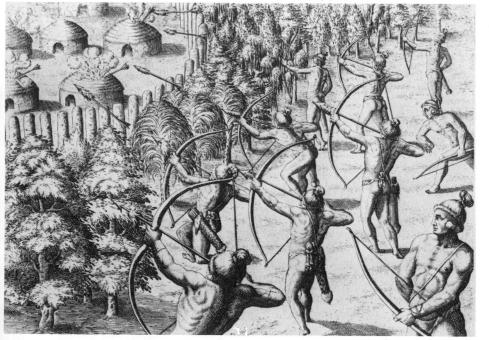

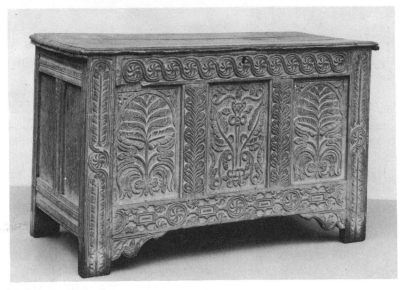

Attributed to THOMAS DENNIS OF IPSWICH: *Chest* *Courtesy of the Metropolitan Museum of Art*

Le Moyne had been sent over by a publisher, much as *Life* sends out a correspondent today; his drawings and those of White were published in Europe. The artists did their best to record their strange surroundings. White was a brilliant draughtsman in water color, but the Indians he and Le Moyne drew were half-naked Europeans masquerading in tattoo and feathers. Even when they tried, the Englishmen were incapable of expressing the wilderness that was so alien to their culture.

As soon as conditions permitted, the New England settlers ensconced themselves in snug medieval villages. Just as if land were still at a premium, the houses leaned together over narrow streets. Lights gleamed through casement windows; doorstep was close to doorstep and a neighbor's voice was sweet to the ear. As long as no Indian whooped and no wind raised a terrible rushing in the branches, you could imagine yourself home in England.

But the new environment could not be altogether ignored. The settlers, for instance, gave in to the fierce American winds by placing clapboards over the half timber of their houses. Yet the result was not as suited to new conditions as log cabins would have been. Although the New Englanders, as their ancestors had done, used log construction to build forts, they failed to take the

[4]

CONNECTICUT ARTISAN: *Painted Chest*　　　　　*Courtesy of the Metropolitan Museum of Art*

seemingly obvious step of applying it to dwelling houses until shown how by Scandinavians who had used log cabins in the Old World.[2] Modification was practiced rather than invention.

Inside a seventeenth-century American dwelling, the Middle Ages reigned undisturbed. Although England had responded to the Renaissance in things of the mind, her crafts were still folk crafts. Such furniture as the emigrants had brought with them was massive, in the ancient functional tradition of straight lines and right angles. When creating new pieces, American artisans imitated these transatlantic models.

It is important to our study that such furniture was not thought of as decorative in itself: decoration was added to the surface in linear design. The fronts and sides of chest or chair were covered not only with panels, knobs, turnings, and scrolls, but also with borders of foliage, and conventionalized birds and plants. When the embellishments were carved, they were usually tinted. Sometimes the paintbrush took over altogether, covering the surface with an elaborate pattern. Commonly painting imitated the flat designs of carving, but some seventeenth-century pieces bear highly stylized pictures of people and animals strolling through conventionalized landscapes.

[5]

The belief that the Puritan home was soberly colorless is part of the New England myth; seldom has color run such riot through American rooms. A modern chest of drawers must be plain so that it will not distract attention from the entire décor. Since the conception of planning a chamber as a unified whole had not yet developed, the medieval chest suffered from no such restriction. A smooth expanse of wood made early American fingers itch for carving tool or paintbrush. If a Colonial was not in the mood to draw a design, he could at least disguise the surface to make it look like something else. The Metropolitan Museum has a table whose top was painted to imitate marble, while its base masquerades as tortoise shell.

The settler's wife was likely to abet his hatred for plain surfaces by making Turkey-work rugs to throw over the tables, gaily colored cushions for the chairs, and embroidered hangings to further brighten the painted walls. Add copper pans and pewter jugs polished and ranged carefully for display; add spinning wheels and cobblers' tools; add a brood of twelve children playing and working in the kitchen, and you have not a still life of a Puritan in a peaked hat, but a picture of vigorous and hearty living.

The Puritans brought with them from England a tradition of design that had been an integral part of their folk culture for numberless generations. That pigment was applied to walls and furniture, that shapes were sometimes worked in textiles rather than on canvas, does not change the fact that the seventeenth-century settler was familiar with the application of color to achieve a decorative effect. Another medieval necessity required representation in its baldest form. When many people could not read and shop-windows were non-existent, inns and stores were identified by signs with pictures on them. Each business street became a picture gallery open to all, and there are documents to show that the Colonial connoisseurs rushed to see a new masterpiece of sign-painting more avidly than we rush to the art shops on New York's Fifty-Seventh Street.

Scorn not such humble matters! The esthete who insists that all artists are Promethean individuals apart from ordinary life and superior to it, will understand little of what took place in Colonial

America. Painting was not an upper-class tradition superimposed from above, but an extension of the activities of artisans engaged in utilitarian tasks. Thus it is with pleasurable anticipation that we watch the crafts becoming increasingly important in New England life.

As the political situation in their homeland darkened toward the Roundhead revolution, settlers poured into New England. But after the king was overthrown in 1646, Puritans no longer wished to leave home. The first result in Massachusetts was depression, as the high prices that had been caused by rapid increases in population broke. But the more static society soon discovered it could stand on its own feet. Shipbuilding became so major an industry that many vessels were made for export; mills arose on Colonial watercourses; weavers set up as manufacturers. These developments, combined with an extensive trade in lumber and fish, produced a wealthy class capable of luxury living side by side with artisans skilled in everything from building ships to painting signs. The fine arts were ready to flower.

From the earliest known group of New England painters there emerged a masterpiece. *Mrs. Freake and Baby Mary* (*ca.* 1674) is an odd canvas whose weaknesses are its strengths. That the painter was unable to represent weight or depth creates the floating quality of dream. A young mother, beautifully dressed in lace and an embroidered gown, looks at us gently from an uncharacterized face that might be the face of all mothers. The baby is a perfect little doll who never screams or sickens, a girl's imagining of the child she will one day fondle. Eternally mother and baby reach out to each other in an allegory of happy motherhood.

Three portraits of Gibbs children, all dated 1670, may be attributed to the same artist. They show us not people, but symbols representing people. We have stepped back from nature to a conception more abstract and more naïve. That bodies are almost completely flat would bother us in pictures that set out to imitate reality; here reality is transmuted into a two dimensional pattern. The most versatile weapon in the armory of Renaissance and modern painters, the use of light to define shapes and blend color, is to a large extent ignored. Shadows that turn a cheek or mold a

[7]

nose are the merest whisps and have no consistency based on a single source of radiance. Not subordinated to one another, the colors tend to be equally bright. Margaret Gibbs's yellow hair, her silver necklace, her reddish-brown dress, her red drawstrings and bows, all are depicted independently of each other and placed side

FREAKE LIMNER: *Margaret Gibbs* *Courtesy of Mrs. Alexander Quarrier Smith*

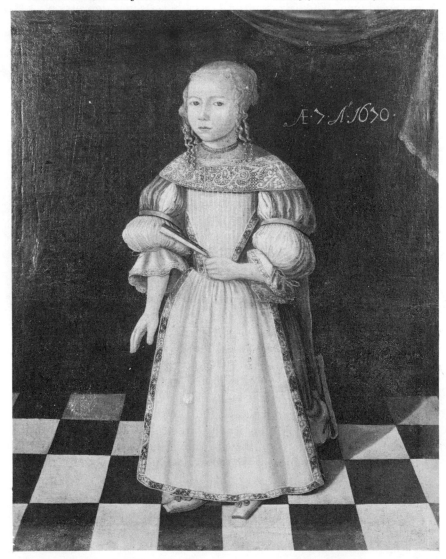

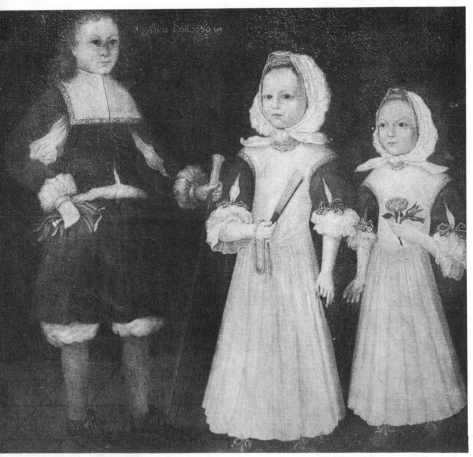

MASON LIMNER: *David, Joanna, and Abigail Mason* *Courtesy of Nathaniel Hamlin*

by side on the canvas. The picture has unity only because it was conceived in a single mind as a single decorative design.

The Freake Limner had an exact contemporary in Boston who, also in 1670, depicted four Colonial children: Alice Mason standing stiffly on a tesselated floor, and in one big canvas her brothers and sisters, David, Joanna, and Abigail.[3] Although stylistically close to the Freake pictures, these canvases were painted in smaller and neater brush strokes with more assurance and less charm.

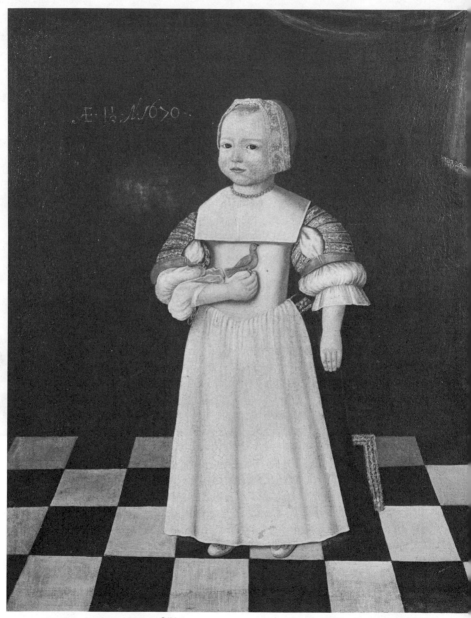

FREAKE LIMNER: *Henry Gibbs*　　　　　　　　*Courtesy of Mrs. Alexander Quarrier Smith*

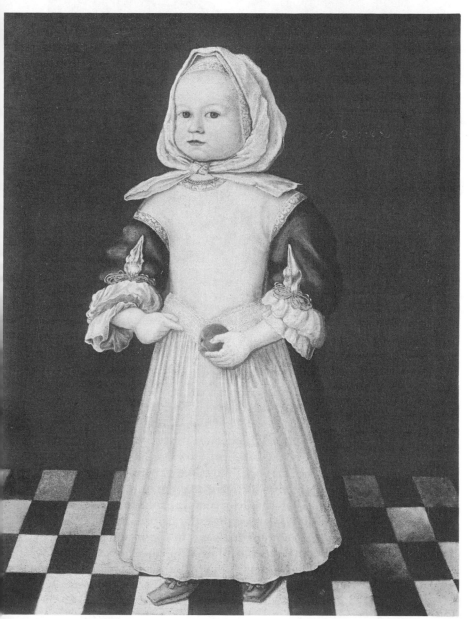

MASON LIMNER: *Alice Mason* *Courtesy of the Adams Memorial Society*

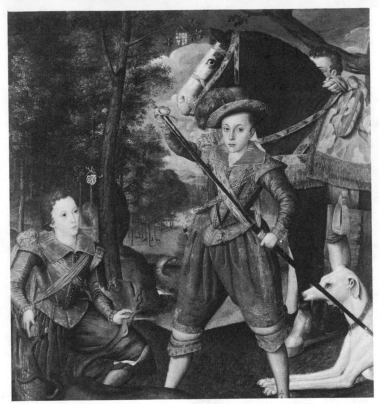

BRITISH SCHOOL: *Henry, Prince of Wales, and Sir John Harrington (Detail)*
Courtesy of the Metropolitan Museum of Art

That both the Freake and Mason Limners painted very differently from the fashionable English artists of the time has encouraged nationalists to shout that they had created an 'American manner,' unrelated to Europe. This is, on the face of it, ridiculous. In 1670, Boston had been settled only thirty-four years: the vast majority of the adult population had grown up abroad. As Americans, the painters were very close to being Englishmen.

The Freake and Mason styles were, like the furniture over which they hung, a survival of English medieval forms. All during the great days of the Italian Renaissance, the British, isolated on their northern island, had continued to paint in the manner created by their manuscript illuminators. When England became a world power during Elizabeth's reign, its greater contact with the continent was counteracted by a rise of nationalism. Elizabeth, herself, disliked the art of the Renaissance, insisting that her own

portrait be executed in the flatly lighted linear manner traditional in her homeland. To the critics of the nineteenth century, this preference seemed impossibly strange in so intelligent a woman; nowadays, when we have broken with so many canons of the Renaissance, we can see that the native tradition had great beauties of its own. *Henry, Prince of Wales, and Sir John Harington* (1603), which exemplifies the most sophisticated manifestation of Elizabethan painting, has great charm to contemporary eyes.

Of course, English prosperity lured foreign masters across the channel. The first major import, Holbein, was forced by local taste to modify his Renaissance technique toward medieval pattern-

Attributed to BRITISH SCHOOL: *Pocahontas*
Courtesy of the Mellon Collection, National Gallery of Art, Washington, D.C.

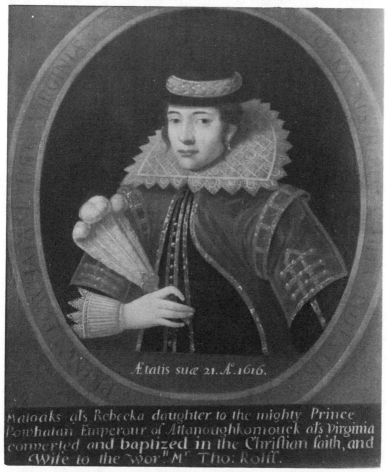

making. However, successive waves of foreign artists finally washed under the native style, the key date being the arrival of Van Dyck in 1632. By 1670, two generations had passed since the medieval manner was fashionable at the British court. But Massachusetts was settled by representatives of the middle class who came from the western counties. There, among the cottages of old England, life at court was a dim rumor, and it was considered a rumor unsuited to virtuous ears. When they created pictures, rural Englishmen adhered to the provincial version of the illuminators' tradition which had so long been their folk approach, the very style that the Freake and Mason Limners practiced.[4] *Pocahontas* (1616) is an example. This style was very well suited to the needs of naïve painters, for it reflected the natural esthetic interests of simple people. If largely inspired by his own imagination, an amateur of any century will create pictures whose emphasis is on outline and geometric balance.

Whether the Freake and Mason Limners had been professional portraitists in England it is impossible to be certain; they could have received all the training they needed from the humbler branches of the painter's trade; coloring walls, brightening furniture, blazoning signs. Indeed, a canvas was built up much as a room was decorated: lace there, a red ribbon here, each adding its own touch of delicacy and color. In this, the paintings were a true expression of their place and time. That seeming paradox, the beauty of some of New England's earliest paintings, is explained by their being profoundly part of the folk culture the settlers brought with them to the wilderness.

The Freake pictures then were a mingling of tradition and innocence. A mixture containing a higher proportion of naïveté, is to be found in a group of portraits, also painted about 1670, which show less contact with foreign models. These have been tentatively attributed to John Foster (1648-1681). Foster was typical of the rapidly expanding society where there were many needs and few ways of supplying them. To be a large frog in a little puddle was so easy that able men searched for many puddles to conquer. Graduated from Harvard at the age of nineteen, Foster taught English and Latin. During his spare time, he incised pictures in wood, becoming the first engraver in English-America. A year or two later he heard that a printing plant was for sale.

[14]

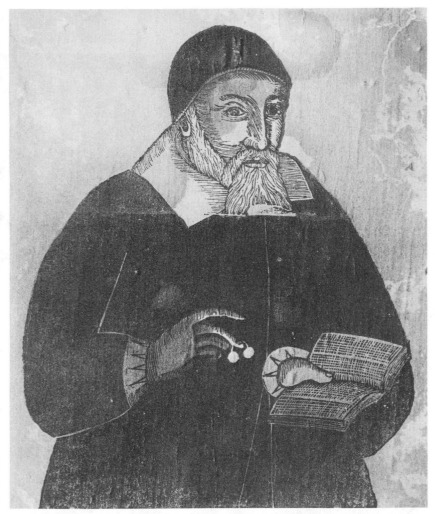

JOHN FOSTER: *Woodcut of Richard Mather* *Courtesy of the American Antiquarian Society*

Although his entire experience consisted of a few hours he had spent gossiping in Samuel Green's printshop in Cambridge, he set up as the first printer-publisher in Boston. Soon he was drawing a map of New England for one of his books. As a publisher, it was natural that he should prepare an almanac, and what was an almanac without some comment on the stars? Since he thought it

[15]

Possibly JOHN FOSTER: *John Davenport* *Courtesy of the Yale University Art Gallery*

would be more fun to work on a basis of science than of old wives' tales, he wrote a learned treatise entitled *Comets, their Distance, Motion, and Magnitude*. When the heavens were too cloudy for astronomy, he played his violin or, if in a somber mood, read medical books. Who knows what fine theory of disease he might have evolved if the germs had not attacked first? He died of tuberculosis in his thirty-fourth year.

That John Foster was also a painter is indicated by a mosaic of evidence. His inventory shows he owned 'colors'; an elegist referred to him as a 'cunning artist' who, but for his untimely death, would have become 'a rare Apelles'; he engraved a view of Boston as well as the first portrait-engraving in the Colonies, that of Richard Mather. The oil from which this print seems to have been taken still exists, but in such bad condition that few inferences can be drawn from it. However, a portrait of John Davenport, dated 1670, has many resemblances to the Mather engraving, as John Marshall Phillips of Yale had pointed out.[5]

Davenport is depicted in the flat style of the Freake Limner, but much more crudely. Heavy brush-strokes define the forms by running along the edges, as if pigment had been naïvely added to a line drawing. The artist was asked to make a likeness and he made it matter-of-factly, producing a literal record of a face, a thing of use, not a thing of beauty. Yet there is an instinctive charm in the placing of forms, as the portrait said to represent John Wheelwright, which is probably by the same hand, also demonstrates.

Such simple likenesses, or even the enchanting anachronisms of the Freake Limner, could not monopolize the art market in the bustling waterside metropolis linked by a flying shuttle of ships to the Old World. Trade made men rich and gave them knowledge of transatlantic elegance. Sending abroad for the latest coat and neckcloth, a Colonial merchant could not be satisfied with portraits generations out of date.

Thus when the curtain rises on New England painting about 1670, we find active, in addition to the medieval craftsmen, painters working not in the manner of the British counties but of the court. Of these, Thomas Smith has been identified. He is said to have been a sea captain who reached Boston from Bermuda about 1650; in 1680 he was paid four guineas by Harvard for a portrait now

lost. This ends our documentary knowledge of him, but we have his self-portraits of himself and his daughter, Maria Catherine Smith. Both are in violent contrast with the Freake style.

The difference is the difference between two ages of man: the static Middle Ages and the restless Renaissance. In their search

THOMAS SMITH: *Maria Catherine Smith* *Courtesy of the American Antiquarian Society*

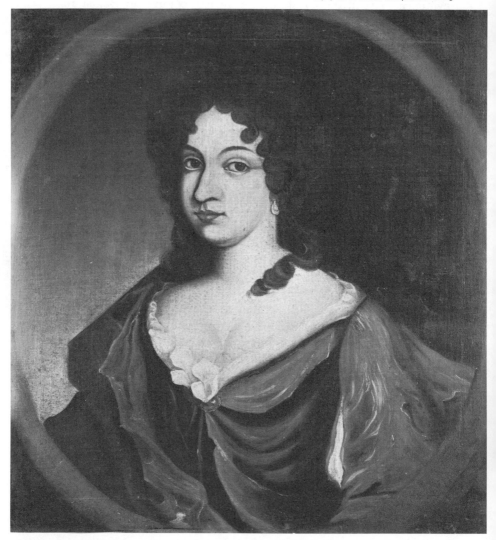

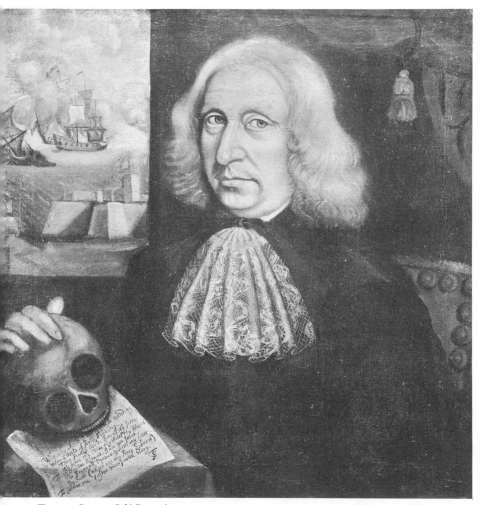

THOMAS SMITH: *Self Portrait*

Courtesy of Edmund B. Hilliard

for meaning, Renaissance artists desired an accurate visual understanding of nature. The body was no longer a major pattern holding together the minor patterns of costume and decoration; it had weight, shape, and existence in space. Variations of light and shade, called chiaroscuro, were used to made round things round and square things square. The most important elements of the picture were placed in the greatest light, creating an emphasis unknown in the Middle Ages. Local patches of color were outlawed in favor of a general chromatic scheme, part of the light and shade pattern and subordinated to the over-all conception.

Thomas Smith applied this technique with the ardor of a recent convert. To make each passage as expressive as possible, with a dripping brush he overemphasized form, contrast, movement of light. Highlights are sharp and crude, shadows heavy. He rewrote the string quartets of the British court painter Sir Peter Lely for some wild back-country instrument.

Smith's pictures are interesting commentaries on the Puritan mind. He made his self-portrait instinct with life: strong flesh, firm character, and in the background a sea battle. But death, that obsession of the Puritans, is also present. The right hand holds a skull which rests on a paper inscribed:

> Why why should I the World be minding
> therein a World of Evils Finding.
> Then Farwell World: Farwell thy Jarres
> thy Joies thy Toies thy Wiles thy Warrs
> Truth Sounds Retreat: I am not sorye.
> The Eternall Drawes to him my heart
> By Faith (which can thy Force Subvert)
> To Crowne me (after Grace) with Glory.
>
> T. S.

This seeker after grace painted his daughter in a most physical manner. He showed her as a luscious brunette with huge dark eyes, curly hair, and provocatively pouting mouth. Perhaps the Puritans, those begetters of large families, were not as opposed to sex as Victorian writers would have us suppose.

Other Boston canvases, painted in the Renaissance manner or in a middle ground between that and the Freake style, cannot be attributed with certainty to any of the artists we have discussed; *Rev. Oliver Peabody* (so called), *Elizabeth Paddy Wensley*, and

Mrs. Patteshall and child are examples. The known portraits produced between 1670 and 1690 must represent the work of at least five men. Possibly that number should be doubled to explain existing pictures. However, the canvases that have weathered two and a half centuries are certainly only a small proportion of those painted; the entire output of several painters has probably been lost. When we recall that Boston had only some fourteen thousand inhabitants, we realize that the seventeenth-century Puritans were well supplied with artists.

Attributed to THOMAS SMITH: *Major Thomas Savage* *Courtesy of Henry L. Shattuck*

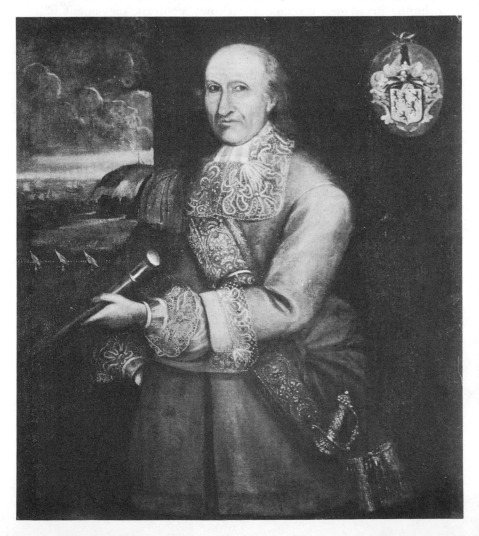

The large number of hands is due in part to the tendency of the painters to practice many crafts, laying down joiners' or printers' or cordwainers' tools when they picked up their brushes. Yet Boston's artistic activity went far beyond what might be expected from the dour world-haters of the New England myth. This makes us question the traditional statement that the Puritans were opposed to painting on religious principles. Indeed, the older generation of scholars, who depicted them as fanatics sewing scarlet letters on high-spirited young ladies, has been succeeded by a school that demonstrates their interest in the liberal arts.

Like all the ideals of man, Puritanism was superimposed on the ordinary complexities of living. Men went to church, it is true, but they also ate and traded and conceived children and spent long winter evenings by the fire. The argument as to whether the settlers came over to worship God or to catch fish could perhaps be resolved by saying that not only were both motives present, but they were so fused together that the Puritans themselves could not have separated and evaluated them.

For Puritanism was not exclusively a religious movement; it was part of the long battle of the middle classes against the aristocracy. With the breakdown of the static conditions of the Dark Ages, there started a great shift in the condition of mankind — call it religious or economic or cultural or what you will — that has not yet reached dead center. New classes appeared and with them new philosophies suited to their state of living; they used these philosophies as battering rams to attack the prerogatives and philosophies of the classes trying to preserve the *status quo.*

An expression of the British mercantile classes, Puritanism was a way station on the road to democracy. It reflected the preconceptions of the group from which it stemmed, altered in some particulars by reaction against the preconceptions of the group against which its believers were fighting. It did not attack the handicrafts practiced by its own constituents, but rather the elegant arts of the courts. Thus a Turkey-work rug was acceptable, while an elaborate lace stomacher was not. Efforts were made to keep down luxury, but luxury was thought of not in middle-class but in aristocratic terms.

Portrait-painting seems always to have been accepted, perhaps

[21]

because it reflected one of the conceptions basic to the Puritan revolt: interest in the individual. There could be no objection to preserving the face of a God-fearing merchant or minister; indeed therein lay piety to the middle-class ideal. But honest men of the people should not be tricked out by the artist to look like pimps from court. The voluminous lace in which the Freakes were painted represented some recession from Puritan thinking, but the fact that they were painted did not.[6]

The adverse effect of Puritanism on the visual arts was not, as is often stated, due to a general opposition to handicrafts and painting, but rather to the fact that it excluded them from the greatest preoccupation of the people. The pioneers poured out their emotional, their imaginative, their esthetic selves into their revolutionary worship of God. When a new settlement was made at Worcester, the General Court organized a meetinghouse so that the people should not feel like 'lambs in a large place.' The sermon was the settlers' favorite art form, and let not those who have slept through the prosing of some twentieth-century minister think it a bad one. Describing the effect eighteenth-century ministers sought, Michael Wigglesworth wrote, 'Eloquence gives new lustre and beauty, new strength, new vigor, new life unto truth; presenting it with such variety as refresheth, actuating it with such hidden, powerful energy that a few languid sparks are blown into a shining flame.' [*] Similar words could be used about painting. The people loved sermons, rushed to them as we wish today the public would rush to art galleries, discussed them endlessly; in fact, were so enthusiastic that in order to get necessary work done legislation had to be passed limiting the number of religious discourses.

When John Cotton preached, so an admirer wrote:

> Rocks rent before him, blind received their sight,
> Souls leveled to the dung hill stood upright.

Had a Colonial painter been permitted to depict this scene, he would have been working out of the profoundest depths of his consciousness. He was not permitted. In their opposition to Catholicism, the Puritans had banned the 'siren wiles' of that

[*] Except for inscriptions on pictures, I have modernized the spelling and punctuation in documents I have quoted.

church, including religious painting. They were following a long-seated English tradition.

No models existed on that northern island to inspire a love of

AMERICAN SCHOOL: *Elizabeth Paddy Wensley* *Courtesy of Pilgrim Hall*

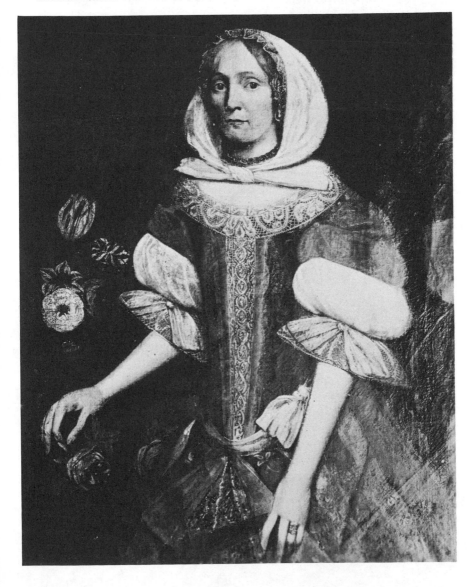

religious art. The devotional painting of medieval England was smashed as part of Henry VIII's attack on Catholicism, and when, almost a century later, England came at last in contact with Renaissance traditions, the prejudice against 'Popish' painting was deep-rooted. The British were as immune to the major interest of the great European painters as the Colonists were to the religious art which flourished to the north and south of them; in French Canada and New Spain.[7]

However, the taboo that excluded New England painters from the major emotional preoccupation of the people had one loophole.

A TYPICAL SEVENTEENTH-CENTURY NEW ENGLAND STONE

Old Granary Burying Ground, Boston

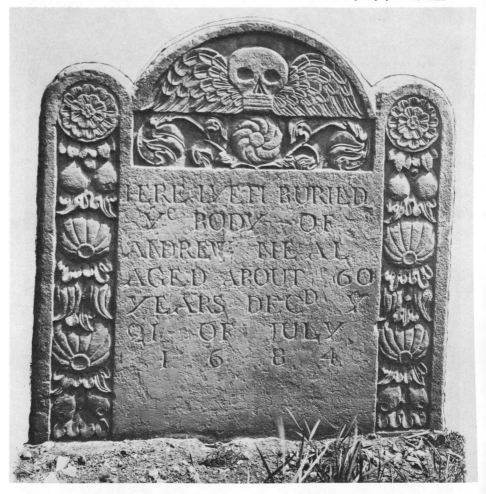

Death was forever in the Puritan's mind; it was both the finis and the apotheosis of human endeavor. When no circuses came to town and dancing around a maypole was a heinous offense, the funerals of great men provided exciting pageants for the pomp-hungry citizens of New England towns. Ostentation and display, forbidden to the living worshiper, was permitted to his grisly corpse. As Harriette Merrifield Forbes points out in her fascinating book on early gravestones, the New England artisans received more business from the death of a rich man than from his entire life. Painters were employed with the other craftsmen. Waitwell Winthrop's heirs spent twenty-two pounds for pictures carried in his funeral pageant. When we recall that Thomas Smith received only four guineas for a portrait, we realize that this must have bought a great deal of art.

The mortuary painting, which seemed gruesome to the Puritan's descendants, have all been destroyed, but old records show that the painted designs were the counterparts of those carved in durable rock by the gravestone cutters. Winged skulls were the most common gravestone decorations; similar death's heads were painted to be worn on the foreheads of funeral horses. On the sides of the horses often hung coats of arms, the painted equivalents of those found on the more expensive stones. A winged hourglass, indicative of passing time, was worked both on rock and canvas; indeed, as a payment to Thomas Child reveals, this symbol even invaded the supposedly pictureless churches. When we read that mourning cloths were hung over the pulpits during funeral sermons, our curiosity is intense to know what, if anything, was drawn upon them.

That Thomas Child (1655-1706),[8] who was trained in England as a painter-stainer, specialized in mortuary art is shown by a verse Judge Sewall wrote when the craftsman himself died:

> Tom Child has often painted death
> But never to the life before.
> Doing it now, he's out of breath;
> He paints it once, and then no more.

Henry Wilder Foote, that inveterate reader of old records, explains this passage by stating it was common to depict corpses lying in their biers.

[25]

John Foster, the painter, publisher, and engraver, embellished so many of his books with the same woodcut that it seems practically his trade-mark. Two winged cherubs, fat, bouncy, and naked, are blowing trumpets while between them a skeleton climbs comfortably out of his coffin. The design is held together by flowered borders similar to those that run down the sides of tombstones. This mingling of fat flanks with bare bones, of *putti* with a death's head reflects amusingly the marriage of convenience between the Middle Ages and the Renaissance which was Puritan culture.

JOHN FOSTER: *Book Decoration* *Courtesy of the New York Public Library*

Foster's own gravestone carries a picture that might have been executed more felicitously with a brush than with a chisel. On a globe of the world supported by formalized birds rests a candlestick, representing the Church, holding aloft the candle of Foster's individual life. Death, clad only in his ribs and grinning horribly, is about to snuff out the candle despite the efforts of Father Time, a bearded man with wings and an hour-glass, to stay his skeleton arm. Above all shines the sun, a human face emitting rays. Foster may have designed the stone himself. Records, although admittedly from a later date, show that the pictures from which gravestones were cut were sometimes drawn by painters.[9]

The symbolism of the gravestones, and thus presumably of the mortuary paintings, was rich in the extreme. Mermaids rise before us, naked and unashamed, indicating that Christ was half man and half deity. Peacocks strut, representing resurrection. The world spins in its sphere, surrounded by the sun, moon, and stars. Arrows, pick-axes, palls, and spades speak of the inevitability of death.

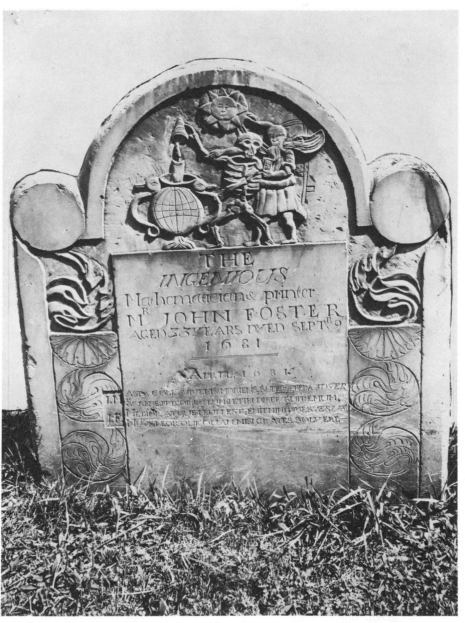

TOMBSTONE OF JOHN FOSTER *Dorchester, Massachusetts, Graveyard*

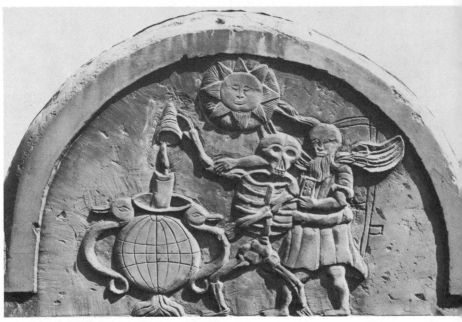

DETAIL OF TOMBSTONE OF JOHN FOSTER

The decorative borders running down the sides of the stones combine pomegranates, promising eternal life, with figs, denoting prosperity and happiness. A grapevine shows that the deceased had labored in the vineyard.

The spirit of early New England still reigns undisturbed in many a crumbling graveyard. A few steps from the highroad through rank grass carry us into the intellectual world of our distant forebears. Louder than the shrilling of crickets and the song of birds, lank skeleton jaws shout 'Memento mori! Fugit hora!' But every skull is tipped with living wings and many a bony forehead wears a crown. All these hollow eyes and lipless mouths bring not terror but majesty. We stand in the world of Raleigh and Burton; this is the shrine of Elizabethan death. Calmly and regally, he calls his subjects home. Then merchant and artisan lie side by side. Soon there is a stirring in the soil; grass raises little spears that speak of resurrection; it is spring on earth as in heaven, and the sun of God's grace shines warm on the blossoming New England hill.

[28]

The graveyards remain, but the funerals of old New England must be recreated from brief jottings in ancient diaries. Only in imagination can we return to those unpaved streets, mingle under jutting second stories with the awestruck Puritans who, so Judge Sewall tells us, not only leaned out of every window but perched 'on fences and trees like pigeons.' The procession comes at a death's pace, slow, so slow. The horses have become creatures from a fabulous world: their hooves are muffled, they wear long black stockings, each equine face has been transmuted by a picture on its forehead into a skull. Hangings thrown over the horses' flanks, placards in the mourners' hands, speak both of vanity and its defeat. The deceased, now locked in that coffin, is perhaps depicted as he looked in the first still moments of death; hourglasses and other symbols of passing time are rendered in somber colors. In imagination standing beside our ancestors, we marvel at the majesty of an early American art dedicated to death and resurrection.

CHAPTER TWO

Dragons in the Way

ALTHOUGH POPULATION and prosperity mounted rapidly, after the generation of 1670 New England painting went into a decline that lasted half a century.[1] The masterpieces of the early years had been illumined by the last spurt of flame before the Middle Ages sank into darkness. Even when they were painted, the canvases of the Freake Limner had been anachronistic. Those impersonal designs, reflecting an age of mass thought and mass action, were not suited to a culture that believed increasingly in the importance of the individual. Men who were subduing a continent wished to be represented as persons of importance, not as symbols of humanity.

Although crafts respond to fashion more slowly than arts, the attitude toward design exemplified by the Medieval-Type painters was failing on every side. At about the turn of the century, an ordered elegance supplanted the episodic medieval chamber. Furniture was made handsome in shape, rather than by surface decorations. The tradition that had produced the Freake and Mason Limners became increasingly tenuous.[2]

A new tradition was needed, preferably one that was suited to expressing the society that was evolving in the New World. Yet it had to be based on European models. To expect our painters to embark at once on an altogether original style would show an ignorance of the historical process. Pasteur and others have fought triumphantly against the conception of spontaneous generation in biology; a similar fight in the field of history has not yet scaled the last strongholds of ignorance. It cannot be overemphasized that in his thinking man never starts from a vacuum; he builds on what he already knows. Artists everywhere, even when they are

in revolt, are connected with esthetic forebears in a continuous chain of influence that goes back to the beginning of time.

The American painters attempted to modify the aristocratic art that flourished in Europe to serve the increasingly revolutionary ends of their own civilization. The story of this struggle is the story of all our Colonial art, of the esthetic activity of the full century that stretched between the Freake Limner and the American Revolution.

European society was dominated by hereditary aristocrats whose fundamental philosophy was the divine rights of kings. Because of intermarriage, the rulers were related, forming a closely knit society which spread like a thin roof over the rising national states. Naturally, the art they encouraged was international and aristocratic, often superimposed from the outside on the nations in which it flourished. Yet, like the rulers themselves, it received its vitality from occasional contacts with the national traditions which became the great pillars on which the rest of the activity was hung.

Titian and Rubens were the forerunners of the international portrait manner, but its creator was Van Dyck, who diluted and sweetened and conventionalized Rubens's lusty work into a medium eminently suited to the royal courts of the time. His style swept Europe. As we have seen, he drove traditional English painting into the hedgerows. He was succeeded in London by Sir Peter Lely, a Fleming who, with personal variations, practiced the Van Dyck manner for thirty-nine successful years. Even Lely's death opened no loophole for native talent. Sir Godfrey Kneller, a recent arrival from Germany, leaped into the breach and carried the English international style on to his death in 1723.

This tradition, like its counterpart in other nations, expressed the thinking of the class it served. The most important thing about humanity was rank. Any man, whatever his personal character, would be a duke provided he were born in the right bed. Even if he seemed a sniveling creature with half a mind, to paint him thus would miss the basic point, for he was not weak but tremendously powerful, master of thousands of other men. Theorists argued on grounds they insisted were esthetic that portraits of ladies should make them beautiful, and those of noblemen should make them sublime, because beauty or sublimity were their

[31]

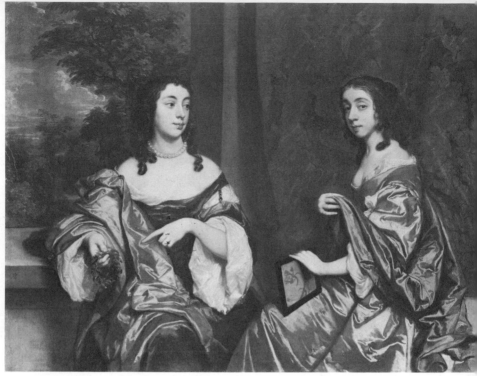

SIR PETER LELY: *Mary and Elizabeth Capel* *Courtesy of the Metropolitan Museum of Art*

essential qualities, deeper than the chance of personality or physical type.

Using subtle underpaintings, delicate glazes, refined patterning of light and shadow, the portrait-painters created highly sophisticated symbols of authority. A king might have any kind of face, but he would have one kind of home and one kind of costume: the most regal imaginable. Therefore costume and setting were correctly a more significant expression of what the painter wished to say than the sitter's features. Another characteristic of the aristocrat was elegance of manners; you could tell a lady from a huckster's daughter by the way she carried herself. Pose and gesture were in the forefront of the artists' minds.

Painting is a language, and like any other, it has its idioms. Usage defined the positions, the gesticulations, even the colors of costume suitable to each class of sitter. This was only logical; you would not wish a king to simper at a flower. If the poses were a

[32]

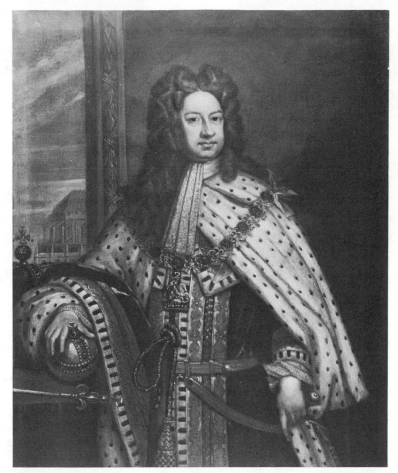

FACTORY OF GODFREY KNELLER: *George I* *Courtesy of the Yale University Art Gallery*

little extreme, that too was correct, since the painters, so their theorists told them, should show the sitter not at a random moment but at his best. The king on canvas could with a glance subdue an army, and so, with a very different kind of glance, could the pretty young countess. This language was carried to America. In 1754 Lawrence Kilburn, 'just arrived from London,' advertised in New York that 'he don't doubt of pleasing' the Colonials 'in taking a true likeness, and finishing the drapery in a proper manner, and also in the choice of attitudes suitable to each person's age and sex.'³ But where in his pattern book was the gesture suitable for a

[33]

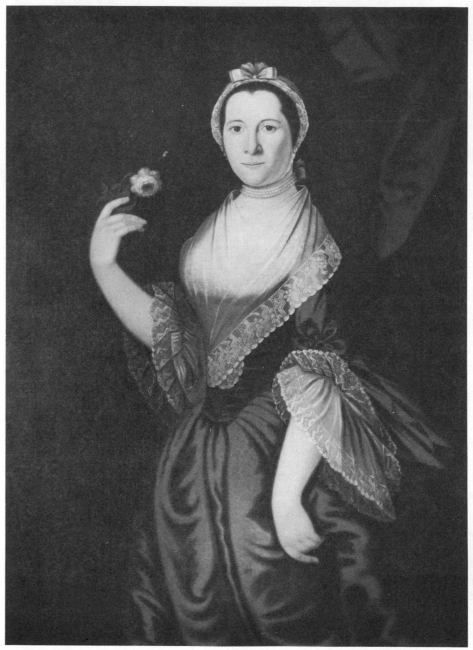

An attitude suitable to the 'person's age and sex.' LAWRENCE KILBRUN: *Mrs. James Beekman*

Courtesy of the Beekman Family

merchant who had just bought prime beaver skins from a naked Indian?

All the individual considerations of the international portrait style had to be brought together into a whole that also expressed court life. The aristocrats may not have been moral, but they were sure they were refined. Grace was regarded as the most important quality of painting; it was thought of as a smooth flow of form. Anything brutal or strong was barred. Surfaces could not be angular or precipitated into each other; composition, drawing, and subtle coloring all fused into a single harmony; jewels, laces, and drapery adorned the picture with an easy elegance. Light, itself the slave of the regal sitters, completed but never dominated the composition.

The application of this formula became as the years passed less an esthetic activity than a social trade. For his routine portraits Kneller painted only the face, sometimes running it up in his studio from a chalk sketch that was his sole contact with the sitter. A periwig expert clustered curls close around the cheeks, handing the canvas on to a colleague who superimposed the hat. Enough craftsmen to make a baseball team worked on the lower part of the picture. Kneller's expert on lace handkerchiefs was not entrusted with heavy gold brocade. Henry Ford had predecessors in the invention of the assembly-line.

England was, of course, alive with forces that opposed the aristocratic point of view, but they failed to find expression in art. During the Commonwealth, when the Puritans were at last in control, Lely remained a leading painter by the simple expedient of toning down his portraits a little, making his men more male and his women less female. The style of Robert Walker, the Roundheads' own artist, is always described in negatives. He omitted the most conspicuous smirks and laces and fancy backgrounds, but adhered to all the basic characteristics of the court manner, even to its elaborate language of gesture. The Puritans had no esthetic innovations to offer.

Indeed, they might have been puzzled that such innovations were asked of them. We see today that the final implication of their doctrines was bourgeois democracy with its interest in the individual for his own sake, but the Puritans, like all human beings, saw little further than their own lifetimes. Far from want-

[35]

ing to destroy the English class structure, they wished only to skim off the aristocracy, leaving themselves on top. Thus, although they were opposed to some of the gewgaws of the court portraits, they felt no need for basic reform. Merchants were not above being flattered at being shown to posterity as princes were shown. Commoners sat for the court artists or, if they lacked the price, for lesser practitioners of the same manner.

The American Puritans were the fundamentalists of the faith, politically more conservative than their English brethren. According to their theocratic ideas, the minister and his elders were absolute, forming a godly king and court. Yet they too were the

ROBERT WALKER: *Oliver Cromwell* *Courtesy of the National Portrait Gallery, London*

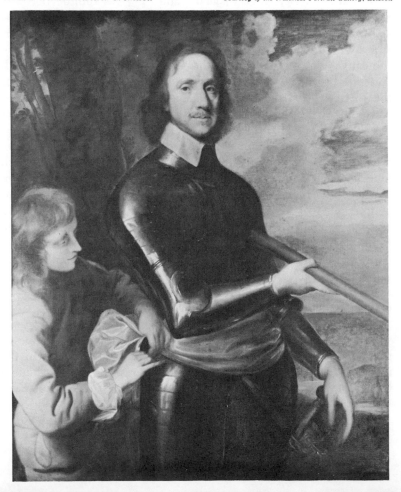

products of transition. How those early divines would have been shocked to realize that they carried with them to the new world, under their black coats, the invisible seeds of social change, seeds that were to grow like Indian corn in the rich new soil. It is impossible to hold hierarchies static when everything else is on the move. In America, a perpetual crashing of trees presaged new villages, often built to house ideas too revolutionary for the older settlements. Money appeared in the strangest pockets, creating not the spiritual rebirth the Puritans encouraged but a secular rebirth they feared. Men who had been indentured servants walked as the financial equals of men who had a few years before imported them as so much cattle. Before a half century had passed, power was snatched from the theocratic divines by a new class of rich merchants.

This group was, like all *nouveaux riches*, passionately conservative. How eagerly they aped the London aristocrats! A royal governor held a miniature court in Boston, while merchants flocked to join the socially correct Church of England from which their ancestors had fled. Even the Congregational Meetinghouses succumbed to the new spirit. The pulpit, once placed in the center with the benches of the sermon-loving worshipers crowding close, was moved to one side to make way for the altar, and a formal aisle down which the temporal great might sweep to their front seats. Shoved into a corner with their rostrums, the clergy screamed unavailingly against the 'giddy, carnal, rising generation.'

Like a wilderness torrent, American society was flowing through unexplored country toward an end no one could foresee. As young men, the settlers had been delighted with the roaring flood that swept them upwards, but when their coffers were full and a coat of arms, an unthinkable appendage for their ancestors, was painted on their hatchments, when they had been washed to the top of American society, they called for the waters to subside and the evolution to stop. 'In my generation,' the recent aristocrat would shout, 'America has been created. My family has been established forever; these farmers and artisans around me shall serve my descendants for a thousand years.' Clinging to the bank of the river, the merchant would call on the portrait-painter to perpetuate his newfound eminence. But even as the artist set up his easel, the waters crashed on toward a new combination.

[37]

Who were the painters who grappled with this herculean task? In 1684 Nathaniel Mather wrote from Dublin to his brother, Increase, in behalf of one Joseph Allen: 'He was bound apprentice to an iron monger, but hath so strong a natural bias to ingenious handicrafts that he is thereby mastered, and indeed carried, that he cannot thrive at buying and selling, but excells at other things, and thence hath acquired good skill at watchmaking, clockmaking, graving, limning, [and] that by his own ingenuity chiefly, for he served an apprenticeship faithfully to another trade. His design in coming to New England is that he be under a necessity of earning his bread by practicing his sk[ill] in some of these things.' In addition to ironmongers, there undoubtedly were house-painter portraitists. Such men were Thomas Child and John Gibbs, who mingled mortuary art with the priming of fences, were unlikely to have overlooked the possibilities of picking up further cash by the creation of 'effigies.' Versatility was the order of the day in early New England.

Should you feel that your dignity called for a professional artist, such men were sometimes available. Although the statement that Jeremiah Dummer (1645-1718), the distinguished silversmith, was also a painter, is open to question,[4] we read in the records of the Boston Selectmen, 1701, that 'Lawrence Brown, a limner, asks admittance to be an inhabitant of this town, which is granted on condition that he give security to save the town harmless.' Brown may well have been an Englishman. That his name cannot be found in any list of British painters proves nothing, since the artists who emigrated to the wild plantations of America were, as the quality of their work shows, provincial daubers too obscure to attract attention in their homeland.

A new wave of English influence swept Boston about the turn of the century. The large three-quarter length canvases of the earlier period became obsolete, as did the rugged energy of Thomas Smith. A jewel-like perfection was now sought, however vainly. The typical likeness of the period shows the sitter cut off slightly above the waist, and often enclosed in a painted oval. A hand and forearm, with no elbow showing, enters from the left to form a horizontal line at the bottom of the picture. Long, characterless fingers are flexed elegantly. Whatever their actual age, the subjects all seem in their early twenties. The faces, even of

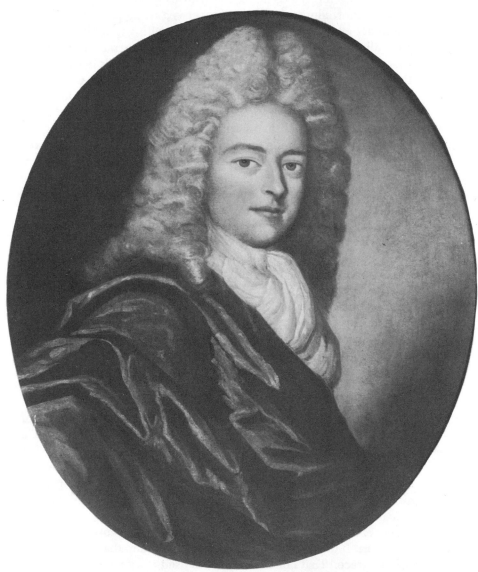

AMERICAN SCHOOL: *Daniel Russell* *Courtesy of Russell S. Codman*

warriors and shrewd traders, have a shallow, hardly-human pretti-
ness. Almond-shaped eyes squint charmingly, and the invariably
cupid-bow mouths are pulled into a half gracious, half supercilious
smile.

[39]

The figure forms a triangle that contrasts with its square or oval setting. Protruding toward the viewer is a rising plane made up of an elbow and outstretched arm covered with the folds of an unnaturally heavy scarf. In a typical man's portrait, like *Daniel Russell*, the eye, having followed this upward line, is carried on to the top of the picture by a wig's complicated curls. After being held momentarily by the part, the eye then falls steeply down the other side of the wig, is impeded by an elegant neckcloth, and drops to the bottom of the picture. Inside this structure of brightly painted stuffs the sitter's face is by-passed as a digression of little importance. Such pictures imitate the English court style unexcitingly and by rote.

The problems faced by a less derivative painter are exemplified by the companion canvases of the Reverend and Mrs. James Pierpont (1711).[5] The artist strove to make the wife, despite her thirty-eight years, into a spirited belle. He labored grimly over the face in a search for conventional attractiveness; if the far eye got too big, that was because of too much trying. The result was messy and confused, but probably flattering to the sitter. For the costume, he employed a different technique. Remembering how dashingly the court painters represented stuffs, he set his brush dancing too, but awkwardly, creating a slurred improvisation that contrasted ridiculously with the tight painting of the features. If there is any sincere study of life behind this picture, it escapes the viewer.

How different is the portrait of Mrs. Pierpont's husband! In painting that pious New Haven divine, the artist was relieved of all pressure to seek elegance. No wig tempted him to draw a tumble of curls; no stylish costume called for virtuosity. Having nothing in his repertoire to substitute for such elements, he turned out his worst composition: the head rattles around at the top of an almost empty expanse of canvas. But the disembodied face is worth prolonged study: it is a serious piece of work, meditative, grave, emotionally felt despite its hardness of execution. Realism was more fundamental to the Pierpont Limner than any cosmopolitan grace. That he realized this himself is by no means certain. If he did, he lacked the courage of his convictions when customers demanded a more socially suitable product.

The reader is undoubtedly waiting to be told whether the Pier-

[40]

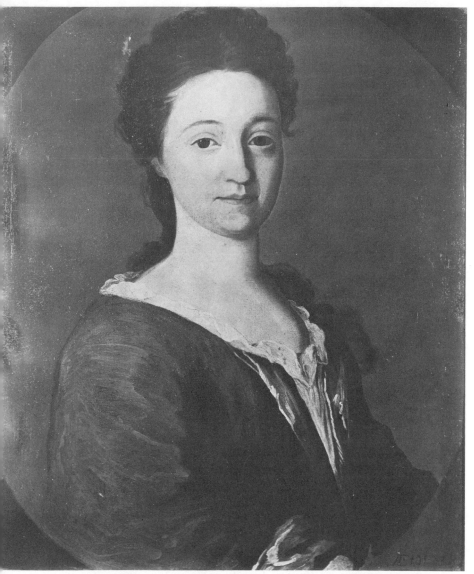

PIERPONT LIMNER: *Mrs. James Pierpont* Courtesy of Allen Evarts Foster

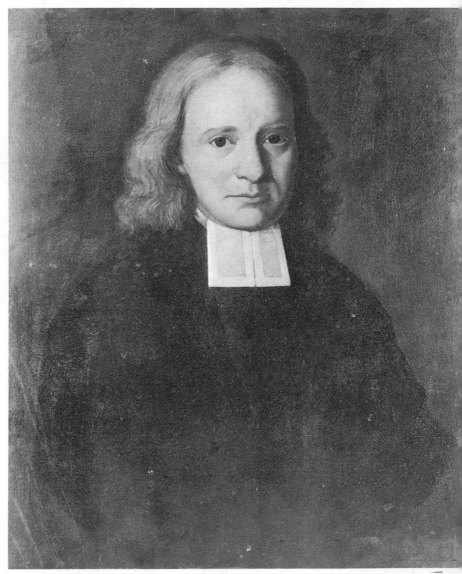

PIERPONT LIMNER: *The Reverend James Pierpont* *Courtesy of Allen Evarts Foster*

pont Limner was an English or a native artist. Critics are perpetually asked to distinguish between 'American pictures,' pictures painted in America by foreigners, and pictures imported from abroad. Attempts to do this on stylistic grounds lead to confusion, since no sharp line can be drawn. Most paintings connected with early America reveal a mingling of tradition and primitivism. How each came by its particular mixture can only be determined from written documents, since sources of traditionalism existed in the Colonies, while back-country European pictures were often primitive. Indeed, a rural English amateur might easily turn out pictures that were cruder than the work of an American artist who had seen imported engravings and canvases. The theory that pictures which show a rough originality are by definition 'native American' made a fortune for crooked art dealers of the last generation, who bought the work of obscure English artists and added the 'signatures' of America's earliest painters. Even the experts were fooled.[6]

Observe the portrait of Andrew Oliver here illustrated. A glance is enough to indicate that it is in the most traditional English mold. Yet it is an authentic work of the first painter who can be proved by documents to have been born and trained in America. When Nathaniel Emmons died in 1740, his obituary in the *New England Journal* began: 'He was universally owned to be the greatest master of various sorts of painting that ever was born in this country. And his excellent works were the pure effect of his own genius, without receiving any instruction from others.'

Emmons may have had no human teachers, but he leaned heavily on imported engravings; furthermore, in his mind the distinction between a print and a painting was very dim. All his surviving works were done in black and white tempera on panels just the size of a portrait engraving. He probably traced everything except the head. Further following the print-makers, he added inscriptions according to their practice, and turned out several almost identical likenesses of the same person. His five known works contain two pairs. That Emmons was a leading artist his obituary makes clear; he died a relatively wealthy man.[7]

A striving for traditional elegance was so typical of the time that it engulfed even the humbler artisan painters. Sometimes these simple souls seem to have tried to compensate for the roughness

[43]

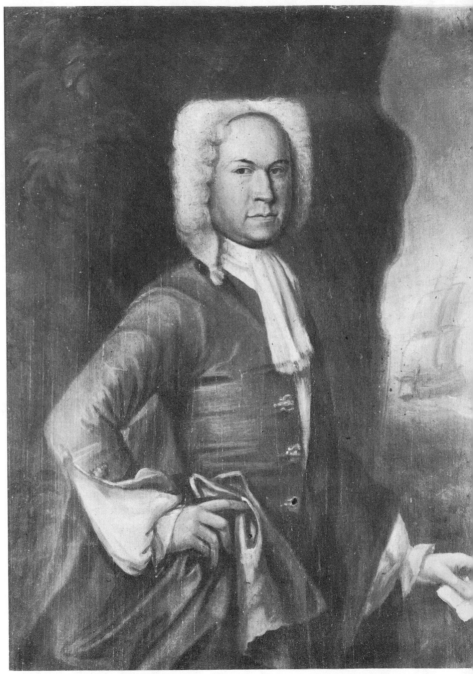

NATHANIEL EMMONS: *Andrew Oliver*

Courtesy of W. H. P. Oliver

of their techniques by the fanciness of their conceptions. J. Cooper (active *ca.* 1714-*ca.* 1718), created in quantity pictures of personages from history or legend which, although not in themselves signs, probably give us an insight into the sign-painting art of the period. Clearly influenced by engravings after international court artists, these pictures cram into their narrow space jewels and medals, shining silk and gleaming armor; wigs, heavy drapery, and monstrous lace. Here a cornucopia is added, there a plumed helmet, there a cherub. Although Cooper lacked the technique to achieve even the limited effects of Emmons or the Pierpont Limner, he did his best. That the result is parody, was not due to lack of striving.[8]

Such pictures as Cooper painted are an uneasy mixture of oppo-

J. Cooper: *Allegorical Figures* *Courtesy of the Lyman Allyn Museum*

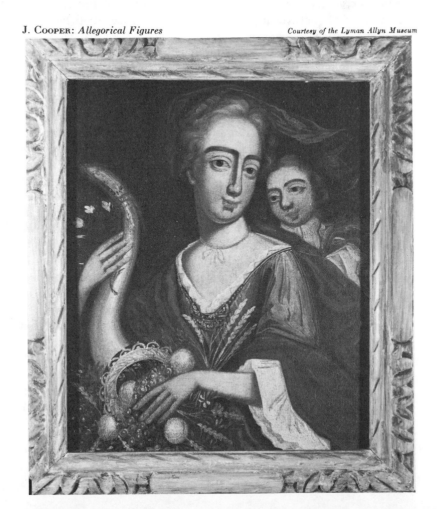

sites. The Lely-Kneller style called for a relationship between round forms existing in space and worked out in great detail, but the artisan-painters tended to see shape as outline and compose in geometric patterns that had little depth. While the court artists made color an intrinsic part of the composition, the artisans added it to already defined shapes as an afterthought. In contrast to the sophisticated artists, who sought a semblance of visual reality, the primitives tended to place an unnaturalistic emphasis on those aspects of the design that most simply told their story. Therefore, when Cooper and his colleagues tried to paint in both styles at once, they resembled that legendary hero who mounted his horse and rode off in all directions.

The predilections of the artisans resemble in many ways the medieval style as exemplified by the Freake Limner, but this does not prove that pictures like Cooper's are a battleground between the Renaissance manner and its predecessor. As we shall see exemplified again and again, a tendency toward simple and emphatic statement, flat geometric forms, and unorganic color has welled up anew in every generation of humble painters up to the present day. In the early eighteenth century, the approach natural to untrained hands may well have been strengthened by shreds of an old tradition not yet completely vanquished, yet had the medieval style been so far in the past that it was forgotten, the result would have been very much the same.

Indeed, the Freake manner was so completely out of fashion that most of the artisan painters, in their eagerness to achieve the court style, regarded their natural predilections as impediments to be glossed over. The result, of course, was unfortunate. Today we admire the paintings in exact proportion to the artist's ability to walk sincerely down his own path. Minglings of the two styles in which the primitive elements are strong enough to give the pictures validity include *Elisha Cooke* and *William Stoughton,* the latter closely allied to the painting being practiced in New York.

The artisan style was most completely realized in a picture that was not a social portrait but an historical document. Painted when she was over a hundred years old (1721), Ann Pollard was regarded as a curiosity and a symbol. The old crone, a former tavern-keeper who could gather around her one hundred and thirty descendants, was the last survivor of the original settlers of Boston.

Possibly by POLLARD LIMNER: *Elisha Cooke* *Courtesy of Mrs. R. M. Saltonstall*

POLLARD LIMNER: *Ann Pollard* *Courtesy of the Massachusetts Historical Society*

Indeed, she claimed she was also the first settler, and no one lived to contradict her. As 'a romping girl' of ten, so she insisted in the squeaking voice of extreme age, she had leaped from the boat which brought an exploring party to Boston Neck, leading Winthrop on to the territory which was now America's greatest city. In those distant days, she recalled, the ground 'was very uneven, abounding in small hollows and swamps, covered with blueberries and other bushes.'

Far from attempting to show this relic as a simpering belle, the painter strove to put down as directly as possible the facts of the figure before him. Using the convention that was natural to him of a painted oval, a conspicuous right sleeve, and a horizontal right

AMERICAN SCHOOL: *William Stoughton* *Courtesy of Harvard University*

POLLARD LIMNER: *Mrs. John Dolbeare*　　　　　　　　*Courtesy of Thomas S. McLane*

arm, he applied it unself-consciously to his own ends. The whole canvas is an exercise in geometry; the twin triangles of the collar state a theme that is repeated in every detail. Bad painting serves the artist's ends as much as good: that Mrs. Pollard's far cheek is given too much roundness for its position in the picture results in a sharp triangle that completes the design. Color is added but never allowed to become conspicuous enough to impede the linear construction.

Leaving visual realism far behind him, the artist produced the most realistic picture of his time. No portion of the beldame's body is shown as it was in life, yet the complete woman sits before us. We can almost see her rising spryly from her chair to emphasize the story of her famous leap, and then glancing at the artist out of shrewd old eyes to see if he dared to doubt so circumstantial a narrative.

Within this canvas lie the seeds of an art form that were not to quicken for more than a century. The quality of *Ann Pollard* is the quality of expressionism. She demonstrates that a man's vision of reality can give an impression of truth greater than reality itself.

However, such an esthetic theory would have seemed pure idiocy to the Pollard Limner's contemporaries; that it had never been formulated in the painter's own mind is clear from his other pictures. Eight portraits may be attributed to this artist.[9] Not one of the others approached *Ann Pollard* in quality. The ordinary run of the artist's work is exemplified by *Mrs. John Dolbeare,* where the design, although still interesting, has been confused with irrelevancies of costume and gesture. It may well be that the painter regarded his bare, almost scientific likeness of the centenarian as the least admirable of his pictures. Certainly it was the least typical not only of his own output, but of the art of his time.

Unsuited to its environment, the *Ann Pollard* manner gleams like a mirage and then vanishes, leaving us in the sterile desert of early eighteenth-century New England painting. For other significant works, we must journey to the province of New York, where conditions were better suited to the development of a valid style.

[51]

CHAPTER THREE

Dutch Realists and the Patroon Painters

IN THE YEARS when the Freake Limner painted, to travel from Boston to New York was a serious undertaking. The ocean offered the easiest route, but, since all lines of trade run abroad, coasting vessels were hard to find. Probably we shall have to go on horseback, riding between widely scattered settlements on trails so narrow that our saddlebags snarl in the branches of trees. Catamounts and Indians are not the only hazard; as one European complained, 'Birds also fill the woods, so that man can scarcely go through them for the whistling, the noise, and the chattering.'

After the wild scenes of our journey, the little settlement of New York seems the vision of man deranged with loneliness. Here are all the homely comforts of Holland in doll-house miniature. Although the city fell to the British in 1664, its Dutch character remained for some time unchanged. Brick buildings, bright with tiles and rising to stepped Dutch gables, are reflected waveringly in a neat little canal. Round each trim dwelling stretches a garden where the rarest blooms of Europe nod under intensively cultivated orchard trees. From behind leaded windows emerges the banging of mops and the embattled cries of housewives. The cleanliness of the Dutch embarrassed foreigners. An English Puritan wrote, 'They keep their houses cleaner than their bodies and their bodies cleaner than their souls.' To this a Frenchman added a tragic plaint, 'The floors are washed nearly every day and scoured with sand, and are so neat that a stranger is afraid to expectorate upon them.'

Should we feel ill after our arduous journey, we might find ourselves in the waiting-room of the barber-surgeon, Doctor Jacob de Lange. Our New England eyes would pop with amazement. Before us is a handsome 'East India cupboard' filled with porcelain

and fine earthenware. The chimneypiece carries a blue valance on which stands more china: basins, flagons, pots, bowls, a small dog, a duck, two swans, and six white figures of men. The windows are hung with blue curtains, and a handsome looking-glass in a gold frame brightens the room with its reflections.

Most strange, perhaps, are the objects hanging on the walls: five landscapes, one depicting evening; a small seascape; and five 'East India pictures,' probably prints.[1] If we express interest, the doctor might take us into the front room where we would see three of those paintings of banquets the Dutch so loved, two still-lives of fruits, a representation of dawn and another of winter, a genre painting of a cobbler, another landscape, and a portrait. Since no Bostonian owned more than a few paintings, most of them portraits, we express the greatest surprise, but the doctor, smiling tolerantly, merely ushers us into the 'great chamber.' Here hang three banquets, ten landscapes, three flower-pieces, one depiction of peasants at a frolic, *Abraham and Hagar* taken from the Bible, a *Plucked Cock Torn*, and a single portrait.

Doctor de Lange owned sixty-one pictures, most of them paintings, and only a small minority portraits. Although he was the outstanding collector in New York, he was not unique. Other burghers had quantities of paintings ranging from battle-pieces to apostles, from still-lives to representations of ships.

To explain this flood of pictures in the wilderness, we must examine the history of Holland. Strategically situated on the routes of trade, and fortunate enough to secure local autonomy by playing one neighboring king against another, the Netherlands had by the end of the Middle Ages developed commercial cities. They boasted Europe's greatest concentration of wealth and population. In contrast to England, where the typical figure was a nobleman in his baronial hall, the Low Countries fostered merchants who, in their city counting-rooms, kept records that revealed their contact with the entire known world. Such prosperity incited, of course, the covetousness of kings. In the resulting struggle for independence, the Flemings went down, but Holland managed to rise from the storm, autonomous and more commercially minded than ever.

Shining along the pathways of trade, the light of the Renaissance had long illuminated the Low Countries. When a basically

REMBRANDT: *The Standard Bearer* *Courtesy of the Metropolitan Museum of Art*

bourgeois civilization triumphed in this region steeped in the great traditions of painting, there arose the first middle-class art the world had ever seen. Man was revealed not as an inhabitant of royal courts but as a domestic animal. Genre scenes showing life in comfortable homes enjoyed a tremendous popularity. The housewife, who had so often dusted the Delft china herself, wanted it depicted in its cupboard exactly as it was: no swirl of pigment, however expert, was a satisfactory substitute. Realism dominated. Still-lives, landscapes, the activities of the rich and the poor, all the pleasure and interests of a contented people were reported with loving accuracy

[54]

Dutch portraiture also reflected the new attitude toward man's place in society. Let us compare two pictures showing individuals as symbols of the state: Van Dyck's *Robert Rich, Earl of Warwick*, typical of the international court style, and Rembrandt's *The Standard Bearer*. The former might be the canvas described years

VAN DYCK: *Robert Rich, Earl of Warwick* *Courtesy of the Metropolitan Museum of Art*

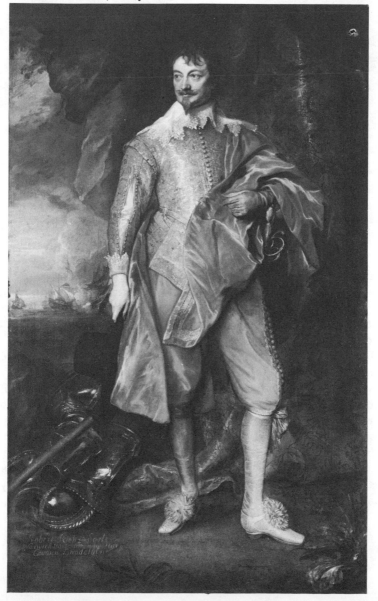

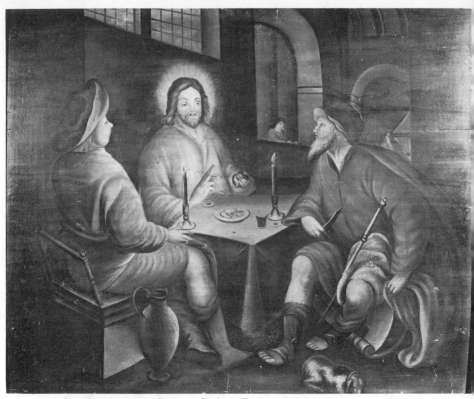

Attributed to AMERICAN SCHOOL: *Christ at Emmaus*

Courtesy of the Albany Institute of History and Art

later by Gilbert Stuart, 'How delicately the lace is drawn! Did you ever see richer satin? The ermine is wonderful in its finish! And, by Jove, the thing has a head.' [2] This head, when we find it at last in the middle of its elegant setting, proves to be a handsome and disdainful symbol of authority.

Rembrandt kept background and body in shadow, letting the light fall on his subject's shoulders and face. We are shown a nearsighted citizen who seems both proud and shy to be the temporary custodian of the banner he carries. Were we to offer to shake his hand, he would first wipe it against his coat lest nervousness had made it sweaty.

Not aimed at an aristocracy that stood apart from the people, Dutch art pleased poor and rich alike. For the first time in European history, easel pictures were commonly hung in ordinary homes. They were even carried in quantity to the New World.

The paintings brought over in those early years have long since vanished, yet we may catch a glimpse of the pictures they inspired in the New World. About 1650, Laurens Block drew New Amsterdam in water color, creating a landscape that, despite superficiality and lack of power, reveals much of the charm of Dutch art. He probably was foreign-trained. However, the author of *Christ at Emmaus* may well have been an indigenous painter inspired by the imported pictures that hung on burghers' walls. In his canvas Old World traditions reverberate like dim echoes, just as they must have reverberated over the Indian trails. It is a crude work from the hand of a very unsophisticated artist, yet the deep space in the background whispers of Tintoretto and the late Italians, while the stolid burgher to the right, who looks as if he had just come from the taxidermist, is clearly Dutch.[3]

No portraits remain from the years before New Amsterdam became New York. We have, however, three canvases by an artist who worked just at the moment of transition.[4] He was clearly a Dutchman. When he painted Peter Stuyvesant, he did not try to use his maulstick as a fairy wand, turning the crusty old governor into a butterfly. Stuyvesant has the right side of his mouth pulled up and one eye partly closed in an expression of fierce disapproval. Chiaroscuro, the contrast between light and shade, is employed to a much greater extent than was approved of in London or Boston; picked out in the brightest light, the features are overmodeled to form a likeness almost brutal in its strength. Far from casting a general haze of youth over everyone, the painter made youngsters look mature, as his portrait of seventeen-year-old Nicholas William Stuyvesant (1666) shows.

The Governor's son demanded to be placed upon a horse. The artist, so we gather, lacked a large enough canvas or panel, and it would have taken a year or two to import one from Holland. He solved the dilemma in a manner typical of the Dutch point of view. Having painted the brightly lighted face so large that it was impossible to make the rest of the picture agree, he added a tiny body and a pigmy horse whose backbone was no longer than his neck. Where an English artist would have concentrated on the symbols of rank and made the sitter's features perfunctory, the Stuyvesant Limner created a picture very like a modern caricature.

As in New England, it is difficult to link the names of artists with

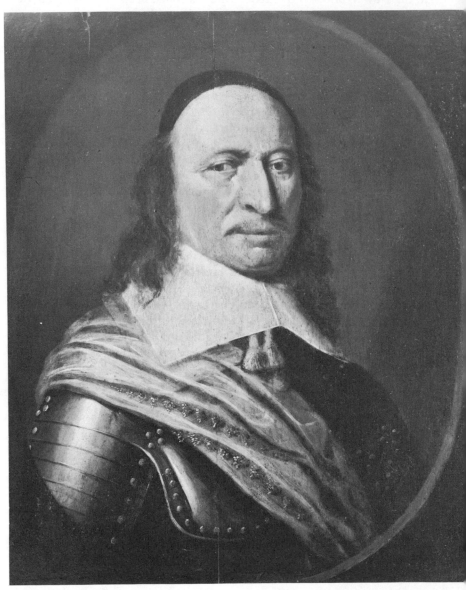

STUYVESANT LIMNER: *Peter Stuyvesant* *Courtesy of the New-York Historical Society*

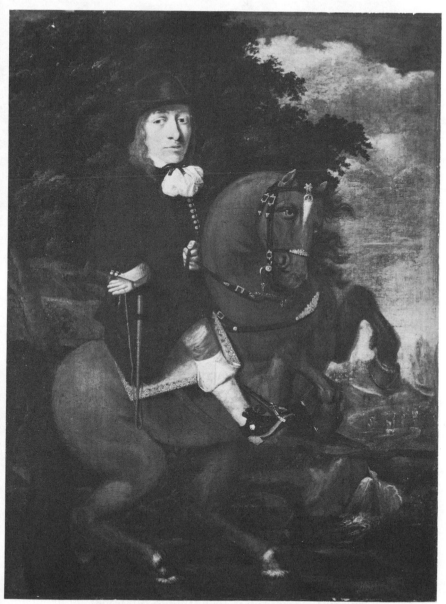

STUYVESANT LIMNER: *Nicholas William Stuyvesant* *Courtesy of the New-York Historical Society*

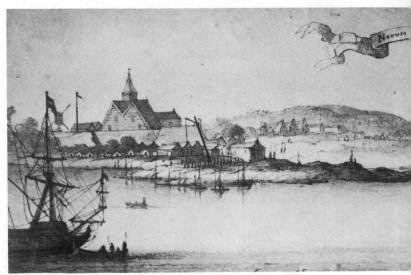

LAURENS BLOCK: *New Amsterdam*

specific pictures.[5] Written records, however, reveal a dynasty of painters. Evert Duyckinck came to New Amsterdam from Holland in 1638 at the age of seventeen as a professional soldier. Stationed at Fort Hope, near what is now Hartford, Connecticut, he engaged in the 'cabbage war' with the English settlers that is so amusingly described by Washington Irving; then he settled down in New Amsterdam to grow his own cabbages. He was variously described as limner, painter, glazier, and burner of glass. He blazoned the city arms on fire-buckets, and engraved them on the windowpanes of the Stadt Huys so expertly that for forty years his work was pointed to with pride. He owned considerable property when he died about 1702.

His son Gerret, born in New Amsterdam in 1660, was known as a glazier, a profession that involved painting, as when he decorated the windows for a new church at Hysophus. He taught drawing, at least on an amateur basis. He was active enough in politics to have called Governor Sloughter a murderer who deserved hanging, and he was rich enough to have owned four Negroes simultaneously. Dying about 1710, he left eleven children.

One of these, Gerardus (1695-1742), advertised in 1735 that 'at the sign of the two cupids' he bought, sold, and repaired looking-glasses, japanned or flowered their frames, and sold oil paints.

Courtesy of the New-York Historical Society

'Also all sort of pictures made and sold; all manner of painting work done.' His son Gerardus, Junior, announced in 1746 that he 'continues to carry on the business of his late father deceased, viz: limning, painting, varnishing, japanning, gilding, glazing, and silvering of looking glass all done in the best manner. He also will teach young gentlemen all sorts of drawing and painting on glass.' When we add that the first cousin of the elder Gerardus, Evert III (1677-1727), was referred to in old records as a limner, we have mentioned all the known painters in this prolific dynasty.

Clearly the Duyckincks were craftsmen first and painters only occasionally. No pictures by Evert I have been identified, but we may asssume that the soldier and glazier who emigrated at the age of seventeen brought with him from Holland little formal training. Three portraits painted about 1700, are attributed, on inconclusive evidence, to his son Gerret.[6] Resembling somewhat Dutch models of the mid-seventeenth century, they are the product of a long evolution toward primitivism. In the so-called portrait of Gerret's wife, visual reality has given way to a crude grasping of major forms. The sitter seems a doll, whittled from hard wood for a rural child satisfied with any shape that implies humanity.

A comparison of *Mrs. Duyckinck* with the Massachusetts portrait of Ann Pollard reveals that the New York artist gave much

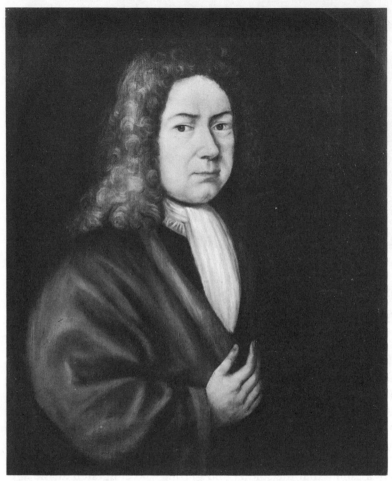

Possibly GERRET DUYCKINCK: *Self Portrait*　　　*Courtesy of the New-York Historical Society*

less reign to his imagination. Not accepting the symbolic approach forced on him by his inability to create a semblance of visual reality, he attempted to approximate the literalness of the minor Dutch masters. In contrast to *Mrs. Pollard,* who has been metamorphized into a design, *Mrs. Duyckinck* seems an exact rendition of a half-human shape. Yet there is sincerity in the picture, a lack of the empty showmanship which Boston demanded in the portrait of any woman younger than a hundred years.

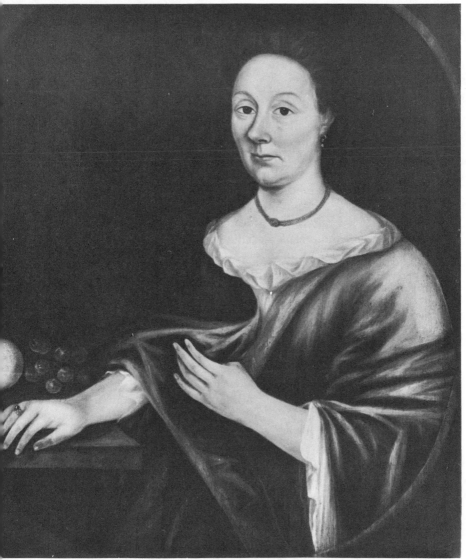

Possibly GERRET DUYCKINCK: *The Artist's Wife* Courtesy of the New-York Historical Society

Mr. and Mrs. David Provoost (*c.* 1700), by a more robust and less sensitive hand, show that other New York artists were working in the same manner. Characterized by earnest labor, these likenesses also make no attempt to follow the will-o'-the-wisp of dash and glitter that led the New England painters into a morass of formula. Indeed, the artist dwelt with a heavy hand on the lady's double chin.

Here is seeming paradox! We have been taught that Boston was Puritan and New York a center of worldly vanity. That portraits seem to show the opposite was probably less a reflection of Colonial conditions than of the art styles which, with all the prestige of foreign models, swayed the local limners. The court tradition that dominated New England urged the craftsmen-painters to work according to the preconceptions of the rich merchants they served, while the Dutch tradition in New York forced the merchants to accept pictures that grew more naturally out of the craftsmen's own lives. In both regions both approaches had a meaning. All Americans, whatever their social rank, carried in their minds, although in different proportions, a hunger for aristocratic elegance and a middle-class absorption in reality. Their ancestors had brought this conflict over with them from Europe, and it was far from being resolved. Even the most elegant American plutocrat remained basically a product of the bourgeois revolution, while any craftsman recognized the possibilities offered him by America to jump class lines and become a great man in his own right.

Indeed, no nation in the Western world was yet ready for a continuous anti-aristocratic tradition. Even in its Dutch homeland middle-class painting had not been able to keep afloat on the billowy waters of history. As the generation that had fought in the Dutch war of freedom died out, their descendants became ashamed of their mercantile origins. They aped the manners of the courts. Then, in 1672, a French invasion put an end to Holland as a world power. French court styles prevailed, drawing Dutch painting into line with the aristocratic manner that dominated the rest of Europe. Like buds that open in the treacherously warm days of early spring, the world's first flowering of middle-class painting was killed by the frosts of returning winter.

The collapse of Dutch power had been reflected in the New

[64]

PROVOOST LIMNER: *Mrs. David Provoost* *Courtesy of the New-York Historical Society*

World by the fall of New Amsterdam to the British. New York City became the most polyglot of all Colonial metropolises. The fate of the paintings imported during the Dutch rule is revealed by a letter, written in 1779, by the Swiss miniaturist Du Simitière that offered for sale some 'pictures, chiefly painted in oils, on boards, in black ebony frames highly polished, of those kinds the Dutch settlers brought a great many with their other furniture . . . I have picked them up in New York, in garrets where they have been confined as unfashionable when that city was modernized.'

New sensations were sweeping the city. In 1718, Nehemiah Partridge, who described himself as a japanner and painter, arrived from Boston where he had exhibited: 'The Italian matchean or moving picture, wherein are to be seen wind mills and water mills moving round, ships sailing on the sea, and several figures delightful to behold.' That he produced America's first recorded movies emphasizes the fact that our early artists often used their skill in simulating reality to create public amusements. Sometimes this encouraged them to seek the kind of realism which is today called *trompe l'œil*.

The rising British tide washed in a Scotch painter, John Watson (1685-1768).[7] Although an unimportant artist, he is the first one about whom we have much biographical information. The story begins to the droning of bagpipes in Scotland. A most annoying droning to Watson, who was looking in at a window. There by the fire sat a handsome young heiress and beside her that pestilential piper who was always calling. The young man watching from the street carried with him still some of the burliness of a shepherd but he no longer followed that bucolic calling. No, indeed! He had raised himself in the world; now he could paint a house as well as anybody, and some of his signs with pictures on them hung before the best shops in Dumfries. Yet rather than walk down the street and admire these wonders of art, the heiress preferred to sit in her parlor and listen to endless pibrochs blown, Watson was certain, a little out of tune.

The next act in the drama shows our house- and sign-painter rocking tipsily in a taproom, squandering his substance in the manner proper for a jilted lover; the lady and the piper have married. Finally, in desperation, Watson threw himself away for good, seeking exile in the wild plantation of New Jersey. He

[66]

arrived in the lively port of Perth Amboy during the early seventeen-tens.

His account book shows that in 1726 he painted more than ten portraits in New York City for a total payment of £23.10.0. No oil painting can definitely be attributed to Watson, but we do seem to have a few simpler examples of his work. If a sitter was unwilling to pay two or three pounds for an oil, Watson would make a small portrait drawing for ten shillings. Such a work, executed in black lead on paper and showing Governor William Burnet of New York, belongs to the New-York Historical Society. The pose was probably adapted from a portrait engraving. The drawing of the head achieves some success in depicting a round shape, but at the cost of obliterating all subtleties. We may doubt that, after studying this featured egg with its conventionally smirking lips, we could, should we meet him on the street, recognize the Royal Governor.

JOHN WATSON: *Governor William Burnet* *Courtesy of The New-York Historical Society*

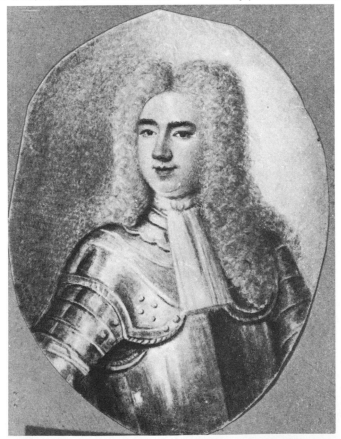

The children at Perth Amboy gazed with awe at the little house Watson used as a studio, for the Scot had divided his shutters 'into squares, and each square presented the head of a man or woman, which, if memory can be trusted . . . represented personages in antique costume, and the men with beards and helmets and crowns.' Watson probably staged this display as much from eccentricity as from a desire to attract sitters, for, although never averse to making a penny, he had turned his major energies to more lucrative pursuits than painting. He was a merchant, a real-estate broker, a personal banker. Dearly loving litigation, he plagued the Colonial courts until they made him pay the costs even when he won an action by reason the said Watson having obstinately refused to make up, settle, and adjust accounts any other ways than by a law suit.'. He was indicted for usury, and generally considered a miser.

The older he grew, the tighter he clasped his purse-strings. Even when his roof began to fall in, he refused to have it mended. A nephew who hoped to inherit the house took a terrible risk. Since Watson was both bedridden and deaf, this nephew made a secret compact with the builders. All was serene for a day or two; then the miser rose upright in his bed. 'What,' he demanded, 'is the meaning of the pecking and knocking I hear every day?'

The nephew paled. 'Pecking! Pecking? Oh, ay! It's the wood-peckers. They're in amazing quantities this year; leave the trees and attack the roofs of the houses. There is no driving them off.'

Watson's deflection from the arts was no loss; indeed, it may have been encouraged by inability to compete with a brilliant group of painters who had risen like rockets into the New York firmament. The new local taste called for decorative pictures, and these were produced in quantity between 1715 and 1730. Many of the canvases show a weird and primitive beauty. In contrast with the small, prissy New England portraits of the same period, the inspired New Yorkers created lusty three-quarter- and full-lengths. Energy, movement, rhythm, these were their attributes. Large canvases enabled them to compose broadly. Long lines, straight or curved, held the pictures together, often crossing near the center. Such portraits represent a considerable deviation from recognized European models, and in America they are almost unique.

The pictures were created by a half-dozen or more painters who

[68]

DE PEYSTER MANNER: *De Peyster Boy with Deer* Courtesy of the New-York Historical Society

worked closely together to form a style that had an all-over unity despite personal variations. We might call the artists, who form the first clearly recognizable school in American art, the Patroon Painters, since they usually served the Dutch families still powerful in New York.

Conspicuous among the Patroon pictures is a style which we shall call the De Peyster Manner. It mingles elaborate conceptions, reflecting foreign models, with simplicity of statement. Quite unconcerned with placing figures in space or giving them any weight, it eliminates at one swoop many of the profounder problems of art. The subtle coloring employed in Europe gives way to a few tints broadly applied with a daring use of contrasting highlights. Search for character also goes by the board; faces are charming symbols, light as the bodies they surmount.

Although the literalness of the Dutch-inspired artists of the previous New York generation has vanished, their fundamental integrity of approach has not. Despite its iconographical resemblances to the international court style, the De Peyster Manner is seldom marred by parrotlike repetition. Technique has been simplified to a point where it is completely mastered. Sincerely and without self-consciousness, flat masses are juxtaposed into designs that have inner validity. In the double portrait of Eva and Katherine De Peyster which hangs in the Metropolitan Museum's American Wing, the painter has endowed the sitters with such diabolical energy that, were I the curator, I should not sleep nights for fear that the girls would escape from their frames and smash every antique in the place.

The nubile young lady, *Elizabeth Van Brugh*, exemplifies energy in a more graceful form. Startled by the artist as she dances into the room, she halts in the middle of a pirouette and looks at us with shy surprise. Her face, depicted with a minimum of shadow, expresses a generalized soft innocence. The painting might well be an illustration for Wordsworth's lines:

> She was a phantom of delight
> When first she gleamed upon my sight;
> A lovely apparition sent
> To be a moment's ornament.

The masterpiece of this style is the picture of a little De Peyster boy in converse with a deer. It is as if two brown-eyed woodland

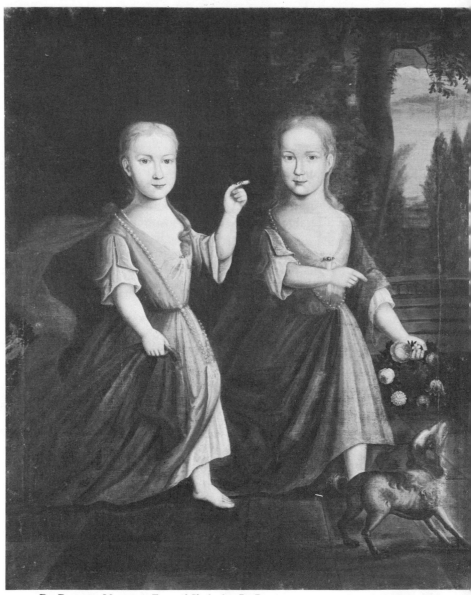

De Peyster Manner: *Eva and Katherine De Peyster* Courtesy of A. C. M. Azoy

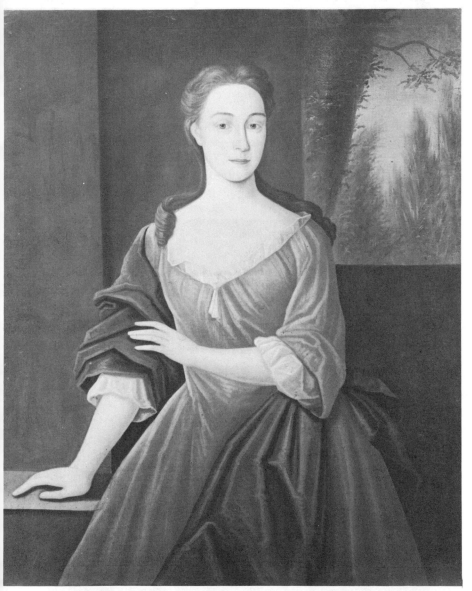

DE PEYSTER MANNER: *Elizabeth Van Brugh*　　　*Courtesy of the New-York Historical Society*

creatures had come together in secret, shy encounter. The composition is borrowed from Kneller, probably via a print; the boy stands on a formal terrace before a formal park. Yet the mood of baroque has completely vanished: elegance has given way to wonder, worldliness to innocence.

This fresh outlook was most successful in representations of youth. Portraits of adults in the De Peyster Manner reveal clearly its conventional origins. Moses Levy, that successful merchant, is posed in the inflated manner of a British three-quarter length, with his stomach forward and one elegantly flexed hand outstretched. Yet even in such pictures the artist is inclined to compose broadly, subordinating his whole composition to a few diagonal lines.

DE PEYSTER MANNER: *Moses Levy* *Courtesy of the Museum of the City of New York*

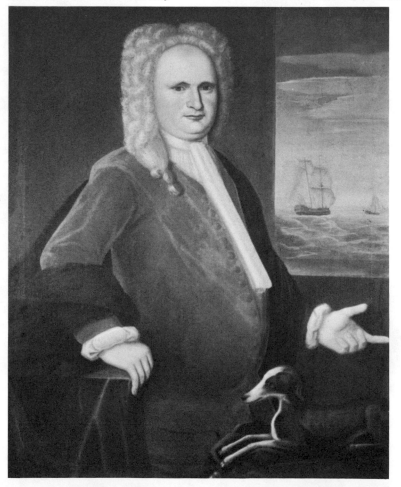

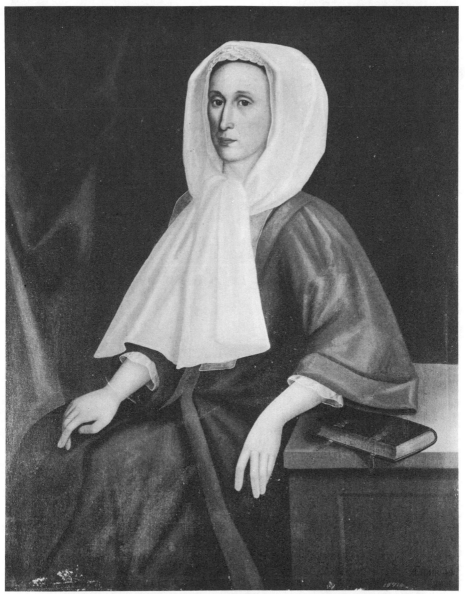

PIETER VANDERLYN: *Mrs. Petrus Vas* Courtesy of Mrs. Edwin Denyse Shultz

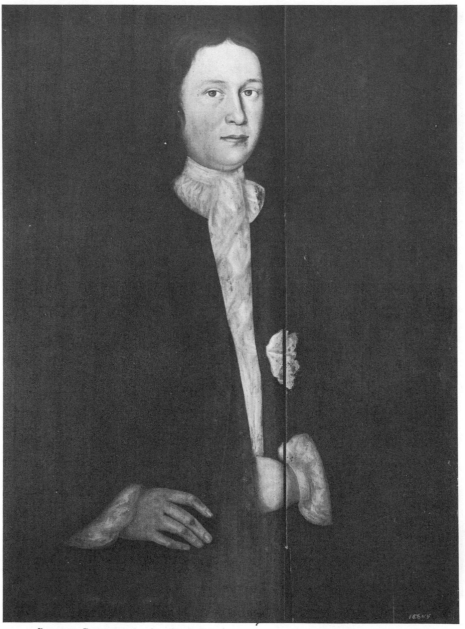

PATROON PAINTER: *Jacobus Stoutenburgh* *Courtesy of the Estate of Caroline T. Wells*

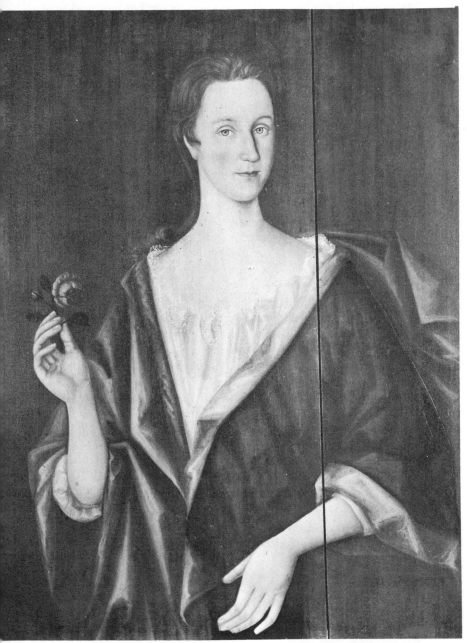

PATROON PAINTER: *Mrs. Jacobus Stoutenburgh* *Courtesy of the Estate of Caroline T. Wells*

Who painted the De Peyster pictures has not been proved to the hilt, yet many of them may well be the work of Pieter Vanderlyn. Born in Holland about 1687, Vanderlyn joined the navy and is said to have spent his young manhood cruising off the coast of Africa. After a period on Curaçao, he reached New York about 1718. There he 'turned his attention to portrait painting.' One of his pictures, *Mrs. Petrus Vas* (1723), has been definitely identified. Although it lacks some of the excitement and flare we like to associate with the De Peyster Manner, there are close technical resemblances.[8] Vanderlyn alternated painting with land speculation, music, preaching, and perhaps medicine. After he had traveled the roads of peace for more than sixty years, Mars caught him up again. The British burnt Kingston in 1777, and the nonagenarian was forced to flee; he walked twenty-eight miles to the home of a son, and lived another year to tell the tale. He died in 1778. Like Evert Duyckinck, Pieter Vanderlyn founded a painting dynasty. His son Nicholas, being unable to achieve the father's eminence, worked largely as a house- and sign-painter, but Nicholas' son John became, during the early nineteenth century, one of America's most important artists.

Radiating from the core of the De Peyster Manner are a bewildering variety of pictures that seem to show the idiosyncrasies of various hands. The painter of Mrs. Jacobus Stoutenburgh gives his lady a face very similar to Elizabeth Van Brugh's, but modified the De Peyster Manner by making the picture primarily a costume-piece; he glories in the texture of fur and the intricacies of lace. However, this panel, like the less elaborate likeness of Mr. Stoutenburgh, has a quiet dignity and a mahoganylike richness of dark hues which exemplifies the vitality that electrified the Patroon tradition. Another offshoot of the De Peyster Manner has been somewhat irresponsibly called the work of Evert Duyckinck III; Magdalen Beekman is a typical example.[9] Here an already primitive style has been made harder, more linear, less graceful. The Old Print Shop's *Portrait of a Young Girl* reveals still another variation.

A second influence vied and mingled with the De Peyster Manner in the Hudson River Valley to add further variety to the work of the Patroon Painters. In the Mayor's office at Albany there hangs a swashbuckling portrait of Pieter Schuyler. Far back in the

genealogy of its style, perhaps, there was the influence of Michael Dahl, the Swedish artist who worked in London, but the picture is primitive according to his standards. For America, however, it is sophisticated. Designing broadly, with an almost frightening assurance, the Schuyler Limner embellished his basically linear approach with a naïve yet not altogether ineffective search for weight. Seizing on the most obvious aspects of form, he shaped his sitter like a bell, the head the ring on top and the legs elongated clappers. Not a wisp of the imagination, Pieter Schuyler stands heavily on his feet. The artist went in for architectural imagination, cluttering his backgrounds with ponderous Italianate struc-

/

PATROON PAINTER: *Magdalen Beekman* *Courtesy of the Beekman Family*

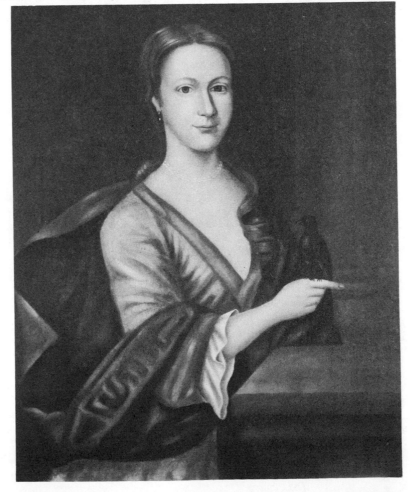

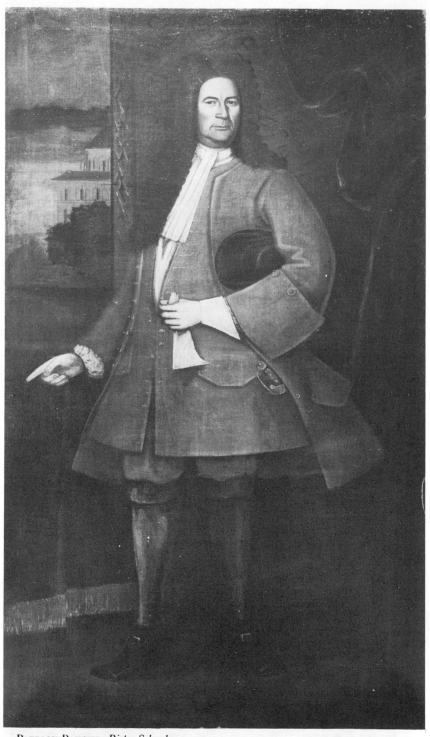

PATROON PAINTER: *Pieter Schuyler* *Courtesy of the City of Albany*

tures, and in one case adding a statue of a lady in a toga, who stands on a pillar but is delicately lifting her skirt as if she were preparing to leap for the ground. The existence in Albany and Rhode Island of several portraits seemingly by the same hand suggests that the painter, whether European or native trained, spent some time on these shores.

A flood of paintings reveal a cruder rendition of this style. Schuyler's face is simplified into a fierce mask with slits for eyes, a sharp nose, and a pointed chin. A translation of his body into linear forms is repeated with fidelity. Almost invariably, the forearms are arranged as in *Pieter Schuyler* to carry the eye across the canvas in a diagonal line; one hand is bare, the other gloved and holding the second glove in a little design of triangles. Female bodies are slightly more various. Many of the pictures are inscribed in the obsolete manner 'Aetatis Sue,' followed by the sitter's age and a date within a few years on each side of 1720.

Although following so closely the painter of *Pieter Schuyler*, the *Aetatis Sue* Limner was not a copyist; he used no element of style until he had made it his own. When in the portraits of Mr. and Mrs. Thomas Van Alstyne (1721) he attempted to escape his own linear preconceptions by following his master into a search for weight, the result was not imitation but experiment. Grimly, every muscle of his painting arm tense, he molded Mr. Van Alstyne's features with coal-black shadows, brick-red half shadows, and creamy pink highlights to form a wild face that has a superficial resemblance to the conscious archaisms of Rouault. Mrs. Van Alstyne's head was square and too long; he treated it like a still-life, producing a likeness unflattering but powerful.

Seeking to express his vision, the painter did not consider stylistic consistency. Plasticity appeared only when it suited his design — more in Mr. Van Alstyne's hands, for instance, than in the wife's — while he did not hesitate to complete his pattern by giving the lady two left hands, and enlarge one arm to twice natural size. The crudely painted fingers are elegantly flexed and hold a spray of flowers.

The *Van Alstynes*, which hang in the New York Historical Society, inspire laughter in the casual visitor, yet if you stare at them hard you find yourself going under their spell. Many a time my own feet have led me back to the gallery to look and wonder

[79]

why canvases, superficially so absurd, should have the striking power of a shillelagh. The answer is, I think, that any sincere and strong manifestation of the human spirit is moving if looked at through eyes free of educated prejudice.

When he paints young women the *Aetatis Sue* Limner sometimes mixes with his fierce gravity a lyrical grace and charm which seems to show the influence of the De Peyster Manner. In a peculiar blend of weight and lightness as piquant to the palate as a bland food with a hot sauce, he lifts heavy drapery in powerful hands and makes it fly. Such frivolity seems to be torn painfully from a temperament basically grave. *Girl of the Schuyler Family* reveals the frightening intensity of an adult tomcat playing in a sudden passion with a kitten's ball. Intensity is his basic characteristic; shining through the crudeness of his forms, it irradiates his pictures with a strange, other-worldly glow. Indeed, the emotional kinship of this painter from the Hudson River Valley is with some true primitive from an African jungle or Pacific isle whose mind's eye sees visions, distorted to our civilized eyes, which are to him truer than reality itself.[10]

An opposite temperament is revealed by the Gansevoort Limner, who worked near Albany in another modification of the Patroon Style. Accepting his provincial limitations, he produced canvases not experimental but finished, not violent but immersed in pastoral calm. *Mrs. Leonard Gansevoort* shows how completely familiar baroque elements of pose and costume — probably gleaned from prints — have been transmuted into something new and strange. Indeed, the picture is closer in mood and style to the work of the nineteenth-century French primitive Rousseau than to its eighteenth-century models. The shades of the prison house have hardly begun to close about the backwoods painter. His *Pau de Wandelaer* is a vision of adolescence more moving than many a sophisticated struggle for the same emotion. The bird perched on the young man's finger has its iconographical history. In Europe it was a conscious affectation, more cute than moving, but here it takes on a deep validity. We seem to see the kinship of untamed things.

To explore fully all the excitements of the Patroon Painters must be the happy labor of some writer who can give a whole book to the subject. Yet the sampling we have undertaken here

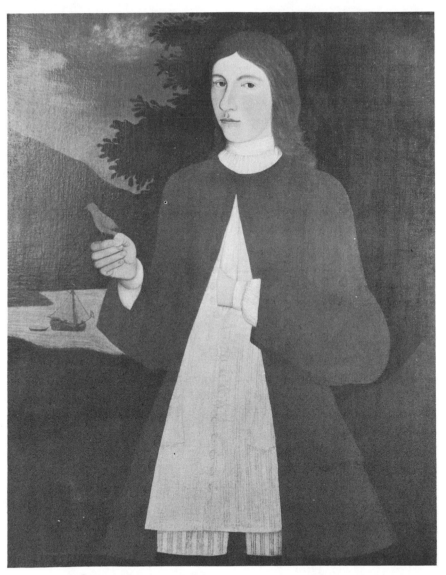

GANSEVOORT LIMNER: *Pau de Wandelaer* *Courtesy of the Albany Institute of History and Art*

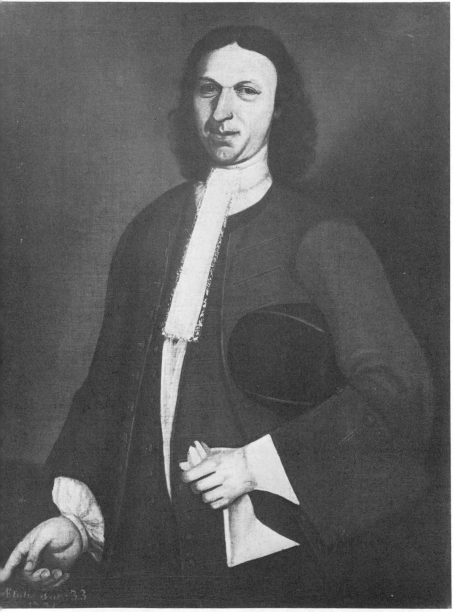

AETATIS SUE MANNER: *Thomas Van Alstyne* Courtesy of the New-York Historical Society

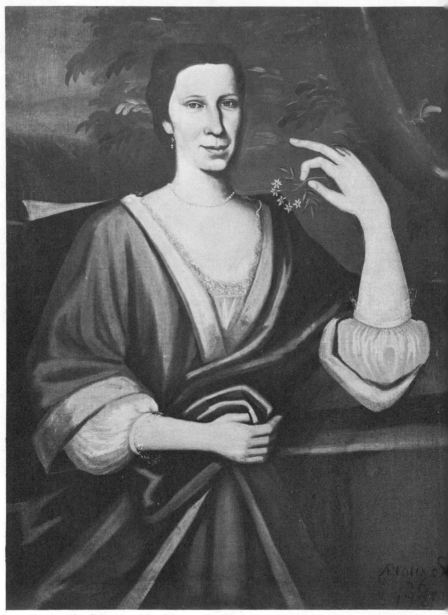

AETATIS SUE MANNER: *Mrs. Thomas Van Alstyne*　　　*Courtesy of the New-York Historical Society*

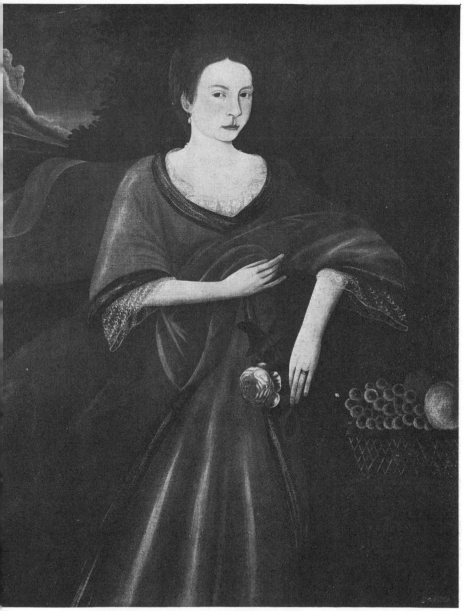

AETATIS SUE MANNER: *Girl of the Van Rensselaer Family* *Present location unknown*

should demonstrate that there grew up in the Hudson River Valley a native school of considerable merit. The American spirit had for the first time flowered into authentic art.

This took place in a region where the influence of the international court style was superimposed on Dutch realism. By itself, the Dutch style was unsuited to the Colonies. To achieve an illusion of visual truth requires great technical virtuosity; it was far beyond the powers of the local artisans. When trying to follow Dutch models, they turned out the homely prose of the Gerret Duyckinck and Provoost portraits.

The untutored artists were forced to express themselves in symbols. This far, they were in agreement with the court style, which was also symbolic; but the metaphors practiced by Lely and Kneller expressed a social order which existed in the wilderness only in palest parody. A slavish attempt to reproduce imported idioms was bound to result, as it had in New England, in sleazy affectation. The need was to translate the Old World symbols into a language that was technically simple, and also suited to Colonial conditions. In this labor the Dutch traditions planted in New Amsterdam were of the greatest assistance. During the several generations when attempts had been made to practice realism, the artists had been forced to study the objects before them. The public had become used to pictures that were not altogether froth. The atmosphere of the time and place was opposed to painting by rote.

Although their lack of training forced the Patroon Painters to work in symbols, it did not determine what symbols they chose to make their own. Harsh, three-dimensional caricatures like the *Van Alstyne Portraits* could have been the rule rather than the exception. Or the painters might have employed the crabbed lines and tight forms of *Ann Pollard*. That America's first school of painters used sweeping lines and gay colors, that they sought not seriousness of content but lightness and charm, must have been a reflection of local taste.

In the early eighteenth century there were two Americas and only one of them was articulate. Back from the cities were tens of thousands of farmers whose ancestors in the Old World had always worked for others. They found a new self-respect, a wild, heady elation in owning their own acres and being able to look

[84]

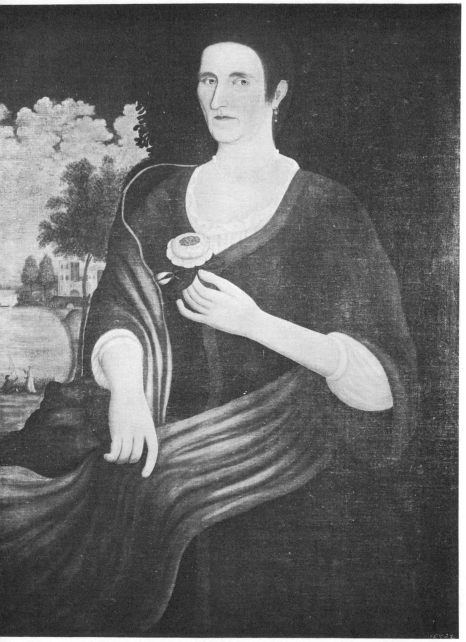

GANSEVOORT LIMNER: *Mrs. Leonard Gansevoort* *Courtesy of Miss Mary V. Hunn*

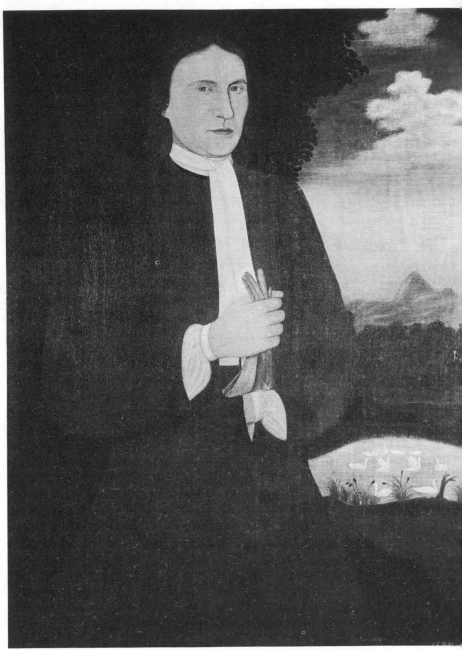

GANSEVOORT LIMNER: *Leonard Gansevoort* *Courtesy of Miss Mary V. Hann*

any man in the eye. But the time had not come when they were to make themselves a power in our national life. They sought self-expression not in the little motion of pen or brush, but in the swing of the axe and the long rhythm of the plough. Fallen forests, not stacked canvases, expressed their dream.

Fortunes were made not by growing a little corn in a wilderness clearing, but by exchanging the raw products of the New World for the riches of the Old. Merchants formed an upper class that dominated not only the politics but also the taste of the time. Although these men had come from simple backgrounds, they now advised royal governors. They dealt as equals with the great traders of London. Serving them were the artisans of the cities who, except for an occasional outburst of indignation, were quiet still under the leadership of their betters.

Looked at from the standards of the Old World where class evolution was so slow, the colonial aristocrats were characters in a fairy tale. Cinderella rode down the streets of New York in her pumpkin carriage, but she did not have to fear the chimes of midnight; *her* horses would never change back to mice. Sitting behind a ledger heavy with the records of prosperity, Dick Whittington knew that he had been his own puss in boots.

Out of a frowning coast and a dark forest had come a pot of gold; the rainbow's end rested permanently on New York. Wealth, position, grace, ample living: these were the gifts of America. How could you be crabbed and sad; you had to sing. And the lyricism of life found expression in the canvases of the Patroon Painters.

The men and women who move so energetically before us, as if they would burst from their frames, are not factual representations of the inhabitants of the Hudson River Valley. That youth with a bird on his finger, that swashbuckling elder staring so fiercely into a distance: who could imagine them trapped for twelve hours a day in a counting-house? Certainly the money in their pockets has fallen from heaven. And the ladies! They have not dimmed their eyes by leaning over the tanning vat of the pioneer; the household generalship and embroidery frame of the richer matrons would not appeal to them at all. Their feet are dancing feet that carry them eternally through a world of innocent gaiety.

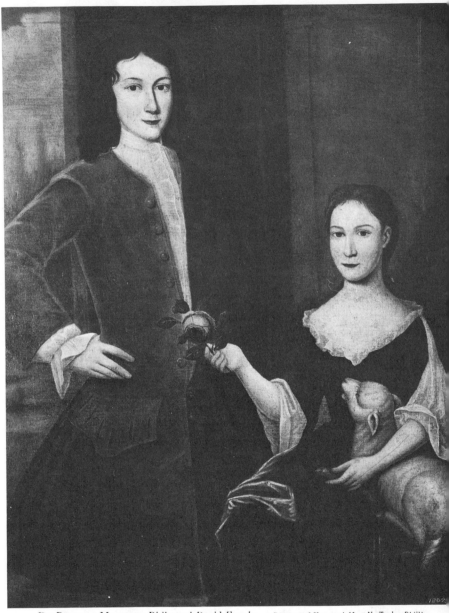

DE PEYSTER MANNER: *Phila and David Franks* Courtesy of Hon. and Mrs. N. Taylor Phillips

There is unreality here, but it is not the unreality of the court tradition. These painted people would be even more out of place in a royal palace than in a wilderness. The fresh young girls would blush and fluster under the eyes of courtiers; the men would walk with an ungainly energy through the ornate rooms of Saint James's. Their path runs between the long aisles of trees in those gardens that are to be seen in the backgrounds of their pictures. They dance not under the glow of ornate chandeliers but by the light of the moon. And the children, who make perhaps the most charming paintings of all, are, despite their elegant costumes, alien to the world of cities. There is a fairy court somewhere under the overhanging branches where young boys stand on terraces fondling does who are not afraid.

The first fresh note struck by American painting is not realism, as so many writers would have us believe; it is innocence, innocence and joy. Wielding an untutored brush, the artists lack the majesty of Old World art — there are no notes here for full orchestra — but they lack too the hackneyed touches. Such skill as they possess, they have struggled for and made their own. The figures on the canvas are figures in a dream, a milkmaid's dream of what it would be like to be a princess.

CHAPTER FOUR

Aristocracy versus Art

SINCE EARLY AMERICAN PAINTING, stemming from the international court style, sought elegance and grace, we should expect to find the finest work in the South, where real ladies and gentlemen — who did not, like the Northerners, have to fabricate spurious coats of arms — sat in spacious halls. Here was an aristocracy based, in the European manner, on the ownership of land.

Thus with great excitement we up anchor in New York and set our sails southward, avoiding, by tacking along the coast, hundreds of miles of wilderness trail. We are headed for Virginia, but it is hard to know where to land, where to begin our search for pictures. Although by the early eighteenth century the Colony was extremely rich, there were no cities and hardly any villages. Each plantation, separated by wild land from its neighbor, had its own wharf on the tidewater. We must ferry from one private landing to another, visiting individually each baronial hall.

We are not disappointed by any lack of elegance. Furniture, silver, even the windowpanes, have been imported from the Old World. Our host speaks like an Englishman, for he was educated in London. True, the butler has a black face and an African tangle to his tongue, but we ignore him as if he were a stick of tropical wood.

On the walls hang portraits in fine frames; eventually they will all be attributed to Kneller. Although only a few are by his hand, many were painted in England. If the visit of a planter to his agents in London did not coincide with his itch for a likeness, he could always send abroad a written description of himself. This may seem ridiculous today, but it was a logical application of the international court philosophy, which taught that fashionable accessories were more important than faces. Thus indigenous art

was discouraged. During the seventeenth century, when the Freake Limner worked in Boston; during the early eighteenth century, the years of the Patroon Painters in New York, Virginia produced no interesting art that has been preserved and recognized.[1]

Perhaps we can blame this on the lack of cities. But South Carolina had an urban center; let us up our sails and hurry on to Charleston. There we find an artist in residence. We are introduced by landowners bearing such titles as Landgrave or Cassique to Henrietta Johnston (active ca. 1708-1728/9), who practiced a rural English version of the fashionable style of pastel, recently developed on the continent for rooms so delicately rococo that oil paintings were too ponderous on their walls.

We have no biographical facts about Henrietta Johnston.[2] That she was a lady of breeding and grace and charm her pictures imply. Although lacking in force, they are gentle and delicately colored. She makes her ladies look like the softly scented and tinted dolls with which very young adolescents people their dreams. But when she tried to depict a man, she was completely lost. That mighty warrior, Colonel William Rhett, is dressed in armor, yet his little round face is smooth as a babe's. He can be told from the artist's ladies only by his costume and by the fact that his eyes are not two times natural size. There was much that was virile in the society of South Carolina, but it passed Miss Johnston completely by. And when she died, no one appeared to carry on the decorative charm of her work. Even this minor note vanished.

Our last hope is to head north again to Maryland, where the little center of Annapolis, founded in 1694, is rapidly becoming an important town. Here we meet in the best drawing-rooms Justus Engelhardt Kühn (active 1708-1717), a German who fills the air with notes from his flute. He owns two horses and thirty-nine books; he is the custodian of the valuables at Saint Anne's Church: 'viz. two flaggons, one chalice, one dish, two salvers, one Holland table-cloth, and three napkins'; his clothes are so fine we would never suspect he was a painter.

But the man himself is not half as elegant as the pictures he produces; indeed, no resident of all Maryland is that elegant. Six-year-old Eleanor Darnall (ca. 1710) stands before an elaborate stone balustrade carved with baroque masks. Her flat figure, thin

as a paper cut-out, is superimposed on a formal garden that stretches down long vistas of ornate masonry to a domed and spired palace ten times larger than any building in the new world. The execution is slovenly and inexpert; the color has not weathered the years and is now predominantly chocolate-brown. Yet there is a certain primitive rightness in the placing of the figure which makes a photograph of the painting much more charming than the painting itself.

Dreams are as various as dreamers, and always they reflect the yearnings of the human mind. In their play-acting magnificence, Kühn's pictures express hope, aspiration, vision. Looking at these gleaming images, the Marylanders smiled with satisfaction, for this was the way they imagined themselves. Here was compensation for being Colonials; here was surcease for perpetual exile.

HENRIETTA JOHNSTON: *Colonel William Rhett* *Courtesy of the Gibbes Art Gallery*

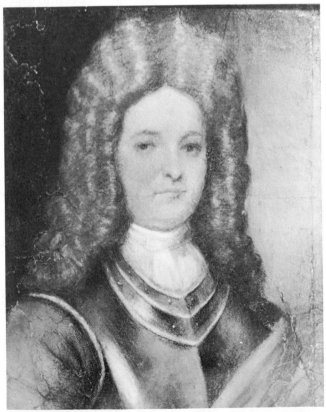

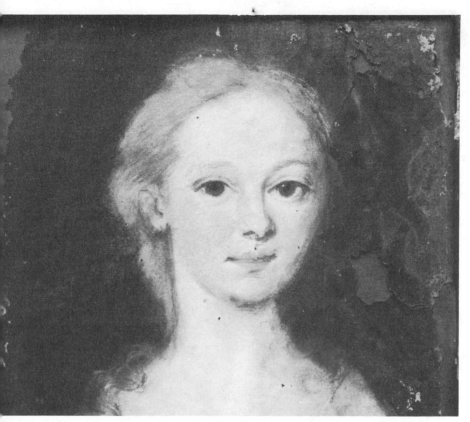

HENRIETTA JOHNSTON: *Anne Broughton (Detail)* *Courtesy of the Yale University Art Gallery*

The Maryland aristocrats were grateful to the artist. Charles Carroll, the mightiest of them all, served as Kühn's executor when the painter died in 1717. Expecting to handle a large estate, Carroll put up a bond of £500. But debts proved to be greater than the assets which totaled only £47.13.5. Seventeen 'pictures and landskips,' three unfinished, were valued at £2.10.0., and an unfinished coat of arms at one shilling. 'Several parcels of paint and all other things belonging to painting' were worth seven pounds. About a fifth of his estate — nine pounds — was accounted for by the elegant clothes which had so impressed the painter's contemporaries; much of the rest represented horses, pewter, etc.

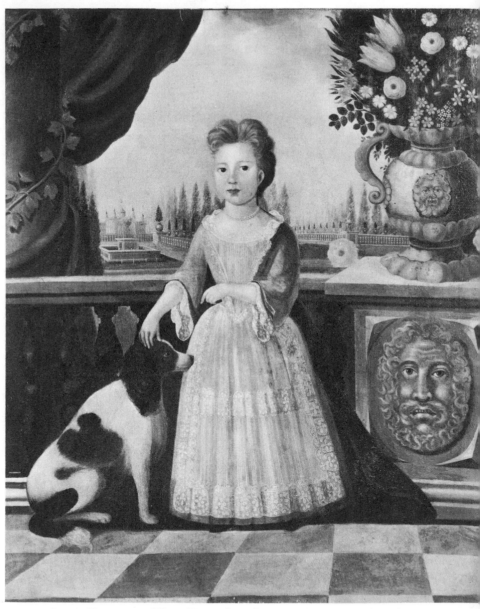

JUSTUS ENGELHARDT KÜHN: *Eleanor Darnall* *Courtesy of the Maryland Historical Society*

A drama of self-conscious colonialism closed with the discovery that Kühn's magnificence was as much a sham as the settings he gave his sitters.

Maryland was a border state between the cultures of the North and South. Although the economy was based on tobacco grown in large plantations, the fields were less fertile than those in Virginia, forcing the landlords to dilute their slave labor with indentured servants whose services could be secured for a smaller initial outlay. Earning their freedom after a term of years, these servants pulled Maryland culture in unaristocratic directions. We need not be surprised then that the painter who succeeded Kühn exemplified more bourgeois tendencies.

Gustavus Hesselius, a relation of the Protestant leader Emanuel Swedenborg, was born during 1682 in central Sweden to a family that bristled with dissenting ministers. He came to this country with his reverend brother Andreas who had been given a parish in the Swedish colony on the Delaware. The two arrived at Christina, now Wilmington, in 1712, but, so the church record tells us, 'Mons. Gustaff Hesselius after a few weeks flyted on account of his business to Philadelphia.' He lived for protracted periods in that city and on the eastern shore of Maryland, making painting trips to Delaware and perhaps Virginia.[3]

God was no easy companion for this artistic sport in a long line of ministers; seeking always a truer revelation, he shifted from sect to sect. He began, of course, in the Swedish Church of his fathers. While in Maryland, he succumbed to a more ritualistic relation to God. His membership in the fashionable Church of England must have helped him professionally, but his non-conformist nostrils could not indefinitely suffer the scent of incense. On his return to Philadelphia, he embraced the low German sect of Moravians. Now he humbly laid his sins before his fellow seekers. In 1744, a church record speaks of 'Brother Hesselius' being uneasy in his mind about beating his Negro when in a passion. The elders considered the South a bad influence on him. 'Hesselius,' they noted, 'has a scheme to go to Maryland which might be a mischief to his soul.' During old age, he struggled back to the church of his childhood, dying during 1755 in the arms of a Swedish God.

Swedish art was a branch of the international court style, so closely allied to the British that a Scandinavian master, Michael

Dahl (1656-1743), became a leader of London fashion. However, the natural bent of Hesselius, scion of low-church ministers, was clearly toward more plebeian painting. Perhaps he hoped that in the New World he could escape from empty graces. If so, he was disappointed. Philadelphia, his usual headquarters, was a Quaker city, it is true, but those Friends who adhered to their hatred of worldliness refused to be painted at all. The other citizens, even if they did not demand extreme graces, wanted to be made charming. And on the eastern shore, where Hesselius lived from 1717 to 1733, there must always have been pressure to paint like Kühn.

Not willing to go the whole way into artificiality, Hesselius, in such commercial portraits as *George Ross* or *George Hawkins,* compromised by watering down his direct style with a thin sugar-solution of conventional graces. But when he painted a portrait of himself, suavity gave way to gnarled realism; the face was over-studied and overmodeled in a serious attempt at character probing.

His portrait masterpieces are two likenesses of Indians which were commissioned not as parlor decorations but as accurate records. Tishcohan (He-Who-Never-Blackens-Himself) and Lapowinsa (Going-Away-To-Gather-Food) were chiefs of the Lenni-Lenape tribe whose lands lay across the path of white expansion. When Hesselius painted them in 1735 for John Penn,[4] the Proprietor was trying to work out some way of stealing their possessions with a show of legality. Eventually, the Indians agreed to sell Penn all the territory beginning at a certain tree and bounded by a day and a half's walk. A day's walk was a standard measurement equaling about twenty miles, but the whites preferred a literal interpretation. They hired runners who charged down a surreptitiously cut trail, more than doubling the distance the Indians had agreed to. Lapowinsa is said to have complained that the sprinters 'no sit down to smoke, no shoot squirrel, but lun, lun, lun all day long.' It was as if the Indians had interpreted the English word 'foot' to mean the foot of a giant.

At the time Hesselius painted them, the chiefs were conferring with Penn, but had not yet been cheated. The artist portrayed in their faces the death of a race. Lapowinsa was an old man puzzled by the strange traders who sat around the camp fire in a parody of Indian ritual. His tight eyes, his wrinkles, his drawn mouth give

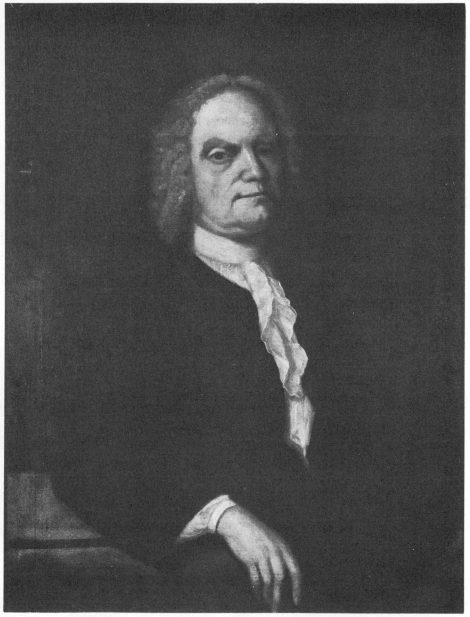

GUSTAVUS HESSELIUS: *Self Portrait* Courtesy of the Historical Society of Pennsylvania

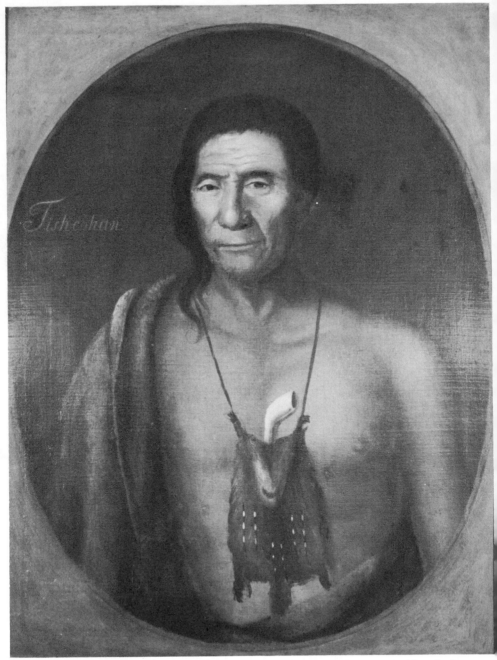

Tishcohan

GUSTAVUS HESSELIUS: *Tichcohan*　　　*Courtesy of the Historical Society of Pennsylvania*

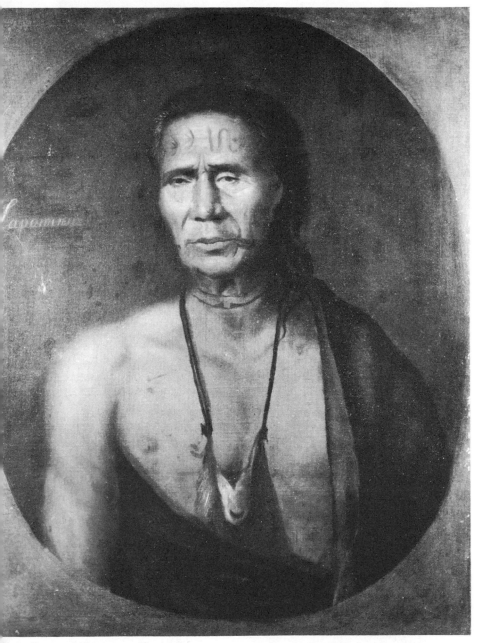

GUSTAVUS HESSELIUS: *Lapowinsa* *Courtesy of the Historical Society of Pennsylvania*

him an intensity that in a European would be close to tears. Yet there is a fierceness about him, and a nobility. He is a patriarch, permitted no longer to walk in the old ways, yet determined to follow his ancestral Gods, if need be to destruction.

Tishcohan represents the younger generation changed by contact with the whites. His face is wrinkled up in a smile, ingratiating and oily. He looks sly and pleased with his own cleverness, as if he thought he could meet the white men on their own ground and trick with the best of them. Yet his cockiness is the cockiness of a servant. The cheap European clay pipe in the chipmunk pouch that hangs against his chest is a symbol of degradation.

Hesselius probably made no such analyses. These portraits of Indians with their faces painted in ritualistic designs, their bead necklaces, their blue blankets wrapped round their naked chests, are awe-inspiring and strange, but not because the artist was trying to be picturesque. He painted the red men as he saw them; the result is moving because his own nature was stirred.

How great a contrast are the classical compositions Hesselius attempted! Study of life gives way to imitation of engravings. He decided to paint a *Bacchanalian Revel,* but his conscience restrained his painting hand. Although it shows naked torsos, giving us our first definite evidence that our American ancestresses were shaped like our wives, the picture amuses by its lack of abandon. The lightly clad males and females stand separately on the two sides of the picture as if in a Quaker meeting, while sin is represented by a bunch of grapes at which one of the females stares fixedly. There is a touching yearning about such a picture. The religiously obsessed artist calls for pagan goddesses to come out of America's Jehovah-haunted underbrush and transport him to a world of esthetic glory he has dreamed of out of books. But in vain.

For Triton was dead; it was apostles who cast their nets in the wilderness sea. When Hesselius painted religious pictures, artificiality gave place to the deep sincerity that was the best part of his nature. During 1721, the vestry of Saint Barnabas Church in Prince George's County, Maryland, commissioned 'Mr. Gustavus Hesselius to draw the history of our Blessed Savior and the twelve apostles at the Last Supper, the institution of the Blessed Sacrament of His body and blood, proportionable to the space over the altar piece, to find the cloth and all other necessaries for the same

[100]

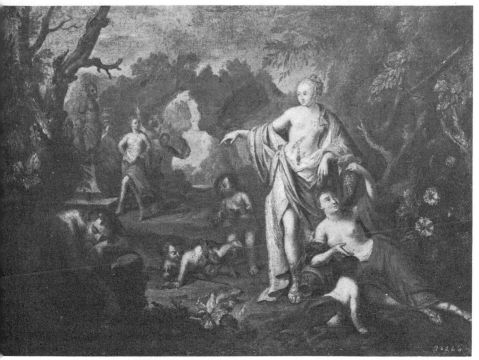

Gustavus Hesselius: *Bacchanalian Revel* *Courtesy of Mrs. F. H. Hodgson*

(the frame and gold leaf excepted which Mr. Henderson engages to procure and bestow on the church). Mr. Hesselius to paint the frame, for all of which the vestry is to pay him when finished £17 current money, and Mr. Hesselius further engages to have it fixed upon the altar at his own cost.'

Although the resulting composition was undoubtedly based on a print, the artist did not, as in his *Bacchanalian Revel,* make an empty copy. Despite his use of baroque chiaroscuro, sincerity of feeling carried him into an archaic awkwardness reminiscent of older styles. This is an authentic translation of a sophisticated manner into the vernacular; a clumsy picture but an emotional one.[5]

Hesselius painted other religious subjects. In February, 1748, strollers down Philadelphia's High Street were drawn motionless by a representation of the Crucifixion in the artist's window. Perhaps this was the picture which John Adams described years later

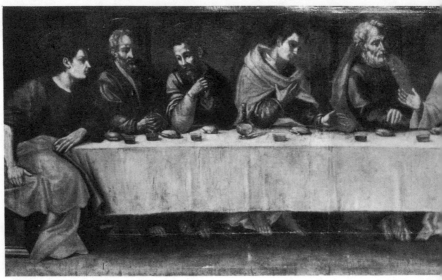

GUSTAVUS HESSELIUS: *The Last Supper*

as hanging in Saint Mary's Roman Catholic Church: 'The cruci-
fixion by Hesselius, with the bloodstains trickling down, the mob
of Roman soldiers, the darkness, etc.'

That Hesselius concerned himself with many types of painting,
an advertisement in the *Pennsylvania Packet* shows: 'Painting done
in the best manner by Gustavus Hesselius of Stockholm and John
Winter of London. Viz. coats of arms drawn on coaches, chaises,
etc., or any kind of ornaments; landskips, signs, show-boards, ship
and house painting, gilding of all sorts, writing in gold and color,
old pictures cleaned and mended, etc.' He also made organs and
spinets, demonstrating that union between painting and music that
we find exemplified again and again in early records.

Despite his sojourn on the Eastern Shore, Hesselius can hardly
be considered an exemplar of Southern culture. Philadelphia was
his headquarters during most of his American career. The Mo-
ravians who feared for his soul in Maryland might also have feared
for his artistic integrity, since his philosophy was basically middle-
class.

Gustavus Hesselius' son John (1728-1778) was for many years
the leading painter of Maryland. According to the chauvinistic

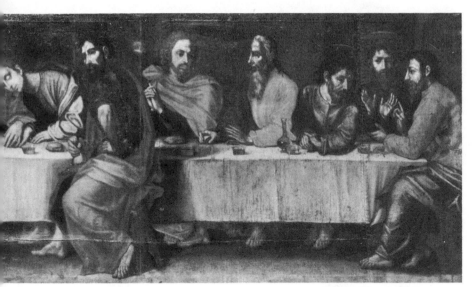

Courtesy of Mrs. Rose N. Henderson

rule of thumb about American art, the younger Hesselius, who was native-born and native-trained, should have differed from his foreign father by being less mannered, more downright, more 'democratic.' The opposite was the case. John Hesselius, who married well and lived like a country gentleman on the Eastern Shore, drained from his father's work all that was quiet and sincere. Character study appears in his portraits only in an occasional untypical flash. He filled the vacuum with aristocratic finger exercises copied from a visiting Englishman, John Wollaston.[6] John Hesselius was a more gracious colorist than his father, and was thus enabled to produce some pictures with decorative charm; *Charles Calvert and Colored Slave* (1761) is one of his best. But in his search for the noble and the impressive, he often lost touch with humanity almost altogether. He enlarged the features of young ladies until their heads are too small to carry them, and the babies he painted have been inflated, perhaps in search for robustness and health, until they look like featured sausages.

The most successful depicter of Southern aristocrats appeared in Virginia in 1735, after the Patroon Painters had waned in New York, and when Smibert had already settled in Boston. The new-

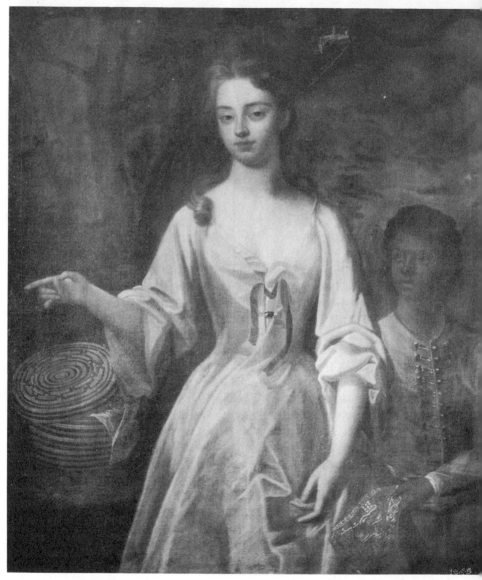

CHARLES BRIDGES: *Mrs. William Byrd* Courtesy of the Misses Stewart

comer, Charles Bridges, was an elderly practitioner whose style had long since hardened in the British court mold.[7] William Byrd II, Lord of the great manor of Westover, described him in a letter as 'a man of good family' who 'either by the frowns of fortune or his own mismanagement is obliged to seek his bread . . . in a strange land.' Although he 'has not the master hand of a Lely or a Kneller,' he deserved to be 'sergeant painter of Virginia.'

Bridges presented a letter of introduction to Governor William Gooch. The king's representative lent him his carriage and entertained him at dinner, but could not help thinking that 'it looks a little odd for a governor to show so much favor to a painter.'

However declassé he may have been considered, Bridges was the most skillful exemplar of purely aristocratic painting ever to reach America. His portrait of Wilhelmina Byrd with her colored servant behind her is painted with delicate restraint and some three-dimensional form. Clad in cool colors; young, feminine, and aristocratic in gesture; surrounded tastefully with the proper accessories, material and human, of rank, she could step easily into the pages of a romantic novel where all the action takes place in the drawing rooms of the old South. The dashing cavalier who will some day draw her to his side will not bruise the innocence of her look; age will draw no lines on her brow, for she is an ideal toward which her society yearned.

A few months after his arrival in the New World, this English artist was able to create the most satisfactory symbols of the Southern aristocratic dream, for that dream too was an importation. Miss Byrd herself had known the strangeness of wild places and the loneliness of Colonial exile. Perhaps she was further from the ideal than the image the British artist painted. Perhaps no native limner, marked by the strange land on which he trod, could have created so satisfactory a vision.

Bridges' American career was brief, but in those few years he practiced an art eminently suited to the philosophy of his patrons. He left behind him pictures to serve as models. We should expect that, like Smibert in New England, he would be the founder of a native school. He did have a few imitators; the painting of *Mrs. Mann Page II and Baby John,* although close to him in style, is probably too late to be his work. One of the best attributed to a Bridges follower, the picture is not without virtues, yet the signifi-

[105]

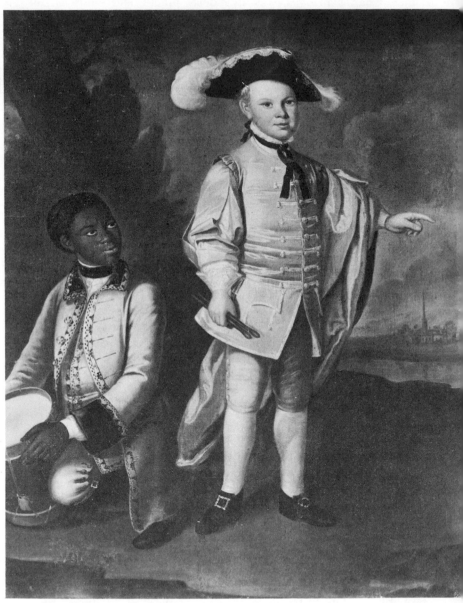

JOHN HESSELIUS: *Charles Calvert and Colored Slave*

Courtesy of the Baltimore Museum of Art

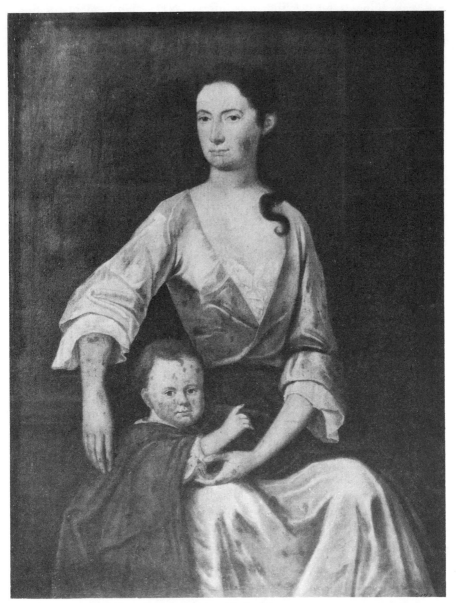

AMERICAN SCHOOL: *Mrs. Mann Page II and Baby John*

Courtesy of William and Mary College

cant thing about it is that it is inferior to the achievements of the master. Smibert's first disciple, Robert Feke, was a greater painter than he, but no Virginia artist was to produce work commensurate in quality with Bridges' finest pictures. The progression was always downward, and soon the impetus supplied by the English artist died completely out.

At about the time of Bridges' disappearance, the following advertisement appeared in the Charleston *South Carolina Gazette*: 'Jeremiah Theus, limner, gives notice that he is removed into Market Square, near Mr. John Laurens, sadler, where all gentlemen and ladies may have their pictures drawn, likewise landscapes of all sizes, crests and coats of arms for coaches or chaises. Likewise for the convenience of those who live in the country he is willing to wait on them at their respective plantations.'

Theus was a Swiss. Occasionally in a male face we suspect a yearning toward character study, but usually he made use of stereotyped features, brightly complexioned. Gleaming clothes cover the cast-iron shapelessness of the sitters' bodies. He was a painter without dash or inspiration or any natural ability, except perhaps as a colorist, but he had learned his lessons in the Old World well enough to turn out portraits that made a handsome show of elegance. This knack paid off so well that he dominated South Carolina art for thirty-four years. When he died in 1774, he left a fortune.

Our expectation that plantation life would fuse with aristocratically inspired foreign sources to create a valid art has been unrealized: some aspects of the environment were deadly to painting. Although in its early years, the South had been settled by freeholders,[8] after the sixteen-eighties the less prosperous whites were swamped by a rising tide of slaves. In the new economy, floating bits of London moored at the planters' own wharves, loading a cash crop — rice or tobacco — and bringing in exchange manufactured goods. When there were no banks closer than the English counting-houses, the whole economic system drove the Southerners to buy anything elaborate — furniture, silver, paintings — abroad. George Washington was typical when he ordered from London 'one neat landskip three feet by 21½ inches.' He was sent a composition 'after Claude Lorraine.'

Skilled artisans were rare in the South. Not only would they

[108]

JEREMIAH THEUS: *Mrs. Gabriel Manigault* Courtesy of the Metropolitan Museum of Art

have had to compete with the greater prestige of London workmen, but the currency situation was against them. Since the planters, whose purchases were regal, were continually in debt to their London agents, little cash flowed back to America in return for exported crops. Virginia artisans had to take their pay in tobacco; Bridges, for instance, received sixteen thousand pounds of it for painting the royal arms. What was he to do with this mass of stuff that had to be carried to England before it deteriorated? If a man must trade in tobacco, he did better to drop tools and brushes, to grow it himself.

Crafts like carpentry and blacksmithing could not be carried out by London workmen; to supply such needs colored men were given manual training. Each major plantation had its brick workshop where favored slaves labored but the mistress of .the house, gathering up her skirts to step over the threshold, entered from another world. Although a few Negroes were permitted to attempt portraiture, they were not sufficiently part of the white man's world to express it in paint.[9]

The economy discouraged the growth of cities and of the artisan class from which painters up North were recruited. In the South, an artist could not make part of his living from another trade. Yet in order to get any business at all he had somehow to build up enough prestige to overcome the lure of transatlantic pictures and to get himself specifically invited to the individual plantations of potential sitters. Under these circumstances, it was almost impossible for native artists to arise. Thus Southern painting was a procession of foreign practitioners: Johnston, Bridges, Kühn, Theus, Wollaston, etc.

The white men in the South were divided into two classes. The poor settlers, already being driven into the Piedmont, remained like their more prosperous Northern brethren a force in reserve; they were too busy fighting for existence to engage in art. But the plantation owners had leisure to cultivate the graces of living; why did they not create pictures? Evidence indicates that they did paint as amateurs. Playing with the Renaissance ideal of versatility, the Southern gentlemen gleamed with decorative information on many arts and sciences, but only in law and political doctrine, which vitally affected their well-being, were they permitted to be experts. Since they had to build houses far from London, a

few studied architectural books and designed their own. But to be really skillful with one's hands was definitely lower-class; it would hardly do for a gentleman to paint like a professional. Who would want to be confused with Bridges, to whom Governor Gooch hesitated to lend his carriage?

The existence of servile workmen who were bought and sold removed all dignity from manual labor. The slave, in taking the plough and hammer from the white man's hand, took also, in a more subtle way, brush and canvas. Only in less prosperous Maryland, where indentured servants cultivated the fields, was painting to rise. Art in the real South was to languish for many generations before it recovered from that peculiar institution, slavery.

CHAPTER FIVE

A Prophet Enters the Wilderness

JOHN SMIBERT revivified New England painting, creating a school that was to include the great Colonial masters, Robert Feke and John Singleton Copley.

When Smibert first opened his eyes at Edinburgh in 1688, the father who leaned over him, so big and impressive, was really nothing but a dyer. After the lad's legs had grown strong enough to carry him into the street, he learned what this meant. Wigs and swords swept by, but such things were not for him. His fate was a leather apron. In the Old World, it was almost impossible to live down the original sin of not being born a gentleman.

Probably when he was fourteen, his father led him into the shop of a house-painter and plasterer. The stranger looked the boy over carefully, his elders discussed terms, and then an indenture was signed. For many years, Smibert was to live in this new house and serve this new master. Then he would be a house-painter and plasterer, too.

During his idle moments, the boy combined the heavy pigments of his trade into pictures. His naïve works seem to have elicited a criticism that would hardly have been heard in America; Smibert learned that it was presumptuous to try to paint until you had drawn from the antique. The youth developed 'a strong inclination to drawing,' but had no opportunity. Long years rolled by to the swish of the house-painter's brush and the pound of the trowel. Then Smibert was twenty-one and a free man.

He threw reason aside and journeyed to London hoping to become a painter. Swallowed up by the metropolis of splendor and poverty, riches, mud, and vice, he had difficulty keeping even a few pence in his pocket. He worked sometimes for a coach-painter, putting his soul into depicting the strange animals that walk in a

coat of arms. Finally he was employed to make the copies of old landscapes which the middle-class used as decorations in their homes. When fashionable portrait-painters rolled by in carriages, he pressed himself against walls to keep from being splashed by the mud from their wheels.

At about twenty-eight, he secured admission to the only art school in London, the Great Queen Street Academy, directed by James Thornhill. Once he had imitated his betters by drawing antique statues, he felt more confident; returning to Edinburgh 'he tried to paint faces.' Soon he was back in London, and then amazingly he made a trip to Italy. Where the funds came from it is hard to say; perhaps he traveled in the suite of some rich gentleman.[1]

Eagerly he copied old masters. As he tried to reproduce the head and shoulders of Van Dyck's *Cardinal Bentivoglio*, every brush stroke should have been accompanied by claps of thunder in the wilderness, for his copy was to be a major influence in American art, giving such men as Copley, Washington Allston, and John Trumbull their first hints of a richer portrait style.

Having completed his copies and purchased, as was proper, a few casts, Smibert returned to London, made over by his European sojourn into a professional painter. Now he enjoyed a little success. He was elected to the less important of the two artists' clubs and was listed by Vertue as one of the twelve painters of the second rank.

He found himself in a professional world run on cut-throat principles. The aging Kneller still led the field, although his production line turned out execrable pictures. When asked if he did not fear for his reputation, he replied that the scholars of the future would not dare attribute such terrible daubs to him.[2] So great was his influence on England's native artists that thirty-two years after his death a French observer described the typical London painter as working at 'a frightening speed' which encouraged incorrectness and negligence. An artist counted less on talent 'than on the support of some powerful friend, some fashionable lady . . . His object is not at all to paint well but to paint a great deal,' for if he could succeed in making himself a fad, he could for a time command all the best commissions in England. 'It is fashion which conducts the public to a painter of whom it

has not too good an opinion, to get him, because of vanity, to start a portrait which the sitter does not need and will receive with regret. But the women particularly are determined that their portraits should be seen in the studio of the painter of fashion.'

Even as late as 1757, when he painted *Mary, Duchess of Ancaster,* Thomas Hudson was working in the Kneller mold.

Poor, low-born Smibert was not happy in this whirlpool; Walpole remembered him as 'a silent, modest man who abhorred the finesse of his profession.' Thus he listened eagerly when the philosopher, George Berkeley, approached him with a scheme to establish for the Indians in Bermuda 'a universal college of arts and sciences.' Berkeley wrote:

> In happy climes, the seat of innocence,
> Where nature guides and virtue rules,
> Where men shall not impose for truth and sense
> The pedantry of courts and schools,
> There shall be sung another golden age;
> The rise of empires and of arts. . . .

To Smibert he entrusted the artistic end of his savage renaissance. Giving up for such a venture a decent living, the result of hard labor, would not have appealed to the fashionable painters; that it appealed to Smibert was regarded as idiocy by that man of the world, Walpole.

Berkeley's party arrived at Newport, Rhode Island, during 1729. Awaiting the money promised him for his college, the philosopher bought a farm and settled down to propound, in his famous book *Alciphron,* the doctrine that all nature was the language of God, a conception that was to inspire the landscape-painters of the future. Smibert journeyed to Boston in search of business. He was instantly accepted by the New England aristocracy. Making a social jump that would have taken several generations in the Old World, he married a beautiful heiress, twenty years his junior.

In 1730, the artist staged the first art exhibition recorded in America. It was all described in a poem by a local Milton more inglorious than mute. New England, so sang the Colonial, had been devoid of culture till Smibert began to paint and he himself to write. Expatiating on the artist's portraits, he called the males by name and gave the ladies aliases out of antiquity. The dis-

cussion of the subject pictures reveals Smibert's taste. A Protestant satire shows how 'gloating monks their amorous rights debate,' while from other canvases 'Roman ruins nod their awful head.' Copies of Van Dyck, Rubens, and 'Th' *Italian* master' are listed, while casts of the Venus de Medici and Homer are styled 'the breathing statue and the living bust.'

> Lanskips how gay! arise in ev'ry light
> And fresh creations rush upon the sight. . . .
> Still wondrous Artist, let thy pencil flow,
> Still warm with life, thy blended colors glow,
> Raise the ripe blush, bid the quick eye-balls roll,
> And call forth every passion of the soul. . . .

Engraving after Thomas Hudson: *Mary, Duchess of Ancaster*
Courtesy of the New York Public Library

JOHN SMIBERT: *Copy of Poussin's Continence of Scipio*

Courtesy of the Bowdoin Museum of Fine Arts

In 1744, the Scotch-born Annapolis physician, Doctor Alexander Hamilton, visited Smibert's studio 'where I saw a fine collection of pictures, among the rest that part of Scipio's history in Spain where he delivers the lady to the prince to whom she had been betrothed. The passions are all well touched in the several faces. Scipio's face expresses a majestic generosity, that of the young prince gratitude and modest love; and some Roman soldiers, standing under a row of pillars apart, in seeming discourse, have admiration delineated in their faces. But what I admired most of the painter's fancy in this piece is an image or phantom of chastity behind the solium upon which Scipio sits, standing on tiptoe to crown him, and yet appears as if she could not reach his head, which expresses a good emblem of the virtue of this action. . . .' Such considerations fall hard on the ear of contemporary connoisseurs, yet they were typical of eighteenth-century taste. We may smile at nothing but Doctor Hamilton's failure to realize that the picture was a copy after Poussin.[3]

[116]

Since the money for his college never arrived, Berkeley accepted an Irish bishopric. In 1735, he tried to lure Smibert to Cork by promising him many times the portrait business Boston afforded. Smibert refused to move. Walpole, to whom the whole American adventure seemed absurd, put this down to 'irresolution,' but Smibert himself tells us a different story. He wrote a London correspondent, 'Your account of the state of painting and painters with you shows a very fickle temper, and is no recommendation of your great town.' He believed that taste at home was 'at a low ebb. If the arts are about to leave Great Britain I wish they may take their flight into our new world.' Thus in one of the earliest surviving letters by a Colonial painter, we find it implied that European art was decadent, and the hope for painting lay in America.

Concerning himself, Smibert wrote, 'I have as much [business] as keeps me employed.' He set up an art shop where he sold painters' materials, engravings, fan mounts, etc. In the back room, a slave called Cuffee, formerly a sailor, ground paint until the longing for the free life of the ocean became too great. In an advertisement, Smibert threatened any sea captain who gave his property employment, and described the runaway as 'a pretty tall, well-shaped Negro with bushy hair; has on a large, dark-colored jacket, a pair of leather breeches stained with divers sorts of paints, and a pair of blue stockings.'

Smibert was a prominent citizen who, so his nephew wrote, 'never was rich, but always lived handsomely and with great reputation.' He held minor civil offices, and tried his hand at architecture, designing the town market which is known to history as the cradle of liberty, Faneuil Hall.[4] In 1749, he wrote, 'I need not tell you that I grow old. My eyes have been sometimes failing me, but is still heart whole and hath been diverting myself with something in the landskip way, which you know I always liked.' He died during 1751, leaving a substantial estate. His son, Nathaniel, started to follow in his footsteps as an artist, but died at the age of twenty-two.[5]

Of Smibert's original paintings, only portraits remain. The style he brought with him to America is shown by the tremendous picture of Bishop Berkeley's party — eight life-size figures, including a self-portrait — which he painted on his arrival at Newport. He gave himself a small, round head; a nose too long and sharp; a

full mouth over a receding chin. The expression is irritable, disgruntled, and sad; an epitome of disappointed bitterness. We recall Vertue's statement that Smibert had left London because 'he was not contented to be on the same level with some of the less painters, but desired that he might be where he might at the present be looked on at the top of his profession.'

In addition to its human story, this face tells us an esthetic one; all by itself it refutes the hackneyed statement that Smibert brought Kneller's worst mannerisms to America. Although the artist was harder on himself than on his companions, none of the heads in the *Berkeley Group* are ideal. The portrait of the scribe in the foreground is masterly in its realism, while even the two ladies and the pious Berkeley are shown with as much accuracy as good manners. The churchman's hand is a strange hand that Kneller would never have painted, for it is distorted from grace by living flesh.

When Smibert set foot on New England shores, he had already moved toward the bourgeois realism which was to produce the American masterpieces of Copley. That this has usually been denied reflects, I fear, a nationalistic desire to make American art opposite to the British. In reality, the two civilizations were evolving along parallel lines. Like many another leader of American thought, Smibert was a European revolutionary who, in his dissatisfaction with his homeland, carried to the New World the advanced ideas of the Old.

England's society was no longer truly aristocratic. Land owning, the traditional domain of titled men, was becoming so secondary in British economy that Government policy encouraged agriculture in the Colonies, making trade and manufactures a monopoly of the homeland. Beneath the ermine on many a titled breast there beat the superficially renovated heart of a money-changer. Perhaps the court style had deteriorated so in the hands of Kneller and his successors because it had ceased to be a true reflection of British life.

The evolution of taste trails behind economic evolution, yet it does not stand still. By Smibert's time, the international court tradition showed signs of breaking down. Writers like Shaftesbury exhorted British painters to eschew foreign masters and create a national style. Even the most sophisticated portraitists wavered

JOHN SMIBERT: *Self Portrait: detail from Berkeley Group*

Courtesy of the Yale University Art Gallery

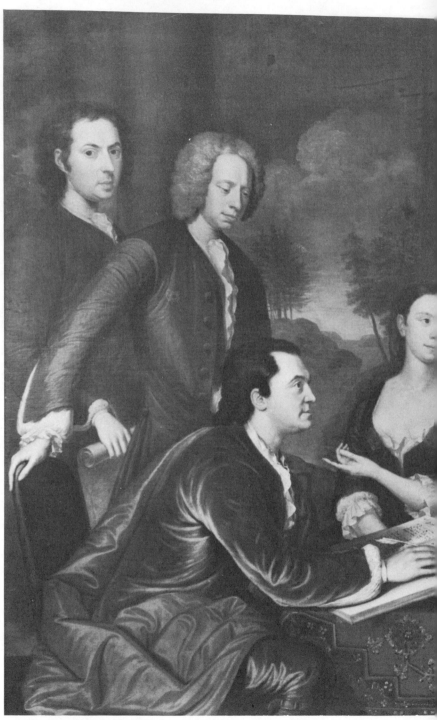

JOHN SMIBERT: *Bishop Berkeley and Friends*

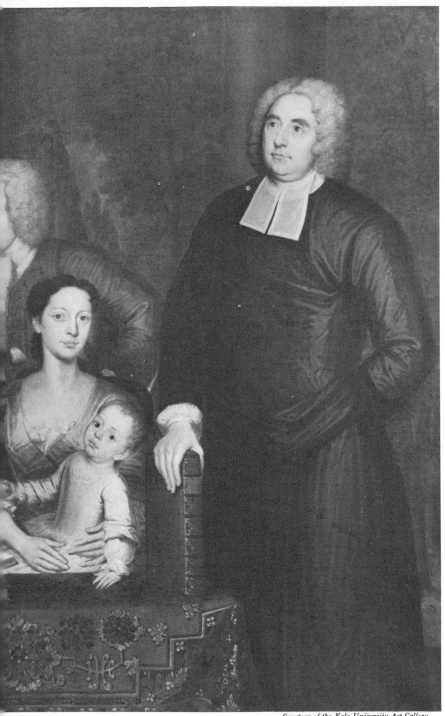

Courtesy of the Yale University Art Gallery

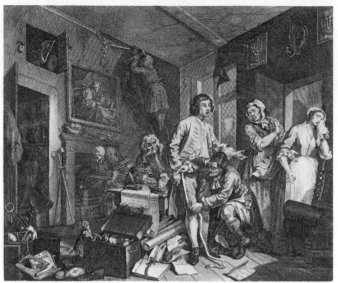

WILLIAM HOGARTH: *The Rake's Progress, I. A bourgeois lad, having received his inheritance, starts on the road to perdition* Courtesy of the New York Public Library

sometimes from the old ideal, perhaps unconsciously. Jonathan Richardson's self-portraits, for instance, have a massive, bull-dog reality that presages a new revelation.

Only eleven years younger than Smibert, in full career when the Scotch painter emigrated to America, Hogarth was the prophet of a new day. Like Smibert, he had received the plebeian education of an apprentice. A social as well as an artistic revolutionary, he preached the moral, sober, thrifty way of life so dear to the middle classes. Aristocrats entered his world as the debauchers of virginal commoners; and young men who imitated their profligate manners were sure to end up dead in a duel or screaming in a madhouse. Hogarth's affinity was not with the classical taste of Dr. Johnson, but with that pioneer sentimental novelist, Samuel Richardson, who also contrasted the purity of the lower orders with the vices of the great.

Gentlemen connoisseurs found Hogarth's subject matter low and his style crude; he had great difficulty selling his paintings. But when the same paintings were engraved, they enjoyed tremendous sales and great celebrity. The radical painter had found a mass market new in the history of British art; he made his living not from a few large fees, but from the accumulation of small sums expended by the multitudinous middle class.

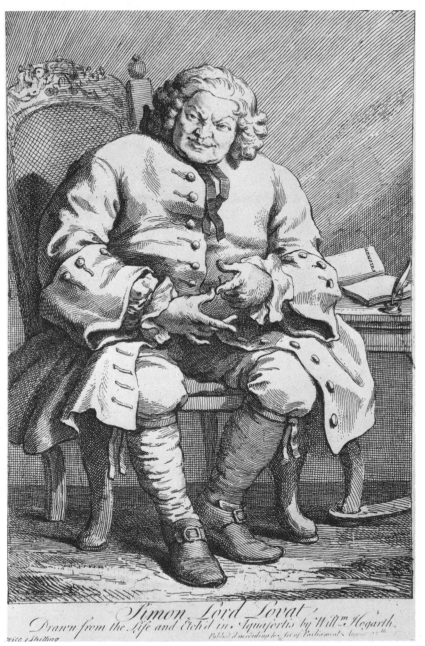

Simon, Lord Lovat.
Drawn from the Life and Etch'd in Iquafortis by Will.ᵐ Hogarth.
Price 1 Shilling.
Publish'd according to Act of Parliament August 25ᵗʰ

WILLIAM HOGARTH: *Simon, Lord Lovat*

Courtesy of the New York Public Library

Smibert, of course, was not as great a painter as Hogarth, nor was he as conscious of being in revolt. Making portraits his business, he never broke completely with fashionable taste. Two ages of man warred within the domed arena of his skull. Inhibited by background and temperament from achieving true elegance, but yet eager to please, he painted with his will rather than with his whole being. The *Berkeley Group,* where he was able to express himself freely, shows considerable technical proficiency, but form, color, composition are all labored and ponderous. The tendency of the period to overmodel faces until they look unpleasantly pneumatic was also typical of Hogarth, but Smibert's heavy rendering makes it a conspicuous blemish. He was well-trained, serious, and competent, but he lacked the charm and fluency essential to a triumphant London career. When he joined Berkeley's revolutionary band, he was motivated by disappointment as well as idealism, despair as well as hope.

In the first pictures he painted on these shores he abandoned fashionable English practice to create likenesses that are almost caricatures. He molded the face of that toothless old worthy, Nathaniel Byfield, with heavy bluish shadows put on, one might imagine, not with a paint brush but an axe. The result is powerful and ugly. Were not Smibert's training revealed by the skill with which the head is drawn in the round, had not the picture been included in his exhibition of 1730, we would be inclined to attribute *Byfield* to some poor but honest Colonial paintchopper. On his arrival in the savage Elysium to which Berkeley had allured him, Smibert threw off fashionable restraints with the enthusiasm of a teetotaller abandoning the pledge. That his behavior was at first grotesque was to be expected.

Smibert did not continue on the road toward bourgeois realism long enough to develop a new and valid style. When he took a second look at the savage Elysium, he saw it was very like London except that the fences between classes were low and easy to hurdle. Quickly he married well and became himself a social leader. Now he played the gentleman with the best of them. A Colonial patrician wrote in 1747, 'I am favorably impressed by Mr. S., whose ingenuity is equalled by his industry and surpassed by his deportment.'

When Smibert painted his pretty wife, who had been the

[124]

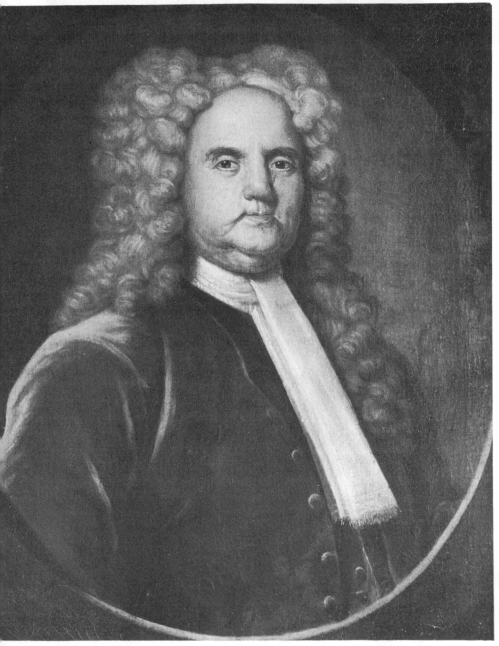

John Smibert: *Nathaniel Byfield* *Courtesy of the Metropolitan Museum of Art*

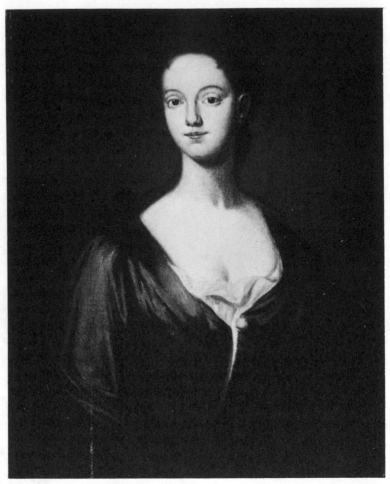

JOHN SMIBERT: *The Artist's Wife* *Courtesy of the Massachusetts Historical Society*

catalyst of his social change, he remembered all he knew of fashionable English practice, combining an alabaster brow, doe eyes, and a swan neck into a likeness as stilted as it was correct. That this portrait, like his realistic *Berkeley Group*, was painted for his own pleasure makes the contrast between the two pictures all the more startling. The dyer's son, in the Old World on the wrong side of the railroad tracks, had like many another immigrant scrambled in America to temporary eminence. Revolt, once a living force, became an uneasy memory.[6]

Smibert's backslide is revealing, but it does not by itself explain why America failed to produce a Hogarth of her own. The very rapidity of social progress impeded progress in art. That English society evolved slowly, suffering no sharp break, enabled Hogarth to satirize it without stepping beyond established patterns. His subject matter was London, a national metropolis. His cast of characters — the lord, the dandy, the dancing master, the milkmaid, the drunken derelict — were recognizable to everyone. When he showed a young lady trying to recoup her gambling debts by staking her virtue on a last turn of the cards, he created a parable that was as clear to Doctor Johnson's circle as to any shopkeeper; indeed, Mrs. Thrale boasted that she sat for the figure of the imperiled innocent.

In America, new ideas were growing up in strange ways in widely separated places. The axe, the freehold farm, the explorer aiming his Kentucky rifle: these symbols did not exist in the iconography of art. Revolt expressed itself on that river bank by the determination of farmers to build a clapboard meetinghouse where it would be convenient for them rather than for the rich men of the village. You could not tell this story in paint so that

JOHN SMIBERT: *Benjamin Colman*　　　　　Courtesy of the Macbeth Gallery

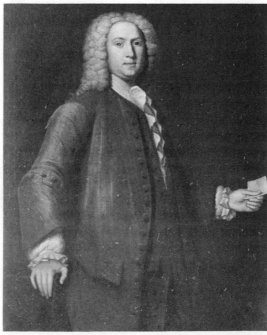

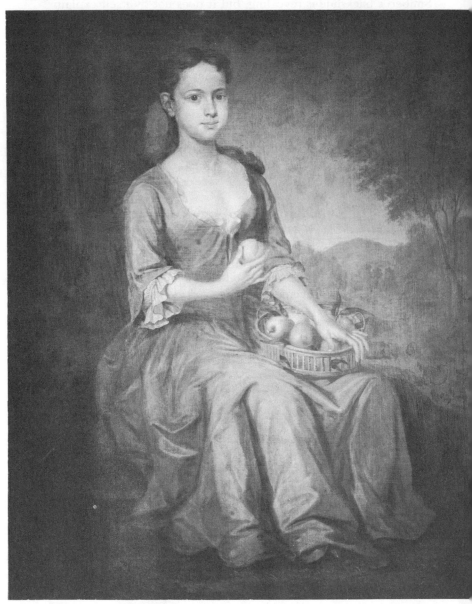

JOHN SMIBERT: *Jane Clark*

Courtesy of the Massachusetts Historical Society

it would have meaning even for a burgher of New York. The industrious apprentice was a familiar enough figure, but how, in a world used to static symbols, were you to make people understand that the fine gentleman in the second picture was the same man? [7] Hogarth would have kept the apprentice ungainly and preached that he would be destroyed if he attempted to jump class lines. But in America, there were no stable classes. Under the veneer depicted by the portrait painters, everything was in turmoil. True, there hovered over all a single genius of change, supported by the twin wings of cheap land and easy opportunity, but synthesis lay far in the future. Of all phenomena, change is hardest to paint.[8]

Although esthetic expression is inter-related with social evolution, there is a limit to the steepness of the slope up which art can travel. If society moves too quickly, it leaves art — i.e., synthesis — so far behind that contact is temporarily lost. Thus revolutions rarely carry painting with them. The art of the French Revolution fled under the leadership of David into archaism; it is not 'Republican' but 'Empire.' In the same way, contemporary Russia is floundering in highly traditional forms.

Smibert, when he found himself a member of the class that roosted so precariously on the pinnacle of Boston society, banked down the revolt that had once flamed within his breast. Yet, a comparison of his canvases with those of the Virginia master, Charles Bridges, shows that he remained basically a middle-class artist. It was his great gift to America that seeds of both the past and the future of English painting lay within his style, waiting to quicken in the work of two generations of native artists who raised their own conceptions on the foundations he laid. The first of these was the first great name in American art: Robert Feke. The direction in which his work traveled will give us further insight into Colonial society.

CHAPTER SIX

The Lyrical Mariner, Robert Feke

ABOUT 1741, a seafaring man made the acquaintance of Smibert, probably by walking into his art shop and expressing an interest in paints and prints. He revealed none of the swagger that usually accompanied the web-footed gait of the sea. 'This man,' a contemporary wrote, 'has exactly the phiz of a painter, having a long, pale face; sharp nose; large eyes with which he looked upon you steadfastly; long, curled black hair; a delicate white hand; and long fingers.' The newcomer introduced himself as Robert Feke. Smibert, who was to befriend him, undoubtedly asked his history; it would be worth years of research to listen in on the reply. Although a persistent rumor, which cannot be traced back before 1860, states that Feke was born in Oyster Bay, Long Island, the son of a prosperous Baptist preacher, our first certain evidence that he existed is the writing on the back of a portrait. After identifying each of the five life-size figures as members of the family of the Bostonian Isaac Royall, the inscription states: 'Finisht Sept. 15th 1741 by Robert Feke.' [1]

This picture proves that Feke frequented Smibert's studio, for it is based on the *Berkeley Group* that was hanging there. Feke arranged his own sitters in similar poses to Smibert's around a similar table covered with a Turkey-work rug. The reader, who has the illustrations before him, will find it amusing to identify the many duplications of detail. Yet Feke's canvas is far from being a slavish copy. Indeed, where the painting is closest to Smibert, it is least expert. In the head of the second lady on the right, which seems to be falling off its neck, Feke had tried unsuccessfully to imitate the equivalent pose in the *Berkeley Group*, which showed the lady looking downward with her forehead further forward than her chin. On the other hand, the lady at the end of the table, who

is not based on the *Berkeley Group*, is the most successful of Feke's figures. Her green dress with yellow highlights is handled with considerable sureness. She has grace, good proportions, and an air of gentle charm. If separated from the rest of the *Royall Family*, she would be a portrait both finished and conventional according to Colonial practice. The standing figure of Mr. Royall is also successful, and also more traditional than any of Smibert's figures.

In modifying the composition of the *Berkeley Group*, Feke destroyed it; his sitters are given little relation to each other in space and design. Yet the picture is much more charming than analysis implies. All the forms, even when crudely drawn, have a gentle sensitivity. The whole is bathed in a delightful soft radiance of hues which shows that Feke, even at the start, was a subtler colorist than his master.[2]

We gather that when he visited Smibert's studio, Feke was already competent in painting conventional single portraits. Where he procured this experience, we do not know. If he really came from Oyster Bay, he could have been familiar with Patroon paintings. His style has many similarities to the De Peyster Manner, but it would be extremely difficult to prove this the result of direct influence. The lyrical mood was typical of much Colonial painting. As a mariner out of New York or New England, Feke would have been carried to the British Isles, where he could have assimilated identical technical tricks. And engravings were always available in the New World. We must leave the question open, for, textbooks to the contrary, no canvases exist which were certainly painted by Feke before he fell under Smibert's influence.[1]

How great was this influence is further shown by Feke's self-portrait. It is amazing that no one has noticed that his most famous of his early works is based on the self-portrait of Smibert placed in the rear of his *Berkeley Group*. The two heads are in exactly the same pose, the eyes similarly handled. If we take into consideration the fact that during some attempt at cleaning the Feke portrait was skinned, losing the shadows and highlights with which it was originally modeled, its resemblance to the Smibert painting becomes even more obvious. Indeed, Feke followed Smibert's picture so closely that he shaped the features in very much the same manner. A quick glance gives the impression that the two pictures are of the same person.[3]

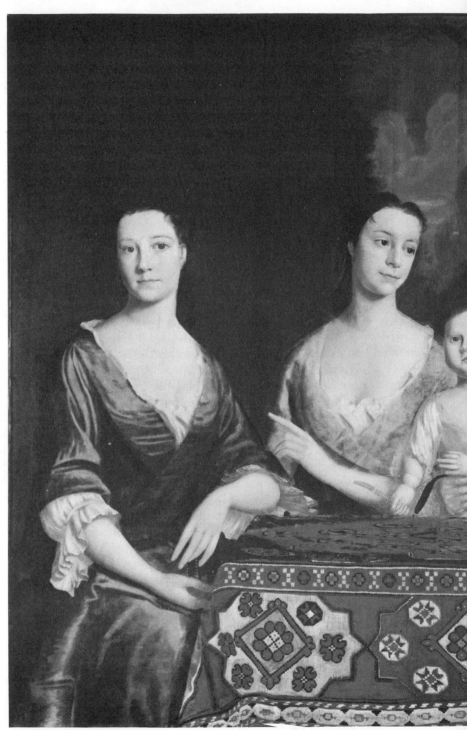

ROBERT FEKE: *Isaac Royall and Family*

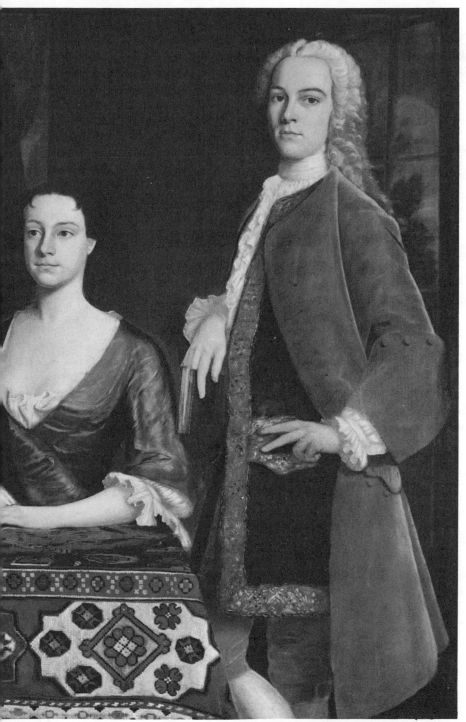

Courtesy of Harvard University

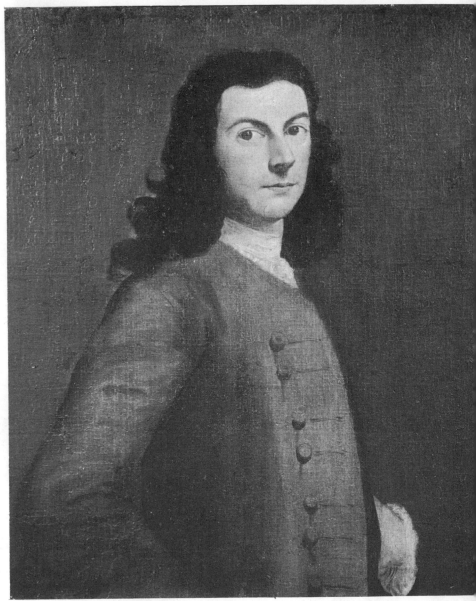

ROBERT FEKE: *Self Portrait* *Courtesy of Henry Wilder Foote*

Likenesses of Mr. and Mrs. Gershom Flagg IV came down in the same family with Feke's self-portrait, in identical old frames. This inspired the writer to try to find models for them among Smibert's works. Leafing through Smibert photographs, he came on several that resembled Mrs. Flagg, and then suddenly on a picture practically identical in composition. What was his excitement to discover that this was a likeness of Mrs. Smibert which, since the artist painted it for himself, would undoubtedly have remained in his possession. Thus three early canvases by Feke were closely allied to pictures which the younger painter must have seen hanging in Smibert's studio.

ROBERT FEKE: *Mrs. Gershom Flagg IV* *Courtesy of Henry Wilder Foote*

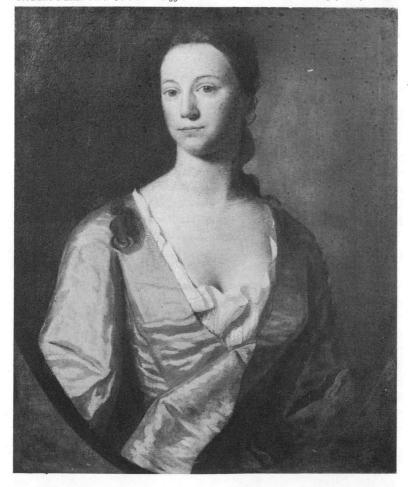

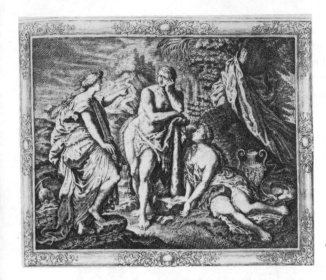

PAULO DE MATTHAEIS:
The Judgment of Hercules

Courtesy of the New York Public Library

By 1742, Feke was a resident of Newport. Two years later that ubiquitous traveler, Doctor Hamilton, turned up there. 'This town,' he wrote, 'is as remarkable for pretty women as Albany is for ugly ones, many of whom one may see sitting in the shops in passing along the street. I dined at a tavern kept by one Nicolls at the sign of the White Horse, where I put up my horses, and in the afternoon, Doctor Moffat, an old acquaintance, led me a course through the town. He carried me to see one Feake, a painter, the most extraordinary genius ever I knew, for he does pictures tolerably well by the force of genius, having never had any teaching. I saw a large table of the *Judgment of Hercules*,[4] copied by him from a frontispiece of the Earl of Shaftesbury's, which I thought very well done.' Hamilton then launched into the description of the painter we have already quoted.

Since the Doctor Moffat who was Hamilton's guide was also Smibert's nephew, the statement that Feke was entirely self-taught shows that Smibert never regarded the younger man as his student, but merely gave him the freedom of his studio. In Colonial America, the pupil-master relationship was likely to be a very loose one. Young painters called on more experienced practitioners, and if the older man was in a friendly mood, he invited the neophytes in, let them wander through his studio, and even allowed them to copy a picture or two. When Feke dropped in on Smibert, the Scotch painter was recovering from a serious illness. This may

[136]

explain why the beginner was given the impressive *Royall Family* commission. Perhaps Smibert recommended him, and for that reason allowed him to make an unusual amount of use of his *Berkeley Group*. Smibert's recovery, which allowed him to take up his brushes once more, may have encouraged Feke's removal to Rhode Island where, as we have seen, he continued his education by copying prints.

Signed and dated pictures show that Feke worked at Newport in 1745, at Philadelphia in 1746. By 1748, Smibert's sight was failing; Feke showed up again in Boston. He may have made a brief visit to Long Island. On April 17, 1750, a Philadelphia diarist 'went to Fewke's, the painter's, and viewed several pieces and faces of his painting.' Then the artist disappears. What happened to him is, despite the usual crop of rumors, impossible to determine. We only know that when his daughters were married at Newport during 1767, Feke was dead and considered by the recorder to have been not a painter but a 'mariner.

Since none of Feke's authenticated pictures need have been created outside the decade, 1741-1750, his known career is brief. Yet during these few years his style underwent an evolution significant not only esthetically but for the light it throws on the social thinking of the time. At first, Feke fell increasingly under Smibert's influence. Pictures typical of the early half of his career (1741-1745), show a head and shoulders merely, centered in a painted oval. This composition focuses attention on the features, which sometimes reveal considerable insight into character. Thus *The Rev. Thomas Hiscox* (1745), with eyes both cold and burning, with a downcurved scimitar of a mouth, is the very paragon of a clergyman who weekly shook his congregation over the fires of hell. The execution is sober in the manner of Smibert, and the colors are restrained, but there is considerable skill in the way the texture of the soft white hair differs from shiny whiteness of the starched collar.

At Philadelphia a year later Feke tried out a different style. With amazing suddenness he emerged from Smibert's influence and returned to the decorative and aristocratic preconceptions which we gather had swayed him before he stepped into the Scotchman's studio. Faces grow less pneumatic looking, less carefully modeled. They smooth out into generalizations, while their lead-

[137]

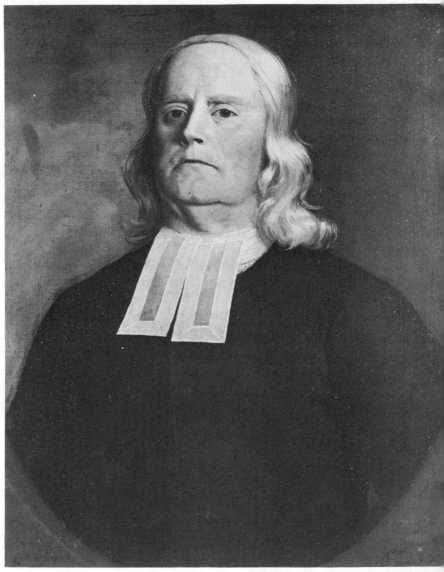

ROBERT FEKE: *Reverend Thomas Hiscox* Courtesy of Countess Laszlo Széchény

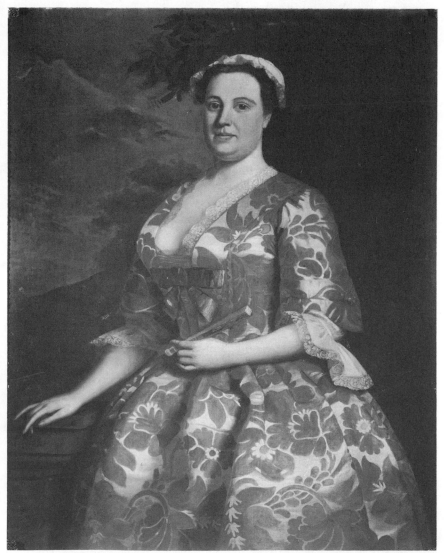

ROBERT FEKE: *Mrs. Charles Willing* *Courtesy of Edward Shippen Willing*

ing role in the compositions is taken by bodies wearing sumptuous costumes. Simultaneously the canvases expand, bust portraits giving way to three-quarter lengths.

Mrs. Charles Willing (1746) exemplifies this period of transition. In every inch of the picture there is a struggle for largeness of conception and handling, but the brush is still hesitant, not ready to let itself go as it was soon to do. The drawing is clumsy sometimes, the shapes awkward. Indeed, it is a great compliment to the subtlety of Feke's approach that this woman with her tremendous bosom covered with tremendous flowers — she is one of the fattest females in all Colonial art — does not give a gross impression. Much is achieved by the color which, although Feke has not yet achieved the brilliance of his later hues, is very harmonious. The mauve ribbon beneath the lady's breast strikes a note that is echoed and re-echoed throughout the composition, sinking here to gray-brown, there to gray, there to ivory.

By 1748, Feke had achieved his mature style. From the influences, social and esthetic, that bore upon him, he had selected a few elements that suited him profoundly, and then filtered them through his consciousness until they were truly his own. Once satisfied, he repeated his discoveries over and over, with a constancy both shameless and passionate. He had developed a formula, narrow in range, yet instinct with overwhelming charm.[5]

Naturalism, with its required interest in anatomy, came to bother him hardly at all. He achieved a typical distortion apiece for the male and female figure. Men, usually shown in three-quarter lengths, place one hand on their sides to hold back the long coat of the period, making it flow out copiously behind. The artist balanced the resulting shape by extending the front of the body until a perpendicular line drawn up from the stomach would miss the face by a distance of about a foot. In Feke's one full-length, his altogether charming *General Samuel Waldo,* the unnaturalness of this pose becomes clear; the warrior is in the process of pitching over on the back of his head. But in his usual portrait, Feke saved himself by not showing the legs or in any way indicating their position under the mass of costume.

Feke's ladies are usually seated, with the body at an angle to the viewer. An unnaturally extended bust is contrasted with an unnaturally tiny waist to make the torso a massive, jutting triangle,

[140]

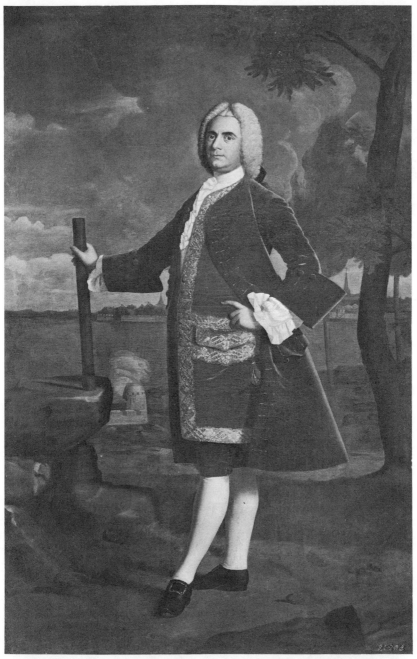

ROBERT FEKE: *General Samuel Waldo* *Courtesy of the Bowdoin Museum of Fine Arts*

which rises imposingly from the spreading bell of folded and gleaming drapery which is the lady's skirt. In this formula, some of Smibert's poses have undergone a sea change. Where the older artist allowed dresses to hang loose and gave just a piquant suggestion of the body beneath, Feke pulled them tight as one-piece bathing suits over vast bosoms and contracted waists. Although our proper critics have ignored the fact, any anthropologist up from Africa to study American customs would instantly recognize these images as sexual symbols.

Should we follow some writers in arguing that Feke was con-

ROBERT FEKE: *Mrs. William Peters* *Courtesy of the Historical Society of Pennsylvania*

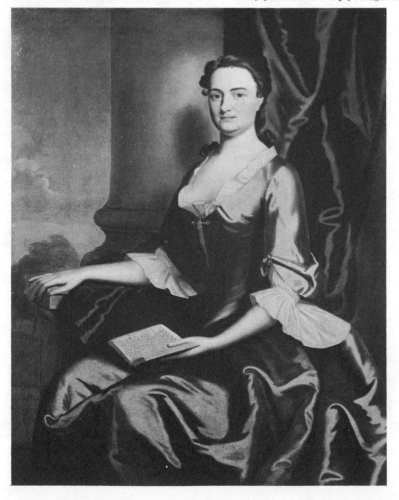

cerned in his mature work with depicting character in faces, we should be forced to the conclusion that Colonial America, like Huxley's 'brave new world,' was populated by sets of identical individuals. His women in particular are so alike in features that groups of them could be the same person. (Take for instance *Grizzel Apthorp*, *Mrs. James Bowdoin*, and *Mrs. William Peters*; or *Mrs. Charles Apthorp*, *Mrs. William Bowdoin*, *Mrs. Josiah Martin*.) Feke liked his women dark — he painted only one blonde — and he would have had as little interest as Reubens in the nervous skeletons who gyrate at contemporary débutante parties. All his females

ROBERT FEKE: *James Bowdoin II* *Courtesy of the Bowdoin Museum of Fine Arts*

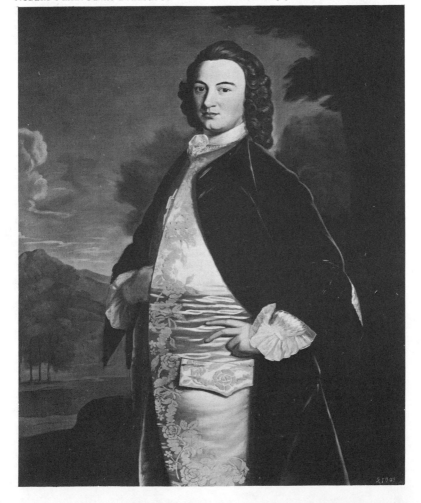

have ample faces, and some wear double chins proudly. Following Smibert by giving them huge, prefabricated eyes, he added stilted brows that bend in a uniform arc. As was typical of the time, Feke diversified men's faces more than women's, but we find such male triplets as *Gershom Flagg III, Isaac Stelle,* and *Tench Francis Sr.* Yet he never made two identical compositions. Although his vision was restricted, each application of it was a new creative labor.

Feke built high walls about his garden, and then cultivated intensively in the little tract within. His kinship was not with sophisticated practitioners who were able to produce a wide variety of blooms because they bought their seeds neatly packaged from the hay and feed stores of tradition. Once he emerged from Smibert's shadow and began to grow his own flowers, his development, so narrow in range, was typical of self-inspired artists. Feke belongs with such early Colonial painters as the *Aetatis Sue* Limner, or with the nineteenth-century people's artists whose pictures have been dubbed 'American primitives.' To postulate for him, as some critics have done, a period of European study in the middle of his career is to misunderstand the dynamics of his style.[6]

When the *Aetatis Sue* Limner reached out for plasticity, he was defeated by utter ignorance of how to proceed. Having the advantage of Smibert's example, Feke was able to create his formulas in terms of weight and space. True, he lacked the technique necessary to give three dimensions to very complicated shapes. Casting detail and its attendant naturalism overboard, he conceived of his men as cones. His women are an interplay of expanding and contracting forms. To him belongs the honor of being the first known American artist to achieve plasticity.

Making simplicity his touchstone, working surely within the narrow confines of his learning, Feke created pictures of great beauty. No contemporary veteran of Picasso exhibitions need be reminded that quality is not dependent on anatomical correctness. Among all our Colonial painters, Feke is most admired by partisans of the school of Paris. For through the use of imagination, he brought to life not reality itself, but symbols of reality.

Feke's rendition of Isaac Winslow, a rich merchant who was to be a Tory during the Revolution, is one of his masterpieces. Our first impressions are of form and color; the fact that a man is de-

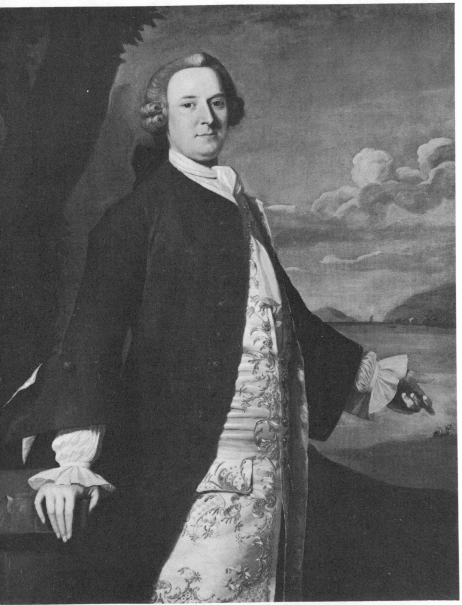

ROBERT FEKE: *Isaac Winslow* Courtesy of the Museum of Fine Arts, Boston

picted is less important. Winslow's body is geometrically constructed of two interlocking half moons. One is a long coat of russet brown, the other an oyster-white waistcoat varied with grayish shadows and golden embroidery. The two together form a curving horn which rises to an unemphatic face. On the left a misty tree trunk, swelling softly in the space between Winslow's back and the frame, holds upright by some alchemy of composition the figure that would otherwise be falling over backward. This passage is shallow in depth, tense and tight. But the eye, carried to the right and backward by the free swing of a pointing arm and hand, suddenly finds itself dropping dizzily into an immensity of space. Below and far away is a blue bay, stretching far to its enclosing blue-gray hills. Overhead the sky, whose echoing color is varied with white clouds, goes back to infinity. Foreground, distance, body, hand, water, and embroidery are held together not only by form, but by color harmonies which give an impression of great radiance.

ROBERT FEKE: *Charles Apthorp* *Courtesy of the Cleveland Museum of Art*

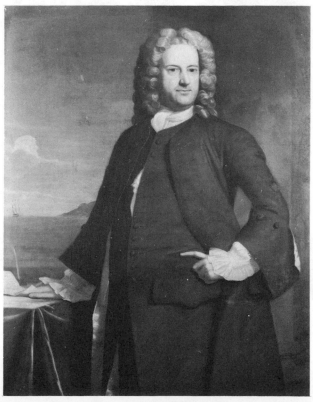

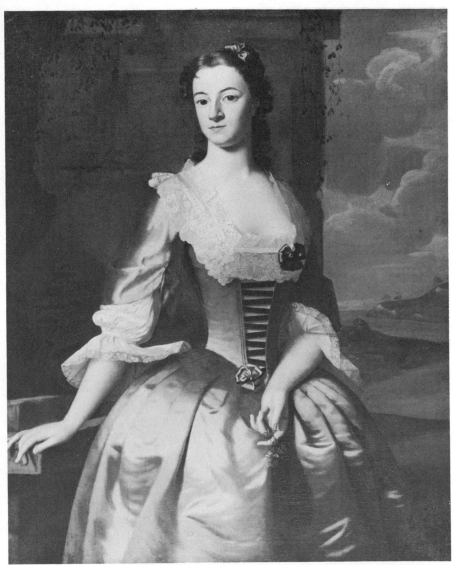

ROBERT FEKE: *Young Girl in Flower*

Courtesy of the Brooklyn Museum

In the Brooklyn Museum hangs a portrait of an unidentified young woman who seems to be the girl in every adolescent's dream. There she stands with charmingly colored face and huge eyes, a fine soft column of a neck, and richly swelling breasts. If her face is stylized, not the face of any particular person, that is typical of ladies who come to us in visions. And her body is a symbol of the young girls in flower who make the world bright. She stands beside a landscape that is, like her, young and fresh. Softly a blue river flows between a green headland and warm brown fields, while the clouds, motionless in an azure sky, speak of warm summer days when love comes as gently as reverie. Feke was a master at expressing the dreamy romanticism of youth.

Smibert had brought to America a style capable of inspiring either realistic portraits or symbolic ones. His first native disciple grounded his style on the *Berkeley Group*, yet soon lost interest in the character studies, reflecting middle-class individualism, which that picture contained. With loving enthusiasm, Feke painted delicate silks and shining satins; he heightened flesh to a rosy glow. Clothes meant as much to him as faces, and both were carried toward perfection by the inner eye. Once he achieved his mature style, he was patronized only by the pleasure-loving upper classes. They flocked to his studio because he painted them as they saw themselves. But low-church clergymen and their parishioners entrusted their effigies to less flamboyant hands.

Yet Feke's temperamental affinity was less with the British court practitioners than with the Patroon Painters who had preceded him in New York. He expressed not aristocratic glory but simple, sylvan joys. Even in their frank sexuality his visions have the innocence of adolescence. Feke carried to its zenith the mood which had dominated American art since painting first appeared in the wilderness cities. His pictures were the most finished creations of the early Colonial style.

Painting in All its Branches

DURING 1740, the *New England Journal* mourned the death of Nathaniel Emmons: 'He was universally owned to be the greatest master of various sorts of painting that was ever born in this country. And his excellent works were the pure effect of his own genius, without receiving any instructions from others.[1] Some of his pieces are such admirable imitations of nature — both in faces, rivers, banks, and rural scenes — that the pleased eye cannot leave them; and some of his imitations of works of art are so exquisite that, though we know they are only paints, yet they deceive the sharpest sight while it is nearly looking at them; and will preserve his memory till age or some unhappy accident or other destroy them. He was sober and modest, minded accuracy rather than profit.'

Here is our first account of an American-born and trained painter that mentions the types of pictures he created. The more familiar one is with books on American art, the more puzzling the passage will seem, for it has long been considered axiomatic that the Colonials painted only portraits.

That Emmons was admired for his representations of 'rivers, banks, and rural scenes' urges us to reopen the questions of the scope of Colonial art. An examination of identified pictures reveals the source of the statement that only portraits were painted; the cupboard is almost bare of other types of canvases. But if we add to the resources of the art critic those of the historian, we find in documents a flood of evidence that the early painters worked in a variety of modes.

During the nineteenth century, the primitive manner in which Colonial pictures were painted seemed so crude that anyone who called them art would in his turn have been considered feeble-

minded. Family pride became the only motivation for the preservation of canvases. However poor it seemed as a painting, great-great-grandfather's portrait, gleaming yellowly under its discolored varnish, was a charm against the pretensions of 'foreigners' whose families had more recently reached these shores. The old gentleman might be repainted so that he would look prettier — or richer — but he would not be destroyed.[2]

Landscapes had a similar interest only if they were easily recognizable views of early cities. When the nineteenth-century housewife found in her attic an old painting that told her no particular story, a canvas weird in technique and shedding paint like a chicken in molt, she knew what to do. If the frame was worth keeping, she placed it around an engraving of a baby hugging a lamb. In any case, the painting took its last ride on the ash man's tumbril. Emmons's case is typical. We have several portraits by his hand, but the 'age or some unhappy accident' which his eulogist feared, has destroyed all his landscape and subject pictures.[3]

Paintings are perishable objects. Even if allowed to stand in a dark corner completely untroubled, expertly painted ones need attention every century or so; back-country works peel and split more quickly. To the uninitiated, a broken picture seems hopelessly spoiled. I know a highly cultured lady who sold a valuable eighteenth-century portrait as junk because one eye had been torn; she was greatly annoyed a few months later to find her discard, seemingly in perfect condition, hanging in a leading American museum. Incidentally, the idea so rampant among Southerners that their ancestral portraits were slashed by Yankee bayonets reflects popular ignorance of how old paint behaves on rotting canvas.

The non-portraits that successfully ran the gauntlet of the years were so few that they did not catch the eyes of the first writers on Colonial art, and once the legend that they never existed was well established, all eyes were closed. Any seventeenth- or eighteenth-century composition that was found in attic or junk-shop was automatically assumed to be European in origin. It will be a long and arduous task, involving the co-operation of many men, to identify at this late date the key pictures that will make possible a full discussion of early American subject and landscape painting. Yet much can be reconstructed from the documents.

It is easy to prove that the Colonials possessed many pictures not portraits. As we have seen, the walls of New York burghers groaned under landscapes, genre, still-life, battle, and Biblical scenes. Southerners and New Englanders also owned pictures of various types, although in smaller numbers. To make a few examples stand for many, as we shall have to do all through this chapter: In 1690, the Virginian David Fox willed 'three pictures in the parlor and twenty-five pictures of scenes in the hall.' Fifty years later, another Virginian, Alexander Spotswood, left 'a scrip-

Benjamin West: *Landscape with Cow*

ture piece of painting, *The History of the Woman Taken in Adultery.*' The Reverend Mr. John Checkley of Boston owned 'a number of large pictures painted on canvas,' which could not have been family portraits since they were auctioned off after his death in 1757. The *Boston News-Letter* reported in 1760 that some villain had stolen from a burning house 'two small pictures of dead game in their proper colors, one representing a hare hanging by the hind feet, emboweled; the other a lark falling.'

If their exact nature is not specified, the many pictures listed in

Courtesy of the Pennsylvania Hospital

inventories may be engravings, yet engravings also show the trend of taste. They constituted America's major contact with European art. Whenever the documents are full enough, we find the native painters copying transatlantic prints. Feke imitated *The Judgment of Hercules*; West, *The Death of Socrates*; Copley, *Mars, Vulcan, and Venus.* [4]

Colonial newspapers carried many advertisements of print-sellers. At first, individual subjects were not specified, but about 1750 lists appear. We find religious compositions, not excluding that Catholic favorite *The Virgin and the Child*; allegories (*Liberality and Modesty* by Guido); neo-classical subjects (*Caesar Putting Away Pompey and Receiving his Wife*); genre pictures (Hogarth's *Harlot's Progress*); 'several hunting pieces under glass'; selections of 'handsome prospects,' etc., etc. Wall-paper often simulated mural painting, and depicted genre scenes, romantic landscapes, Chinese pagodas, medieval ruins.

Paintings too were offered for sale in surprising quantities. During 1720, 'Mr. Shores in Queen Street' announced in the *Boston Gazette* 'a public vendue at the Crown Coffee House on Long Wharf of a collection of choice pictures fit for any gentleman's dining room or staircase.' Gustavus Hesselius' one-time partner John Winter advertised to Philadelphians in 1771: 'One landscape of cattle going out in the morning . . . suitable for any gentleman's room in America; another landscape, representing evening, painted after the manner of Pusine [*sic*]; also a fire piece, representing a large pile of building on fire, copies from one of the best pieces extant; likewise a set of six small landscapes done by Zacharilli in London; one other small picture of Mary Queen of Scots, copied from a virginal painting of Holbein. . . .'

The importation of subject pictures and landscapes reflects a market that was as attractive to the native artists as to the dealers. Advertisements and other documents prove that the American painters created, in addition to portraits: landscapes and seascapes in oil, water color, and India ink; 'perspective views' of houses and topographical views of cities; story-telling pictures from the antique; allegories; altar-pieces and other religious paintings; genre and hunting scenes; fruit- and flower-pieces; paintings on glass: coats of arms separately and on coaches, etc.; decorative paintings

[152]

on walls; mortuary art, including designs for gravestones; mourning brooches in water color; maps; signs; theatrical scenery and moving pictures. Many were engravers. They copied and restored old pictures, and engaged in a hundred humbler crafts, from glazing to plastering, from japanning to painting barns. They even constructed pictures from feathers and human hair.

Artists who kept their advertisements brief offered 'painting in general,' a phrase that fits accurately the activity of most Colonial painters. Almost every artist about whom we have any documentation can be shown to have branched out from portraits into other modes, as an alphabetical list in the appendix of this book proves.[5]

The diversity of Colonial art was further increased by the amateur artists who must have existed in quantity to support, even on the most meager basis, the many art classes advertised all through the Colonial period. Professional painters often offered instruction in 'drawing in all its branches.' A complete curriculum was published in Charleston during 1774 by 'John and Hamilton Stevenson, limners, who propose to teach the principles and practice of this beautiful art in all its various branches, after the manner they are taught in the Roman Schools, viz: portrait, landscape, flowers, birds, figures, and drawing from the bust and statue in a style never before taught in this province; painting from the life in crayons, and in miniature on ivory; painting on silk, satin, etc. Fan painting together with the art of working designs in hair, on ivory, etc.' Several of the schools were aimed exclusively at 'gentlemen,' which casts doubt on the generally accepted belief that art was considered effeminate in early America.

The professional painters used their skill in creating likenesses to carry them into the realms of the imagination. Thus Watson drew 'personages in antique costumes, and men with beards and helmets and crowns.' The mysterious sign-painter, J. Cooper, created kings and queens dripping gold and attended by cupids; ladies dressed like Diana, surrounded with dead birds; other ladies holding cornucopias while childlike figures whispered in their ears.

In 1757, Joseph Badger sold a 'painted laughing boy' and a 'painted highlander.' Copley painted a *Nun by Candlelight,* and West posed his landlord in a dark closet with candles around him

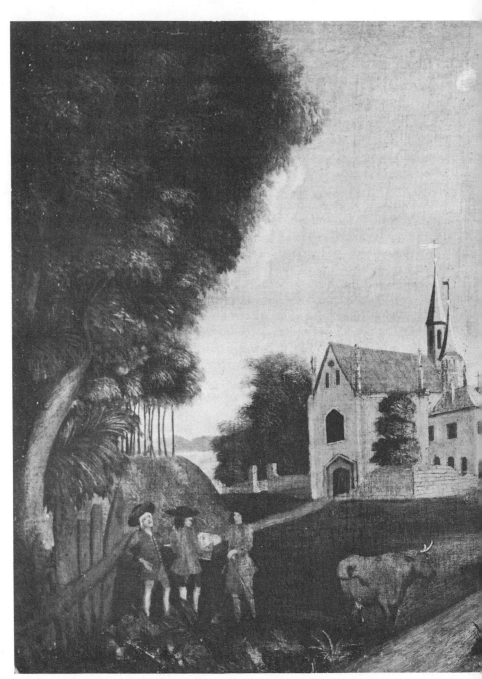

AMERICAN SCHOOL: *Landscape*

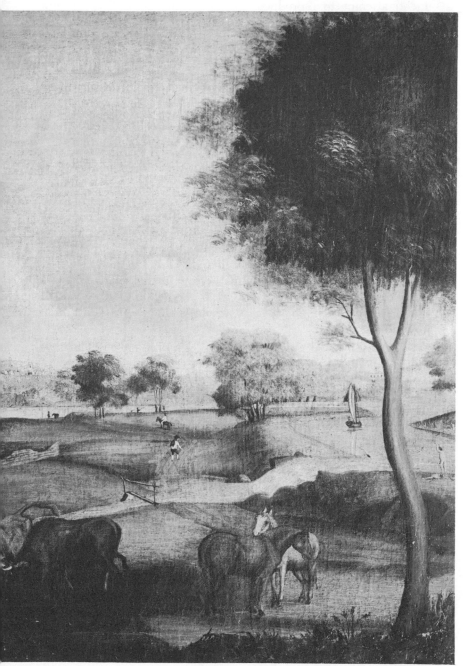

Courtesy of Colonial Williamsburg

in an attempt to reproduce Spanish chiaroscuro. Tavern signs called for an ideal head of a hero, or a still life exhibiting a merchant's wares, or a pair of cupids, or a noble buck.

We have reproduced several of the heroic figure compositions that have survived from Colonial times. They show not Indians with feathers, but cherubs with wings; the ladies, being goddesses, reveal an immodesty that would make local housewives blush. Such pictures have the wistful quality of a child putting her doll to bed in a cigar-box. In a maturer period of American art, Benjamin West was to marry it after a fashion with the great painting of Europe, but that time was not yet. Affectations learned from books, the historical pictures were likely to be copied from engravings in the same volumes. That the 'grand style' was not used to record events of America's past or present need not surprise us. On both sides of the ocean, modern history was still considered too mean to be worth studying in colleges or recording in paint. Only at the time of the Revolution did the Colonials begin to regard their own deeds as comparable with the achievements of men long dead. As for religious art, it was taboo to all except the small part of the population for whom Gustavus Hesselius and a few others painted.

Thus historical painting did not sink its roots into the Colonial soil. Although some subject pictures became altar-pieces in churches or decorations on private walls, the artists seem to have created them largely for their own training, and out of a yearning to identify themselves with the great names of the past. This was certainly the case of the mother country. During 1755, the Swiss painter, J. A. Rouquet, wrote that there was so little market for historical painting in England that it was amazing the artists persevered.

On another mode, Rouquet gave an exactly opposite report: 'Landscapes are strongly the fashion. This branch is cultivated with as much success as any other. There have been a few masters of the talent who have been much superior to the painters who now enjoy first rank in London.' Perhaps the writers who like to consider the landscapist Richard Wilson (1714-1782) as an almost isolated figure in mid-eighteenth-century England are as myopic as Americans who banish landscapes from Colonial art.

The documents leave no doubt that many such pictures were

produced in Colonial America. Some skill at recording nature was essential to portraitists who so often followed the international tradition of posing their subjects in the open air. Backgrounds for likenesses employed their own rules, of course, yet they show what aspects of nature appealed to American taste. Living like lion-tamers in the same cage with a savage wilderness, the Colonials dreamed of elegant gardens, where every shrub obeyed orders and vistas ended not in the vast tangle of fallen trees but in an urn or statue. Old World romance called hauntingly from across the ocean, inspiring grottos, crumbling castles, and Roman ruins 'nod-

BISHOP ROBERTS: *View of Charleston, detail* *Courtesy of Clarence Blair Mitchell*

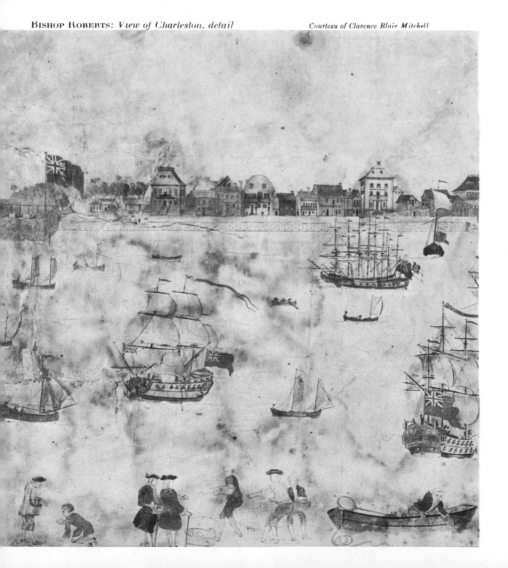

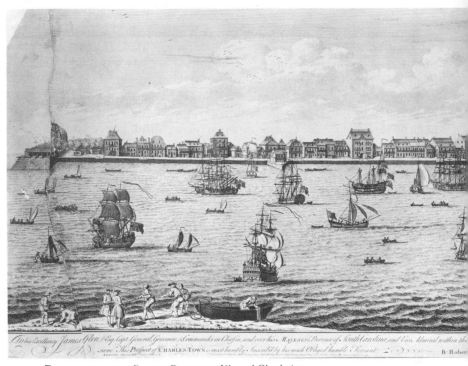

ENGRAVING AFTER BISHOP ROBERTS: *View of Charleston*

ding their awful head.' We gather that in much Colonial landscape-painting the works and moods of man blotted out the movement of grass in the wind. American art was too closely linked with Europe to have escaped the Italianate style exemplified by Wilson, which made fields everywhere look like the Roman Campagna, and superimposed on the lees and hills of home conceptions prefabricated by Claude Lorraine or Salvator Rosa.

Yet it was hard for a Colonial, who had never seen the Campagna or any castle, to get the formulas right. The very influences that made English painting most derivative, forced the Americans to flap the wings of their imaginations. In a landscape he painted as a boy, West applied the literalness of an artisan whenever he could. He used the *camera obscura,* an optical device that throws a little image in a darkened box, to make lifelike the lean flanks of the cow who was 'the hero of the piece.' But when he placed castles in the background, the result was less allied to realism than

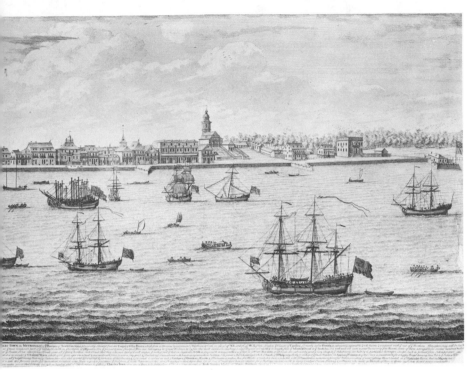

Courtesy of the New York Public Library

surrealism. The architectural impossibility of his medieval monuments was sublime.

This mixture of the matter-of-fact with the unlikely typifies the lack of unity which pervades the whole picture. In every square inch something is going on, but it need have little relation to what goes on in the adjoining square inch. Such bits of action as the immaculately dressed figure fishing in the middle of a waterfall are scattered as if by a shotgun. Objects in the far distance, although smaller than those in the foreground, are just as sharp, for the artist has ignored the blurring effects of atmosphere. Here is the *naïveté* of the true primitive.

In another landscape, attributed to West with much less reason,[6] we find the same point of view executed with more sophistication. Architectural imagination is exemplified by a Gothic church sprouting statued pinnacles and topped by a tower reminiscent of a Colonial meetinghouse. But the quiet painting of the rest of the

CHRISTIAN REMICK: *View of the Blockade of Boston*

picture reminds us of landscapes from the Low Countries. This may be coincidence, or it may stem from actual influence. The classicism of Wilson did not hold the British field alone. Many Flemish landscapists had worked in England during the seventeenth century; their pictures, which were to influence such men as Gainsborough and Constable, accepted nature's own moods and often recorded details with true middle-class fidelity. Only a little extension was needed to merge their style with that of an artisan who was interested in a bald rendition of what he saw.

The conception of recording the American scene for its own sake is supposed to be relatively modern, or at least not to predate the Hudson River School, yet it appears as soon as we have documents about art. In 1654, Adrien Van der Donk wrote of the Highlands of the Hudson: 'Here our attention is arrested in the beautiful landscape around us; here the painter can find rare and beautiful subjects for his brush.' A similar point of view was expressed by the English critic, Horace Walpole, who postulated that Smibert's departure for the New World 'was in part a pilgrimage to a new theatre of prospects, rich, warm, and glowing with scenery which no pencil had yet made cheap and common by a sameness of thinking and imagination.' When Smibert, as an old man, amused himself with 'something in the landskip way,' he may well have been painting the fields of Massachusetts. Before the Colonial period ended, engravers were publishing 'American prospects.'

Such prints, however, appeared later than views with which many people had close personal association: portraits of cities and colleges.[7] Some of the drawings on which they were based have escaped the bonfires of time. A view of Charleston, executed in water color about 1739 by Bishop Roberts [8] is a charming example.

Courtesy of the Essex Institute

The city's waterfront profile is reproduced with meticulous accuracy, each tiny brick being drawn in its place. International fashion decreed that such a view should be built on several planes: the city itself far back; before it the harbor crowded with so many boats that navigation would be almost impossible; and often, on a spit of land in the foreground, human figures engaged in homely tasks. Roberts shows us fishermen bailing out a boat; other fishermen pulling on a rope, and two gentlemen representing their class by leaning on their canes and doing nothing. In the extreme right corner a boy squats on his knees gathering clams. Roberts' coloring is naïve and gay, applied brightly in spots to achieve contrast. The flags are tiny dots of bright hues; the ships' dark gray hulls gleam with scarlet and gold; the kneeling youngster is resplendent in scarlet against the untouched white paper of the sea.

The oil painting of *British Privateers with a French Prize in New York Harbor* (c.1756-61) is so much more primitive than Roberts' view that we suspect the hand of a sign painter. Each of the boats that crowd the bay is packed to the gunwales with figures dressed in blue or red. Quite oblivious of being giants in proportion to their ships, they are swarming up masts, pulling on ropes, rowing with maniacal energy. The square-riggers seem to have been trimmed by a fashionable milliner: their black and brown hulls are resplendent with green and gilt; their sterns are embellished with gold designs; and almost every bow boasts its figurehead. Most stylish of these sculptures is a Triton, whose emerald fish-tail is tastefully embellished with red, and who holds to his lips a tremendous megaphone. On shore a militia company, each man a half-inch high, drills with the slack pomposity of provincial

[161]

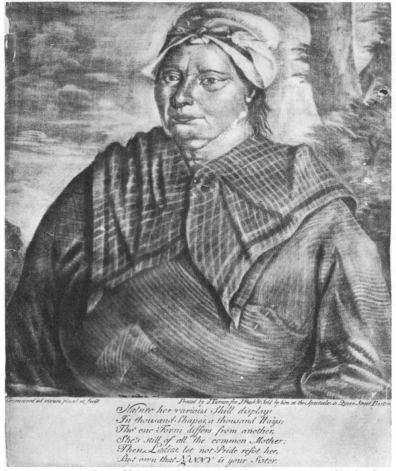

Nature her various Skill displays
In thousand Shapes, a thousand Ways;
Tho' one Form differs from another,
She's still, of all the common Mother:
Then, Ladies, let not Pride refist her,
But own that NANNY is your Sister.

JOHN GREENWOOD: *Jersey Nanny* *Courtesy of the Museum of Fine Arts, Boston*

soldiers, while elsewhere the normal life of the waterfront goes on. Houses and wharves are depicted in detail under a dark blue sky on which the milliner has hung blue-cream bumps and crescents that are meant to represent the sun striking the edges of clouds.

On the mainmast of the boat to the extreme left a British ensign flaps proudly above a flag bearing *fleurs-de-lis;* this is a captured French prize. Perhaps we are viewing part of the fleet described

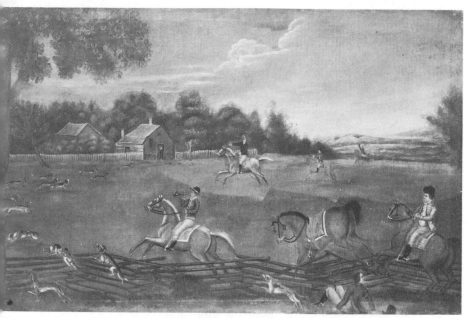

AMERICAN SCHOOL: *The End of the Fox Hunt* *Courtesy of Dr. Wyndham B. Blanton*

by the *New-York Gazette or Weekly Post-Boy* for May 30, 1757. Those privateers brought into the harbor five French prizes: three ships, a snow, and a brig, 'which they took out of a fleet of twenty-seven sail. . . . The ships are fourteen carriage guns each, are letters of marque, stood a hot engagement of some hours, and our vessels were obliged to board them before they struck. They are at least 300 tons. The snow is about 250, and the brig about 200 tons, deep loaded with sugar, coffee, cotton, etc. And we hear that one of the ships has between 80 and 100,000 weight of indigo aboard. The whole, at the lowest computation, is valued at about 70,000 pounds currancy.'

Under the hand of a mysterious artist, Thomas Leitch, views of towns lose their topographical overtones and become marine paintings in the Dutch manner. When he painted New York harbor, he relegated the city to an inconspicuous background, concentrating on boats and clouds and ocean in a delightful rendition of a dark sky brooding over big ships and placid water. Using

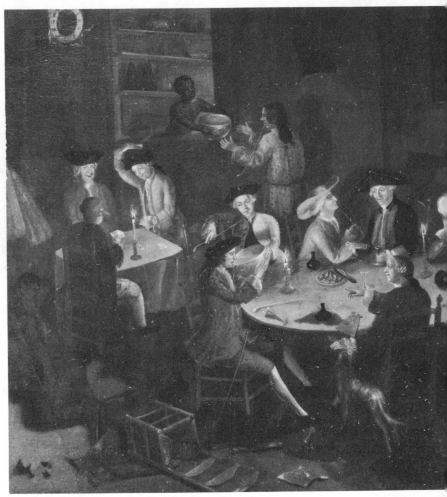

JOHN GREENWOOD: *Sea Captains Carousing at Surinam*

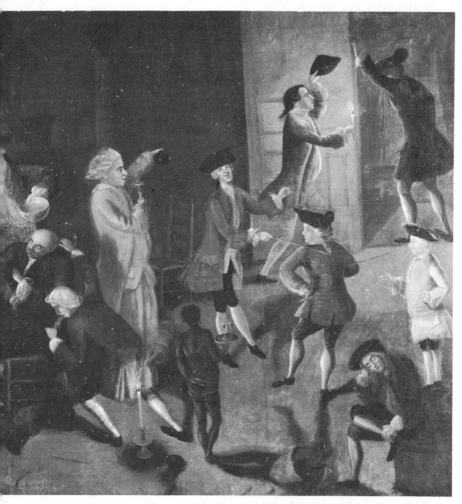

Courtesy of the City Art Museum of Saint Louis

color much more knowingly than Roberts had done, he toned a red flag down to russet so that it would fuse with the general dark harmony of the picture. Concerning the life of this most skillful of Colonial marine painters we know only that he was at Charleston during 1774 when he created a picture of that city which was subsequently engraved in England.

Portraits of towns and streets and public buildings often merged with portraits of historical events, particularly as the revolution approached. Christian Remick (1726-after 1783),[9] a Cape Cod boy turned mariner and painter, made and sold in quantity watercolor drawings of the landing of the British troops in Boston Harbor during 1768; a year later he drew the militia practicing on Boston Common. King Street was accurately depicted in a drawing Copley's pupil, Henry Pelham, made of the Boston Massacre, a picture which Pelham accused Paul Revere of stealing for his famous print. The Colonial period closes as the Connecticut painter, Ralph Earl (1751-1801), posts for Massachusetts to record the battle of Lexington. Since such pictures were usually created to be engraved, they were likely to be in water color.

Thought of as news events rather than as happenings of world-shaking importance, contemporary historical scenes crossed the line into genre, as did other Colonial forms. Trade cards and banners for guilds showed men engaged in homely tasks. No picture of a building or of a city was complete without little figures in the foreground. If the lost easel landscapes followed the English tradition, they too contained figures, and sometimes were crowded with them to become depictions of country life that remind us of the later artist, Morland. Emmons, we recall, painted 'rural scenes.'

The sylvan pleasures of innocent country folk had a romantic charm for eighteenth-century Europeans who were jaded with sophistication. Although the Americans were hardly sophisticated, they seem to have accepted this convention which came packaged with other more suitable, Old World products. The city proletariat, however, interested New World gentlemen no more than it interested Londoners. You would not hang in your parlor a picture of a pewterer in his workshop. When Greenwood depicted a woman of the people, he painted her not for her own sake, but as

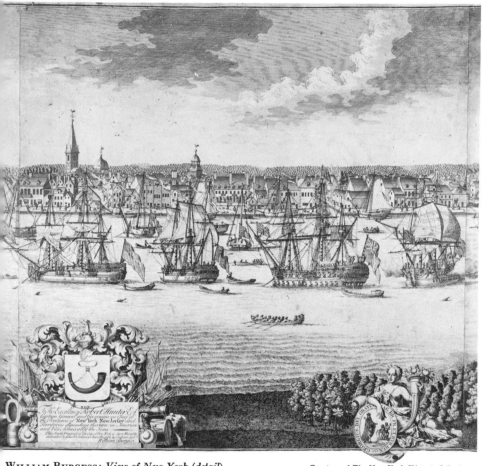

WILLIAM BURGESS: *View of New York (detail)* *Courtesy of The New-York Historical Society*

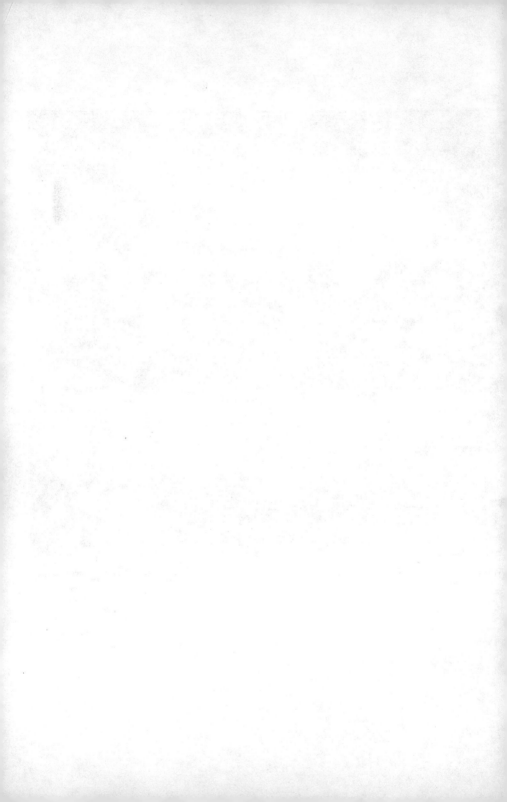

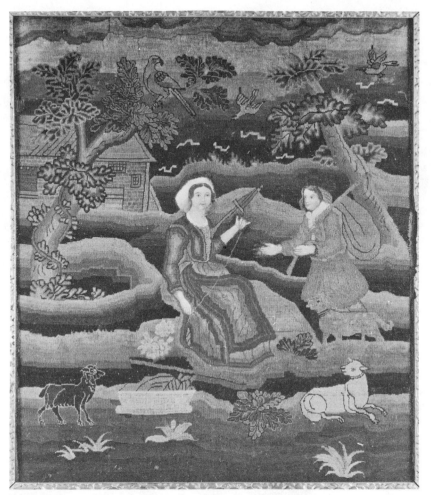

NEEDLEWORK WITH PAINTED FACES AND HANDS: *Lady and Tramp*

Courtesy of Mrs. Philip L. Spalding

an object lesson to fine ladies. Under the engraving he made from his picture, we find a verse:

> Nature her various Skill displays
> In thousand Shapes, a thousand ways;
> Tho' one Form differs from another,
> She's still of all the common Mother:
> Then, Ladies, let not pride resist her,
> But own that Nanny is your Sister.

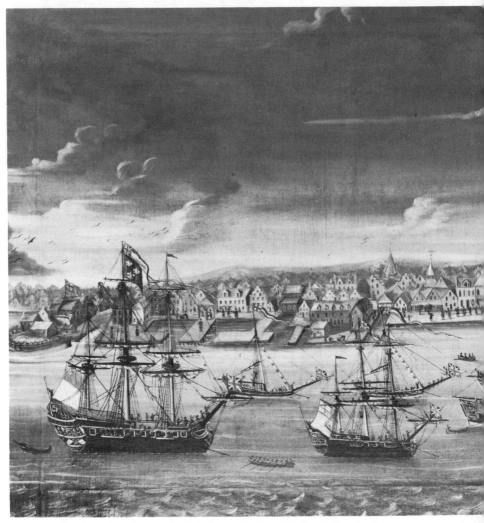

AMERICAN SCHOOL: *British Privateers with French Prizes in New York Harbor*

Courtesy of the New-York Historical Society

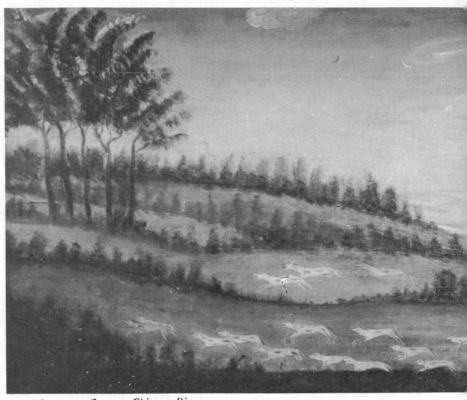

AMERICAN SCHOOL: *Chimney Piece*

The few pure genre pictures that survive depict the pleasures of the richer classes. The Colonials are often shown riding to hounds, and even more often drinking themselves under elegantly furnished tables.[10] Sometimes stag parties were immortalized by grateful guests. George Roupel, for instance, drew (*ca.* 1754) Peter Manigault of South Carolina drinking with his friends on an occasion so interminable that the colored page boy has long since fallen asleep, and even the parrot seems to be longing for morning and silence. In Baltimore, the minutes of the Tuesday Club for the seventeen-forties were crowded with representations of carousals. But the best party of all was recorded in oils by a professional artist; John Greenwood of Massachusetts shows us a gathering of sea captains at Surinam which is slipping not too gently toward a riot. That the genre scenes, both amateur and

[170]

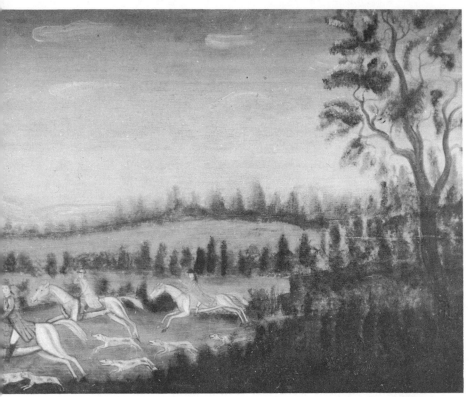

Courtesy of Jean Lipman

professional, reflect the amusements and excitements of men, suggest they were a masculine counterpart of the needlework which the ladies made and collected.

Embroideries go in heavily for the pure, the innocent, and the childlike. A sweet young creature is spinning on a stylized lea under trees overweighted with tremendous and exotic birds, as a tramp approaches, with a bundle on the end of his stick and his dog beside him. But the young lady is not frightened, for the tramp is spotlessly clean and has the face of a cherub. Clearly he will prove to be the disguised son of a rich landholder. In such mixtures of decorative design with sentimental genre the professional painters had a part for, like Peter Pelham, they often taught needlework.

In addition to hanging easel pictures on their walls, the Colonials

used painting more directly for interior decoration. A Philadelphia advertisement is specific: 'Those gentlemen, either in town or country, who have picture panels over the chimney pieces, or on the sides of their rooms, may now have the opportunity of getting them filled at a very moderate rate.' How such pictures were produced in England is revealed by Joseph Highmore's account of a Dutchman named Vanderstraeten who manufactured thirty paintings a day. Having mixed buckets full of 'cloud color' and other useful tints, he stretched a canvas the whole length of his attic and made it into a single landscape, which he 'cut and sold by parcels as demanded to fit chimneys, etc.' You could buy three or four or any number of feet in landscape. One day when his wife called him to dinner, he cried out, "I will come presently. I have done our Saviour. I have only the twelve apostles to do."'

During 1766, the citizens of Charleston read the following advertisement: 'Warwell, painter, from London, intending to settle in this town, begs leave to inform the public that he has taken a house on the Point, opposite Governor Boone's and next door to Mr. Rose's, ship-carpenter; where he paints history pieces, altar pieces, landscapes, sea pieces, flowers, fruit, heraldry, coaches, window blinds, screens, gilding. Pictures copied, cleansed, and mended. Rooms painted in oil or water in a new taste. Decorative temples, triumphal arches, obelisks, statues, etc., for groves and gardens.'

Although fuller than most, Warwell's advertisement was typical of the South, where decorative painters usually boasted they were Europeans importing the latest rage. Considerably fewer such offers were published in the Northern and Middle States, probably

BENJAMIN WEST: *Seascape* *Courtesy of the Pennsylvania Hospital*

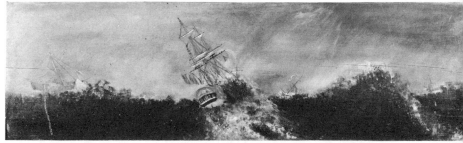

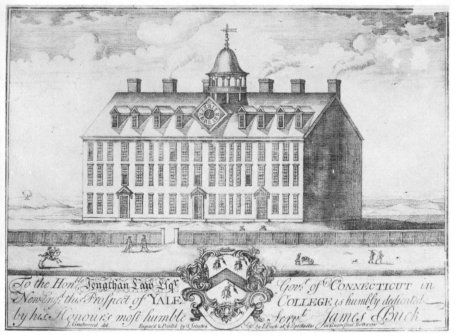

ENGRAVING AFTER JOHN GREENWOOD: *View of Yale* *Courtesy of Yale University*

because most communities had resident painters whose shops were known. Chimney-backs and wall-panels were part of the stock in trade of the more sophisticated artists, but they were also made by house painters too humble to attempt portraits. Isaac Weston advertised in the *Philadelphia Chronicle* (1768) that he practiced 'coach, chaise, chair, and any kind of landscape painting — also gilding and lettering.'

Called on to fill an architectural space in a manner agreeable to the eye, the mural painters often deserted the Renaissance tradition of illusionistic naturalism in favor of decorative stylization. For their purposes, figures and foliage needed only suggest naturalistic origins. A bird could be larger than a man, if that fitted best into the pattern. Early American walls were adorned with every gradation between stenciled flowers and landscapes through which the imagination can walk.

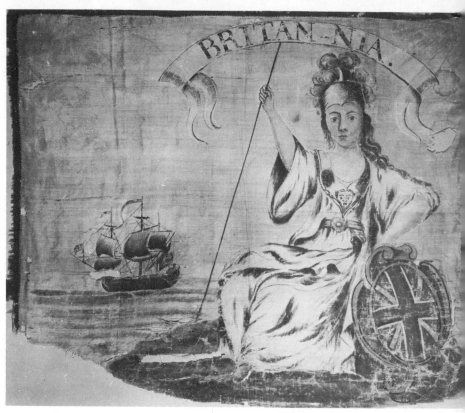

AMERICAN SCHOOL: *Flag Carried at the Siege of Louisburg, 1745*
Courtesy of the New-York Historical Society

A middle ground is exemplified by the frescoes in the central hall of the Warner House, Portsmouth, New Hampshire. Two huge Indian chiefs, based on prints made in England of visiting Mohawks, glower down the staircase from an impressive height. On the lower level, a lady at a spinning wheel watches while an eagle, larger than she, carries off a chicken despite the barking of a monstrous dog. Above, Abraham brandishes his sword over a kneeling Isaac as an angel gesticulates out of a cloud; from a bucolic vista two little figures look on wonderingly. Balancing these scenes is an elaborate landscape with a city forming a background for a large hero on a horse too small for him; this figure seems to have been based on a metal fireback cast in 1745 to represent Sir William Pepperell capturing Louisburg. Be not surprised to find a painter turning to an iron worker for inspiration;

[174]

any source for design was welcome. Indeed, the professional painters were concerned with every branch of the decorative arts, either as practitioners or instructors.

What proportion of the artists' income came from portraits, what proportion from other activities, can only be guessed at from a complex of inconclusive evidence. There seems to have been a good demand for the craft aspects of the painter's trade — house, coach, and sign painting — and for decorative wall-panels and fireboards. On the more self-conscious level, however, portraits seem to have been the best moneymakers. A New England inventory, dated 1732-3, evaluates 'nine painted pictures' at five pounds and 'six family pictures and a coat of arms' at a hundred. In 1757, the same man who paid Badger thirty shillings for two fancy pictures, paid five guineas for four portraits of his children and twelve pounds for full-lengths of himself and his wife. Copley, who charged forty guineas for a full length, twenty for a half-length, and ten for a bust, sold his *Nun by Candlelight* for two, although he stated he only accepted this price because King's College promised to make the picture the nucleus of a public collection.

House painting and portraiture had to be done locally. In this, they differed from easel landscapes, still lives, and genre scenes. When the Bowdoin family wanted their likenesses made, they had to choose between the handful of artists in Boston; it was easy for Feke to get the assignment. But Feke's *Judgment of Hercules* competed in the open market with European pictures, both antique and modern, and with engravings. This situation, combined with the natural desire of the human animal to immortalize his own face, made portraits a more profitable product than other types of canvases.

But the fact remains that the Colonials — ordinary citizens, connoisseurs, and painters alike — did not limit their artistic interests to likenesses. Indeed, the longer one examines the Colonial period, the more one is impressed with how various were the sources of design to which the early Americans were exposed. There under the wilderness trees, our ancestors planted in the rich loam the seeds of every aspect of European art. Although most of the pictures have been lost, it is of the greatest significance to our understanding of our culture that America's first artists practiced all branches of painting that were practiced in the Western world.

[175]

CHAPTER EIGHT

Triumphs of Naiveté

EVER SINCE the curtain rose about 1660, the drama of American painting has been played on a darkened stage. Although a few pictures survived, the earliest painters were lost in blackness. Then the footlights began to glow dimly; we were able to catch here a feature, there a face. Now the floodlights go on: we are inundated with names and pictures and biographies. Where formerly we were grateful for any information at all, we are faced with an arduous labor of selection.

Our copious information about Benjamin West gives us a close-up view of how that exotic plant, a painter, grew in Colonial America.[1] He was born October 10, 1738, to a former tinsmith who kept a rural inn ten miles west of Philadelphia. As a small child, he made drawings of birds and flowers, inspired perhaps by the peasant-decorated furniture which the German immigrants, who paused briefly at his father's tavern, brought from the Old World. His childish scribbles created such wonder that the whole community turned out to help. An erudite neighbor explained about camel's-hair brushes, and the little society thrilled at his ingenuity when West made an imitation from the hair of a cat. Even the Indians who raised their wigwams on the edges of the settlement became interested, teaching him to mix the colored clays with which they painted their faces, or so West remembered as an old man. A traveler from Philadelphia gave him oil paints and some engravings, probably by Gravelot. When the lad combined two prints into a single painting, his mother kissed him 'with transports of affection,' and the crowded taproom surged with emotion. Having produced some childish pictures that would have been a routine assignment in a modern school, West, at the age of eight, was regarded as an artistic prodigy.

Had an orchid pushed up, against all nature, in a Pennsylvania field, the farmers would have cherished it, even if it were stunted as compared to tropical blooms. It was the same with a painter. Far from scorning art, as they should have done according to text-book theorists, the Colonials were too eager. They rushed West off to Philadelphia and introduced him to William Williams, a professional painter. This august personage joined the conspiracy of enthusiasm. Far from lecturing the child on the complexities of art, he received him as a colleague, and soon the two were chattering about pictures with the same naïve excitement. Perhaps Williams was trying to make up for the discouragements of his own early career.

Born in Bristol, England, he had escaped from the droning voice of grammar school by frequenting the studio of 'an elderly artist who painted heads in oil as well as small landscapes.' There he had 'embibed his love of painting,' but no one in the British city had been impressed with the scrawls of *his* youthful inspiration. Painting brought him neither fame nor money, only personal solace. 'From this charming art,' he wrote, 'I derived great consolation in various situations of my life; in the practice of it, I soothed many a bitter hour. The moment I took my pen or pencil in hand, my cares were forgotten, my mind became calm, and I enjoyed a respite from every solicitude.' Williams had many bitter hours to soothe. Forced to seek his livelihood in some practical way, he became a sailor; he was shipwrecked on a savage central-American shore. But to tell the story correctly, we must leap into the future.

It is now July 10, 1805, and West is the president of the Royal Academy, an old man full of fame. As he waits in the London lodgings of a Bristol merchant, Thomas Eagles, he picks up an elegantly bound manuscript entitled: *The Journal of Llewellin Penrose, a Seaman.* Idly he reads this account of the experiences of a castaway, and then a look of amazement enlivens his features. When Eagles enters, West demands impetuously to be told the source of the manuscript. His host replies that some years before he had been accosted on the streets of Bristol by an elderly beggar who asked nothing more than admission to a poorhouse. 'My two sons were killed at Bunker's Hill . . .' he explained. 'I have been a painter, but am now old and alone, and only want somewhere to

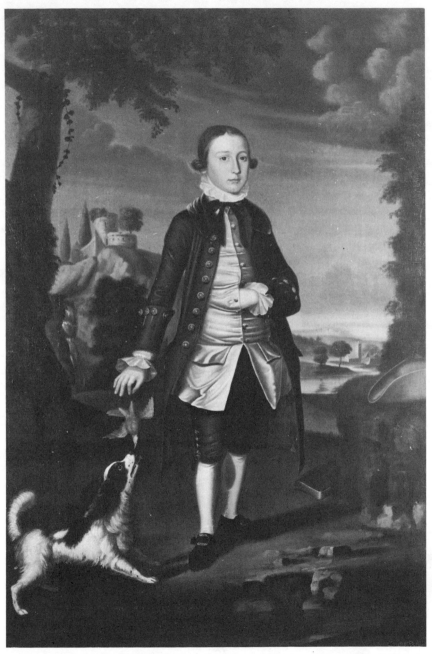

WILLIAM WILLIAMS: *David Hall* Courtesy of Harry F. Du Pont

end my life.' Although not curious enough to discover anything further about the derelict's history, Eagles was helpful. When the old man died in the Merchant's Alms House, he left all his possessions to his benefactor.

The possessions of a beggar? That did not seem anything to take seriously. Yet investigation revealed that the lost soul had transported about two hundred books to the almshouse, among them two manuscripts: *The Lives of the Painters,* and the mysterious *Journal of Llewellin Penrose.*

'Sir,' cried West, 'I have looked at several parts of this book, and much I have seen I know to be true. I know the man too, and what is more extraordinary, had it not been for him, I should never have been a painter.' The manuscript had carried West back to his boyhood. Again he was sitting crosslegged on a chair, breathing in the delightful smell of paints, while his new friend, William Williams, talked excitedly. 'As he was an excellent actor in taking off character, he often, to amuse me, repeated his adventures among the Indians, many of which adventures are strictly the same as related in your manuscript of Penrose, as were also the description of the scenery of the coasts, the birds on them, particularly the flamingo birds, which he described, when seen at a distance as appearing like a company of soldiers dressed in red uniforms. He spoke the language of the savages and appeared to have lived among them some years. I often asked him how he came to be with them. He replied that he had gone to sea when young, but was never satisfied with the pursuit; he had been shipwrecked and thrown into great difficulties.'

The book West held in his hand was a novelized account of its author's own experiences. The hero, Llewellyn Penrose, is described as an amateur painter; probably Williams was drawing a picture of himself. Bookish and shy, Penrose was given to melancholy and apprehension. Such a nature does not relish adventure. Having selected a cave as his home, he rarely went out of sight of this symbol in the jungle. When he met some savages at last, he loved them and took them to his cave, building a family. If one of his dark-skinned brethren ventured out to sea in a native canoe, he felt all the anguish of a mother whose child is in danger.

The Journal, which seems to have been completed by 1784, may predate by a few years *The Power of Sympathy,* the book that is

usually considered America's first novel. Furthermore, it is of much higher literary quality than that sprawling sentimental work. Expertly written in a laconic, verisimilitudinous style similar to Defoe's, the *Journal*, when published belatedly in London during 1815, was a critical success that inspired Byron to write: 'I never read so much of a book in one sitting in my life. He kept me awake half the night and made me dream of him the other half.'[2]

Rescued at last from the jungle that was to inspire his novel, Williams found his way to Philadelphia. There the hobby which had soothed his lonely hours became a profession. People did not smile tolerantly at his paintings; they bought them for money. Like the little boy artist who stared at him now with wide eyes of wonder, Williams had profited from the innocence of the Colonial connoisseurs.

Before he returned to England and poverty, Williams spent thirty to forty years in the Colonies, living in Philadelphia, New York, and perhaps elsewhere. The activities of this forgotten genius spread across almost every branch of American culture. He wrote poetry, as well as biography and a novel. He conducted 'an evening school of the instruction of polite youth in the different branches of drawing, and to sound the hautboy, German and common flutes.' In partnership with a blacksmith, he contracted to build and decorate the first permanent theater in British America. Under signs embellished with Rembrandt's or Hogarth's head, he undertook 'painting in general, viz. history, portraiture, landskip, sign painting, lettering, gilding and strewing smalt. N.B. He cleans repairs and varnishes old pictures . . .'

When West frequented his studio, Williams was at the beginning of this career. Such pictures by Williams as we possess, date from twenty to thirty years later. Typical is *Deborah Hall* (1766). Bathed in sensuous and gay colors, the young lady stands life-size in an ornate garden. How Williams loved imagining classical statues to decorate each vista! How he loved Deborah's elegant clothes; he might have ordered them himself. He created each leaf in the flower beds with the enthusiasm of a pantheistic deity delighting in the labor of his hands. The girl's face is a symmetrical generalization which seems to be another of his many rococo designs. Typically, the artist, who in his writings was more interested in the characters of little animals than of big people,[3]

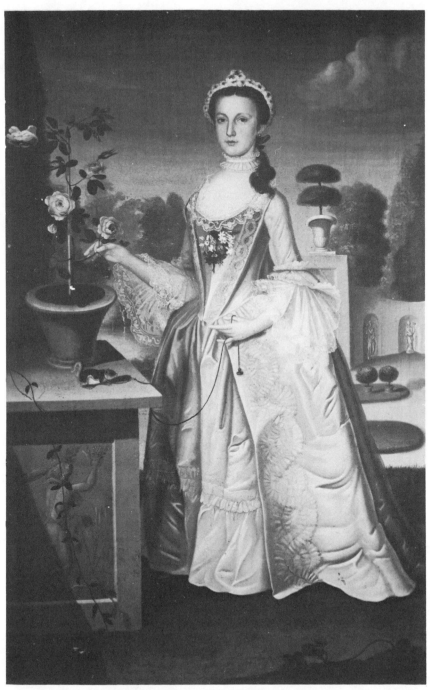

WILLIAM WILLIAMS: *Deborah Hall* *Courtesy of the Brooklyn Museum*

reserved his realism for the squirrel the young lady holds on the end of a chain. Beady-eyed, intense, the animal is absorbed in rodent thoughts of great profundity.

Verve and joy are the watchwords of this charming picture. The mood, of course, is the mood of Feke, but the painter's personality is very different. Where the New England artist worked profoundly in a narrow range, Williams was gifted with almost too much invention. He created a caricature of the vegetarian, Benjamin Lay, sitting in a cave with a scoop of healthful water beside him. He crowded his portraits to the frames with accessories that amused him: waterfalls and flowers and exuberant trees and dogs both fat and thin, with almost always those visual precursors of the romantic movement: crumbling ruins suitable for ghosts and deeds of derring-do. Of course, no medieval masonry existed in America, but what was the use of being a painter unless you could use imagination to correct such lapses?

ENGRAVING AFTER WILLIAM WILLIAMS: *Benjamin Lay*

Courtesy of the Historical Society of Pennsylvania

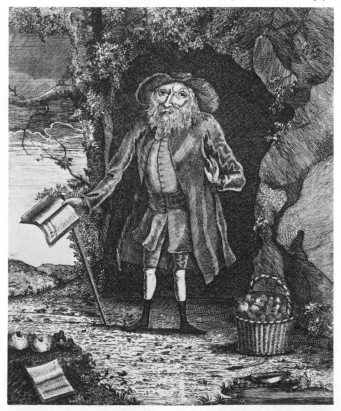

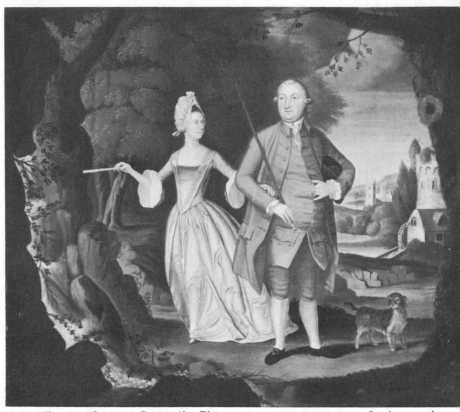

WILLIAM WILLIAMS: *Conversation Piece* *Owned anonymously*

Williams introduced into America a European fashion which showed that even the courts were not immune to the movement of intellectual tides. In France, the aristocrats were playing at being commoners. Great nobles, ostentatiously turning their backs on the throne room, asked to be depicted with their families in little genre scenes of domestic life. Moved by the same *Zeitgeist*, English painters, conspicuously John Wootton and Hogarth, produced 'conversation pieces.' Williams' *John Wiley, his Mother and Sisters* (1771) shows the family sunning themselves in their New York garden, while in the background is a charming landscape said to represent lower Manhattan Island.

[182]

Concerning his childhood visits to Williams' studio, West remembered, 'I saw some cattle pieces, admired them, and inquired how he could paint them so accurately.' Williams replied by handing West a *camera obscura*, a device for throwing a miniature image on the back of a darkened box. The lad made one for himself. 'My delight was then to go to farmyards, and, by means of my camera, draw the cattle, etc.' His *Landscape with Cow* (c. 1749-1752) shows the result of such an experiment.[4]

Having lent him books on Old World art, Williams sent the prodigy back to his rural home with his head spinning. West promptly snubbed a boy who intended to be a tailor; he had learned that painters only associated with 'kings and emperors.'

Before he was well into his teens, West was supplying his rural neighbors with portraits at a price, and soon he was called to Lancaster, the westernmost of American cities. Here he met another exemplar of backwoods ingenuity, the youthful gunsmith, William Henry, who was to forge several important inventions from his native wits. Although he had never been abroad, Henry expressed a taste for a kind of painting which is supposed to have been unknown in America. Henry insisted that West, instead of wasting his genius on portraits, should paint sublime subjects like *The Death of Socrates*. The artist agreed enthusiastically and then asked, 'Who is Socrates?' The matter having been explained and the tiny frontispiece of a book produced as a model, West set to work, doubling the number of characters shown, imagining Greek togas as confidently as he had imagined medieval castles.

This gesture toward the classical taste was a wonder to surpass the prodigy's previous wonders. West was called to Philadelphia where the provost of the college, Doctor William Smith, promised to devise for him a special course featuring the stories of antiquity that would make majestic paintings.

The rural painter found himself in one of the most socially advanced regions in the whole world. Founded two generations later than the other Colonial cities, dominated by a religion that had not even been formulated when the older regions were settled, Philadelphia reflected a subsequent step in the European movement toward middle-class individualism. The Quakers shunned a 'hireling ministry' for they believed God manifested himself in the individual bosom of every man; all men were equal before the

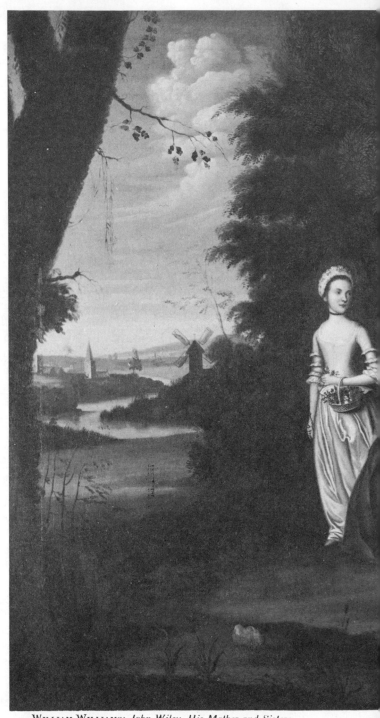

WILLIAM WILLIAMS: *John Wiley, His Mother and Sisters*

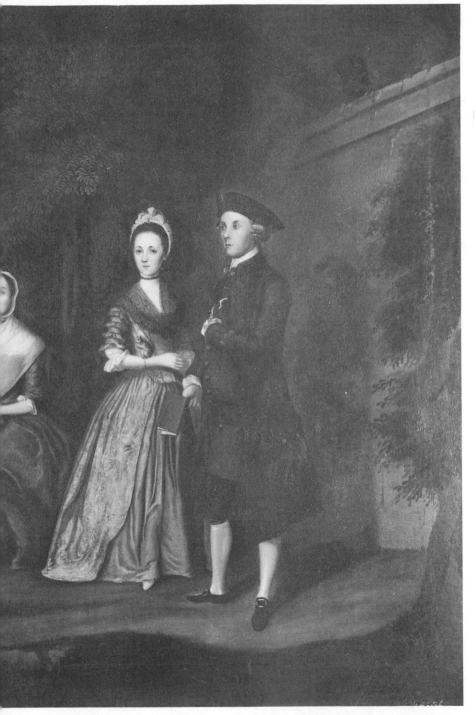

Courtesy of William Ogden Wiley

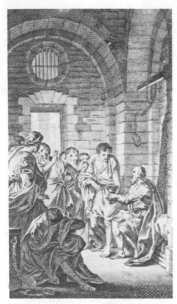

FRONTISPIECE for Rollin's *Ancient History*.
WEST's *model for his Death of Socrates*

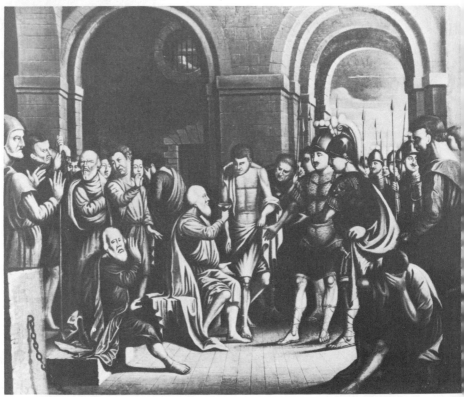

BENJAMIN WEST: *Death of Socrates* *Courtesy of Mrs. Thomas Stites*

BENJAMIN WEST: *Self Portrait in Miniature* *Courtesy of the Yale University Art Gallery*

Lord. Although this doctrine was so far ahead of those times (as it still is of ours) that there was much backsliding, it fostered tolerance. Freedom combined with economic opportunity to make Philadelphia grow in a few years into the second largest city in the British Empire. The college with which West was now connected was closest to modern practice of any university of its time. Perhaps it was no coincidence that the young man who spent his formative years in Philadelphia became a world leader in the development of a bourgeois style.

But for the moment West's problem was not to develop a new style, but any style at all. When he had painted William Henry in Lancaster (*ca.* 1755), he had borrowed, presumably from Williams, a very elegant composition, complete with classic column and distant castle, but in drawing the face he had only been concerned with achieving something, anything that looked possibly human. *Stephen Carmick,* probably the work of his first Philadelphia years, shows a tremendous advance. Now West applies the features in the familiar symmetry of a primitive. In another year he was able to achieve *Jane Galloway* (*c.* 1757) a costume piece of considerable delicacy and tenderness. In its coloring, William Sawitzky finds the influence of Gustavus Hesselius.

After a few months, this influence is submerged by another. Delicacy vanishes. West's faces are suddenly heavy-eyed, with

[187]

mighty jowls. Ponderous drapery is highlighted with extreme zigzags. Responding like a weathervane to every wind, West is now under the influence of a new arrival in Philadelphia, John Wollaston (active in America *ca.* 1749-*ca.* 1767). The pupil of 'a

BENJAMIN WEST: *William Henry* *Courtesy of the Historical Society of Pennsylvania*

BENJAMIN WEST: *Jane Galloway* *Courtesy of the Historical Society of Pennsylvania*

noted drapery painter in London,' Wollaston was one of the least subtle of fourth-rate English artists, but his pictures had a beef-eating impressiveness. His sitters, surrounded with the glitter and sheen of stuffs, were as elegantly posed as they were well-fed. That he allowed the young prodigies of Philadelphia to watch him at work, is revealed in a poem by West's friend, Francis Hopkinson, later a patriot and musician who designed the American flag:

> To you, famed Wollaston, these strains belong,
> And be your praise the subject of my song. . . .
> Ofttimes with wonder and delight I stand
> To view th' amazing conduct of your hand.
> At first unlabor'd sketches lightly trace
> The glimm'ring outlines of a human face;
> Then by degrees the liquid life o'erflows
> Each rising feature . . .
> Nor let the muse forget thy name, Oh West,
> Lov'd youth with virtue as by nature blest!
> If such the radiance of thy early morn
> What bright effulgence must thy noon adorn?
> Hail sacred genius! may'st thou ever tread
> The pleasing paths your Wollaston has led.
> Let his just precepts all your works refine.
> Copy each grace, and learn like him to shine.

In a society boasting many artists, a young man imitates an elder because of temperamental affinity. West imitated Wollaston *faute de mieux*, painting such gross pictures as *Elizabeth Peel* (*ca.* 1757-8). But he soon began to right himself, like a ship coming out from under a wave. His natural daintiness reappeared. Forms grew delicate again, flesh smooth. Discarding Wollaston's hot bricky colors, he painted Thomas Mifflin (*c.* 1758-9) in an exciting harmony of blues. The young man's dark-blue coat and trousers are silhouetted against a river scene painted also in blue. Water and sky are one azure, while even the foliage of the trees is blue, although enough darker to be visible. This gives an umbrageous effect which is very daring: not nature itself but a heightening of nature. However, the face, despite its blue shadows, is a stylized mask with its Wollaston eyes and its little smirk.

West was beginning to move in an original direction. Yet it is hard for a Colonial, who wants to be a companion of kings and

BENJAMIN WEST: *Thomas Mifflin* *Courtesy of the Historical Society of Pennsylvania*

BENJAMIN WEST: *Elizabeth Peel* Courtesy of the Pennsylvania Academy of Fine Arts

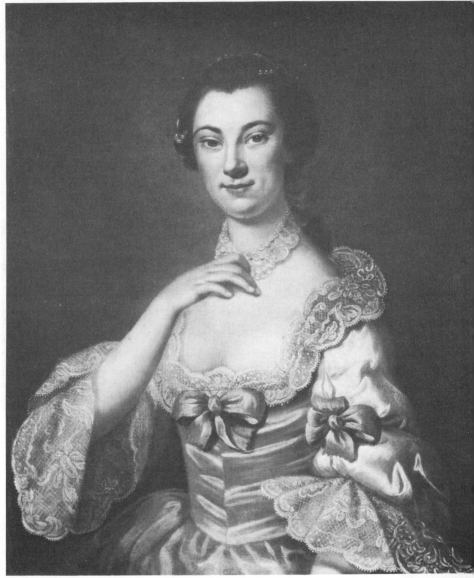

JOHN WOLLASTON: *Mrs. Daniel Blake* *Courtesy of Mrs. Frederick Rutledge*

emperors, to stick to his own last. Happening on a *Saint Ignatius* of the School of Murillo that had been captured with a Spanish prize ship, West stared until he was overcome with his own inadequacy. He determined to go abroad, where there were many such pictures to study.

To earn his passage money, West moved to New York in search of higher fees. Then new forces intervened. These forces were broadly environmental, part of the spirit that was to lead to the American revolution. That Philadelphia was among the largest and most progressive of English cities had not escaped its citizens. Once, like little children far from home, the Colonials had yearned for complete identification with their mother island, but now they were more like adolescents, anxious to be no longer dependent, to impress their elders that they also were old and wise. In the earlier stage, they had tended to patronize native artists only when foreigners were not available; now they wanted to startle the London connoisseurs by making an American painter as skillful as any Englishman. Not yet adult enough to really think for themselves, they conceived of their champion as working in the Old World manner, but better. Toward this glorious end, a group of Philadelphia merchants raised money to enable West to study in Italy. 'It is,' one of them wrote, 'a pity such a genius should be cramped for the want of a little cash.'

In 1759, the twenty-one-year-old Colonial prodigy sailed for Leghorn, initiating the fashion for foreign study which has dominated American art to the present day. His departure presaged the end of the Colonial period in painting, for his own personal influence was to flood our art into new channels. But that time was not yet. While the fuse of change that West carried with him to Rome, to Florence, to Bologna, to Paris, and to London spluttered ever closer toward explosion, the old traditions reached their greatest flowering.

CHAPTER NINE

First Steps of a Genius: John Singleton Copley

JOHN SINGLETON COPLEY was one of the most important figures in all our cultural history; he was the first man to express American life in art maturely, profoundly, and with beauty. The painters who preceded him worked in a much narrower range, expressing naïve visions with grace and charm. The other arts — literature, music, sculpture, even architecture — produced no figures commensurate with Boston's solitary genius. Yet Copley grew naturally in the same seed-bed as the rest of his generation, producing a finer bloom only because of that strange inner germ that is genius. The same adverse factors impeded the growth even of this giant; the same new forces, engendered by the primeval loam of a new continent, pushed him toward revolutionary ends that he himself did not see. Thus we may gain a heightened understanding of ourselves and our culture if we read with rapt attention the record left by Copley of the America that was sweeping toward nationhood.

Our story begins in a little house that jutted out over Boston Harbor. On the very wharf where the sailors moored their ships, 'the Widow Copley' lived and sold 'the best tobacco, cut, pigtail, or spun.' She had come from Ireland, and her husband had disappeared at about the time of her son's birth in 1738.[1] The child watched water lapping the foundations of his house and worked behind the counter of the store. It is pleasant to imagine that Feke, home from a voyage, dropped in there sometimes to buy smokes.

When Copley was ten, his future was determined by an event which at the time he probably regarded as tragedy. His mother married again. Moved to the house of his stepfather, Peter Pelham (1697-1751), the boy became familiar with tools that may well have

fascinated him while he still hated the hands that held them. If, like Cotton Mather, we believed that Heaven intervenes in all human affairs, we would be sure that the Widow Copley's marriage was planned by the celestial Commissioner of Fine Arts, for it carried her son into one of the few households in all America primarily concerned with art.

Pelham had been a successful mezzotint engraver in England. Reaching Boston during 1726, three years before Smibert, he found that in order to secure portraits worthy of engraving, he had to paint them himself. His *Mather Byles* is a stiff translation of his engraving technique into paint. The head has a simplified roundness varied by stock features suitable for a burin. Color, however, is not part of an engraver's trade; in applying pigment, Pelham deviated from the conventional harmonies of the period to achieve a raw brightness. Byles' gown is crimson and his face startlingly red.

PETER PELHAM: *Mather Byles* *Courtesy of the American Antiquarian Society*

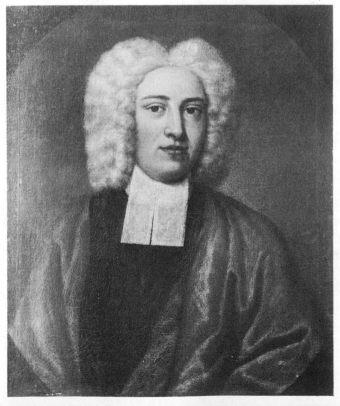

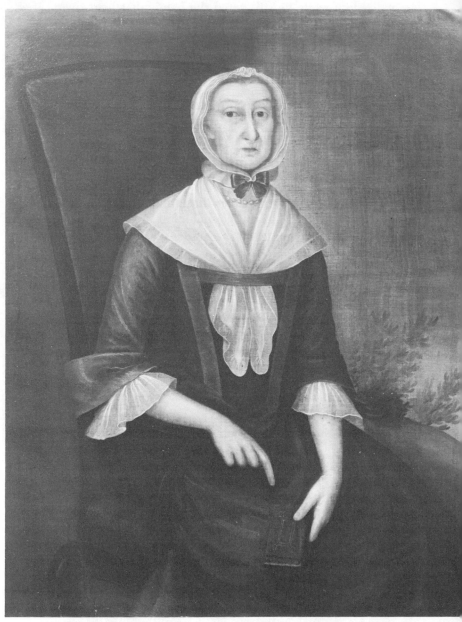

JOSEPH BADGER: *Mrs. John Edwards* *Courtesy of the Museum of Fine Arts, Boston*

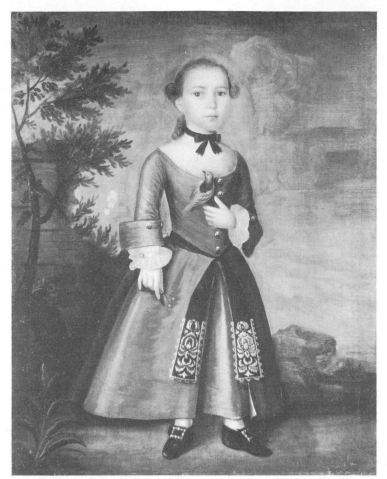

JOSEPH BADGER: *His Son James* *Courtesy of the Metropolitan Museum of Art*

When Smibert arrived, Pelham was glad to put down his brush and engrave that artist's likenesses; only in 1750, when Smibert was dying, did Pelham again paint originals for his engravings. His considerable skill at mezzotint did not enable him to make a living from his craft. In his Boston years, he published only fifteen portrait engravings and one map. He eked out his living by teaching 'dancing, writing, reading, painting upon glass, and all sorts of needle work.'[2]

Copley experimented in his stepfather's workshop with brush and graver; probably he visited Smibert's studio. Did Pelham, that

[197]

aging failure, realize that he had an infant genius on his hands, or did he merely think it thrifty to save apprentice fees by teaching his stepson his own trade? Did Smibert, now old and sick, smile at the enthusiasms of so small a boy, or did he sometimes rise from his bed to guide the brush in the eager hand? We only know that Copley's association with the English artists was brief. Three years after his mother had remarried, both Smibert and Pelham died. At thirteen, the boy found himself the head of a family to which a baby half-brother, Henry Pelham, had been added. With the painstaking seriousness of his nature, he slaved to reach a point where he could practice his trade for profit. He seems to have turned for inspiration to Boston's two remaining painters, Joseph Badger and John Greenwood.

Badger (1708-1765) was a simple artisan. The son of a tailor, he became a house painter and glazier. He was over thirty when he added to these crafts the creation of effigies. Although he borrowed fashionable compositions from Feke, from Smibert, and from transatlantic prints, fine poses were merely a skeleton which he clothed, quite incongruously, in matter-of-fact vision. With grim determination he tried to reproduce the features before him, forgetting about ideal beauty. Crudely painted caricatures stare at us from too close to the tops of his canvases. His earlier efforts were contemporary with the work of Feke, but his sitters inhabit a different world. Feke's ladies move beautifully in a dream; they would burn themselves on a cookstove. If we are hungry, we had better drop in on one of Badger's crones, Mrs. John Edwards perhaps; on the strong homespun covering her table she would serve light biscuits piping hot.

Badger's pedestrian realism depicted each object, be it a chair or a face or a tree or a hand, as literally as possible, and then dropped it into the picture beside the next object. The upholstered chair, in which the old lady sits without relaxing her backbone, has been superimposed, as if with scissors and paste, on a landscape that meanders into the background at its own vagrant will. A lushly growing weed disputes for attention with the sitter's face. This is the vernacular of a countryman who, as he tells a story, identifies the exact point in the barn where he stood, the exact moment when the red cow kicked over the pail.

Badger came closest to imagination in his pictures of children.

Each accompanied by a pet bird or squirrel, they stand with rigid self-consciousness against an indecisive landscape. Stiffly drawn but colored with naïve harmony, they have little movement and no existence in space. Wherein then lies their undoubted charm to the modern viewer? Why, despite their myriad solecisms of technique, do we return again and again to Badger's canvases, hoping always to have them coalesce at last into a profoundly moving vision? I think the answer is that Badger was an intellectual painter. His analytical mind sought not beauty, not grace, but meaning. However much they fail visually, his infants con-

JOHN SINGLETON COPLEY: *Reverend William Welsteed*

Courtesy of the Yale University Art Gallery

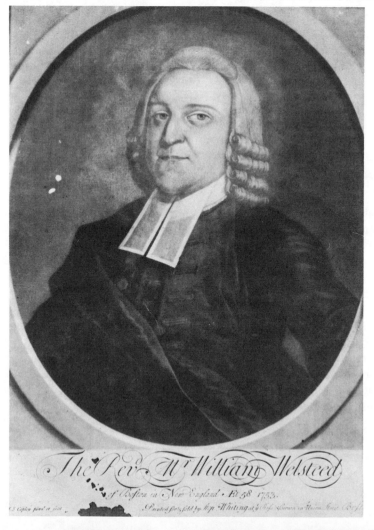

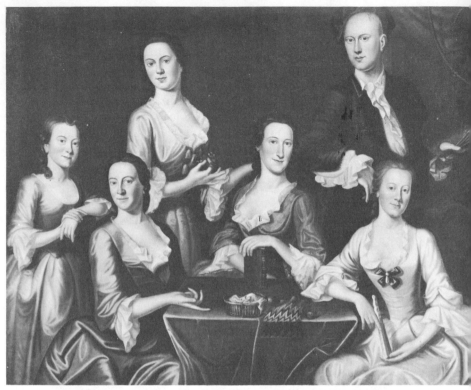

JOHN GREENWOOD: *The Greenwood and Lee Families.* *The artist stands in the background*
Courtesy of Henry L. Shattuck

vey somehow an essence of eighteenth-century childhood. His adults have none of the animal high spirits, the physical joy of living that characterized Feke; these men and women have forgotten their bodies, even as the artist ignored anatomy, to seek reality in the gyrations of the invisible brain.

That Badger was able to compete with Feke before that accomplished poet vanished shows that Boston was now breeding individuals who would rather be caricatured with honesty than remade by the brush of a dreamer. After Feke and Smibert withdrew from the lists, Badger became Boston's busiest painter. Perhaps it is not altogether coincidence that his only important rival was almost as downright as he.

Although the son of a Massachusetts merchant and shipbuilder,

John Greenwood (1727-1792) was, during a temporary slump in the family fortunes, apprenticed to Thomas Johnston, engraver, printer, designer of gravestones, painter of houses, fire-buckets, and ships. But Greenwood soon abandoned his apprenticeship and set up as a portraitist. 'In a few years,' his son tells us, 'he was considered quite a genius, became the admiration of the town for his then quite uncommon productions of the pencil. His company was sought and his time occupied in painting the portraits of his friends.' Like West, Greenwood achieved reputation before he achieved skill.

He accepted success with an enthusiasm unmarred by sensitivity or reticence. Compare his *Greenwood Family* with Smibert's *Berkeley* and Feke's *Royall* groups. The self-portrait he placed in the background shows no introspection: it is scrawled in with his typical shorthand. The picture differs from its predecessors in its slapdashness, its lack of meditation, its uncontrolled energy. To use William Sawitzky's metaphor, the sitters peer out of the canvas with the raucous determination of a nest full of baby screech-owls demanding worms. In his portrait of individuals, Greenwood began, like all his contemporaries, with the conventional poses of the period, but he altered them with a fierce originality which was based as much on carelessness as thought. Heads stand out high above the bodies, joined to the other forms by brusque lines. The ladies have immensely elongated necks and conical torsos. The men, as Greenwood's biographer Burroughs points out, rear forever backward ignoring the hands that gesture frantically at the bottom of the canvas. Again, as in the case of Badger, we find ourselves faced with symbols of humanity more intellectual than sensuous. The result was highly unflattering to the sitter, yet Greenwood did a good business until, at the age of twenty-five, he left the Colonies forever. He was to give up painting and become one of London's most successful vendors of old masters.

In his eagerness to learn, Copley imitated the entire school of Smibert: the master himself, Pelham, Feke, Badger, and Greenwood. His early pictures are so various in style that it is hard to believe they are by the same hand. In his sixteenth year, he made an engraving from his own portrait of the Reverend William Welsteed, creating a serious, undecorative study of a divine that followed Badger into cerebral and homely forms.[3] His oil of

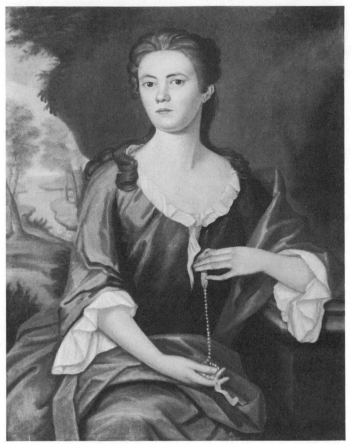

JOHN SINGLETON COPLEY: *Mrs. Joseph Mann* Courtesy of the Museum of Fine Arts, Boston

Mrs. Joseph Mann, although also dated 1753, is more in the spirit of Feke, a fancy portrait of conventional cast. The jutting rock in the background, the elongated hands fingering a pearl necklace, might have come from a copy-book. Only one element is strange; when Copley came to the lady's nose, the painter's eye interfered with the patterns of his hand and he recorded, most incongruously, a realistic pug. The youngster piled on pigment as if, ignorant of the function of contrast, he believed that the juxtaposition of many bright colors would give a bright effect. Our memory of Pelham's *Mather Byles* makes us suspect that Copley inherited this misunderstanding from his stepfather.

[202]

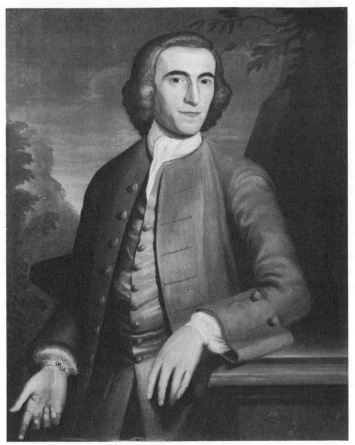

JOHN SINGLETON COPLEY: *Joseph Mann*　　　　*Courtesy of the Museum of Fine Arts, Boston*

Mrs. Mann's husband shows the same hot coloring. The conception seems borrowed from Greenwood, yet the mood is something new. Indeed, *Joseph Mann* reveals so much more striving for visual realism than the portrait of his wife that scholars have dated it a year later. Perhaps the difference was in the sex of the sitter. Less flattery being required, Copley tried to define the shape of the sitter's head by studying the shadows from life. He only succeeded in creating a peculiarly shaped oblong, with the back of the head much wider than the face, yet that he made the attempt is highly significant. Clearly, he would never in the end be satisfied with such a decorative formula as Feke's.

[203]

When at about the same date Copley painted an unidentified engraver, wrongly called *Peter Pelham,* he gave us a glimpse of the social confusion that reigned in the Colonies. In England an artisan, determined to go down to posterity as a gentleman, would banish from his portrait all hints that he worked with his hands. Copley followed the English fashion by dressing his engraver up to the eyes in the most elegant clothes he could imagine — but what are those strange objects behind the sitter's elbow? We see an anvil and a hammer, while in the very foreground are other tools studied with all the fidelity of a Dutch master. Here is a major confusion of styles. The engraver's pose is refined and his costumes unsuited to labor — it is awful to think what would happen when those long cuffs brushed across an inky plate — yet he is shown at his workbench with a magnifying glass in his hand. New forces were at work, and already they were inserting incongruities into the products of the boy artist.

Although Copley's conceptions are confused, his drawing shaky, and his coloring crude; although his attempts at three dimensions are more in the realm of will than achievement; although he has as yet little understanding of space as an element in design, the youth was setting his feet in new paths. Had he died at the age of sixteen, he still would have had a place in the history of American art.

The next couple of years show Copley continuing his experiments and copying allegorical prints to produce such pictures as *Venus, Mars, and Vulcan.* Then in 1755, when he was seventeen, a new influence struck like a thunderbolt. Fate sent to Boston a British painter, Joseph Blackburn, who represented tendencies exactly opposite to the homely directions in which Massachusetts art had been traveling since the disappearance of Feke.[4] Although crude according to London standards, the newcomer (active in Bermuda and America *ca.* 1752-*ca.* 1763) seemed a miracle of skill in America. He worked in that artificial, pearl-studded, and silk-draped style whose leading exponent was Thomas Hudson, the most fashionable of English portraitists. Faces, personalities, intellectual people: these interested Blackburn hardly at all. His work was characterized by a love of costumes and textures. Such sweet-smiling ladies as *Mrs. Winslow* gleamed in dancing-school poses. Often they were irridescent

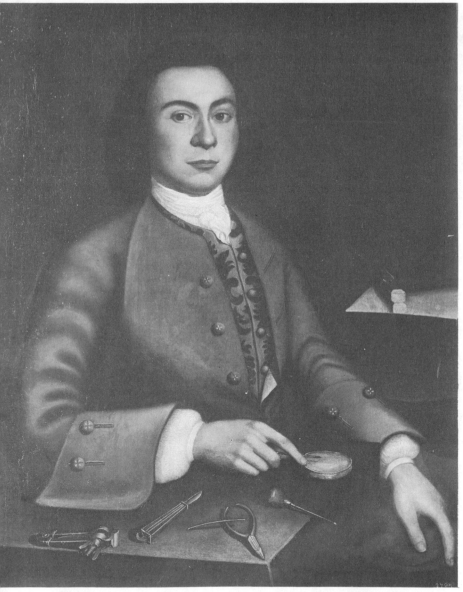

JOHN SINGLETON COPLEY: *An Engraver* Courtesy of C. P. Curtis

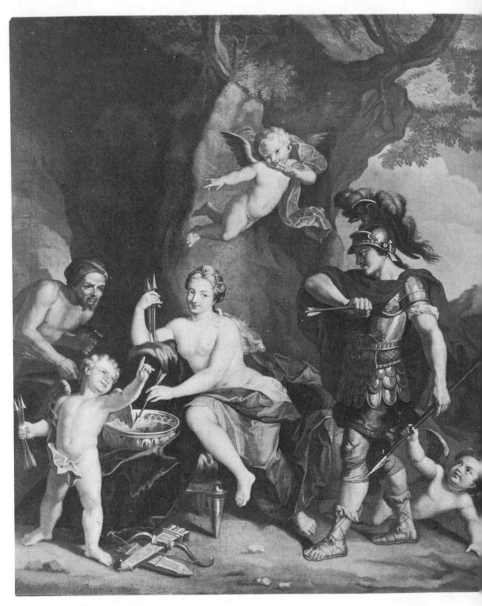

JOHN SINGLETON COPLEY: *Mars, Venus, and Vulcan* *Present location unknown*

with pearls. Yet these displays were never vulgar; Blackburn's touch was delicate.

Perhaps Copley trembled for his livelihood when the newcomer set up a painting room. Soon, however, he was entranced. Here was a new vision of English art. Unlike that prosaic practitioner Smibert, Blackburn was a born painter, a poet with the brush. Despite errors of drawing and superficiality of vision, he saw the world in terms of delicate gradations of color. A balance of chromatic values came to him naturally: luminous white, light blue, pink, golden yellow. Even his landscape backgrounds glowed with a subdued yet prismatic glory that was in itself moving, although he had no special feeling for nature. How these virtues must have appealed to Copley, who was to write: 'There is a kind of luxury in seeing as well as there is in eating and drinking; the more we indulge, the less we are to be restrained!'

An artist who painted primarily in color would have left Copley bewildered, but Blackburn applied his lust for hues within the stiff formulas Copley already knew. Pearls were not indicated with a chromatic hint, but drawn meticulously, as were the still-life objects with which Blackburn characterized his sitters — books, boats, quill pens, vases of flowers. Entranced, Copley tried to paint like the newcomer, even copying the lettering of Blackburn's signature. His *Jane Browne* differs from the English master principally in the greater hardness of drawing and color.

However, Copley soon returned to his own style, carrying with him much of Blackburn's skill in the depiction of textiles and some of his delicate tinting. This newly acquired grace modified but did not basically change his manner. The Colonial stripling did not really want to paint like the mature Englishman. People were not to him tailors' dummies on which to hang a sensuous glow of silks; they were knotty, strange, almost incredible animals that needed to be understood. Copley, so his letters reveal, was a shy man who walked the world in fear and hesitation; to get on with his fellow men was a task that required his most deliberate skill. He could not set down a glowing image in a dash of paint, and then stand back in complacent self-admiration. He was conscious of too many difficulties. There was the personality of the sitter, which he considered it his duty to record. Furthermore, profound technical problems of the fine arts bothered him, not as esthetic

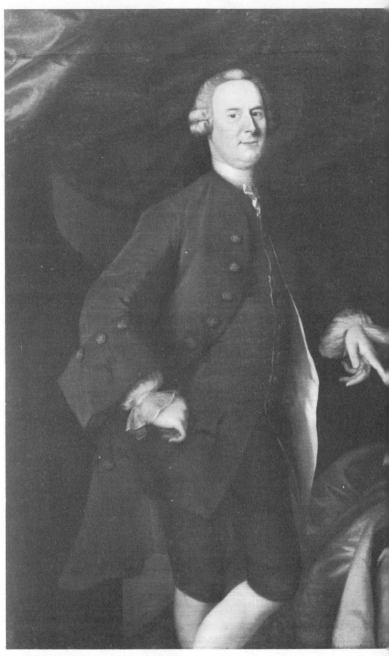

JOSEPH BLACKBURN: *The Winslow Family*

Courtesy of the Museum of Fine Arts, Boston

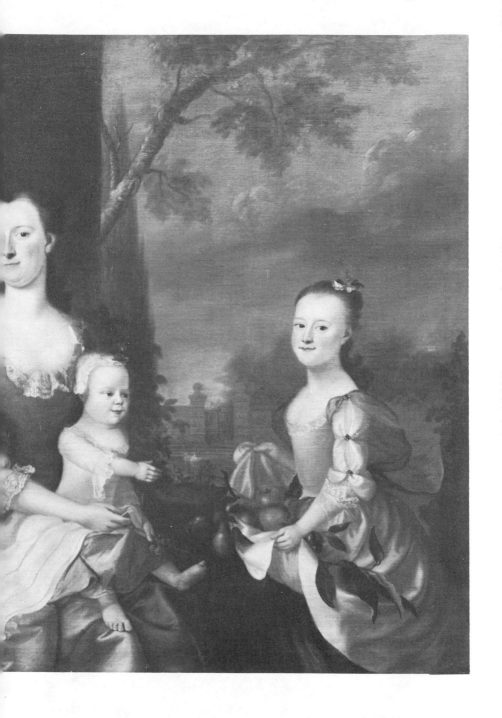

matters, it is true, but as part of the job in hand. A man was not a paper doll; he had weight; surely Blackburn was leaving something out when he slighted this consideration. To show a man in two dimensions was as silly as building a chair with two legs.

Thus Copley struggled to achieve plasticity. For the moment, he was thinking more in terms of weight than space: he wanted bodies to have form, but was not concerned with giving them position in an environment that had depth. His backgrounds remained painted backdrops. In *Mrs. Jonathan Belcher* (1756) he tried an experiment: by throwing a sharp light on her body, he blacked out the background and secured unusually heavy shadows with which to delineate shape. By the use of this method, and any other he could think of or borrow, he soon left Blackburn's superficial images far behind.[4]

JOSEPH BLACKBURN: *Mrs. James Otis* *Courtesy of the Brooklyn Museum*

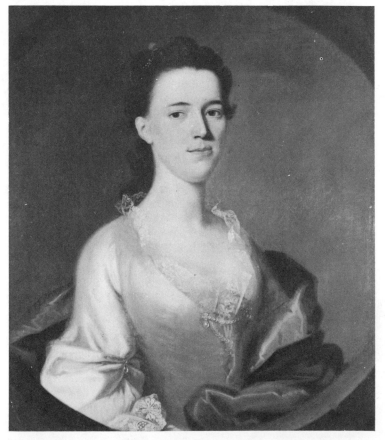

Like most Colonial painters, Copley was picking up income by painting miniatures; he was soon to become interested in pastels, a medium almost unknown in New England.[5] During 1762, he ventured a letter to the famous Swiss pastelist, Liotard. 'You may perhaps be surprised,' he wrote, 'that in so remote a corner of the globe as New England there should be any demand for the necessary utensils for practicing the fine arts, but I assure you, sir, however feeble our efforts may be, it is not for the want of inclination they are not better, but for the want of opportunity to improve ourselves. However, America, which has been the seat of war and desolation, I would fain hope would one day become the school of fine arts, and Mr. Liotard's drawings with justice be set as patterns for our imitation. Not that I have ever had the advantage of beholding any one of those rare pieces from your

JOHN SINGLETON COPLEY: *Jane Browne* *Courtesy of the Mellon Collection,*
National Gallery of Art, Washington, D.C.

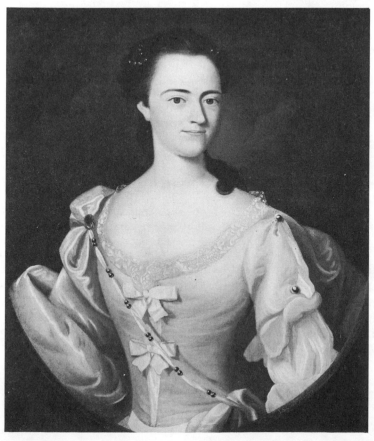

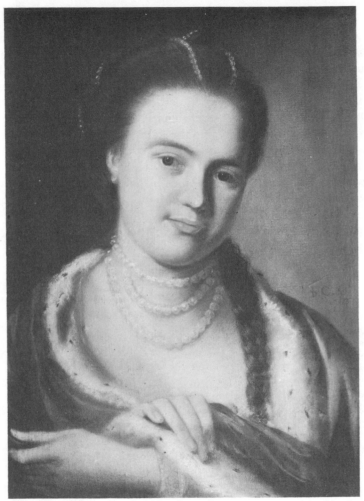

JOHN SINGLETON COPLEY: *Pastel of Mrs. Gawen Brown* *Courtesy of Luke Vincent Lockwood*

hand, but formed a judgement on the taste of several of my friend who has seen them.' He then begged Liotard to help him secure 'one set of crayons of the very best kind, such as you can recommend [for] liveliness of color and justness of tints.' Whether Copley ever received these crayons we do not know, but there can be no doubt that, with practically no models to go by, he taught himself to be a pastelist of charm and grace.[6]

In every direction, Copley was bursting through the limitations of his environment. Before he was twenty, he was in a strange position: although he was still struggling to evolve a personal style, his work was better than any that he had ever seen. He had come to realize that even the glittering Blackburn was poor stuff after all. He was to write to Benjamin West, 'In this country, as you rightly observe, there is no examples of art, except what is to [be] met with in a few prints indifferently executed, from which it is not possible to learn much. . . . I think myself particularly unlucky in living in a place into which there has not been one portrait brought that is worthy to be called a picture.' If he were to go any further in the arts, he would have to plunge into an unexplored wilderness of the mind.

Here is a type of American pioneering which is too often ignored in our historical copybooks. We hear endlessly how the frontiersmen penetrated with only axe and rifle into a forest full of catamounts and Indians: such physical adventure is an accepted part of the American legend. We are proud that pioneers built not Georgian mansions, but log cabins in the wilderness. But when we find equally brave explorers penetrating the forests of the mind, we blush at their productions and call them provincial.

Let us hymn Copley as a brother of Boone, a more intellectual, a more admirable brother. Cramped esthetic considerations hemmed him round; he could have found a successful career between the narrow walls of Colonial tradition. But when he cast his eyes upward, he saw mountains rising in the distance, the Alleghenies of the intellect. No paths led to these enticing peaks; before him lay the unknown and perhaps impossible. Armed with his native wits, a few brushes and some tubes of paint, he left behind him the comfortable environment of his ancestors. Where he was going he could not know, for there were no signposts to mark the way. But there was the exhilaration of adventure, and — who knows? — perhaps in some unexplored valley there lay waiting some unimagined wonder.

CHAPTER TEN

Alleghenies of the Intellect

IF YOU LIVED IN BOSTON during the seventeen-sixties and wanted to have your portrait painted, you would certainly apply to Copley, who enjoyed a monopoly of the best business. The young man who meets you at the door of his painting room is fashionably clothed — John Trumbull found him dressed for dinner in 'a fine maroon cloth with gilt buttons,' — but he lacks the air of a Kneller or a Reynolds. His stocky figure seems more that of a prosperous artisan, a silversmith or perhaps a cabinet-maker. As matter-of-factly as any tradesman, he shows you his wares and quotes prices. Then he sets a date months in the future. When you object to the delay, he motions you to look round his studio, 'a large room full of pictures unfinished which would engage me this twelve months if I did not begin any others.' There is nothing to do but wait, since it is unthinkable you would employ anyone but Copley.

If, familiar with English studio practice, you are looking forward to being entertained by your sittings, you will be disappointed. With an efficient nod of greeting, Copley motions you to a chair. Behind his distant manner you sense shyness, but when he gets to work the shyness vanishes; indeed, he seems to have forgotten you are alive. Far from entertaining you with gossip and anecdotes, he labors in complete silence. The flashing brushwork with which the Old World portraitists awe their sitters is completely lacking; Copley's brush spends most of its time motionless in his hand. Pondering with a corrugated brow, he stares until you become embarrassed. Then he starts to mix a color, pausing momentarily to stare again. At last he takes some pigment on his palette knife, and, walking up to you, matches it to your face. When at last he touches the brush to the canvas, it is with a tight, unrelaxed motion.

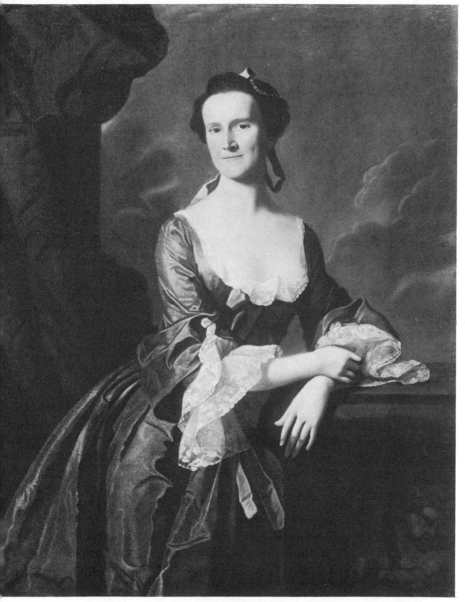

JOHN SINGLETON COPLEY: *Mrs. John Amory* *Courtesy of the Museum of Fine Arts, Boston*

A contemporary remembers that Copley's manner was 'very mechanical. He painted a very beautiful head of my mother. . . . She sat to him fifteen or sixteen times. Six hours at a time!' After several sittings, Copley left the room. 'He requested that she would not move from her seat during his absence. She had the curiosity, however, to peep at the picture, and to her astonishment she found it all rubbed out.'

The contrast between the speed of the English painters, who could complete a head in a few hours, and Copley's slowness, indicated a fundamental difference of method. The transatlantic artists were applying an already established technique; like virtuosi, they played a few variations on a familiar melody. But Copley composed his piece as he went along. Faced with peculiar shadows on a hand, he could not remember how Kneller had solved the problem, or Raphael. He had to solve it for himself, a most exacting and laborious task. He realized that his paintings 'are almost always good in proportion to the time I give them, provided I have a subject that is picturesque.'

The task of recording what he saw was so arduous that it occupied all the best efforts of Copley's brain. Copying from life features, pose, perspective, background, he was drawn irresistibly toward illusionistic realism. This pleased his public. It was regarded as a proof of greatness that when one of his portraits was sent to Scotland, the subject's infant son, having 'eyed your picture . . . sprung to it, roared and screeched, and attempted gripping the hand, but when he could not catch hold of it . . . he stamped and scolded.'

Copley's comment on this anecdote is out of key with a period when familiarity with old masters was considered the cornerstone of taste. 'I confess it gives me no small pleasure to receive the approbation of so uncorrupted a judgment as that of so young a child; it is free from all false notions and impertinent conceits that is a result of a superficial knowledge of the principles of art, which is so far from assisting the understanding that it only serves to corrupt and mislead it.' This statement presages the downfall of Renaissance standards and the rise of the modern taste for untraditional painting that appeals directly to the emotions. But Copley was too much a product of his times to go the whole way

in admiring the untutored eye of a child; it was only 'superficial' connoisseurship which he believed must bow before innocence.

Two opposite theories of art war in this brief statement; the conflict was as basic to Copley's thinking as it was to his opportunities. Forced to achieve his own innocent solutions from a study of nature, he was pleased with the results, but resented the isolation that made him walk so steep a road. In his mind's eye, he saw the artists of Europe riding to fame in chariots ready-made by the old masters. If only he possessed the same knowledge it would, he believed, 'animate my pencil and enable me to acquire that bold and free style of painting that will, if ever, come much slower from the mere dictates of nature, which has hitherto been my only instructor.

He read the few books about art available to him with all the concentration of a virgin deep in tales of love. High-stilted phrases in his usually matter-of-fact letters undoubtedly reflect the printed page. He wrote of 'that mighty mountain where the everlasting laurels grow to adorn the brows of those illustrious artists who are so favored of heaven to unravel the intricate maze of its rough and perilous ascent.' He imagined the 'happy era' when America 'would rival the continent of Europe in those refined arts that have been justly esteemed the greatest glory of Greece and Rome.' Yet, despite the copies and engravings which he sought out so eagerly in Boston, he achieved only the dimmest notion of the pictures about which he read. The authors of books, he complained, 'seem always to suppose their readers to have the works of the great masters before them.' [1]

He hung a reproduction of a *Madonna* by Raphael over his mantelpiece, but he had more immediate use for prints after English portraitists. He copied the composition of Reynold's *Lady Caroline Russell*, even to the small hairy dog in the sitter's arms, and then added the head of a Colonial sitter, Mrs. Jerathmael Bowers Such exercises encouraged him to employ poses and backgrounds that were for him artificial since they did not grow out of the world in which he moved.

Often his pictures break in half. The composition of *Mrs. John Amory* (*ca.* 1763) is baroque: the rock in the background, the self-consciously arranged clouds, the lady's pose, go back through

[217]

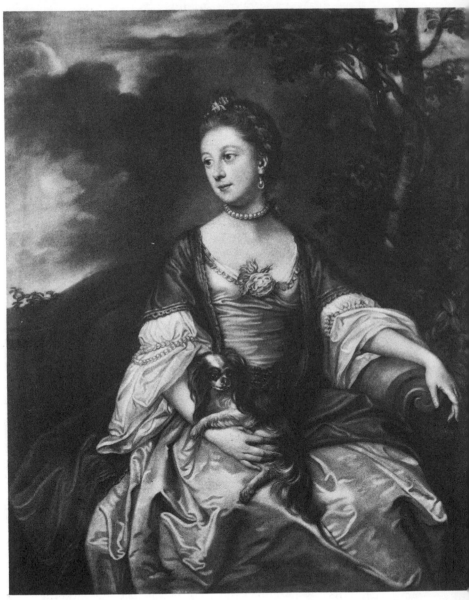

ENGRAVING AFTER SIR JOSHUA REYNOLDS: *Lady Caroline Russell*

Courtesy of the New York Public Library

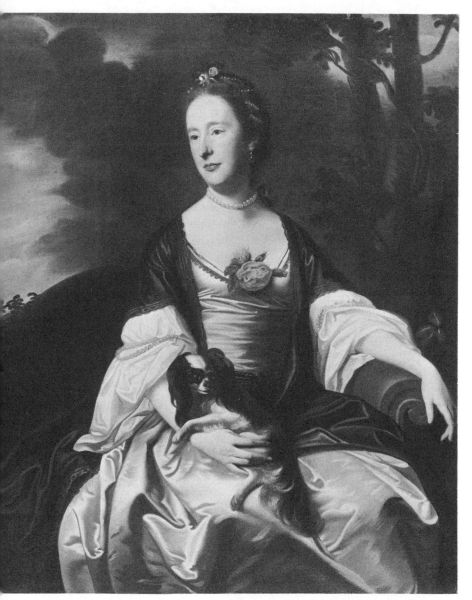

JOHN SINGLETON COPLEY: *Mrs. Jerathmael Bowers* *Courtesy of the Metropolitan Museum of Art*

a hundred imitators to Van Dyck. The costume is frilly enough in conception to have pleased Blackburn; it undoubtedly satisfied the Colonial sitter's yearning for Old World elegance. But the execution of these hackneyed conceptions is out of the baroque mood. Glitter has given way to realism. Flaubert, who said that a writer should be able to describe a horse so it could be distinguished from every other horse in Paris, would have loved Copley's work. Each piece of lace was a portrait; Flaubert could have picked it out from all the lace in Boston.

The same struggle for reality dominates the painting of the head. Mrs. Amory is a handsome woman; it would have taken only a little legerdemain to change her into a conventional doll. But Copley, fascinated by the intelligence of her face, gives us a portrait not only of her high cheekbones and widely spaced eyes, but of the brain behind them. She is a typical strong-minded New Englander. When I was an undergraduate at Harvard, I sat in the parlors of such ladies: they had visited Sacco and Vanzetti in jail, and they would talk with more interest than fear about 'the Russian experiment.'

Trained as an engraver, primarily inspired by prints, Copley conceived his pictures less in terms of mass than of the outlines of the forms. It was a second step when he gave these forms plasticity by the application of shadows studied from nature. The shadows are harsh and overdark, yet they obeyed their master's bidding, creating a powerful impression of weight. Little by little Copley added depth to his other tools, until such a portrait as *Nathaniel Sparhawk* (1764) shows us a three-dimensional world. Yet the shapes do not flow one into another with the fluidity of nature; each stands out sharply by itself.

Copley is on the whole innocent of colors conceived for their own sake. A yellow silk gown may be brilliantly revealed as its folds catch different intensities of light, but the aim is less sensuous beauty of tint than an exact representation of the silk. Such realistic passages are juxtaposed with an eye to general harmony and effect; the hues do not mingle like the notes in a symphony. Copley's coloring is at its best when he paints almost monochromatically, using, as in *Mr. and Mrs. Thomas Mifflin*, a rich gray enlivened, where it contributes to the plasticity, with unobtrusive

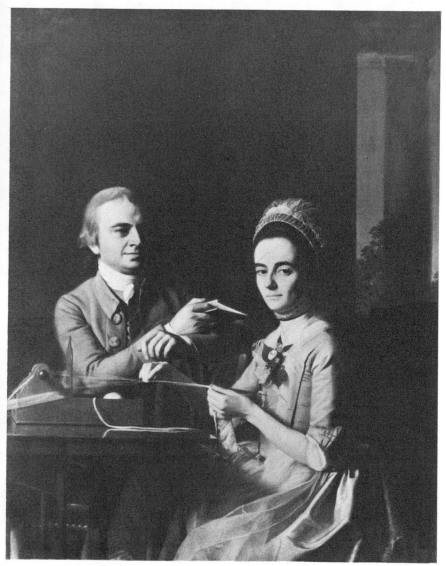

JOHN SINGLETON COPLEY: *Mr. and Mrs. Thomas Mifflin*

Courtesy of the Historical Society of Pennsylvania

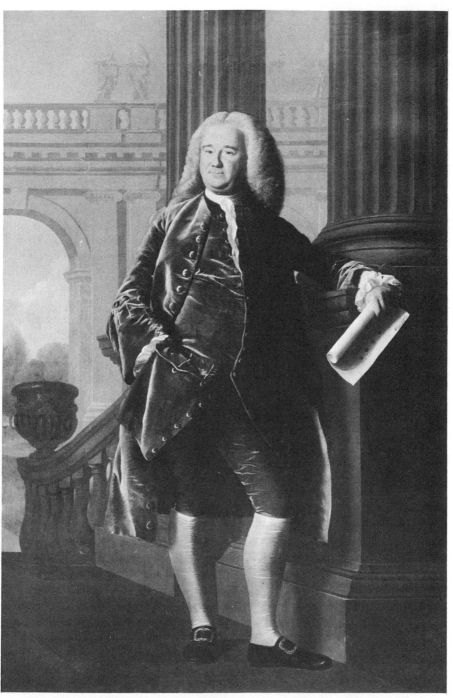

JOHN SINGLETON COPLEY: *Nathaniel Sparhawk* *Courtesy of Mrs. Frederick H. Rindge*

bits of other tints. That Copley has often been praised as a colorist shows how successfully he employed his naïve approach.

Since his technique differed radically from the European, he produced his best pictures when he forgot Old World sources and based the composition, as he had based everything else, on personal observation. Such portraits alternate with more self-conscious efforts all through his adult career. *Mrs. Michael Gill,* painted when he was about twenty-one, was the first exemplar of his mature style. It is amusing to note how often American artists traveled furthest toward realism in depicting old ladies. Colonial women accepted age less rebelliously than did their English sisters; indeed, they felt it unsuitable to be tricked out like any young hussy. Thus in painting Mrs. Gill Copley was encouraged to cast aside borrowed plumage and paint what he saw. That the result is closer in mood to Rembrandt than to Kneller is not due to direct influence but to a similarity of middle-class environments.

Devoid of swirling draperies and fancy background, Mrs. Gill sits plainly against darkness. The face of the rugged old business woman, who owned three ferryboats and a wharf, is plain and shrewd. The mouth sinks slightly because the teeth are giving out behind; the eyes look at the world with a satirical twinkle. Her pose is natural if we think of her as a woman, but if we think of her as a picture it is very strange. Gone is the elaborate idiom of baroque portraiture. To the likeness of the head Copley has added a likeness of the body, a feat impossible to artists who employed drapery painters. She sits in her chair as she did in life, her pose as essential a part of the characterization as the wrinkles under her eyes.

Again and again, Copley was to catch idiosyncrasies of posture and figure as well as of face. He shows us a merchant looking up from his desk; a young girl opening an umbrella; a writer, quill pen in hand, fumbling in his mind for a word. Moving toward his end of photographic realism, Copley was approaching the practice of the candid camera.

Social conventions went down with the stylistic. As a boy, Copley had painted an engraver surrounded with his tools, but had been careful to dress him like a gentleman. When he returned to artisans' portraits a decade or so later, he carried his new vision to a logical conclusion. His silversmith friends, Paul Revere and

[222]

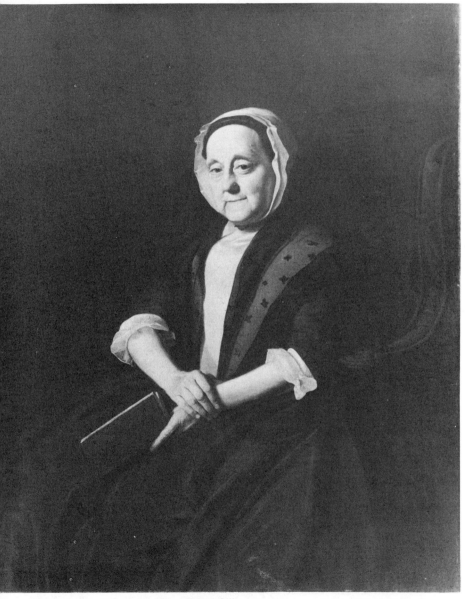

JOHN SINGLETON COPLEY: *Mrs. Michael Gill* *Courtesy of Mrs. L. G. Pinnell*

Nathaniel Hurd, are not only shown surrounded with the tools of their trade, but, caught at their work-benches in an ordinary moment of labor, they sit before us in their shirt-sleeves. Far from being ashamed of their menial attire, they seem unconscious of it. Clearly artist and sitters were all, from the point of view of aristocratic England, social barbarians.

The equalitarian tendency, which had run so long underground in America, came to the surface in art at about the same time as in politics. During its first century, Colonial painting had been predominantly aristocratic. Although the British bourgeois, Smibert, brought to this country a style tinged with realism, his American work remained full of frills; and his earliest disciple, Feke, cast the realism completely overboard. But Feke's disappearance in 1750 marked a complete change in New England art. His successors used Smibert's example for opposite ends; Badger and to a lesser degree Greenwood fastened not on the Englishman's elegance but on his realism, and this they carried over into caricature. The tide was flowing so strongly by the seventeen-fifties that even the charming example of Blackburn was unable to drive Boston painting back into the old channels.

It is not remarkable that the tendency to show people for their own sake, independently of rank, emerged first in Boston. The revolution that was brewing in the Colonies was only in part equalitarian. Planters like Washington, merchants like Robert Morris, saw it as a controversy between two groups of gentlemen, and in the seventeen-seventies this conservative point of view dominated the patriot party almost everywhere. But in Boston the backbone of revolt was a mob of mechanics, most of them too poor to be allowed a vote, who pitted themselves against the gentlemen of the King's Council. At the Continental Congresses, Samuel Adams was frowned on as espousing 'leveling principles.' In politics as well as art, Boston was in the vanguard of the swing toward individual liberty.

We must not think of Copley as a conscious radical, the eighteenth-century counterpart of those moderns who believe they are giving content to their work by painting strikers assaulted by policemen. His closest approach to such subject matter was his *Samuel Adams*, which showed the arch-rebel as Copley imagined he looked when he confronted Governor Hutchinson the day after

[224]

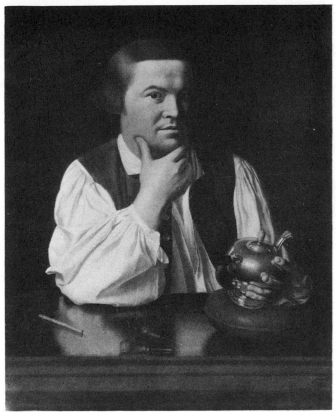

JOHN SINGLETON COPLEY: *Paul Revere* *Courtesy of the Museum of Fine Arts, Boston*

the Boston Massacre. Concerning the scene, Adams wrote: 'It was then, if fancy deceives me not, I saw his knees tremble. I thought I saw his face grow pale (and I enjoyed the sight) at the appearance of the determined citizens demanding the redress of grievances.'

Had Copley appreciated the ideological implications of his realistic portraiture, he would have made this the most downright of all his pictures. Yet he shows Adams standing straight as a ramrod in a conventionally noble pose, while the fingers with which he points at his inflammatory petition are flexed like those of a Kneller lady calling attention to her pet lamb. Whatever there was of the social revolutionary in Copley's paintings came from no conscious thought; it 'just growed.'

Indeed, in his sense of Colonial inferiority, Copley sometimes

complained of the very conditions that created the glories of his style. He mourned that having no assistance, I am obliged to do all parts of my pictures with my own hand,'[2] and added that he preferred to have his sitters simply dressed since he could not secure really fashionable clothes 'unless I should put myself to a great expense to have them made.' He painted Revere in his shirt-sleeves because that seemed the obvious thing to do. He would probably have been mortified had it been pointed out what a solecism he had committed; indeed, Revere himself would probably have put on his coat. Nor must we forget that a silversmith was an aristocrat among Colonial arstisans; it would not have interested Copley to paint a stevedore.[3]

Yet the fact remains that whenever Copley took a step on his own, it was in the direction of realism. Realism rose from the depths of his personality, an uncontrollable source of strength, even when he tried to disassociate it from his painting hand. Basically, he was interested in character, more concerned with individuality than class. His American paintings are great in exact proportion to the triumph of this bourgeois tendency. Consciously or unconsciously, whether he willed it or no, he was molded by his environment toward revolutionary ends he did not see.

Copley himself would have been annoyed at this analysis. 'I am,' he wrote, 'desirous of avoiding any imputation of party spir[it], political contents being neither pleasing to an artist or advantageous to the art itself.' His only interest, he believed, was in painting. He refused business lest a flood of commissions 'retard the design I always had in mind, that of improving in that charming art which is my delight, and gaining a reputation rather than a fortune without that.' For non-commercial pictures his half-brother, Henry Pelham, was his favorite model. In 1765, he painted the lad leaning over a table while in the foreground a pet squirrel calmly ate a nut. Having 'teased' him to finish it, a cosmopolitan sea-captain, R. G. Bruce, carried the picture off to London almost by brute force, so that he might give it to Reynolds for exhibition at the Society of Artists, the predecessor of the Royal Academy. Copley was terrified. He half hoped that the colors would be so changed by a sea voyage that the picture would have to be scrapped.

The year 1766, in which the canvas was exhibited at the Society

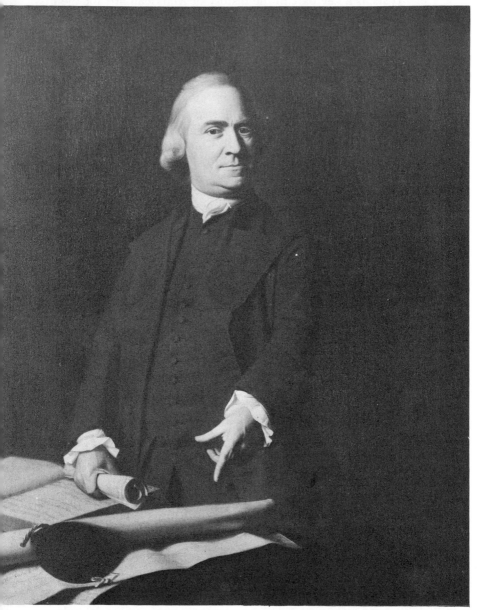

JOHN SINGLETON COPLEY: *Samuel Adams* *Courtesy of the City of Boston*

of Artists, is a key date in the history of American art; for the first time a picture created in the Colonies demanded a place among the leading paintings of the Old World. We may well be as frightened as Copley. English portraiture was close to its peak: what would the cosmopolitan Reynolds, what would the connoisseurs think? Their reactions should give us authentic light on the relation between the American tradition and the British school.

The conception of *Boy with Squirrel* resulted less from European models than from the isolated Colonial's lonely struggles. The sitter looks up from his play with a naturalism that would have shocked Lely or Kneller; we should expect the connoisseurs to be equally shocked. Actually, they accepted the pose so completely that they did not even comment upon it.

Here we see again that art does not move in the test tube, so dear to fundamentalist critics, where nothing takes place unless caused by the influence of Artist A on Artist B. Life as well as esthetics plays tunes to which the painters dance. The same weakening of the aristocratic ideal that molded Copley in the Colonies was active, if less predominant, in England. Although he was familiar with some portrait engravings, Copley's statement that he had no idea how his English colleagues painted contained much truth; yet he had moved certainly in the most advanced directions of British art. Reynolds had abandoned the sterotyped baroque portrait idiom. He substituted, it is true, conceptions borrowed from Italian and Dutch masters, but he put them together to form an illusion of everyday life. His ladies have been out in the garden picking flowers; his sea captains belong not in a throne room but on the quarter-deck of a frigate. And Gainsborough, product of the English back-country, had started out as a realist, although his style was always more suave than Copley's. When he moved to the fashionable centers of Bath and London, he was driven to painting society portraits, but all through his career he alternated with these confections occasional pictures which show as much interest in the individual as Copley's *Boy with Squirrel. Benjamin Truman* (*ca.* 1770) is an example.

Had Copley exported one of the silversmith's portraits that represented the extreme of his social evolution, he would probably have shocked the London connoisseurs. When Zoffany exhibited in 1770 a canvas similar in spirit — *An Optician with his Attendant* —

[228]

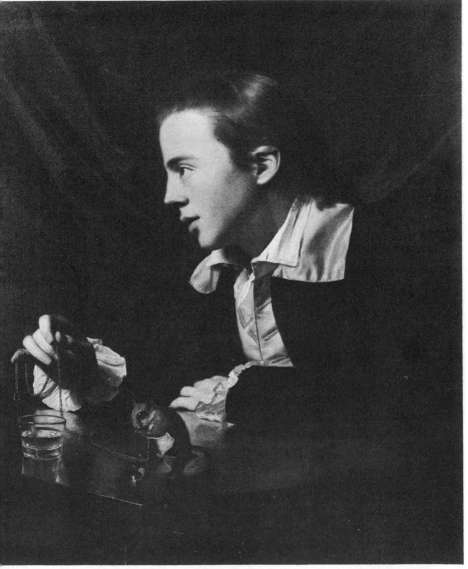

JOHN SINGLETON COPLEY: *Boy with Squirrel* *Owned anonymously*

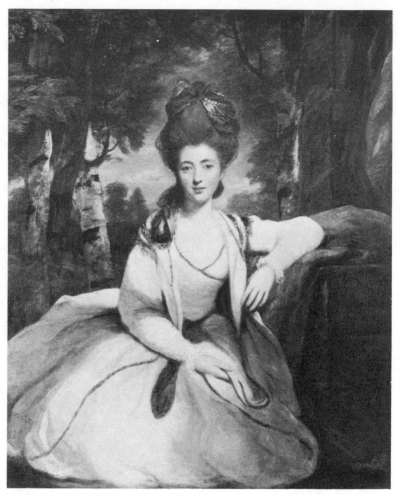

SIR JOSHUA REYNOLDS: *Marchioness Camden* *Courtesy of the Henry E. Huntington Library and Art Gallery*

Walpole potificated: 'Extremely natural, but the characters [of] too common nature.' Yet the very fact that so plebeian a subject was executed by a leading London artist and accepted by the Royal Academy is further proof that similar forces were moving the painters of England and America.[4]

The twenty-eight-year-old American was elected to the Society of Artists on the strength of *Boy with Squirrel*. Reynolds sent word to Boston that 'in any collection of painting it will pass as an excellent picture, but considering the disadvantages you labored

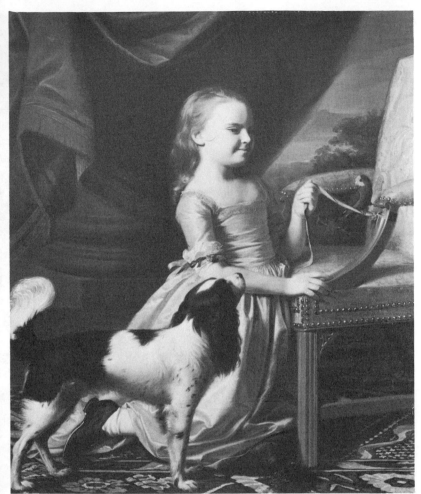

JOHN SINGLETON COPLEY: *Young Lady with a Bird and Dog* Courtesy of The Toledo
Museum of Art

under, it is a very wonderful performance. . . . If you are capable of producing such a piece by the mere efforts of your own genius, with the advantages of example and instruction you would have in Europe you would be a valuable acquisition to the art and one of the first painters in the world, provided you could receive these aids before it was too late in life, and before your manner and taste were corrupted or fixed by working in your little way in Boston.'

Your little way in Boston! Ah, there's the rub! Reynolds ob-

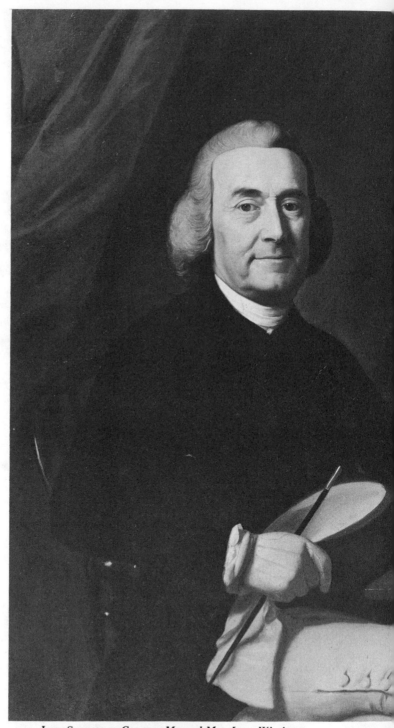

JOHN SINGLETON COPLEY: *Mr. and Mrs. Isaac Winslow*

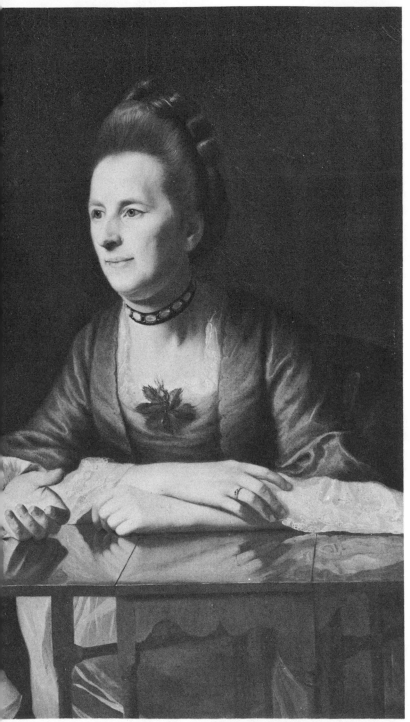

Courtesy of the Museum of Fine Arts, Boston

served 'a little hardness in the drawing, coldness in the shades [shadows], an over-minuteness.' Benjamin West, now one of the most successful painters in London, added that Copley, limiting space with lines rather than imagining forms, had made his outlines too sharp. Before we puff with nationalist indignation at these criticisms, let us take Copley out of his class and compare him with Titian or Rembrandt. Aridness is manifest. And the London masters had put their fingers on some of the causes.

That the realistic conception of Copley's pictures was more acceptable in England than his painting technique need not surprise us. Since the American life he expressed moved with international trends, Copley's thinking had validity for London as well as Boston. But his unaided brain was unable to imagine all the rich technical devices that had been evolved by generations of painters. Of this lack, the Colonial was very conscious. Passionately he studied the criticisms sent him from London. Then he painted a *Young Lady with a Bird and Dog* (1767), in which he tried to obviate them all.

Alas, poor Copley! He had so little visualization of sophisticated techniques that he tried to solve problems of execution in terms of composition. Interpreting West's statement that his figures were too liney as meaning that they stood out too sharply from the background, he submerged his little girl in a vast pool of objects: a spaniel, a broadly figured carpet, a chair, a parrot, a bright red curtain, and, to show that he was not devoid of classic taste, a marble column twice the thickness of his sitter. Since Reynolds thought his colors cold, he reverted to his earliest practice by using all the bright tints on his palette. Confident that he had followed the best advice, he sent the *Young Lady with a Bird and Dog* to England with few misgivings.

Copley must have been amazed when the picture was less well received than *Boy with Squirrel*, the criticisms being directed chiefly at the very changes he had made to please the London connoisseurs. West objected to 'each part of the picture being equal in strength of coloring and finishing . . . the dog and carpet too conspicuous for accessory things.' He attacked the classic column Copley had thought so knowing, saying that as the girl was in modern dress, 'the background should have a look of this time.' The colors were misapplied, 'as for instance the gown too bright for the flesh.' Furthermore, the shadows on the face lacked

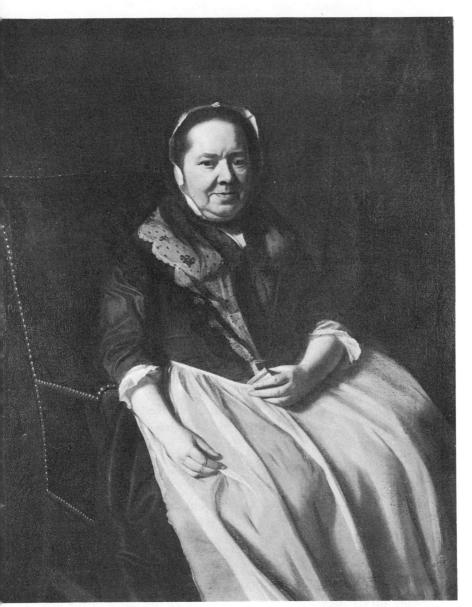

JOHN SINGLETON COPLEY: *Mrs. Paul Richard* *Courtesy of Charles M. Bleecker*

transparency,' a comment Copley was not to understand until he reached England: in his American paintings, the dark side of the face has a tendency to be blacked out. Complimenting Copley on 'drawing to a correctness that is very surprising,' West added, 'These are criticisms I would not make was not your pictures very nigh upon a footing with the first artists who now paints.' Again he urged the Colonial to study in Europe before it was too late.

Captain Bruce blamed the failure of the picture on Copley's 'unlucky' choice of subject; the nobility thought the little lady 'an ugly thing.' This statement puzzles a modern viewer as it must have puzzled the artist, for she seems a nice child, if pudgy. Perhaps on this occasion Copley's realism went too far from English taste. Reynolds's children were elves descended from the best families of fairyland, while Copley's is a puddinglike youngster who might pull the crockery from the table in any bourgeois home.

Copley walked the streets of Boston with a black face, for it was now clear that he could not profit from advice by letter; if he wanted to learn from other artists, he would have to go abroad. In white heat, he started two letters, neither of which seems to have been completed. First he blamed his difficulties on his Colonial environment. 'A taste of painting is too much wanting to afford any kind of helps; and was it not for preserving the ressemblance of particular persons, painting would not be known in the place. The people generally regard it no more than any other useful trade, as they sometimes term it, like that of carpenter, tailor, or shoemaker, not as one of the most noble arts in the world, which is not a little mortifying to me. While the arts are so disregarded, I can hope for nothing either to encourage or assist me in my studies but what I receive from a thousand leagues distance, and be my improvements what they will, I shall not be benefited by them in this country, neither in point of fortune or fame.'

In the other fragment, Copley imagined that he had made a trip to England and Italy. 'But what shall I do at the end of that time (for prudence bids us consider the future as well as the present)? Why I must either return to America, and bury all my improvements among people entirely destitute of all just ideas of the arts, and without any addition of reputation to what I have already gained. For the favorable reception my pictures have met with

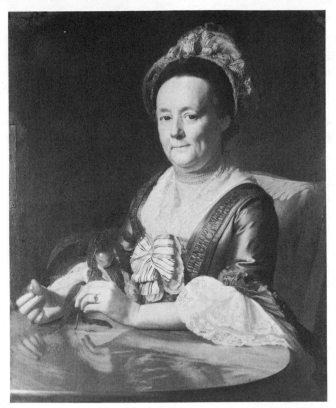

JOHN SINGLETON COPLEY: *Mrs. John Winthrop* *Courtesy of the Metropolitan Museum of Art*

at home [i.e., in England] has made them think I could get a better living at home than I can here, which has been of service to me, but should I be disappointed, it would be quite the reverse. . . . Or I should set down in London in a way perhaps less advantageous than what I am at present, and I cannot think of purchasing fame at so dear a rate.'

In a letter to West actually mailed, Copley stated succinctly: 'I should be glad to go to Europe, but cannot think of it without a very good prospect of doing as well there as I can here. You are sensible that 300 guineas a year, which is my present income, is a pretty living in America, and I cannot think you will advise me to give it up without a good prospect of something at least equal to it.' He begged West to tell him frankly what were his possibilities of becoming a leading portrait-painter in London.

These amazing documents require careful analysis. If we recall

that fifteen years before Philadelphians had sent West to Italy for the greater glory of the Province, Copley's statement that no European-inspired increase in skill would add to his reputation seems surprising.[5] Colonial nationalism was rising, particularly in Massachusetts, to the pitch of war. When orators were shouting that the English were so degenerate that the sturdy Americans could mow their armies down, the Bostonians — even the Tories, it seems [6] — expressed no eagerness to have their leading artist learn foreign tricks. But, reading further, we realize that this nationalism was almost as defensive as that which had assisted West. The Bostonians, too, justified their faith in their painter by believing that he could, if he wished, be equally admired in London. Indeed, they were so conscious of the superior attractions of life in the Old World, they were convinced that should Copley once go to the mother country he would only return if he failed to make his living there.[7]

We shall meet similar patterns of thought again and again. In almost every generation a strong body of popular opinion, undoubtedly motivated in part by a fear of inferiority, wanted American art to ignore Europe as it self-consciously went its own way. Often this point of view was not shared by the artists themselves. Copley, for one, had no sympathy with it. Indeed, he failed to think of the Colonies as a separate entity from the island he referred to as 'home.' Although his attack on the baseness of his environment may have been touched off by his need for something outside himself on which to blame the failure of his *Young Lady with a Bird and Dog*, the fact remains that he had no desire to elevate Colonial taste. His practical mind thought it would be stupid to 'bury' expensive improvements in America.

Copley had refused some commissions in order to practice variations on 'that charming art which is my delight'; this seems to have been the extent of the sacrifice he was willing to make. He believed that a trip to Europe was essential if he were to become a great artist, but as long as the Bostonians would not increase his reputation or income if he painted more skillfully, he considered that knowledge of the old masters would only be worth the expense if he did not have to return to Boston. His own satisfaction in producing beauty was not a determining factor.

It is hard for us to understand today how one of the most

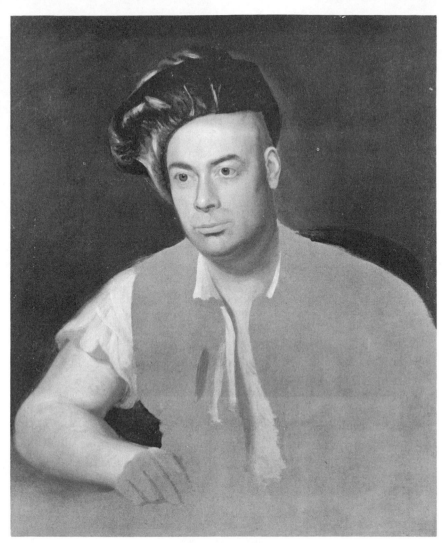

JOHN SINGLETON COPLEY: *Nathaniel Hurd, unfinished*
Courtesy of the Memorial Art Gallery Rochester, New York

naturally gifted painters in his world-generation could take this attitude. Yet Copley's thinking grew naturally out of his background. Remembering the books he had read, he could dream of rivaling the artistic glories of Greece and Rome. However, his footsteps echoed back not from the Colosseum, but from the little houses of Boston. Although he was mortified that his contem-

[239]

poraries regarded painting as no more than a useful trade, like that of carpenter and shoemaker, the same point of view was bred deeply into his own mind. Far down in his emotions, in the ultimate wellsprings of his being, he painted pictures as his friends, the silversmiths, made tankards. Thus at the moment when words gave way to action, he himself behaved as if painting were less an art than a trade. When West's assurances of transatlantic prosperity were not lyrical enough, he determined to remain in the Colonial city whose lack of taste he had blamed for all his failures.

Undoubtedly he was influenced by personal timidity of which he had more than his share; he was terrified of a sea voyage, of the bandits who he believed infested the roads of Europe. His mother became feeble, placing an additional drain on his purse and his affections. Then during 1769 he got married, carrying off triumphantly the daughter of Richard Clarke, one of Boston's richest merchants. In reaching her, the tobacconist's son had not only jumped social and economic hurdles, but political ones as well. He had been born into the class of the burly mechanics who made up Sam Adams' 'trained mob'; his father-in-law owned the tea which that mob threw to the fishes. Like his art, Copley's life was a medley of the old and the new aspects of American society, the plebeian and the aristocratic.

Those writers who believe that any American who was not an ardent revolutionary during the seventeen-seventies was a traitor have called Copley a Tory and have blasted at him from the self-righteous heights of patriotic hindsight. Actually the painter saw justice on both sides. Himself a product of both the warring classes, he did not feel the conflict between them was irreconcilable. One of the gentlest of men, he shuddered at the thought of bloodshed. Despite threats of physical violence, he tried single-handed to stop the American Revolution.

The occasion of his active intervention was the arrival of the portentous tea. Commanded by the mob to send it back, a move which according to British law would have made their ships liable to confiscation, Copley's in-laws, the Clarkes, fled to a British fortress in the harbor. The painter, who, despite his marriage, had remained friendly with the patriot leaders, called on Adams, Hancock, and Doctor Warren; he argued that once the passions cooled, the issue could be worked out by compromise. Didn't his old

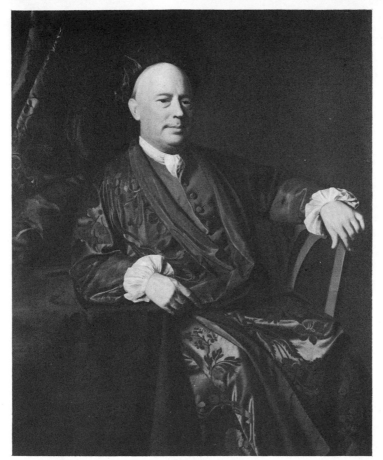

JOHN SINGLETON COPLEY: *Joseph Sherburne* *Courtesy of the Metropolitan Museum of Art*

friends realize that violence produces violence, that an angry solution would lead to civil war? The patriot leaders, who knew this perfectly well and delighted in it, expressed surprise, and insisted that the merchants send back the tea, even if it meant financial ruin.

Copley then did what was for his temperament an act of heroism; he appeared before town-meetings and argued in person with the enraged populace. He carried letters to the merchants in their fortified hideout, and when they, safe behind their battlements, refused to give an inch, he refused to deliver their message. Shuttling back and forth, he gradually toned down both sides until

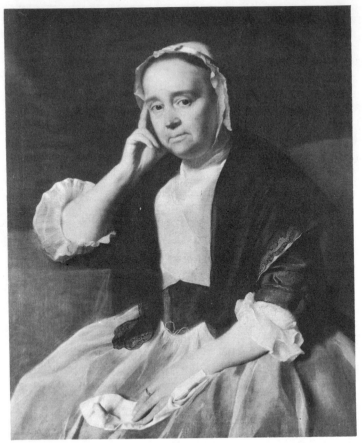

JOHN SINGLETON COPLEY: *Mrs. Nathaniel Appleton* *Courtesy of Harvard University*

he thought he had achieved a peaceful solution. That he was wrong, history tells us.

After the Boston Tea Party, Copley was several times threatened by the mob, which misunderstood the part he had played. A pacifist at heart — he was later to forbid his Tory half-brother to serve with the British forces — he determined to embark on the European trip that would enable him, if necessary, to make his living abroad. Although he foresaw civil strife, he did not expect war for several years, so, when he sailed for London during June, 1774, he left his wife and children behind. He would return or send for them as circumstances dictated. For now that he was actually

on his way to Europe, he was not so sure that he could bear to say good-bye to Boston.

How many strange and contradictory threads tug at the puppet-like limbs of man! We have seen that Copley was a microcosm, a reflection in miniature of those turbulent years in New England. What did he believe; where did he stand on the issues of the day? He believed everything that Bostonians believed; he was a Whig and a Tory and a pacifist; he was an abject Colonial and a self-reliant patriot; he was fascinated by character and conscious of rank; he was a merchant and an artisan and a great painter. Above all, he was a mirror of his age. Perhaps that is why he painted his contemporaries so brilliantly.

All the diverse elements in his thinking merged into a living style because every one had a profound meaning for the artist's place and time. In Copley's pictures, we see the revolutionary generation not as they have been smoothed out for us by historical generalizers, but as they saw themselves, as they lived in their own imaginations and the imaginations of their contemporaries. They are ridiculous sometimes as they yearn in their imported clothes for classical settings; man is a ridiculous animal. But he is noble, too, and this nobility speaks from Copley's portraits. Here are shrewd businessmen who are shaping a new world with those full-veined hands; here are statesmen and fanatics and dreamers; here are the mothers of children; people cruel or kind, wise or foolish, obvious or strange, clodlike or intelligent, but all with blood throbbing in their temples, all with hopes and thoughts and dreams and fears behind then eyes. Here is the human race, habitat America, years 1753-1774. The vision is so intense that despite solecisms in technique which any graduate of a modern art school would despise, we see before us the truth that is beauty.

CHAPTER ELEVEN

The Early American Tradition

As COPLEY WALKS UP the gangplank of a square-rigged ship during June, 1774, our curtain falls behind him, bringing to an end the first act of American art. The years of the American Revolution were to foster as momentous a change in painting as in politics. The same national maturity that made independence essential presented our artists with new problems to solve and new ways of solving them. The Colonial tradition of painting came to an end with the society that fostered it.

For a full century, American pictures existed in isolation. Contact with the great art of the Western world had always been at third or fourth hand. No important painter and, as far as we know, no important picture, had crossed the Atlantic, while not a single American artist can be shown to have brought back to this country the results of European study. Books whose vague texts were rarely elucidated with illustrations; black and white engravings; bungled copies of Old World pictures; inferior imported portraits and inferior imported masters; these were the sources from which American painters received a pale reflection of European art.

Yet it was historically impossible for American artists to start out at once in new directions. The Colonies were offshoots from Europe, and offshoots from Europe they would have remained had that continent sunk into the sea a few years after America was settled. New civilizations evolve only after long travail; no generation can be more than one link in an evolutionary chain. The slightly more than a century that elapsed between the earliest paintings we know and the departure of Copley is but a moment in the history of man. It takes longer for new forms of thinking to arise.

[244]

But Europe did not sink under the ocean; Europe sent successive waves of influence to the New World. It was a tragedy that once the brief Dutch domination of New Amsterdam ended, the most powerful influences flowed from esthetically backward nations. No Italian or Flemish or French or Spanish artists came to these shores to reinforce the inadequate information to be gleaned from prints about their great traditions. We had a sprinkling of Scandinavians, Germans, and Swiss; for the rest, the living imports were British.

The best artists of these regions were provincial workmen in the Dutch and Flemish manner. Receiving enough business at home, they did not travel to the wilderness. Our foreign masters had been second- or third-rate artists in their homelands; they practiced a further provincialization of provincial styles. When the local artists imitated the work of such men they were provincial followers of provincial followers of provincial followers of great European painting. Provincialism thrice compounded; that was the international setting of early American art.

Except for a few groups working in exactly the same place at exactly the same time, the individual Colonial painters were as separated from each other as they were from their European colleagues. The Boston artists of the sixteen-seventies bloomed richly for a season but dropped no seeds to quicken the next generation; the Pollard Limner came and went unnoticed; we may search New York State art in the seventeen-fifties without finding more than a trace of the Patroon Painters, so recently active. Even that culmination of the Colonial tradition, Copley, had no discernable roots that go further back than Smibert or further afield in America than New England.

Partly to blame for this lack of continuity was the great prestige which radiated from each newly arrived foreign artist. Conscious of their isolation, the painters scrambled to imitate this latest ambassador from the esthetic world they had read about in books. But even had the American limners wished to cling to a native tradition, they would have had the greatest difficulty discovering what that tradition was.

Almost no American portraits were engraved before the last years of the Colonial period. Nor, since the lines of trade carried ships directly to England and roads were bad, was there much

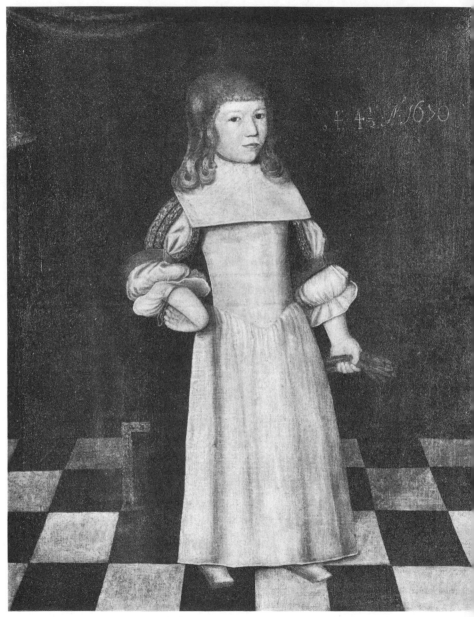

FREAKE LIMNER: *Robert Gibbs*

Courtesy of Theron J. Damon

movement of pictures or even of news of artists. When the young Maryland painter, Charles Willson Peale, visited Boston in 1765, he heard for the first time, from the lips of a paintshop proprietor, the names of Smibert and Copley. The inability of modern writers to visualize this situation is shown by their tendency to ignore incontrovertible documents and say that Peale made the journey specifically to study with Copley. (He was fleeing the sheriff.)

Even if an artist worked in a town where fine pictures had been painted during the previous generation, he could only see them if he could gain access to the private houses where they hung, by no means an easy task since a social gulf separated artists and sitters. To study the work of a living master was easier. Most painters were as generous to young men as Smibert was to Feke, or Copley to Peale; they permitted the neophytes to examine and even copy such pictures as they still had in their possession. But once a canvas was delivered, it vanished from public knowledge.[1]

Yet despite all the forces working for disunity, Colonial painting was fundamentally consistent. Although an experienced eye can distinguish between pictures painted at different places and times, the whole body of work shows as many similarities as variations. Since we cannot explain this by the influence of one artist on another, we must find other reasons.

The successive waves of foreign masters all worked in a unified international style. When Kühn used his Rhineland formulas to paint little children posed stiffly in sumptuous settings he was producing pictures whose counterparts we find on the walls of English country mansions and in the works of such diverse American artists as the Patroon Painters and William Williams. The basic unity of northern European painting was reflected in the Colonies.

As they passed through minds not academically trained, the majestic constructions of the baroque masters were modified in a consistent manner. Ever since the Renaissance, European painters had reproduced the surface appearance of nature. The Colonial artists followed down this path a short distance, then veered into the underbrush. Instead of trying to give a complete visual picture of reality, they separated off those elements that interested them most and assembled them into an image crude yet emphatic. This did not represent a conscious striving for new forms, for

[247]

'abstraction'; it was the result of social and environmental forces which we shall summarize later in this chapter. Yet the fact remains that the painters sometimes clambered over a wall, entering a world whose limitless reaches were not to be explored by sophisticated artists for more than a century.

Since the first American painters were incompetent in the third dimension, the most successful banished it from their style and strove for linear, surface design. Insubstantial, lacking in weight, their inspirations belong behind the closed lids of a dreamer; open your eyes and the vision is gone. The next step was taken by Feke. If you tried to put your arm around the waist of one of his ladies, you would not find yourself gesturing in air. He achieved weight, but through very simple means. Broken forms, elaborate lighting, minute subtleties of shape were subordinated to a few simple solids that might have been hewn with adze and axe. Copley went so much further toward plasticity that he broke to a considerable extent with primitive patterns, yet he revealed his stylistic origins in using sharply defined outlines as the boundaries from which his shapes sprung.

A well-trained painter in the Renaissance tradition gave his pictures a unified point of view; everything is shown as it would appear to a spectator standing motionless at a single spot outside the frame. Oriental art does not share this characteristic, nor do Western primitives, be they Flemish or American. The Colonial limners tended to represent each detail from the angle that would show it best and fit it best into the over-all pattern. As time advanced, this multiple vision became less conspicuous, yet traces of it remain even in the most mature of Copley's American work.

Except for the early New York artists who followed their Dutch models into the fascinating realm of chiaroscuro, the American limners tended to preserve the more even lighting of the northern European portraitists. This made for delicacy rather than strength and accorded well with their rudimentary conception of color. A thousand technical tricks of underpainting, of glazing, of brushwork, or warmness in the shadows, of subtle contrasts failed to voyage across the ocean. Our artists were inclined to lay the paint on a canvas flatly, as you might paint a house. When they attempted to reproduce the subtle tints of a Van Dyck or a Lely, they were doomed to ludicrous failure. The most successful used

[248]

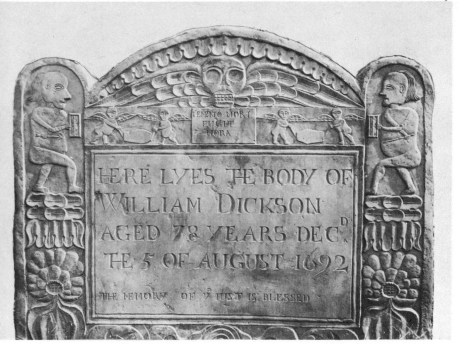

GRAVESTONE OF WILLIAM DICKSON *Cambridge, Massachusetts, Graveyard*

their limited technique to achieve a few contrasts that were as un-complicated and naïvely emphatic as the rest of the picture.

In every aspect of execution, American painting was driven toward innocence and simple effects. There could be no symphonies in paint; our song was the wild woodland note of a bird chanting in the primeval forest.

American life, like American painting, was a mixture of tradition with improvisation. The first generation of settlers had brought with them theories of religion and life they had developed in the Old World but could not apply there. It was as if a farmer's son, back from a local agricultural school with an improved seed, was unable to sow it in his father's acres that were pre-empted by traditional crops. Therefore he cleared new land for his experiments. But in their search for virgin soil, the English radicals had to travel so far that the earth they ploughed was a different kind of earth. Hopefully they planted their Old World seed, expecting an Old World growth. When the plants that came up were queer, they were less delighted than concerned. Writing

home to the professors in agricultural school, they tried to hide that the seeds of reform had produced strange mutations.

The first settlers clashed together the mutually contradictory doctrines they had brought with them from Europe, thus creating an exciting controversial literature, but the writings of their American-born children were concerned with expediency. As the dryads of change that lurked in the American fields rose everywhere like mists after a thunder-shower, published thought became increasingly shallow. In life as in art, deep thinking and profound expression, those fruits of long tillage, refused to grow in the new American soil.

Practice had taken over from theory. Even the prophecies of Roger Williams, which pointed the very direction in which America was to travel, were forgotten while men wrestled individually with their surprising new environment. Whenever they could, the Colonials adhered to Old World formulas, but situations arose continually that defied the soothing voice of precedent. Thousands of times in thousands of widely separated places decisions were dictated by the immediate problems in hand. That these myriad chemical reactions produced in the end a few consistent compounds was not due to forethought or consultation, but to the fact that similar causes produced similar results. Like their painters, the mass of Americans were moving in new directions before they realized what those directions were.

Not a single painter whose biography is known was a gentleman in the eighteenth-century sense. Foster and Greenwood, it is true, came from leading families, but Foster made his living from a dozen ingenious crafts, while Greenwood was apprenticed to a decorator of signs and fire-buckets. Most of the other painters clearly rose from the lower brackets.[2] The Duyckincks practiced for generations the family trade of glazier; West was the son of a tinsmith turned innkeeper; Badger's tailor father apprenticed him to a glazier; Copley's mother retailed tobacco. The reader may complete the list.

When we turn to the foreign artists who came to America, we find that their backgrounds were also humble. Joshua Johnston was apprenticed to a painter-stainer; Watson was a sign painter; Williams a humble seaman; and even the resplendent Smibert

began life as a tailor's son who was apprenticed to a house painter. Only Gustavus Hesselius, as a member of a ministerial family, was born a gentleman, but when he reached these shores he became an artisan like his colleagues, painting coaches and building musical instruments.

It has long been popular with writers who rhapsodize on 'American primitives' to imagine the ploughman painting sylvan visions to the tunes of birds. At least as far as the Colonial period is concerned, we must wipe this image from our minds. Benjamin West, the artisan's son who began painting in a rural inn, is our closest approach to a bucolic painter, but even he spent his whole professional career in cities. Although most Americans were farmers, we do not know of a single farm boy who became an artist without having first been apprenticed to a craft.

A ploughman could start painting for his own amusement, but his rural home would not offer him enough business to become a professional. To find sitters he would have to go to a city. However, as long as he was unknown, he could not expect to support himself with portraits or landscapes; he would need another source of income suited to urban conditions. This a craft offered.

Benjamin West was an exception to all rules. Becoming a recognized prodigy while yet a child, he managed to take a single step from infancy to fame. Most Colonial artists did not set out consciously to be fine arts painters. They were usually apprenticed to an allied trade such as house painting or glazing; whether the choice was dictated by a chance or a fascination with pigments it is impossible to say. Then, as opportunities arose for making money on the side, they moved into portrait work by stages so slow and natural that they themselves did not realize when they had made the break. This is exemplified by an anecdote which is all the more significant because it happened years after the Colonial period ended. During the eighteen-twenties, Chester Harding (1792-1866), a jack of all trades and ne'er-do-well, taught himself painting in the new settlements of the Ohio Valley. Lured by the promise of high fees to the relatively ancient metropolis of Paris, Kentucky, he met there some elegantly dressed clerks 'with ruffled shirts, rings on their white and delicate fingers, and diamond pins on their busoms.' These dazzling creatures overwhelmed him

[251]

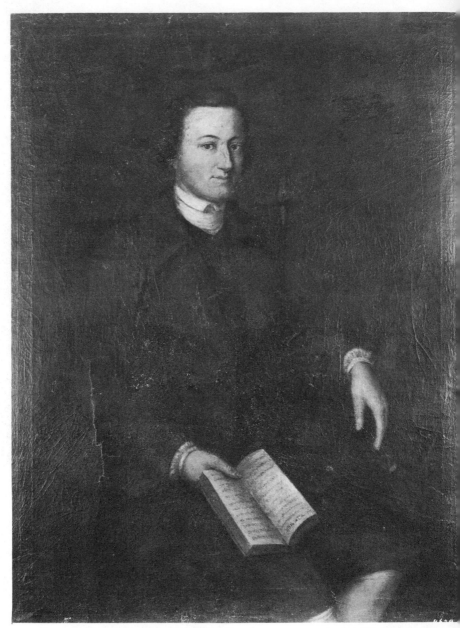

CHARLES WILLSON PEALE: *James Arbuckle* *Courtesy of Mrs. Walter B. Guy*

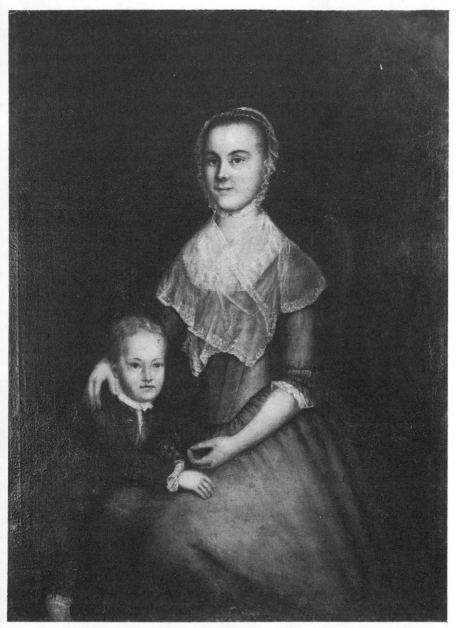

CHARLES WILLSON PEALE: *Mrs. James Arbuckle* *Courtesy of Mrs. Walter B. Guy*

until an erudite gentleman explained that, since portrait painting was a more honorable profession than painting signs, he could look an accountant in the eye.

In many ways typical of the late Colonial period is the biography of Charles Willson Peale (1741-1827), who was to succeed on Copley's departure to the starring rôle in American art. Peale's father had, it is true, been a gentleman in England until he narrowly escaped being hung for embezzlement. Exiled to Maryland, he became a fairly prosperous school teacher, but he died when Charles was only eight. His widow, reduced for livelihood to needlework, apprenticed the child to an Annapolis saddler. The boy proved much too bright for his own good. Becoming his own master at the age of twenty, he set himself up in the most elegant of saddlers' shops, and, when money did not come in quickly enough, tried to extricate himself by adding a whole repertoire of trades, which, without the slightest hesitation, he taught himself. In rapid succession, he became an upholsterer, a chaisemaker, a watchmaker, a brass founder, and a silversmith. He was looking around for new worlds to conquer when an amateur painter named Frazier showed him several landscapes and a portrait. 'They were miserably done; had they been better, perhaps they would not have led me to the idea of attempting anything in that way.'

As a child, Peale had drawn needlework patterns, copied prints, and attempted a picture of Adam and Eve. Now he rushed home, bought brushes and paints from a chaisemaker, and dashed off a landscape 'which was much praised by my companions.' A self-portrait was a natural next step, and then he moved on to members of his family. When a neighbor forced ten pounds on Peale for two portraits, 'this gave the first idea to me that I might possibly do better by painting than with my other trades, and accordingly I began the sign-painting business.'

Coachmakers' pigments satisfied him for portraits as well as signs, until rumor whispered of an easier medium called water color. Eager to investigate, he journeyed to Philadelphia. The most important result of this trip was the purchase of a book, Robert Dossie's *The Handmaid of the Arts*. Convinced by its pages that art was a more complicated trade than saddlemaking, he offered his neighbor, John Hesselius, 'one of my best saddles with its complete furniture' for instruction. Hesselius allowed Peale to

[254]

watch while he limned two portraits, and then painted one side of a face letting the young man paint in the other. From then on, customers who entered Peale's shop might order a saddle or a clock or a portrait.

Peale tells us that he might have gone on dabbling in a multiplicity of trades for years had not his radical activities in Maryland politics induced his prosperous creditors to force him into bankruptcy. He fled from Annapolis and debtors' prison with a heavy heart, but later he recognized his difficulties as disguised blessings. Separated from the more bulky tools and materials of his other crafts, he was forced to specialize in painting.

A ship's captain gave him a free ride to Boston where he stumbled on the reputations of Smibert and Copley; Copley lent him a picture to copy. His new skill enabled him to reproduce in full color a print after Reynolds with such breathtaking success that the gentlemen of Annapolis, eager to have their portraits done, arranged a settlement of his debts. Back home, he created such likenesses as *Judge and Mrs. Arbuckle* (1766). They are crude pictures, owing more to John Hesselius than to Copley, yet they have a delicacy and charm that presages the gentle, sometimes almost lyrical grace which characterized Peale's mature work. In New England, the canvases would not have looked like much, but the Maryland aristocrats were greatly impressed. Remembering what éclat their neighboring city, Philadelphia, had received from its prodigy, Benjamin West, they took up a subscription to send Peale to that master's London studio. During December, 1766, he sailed down Chesapeake Bay and out of this history. Although he returned to Maryland after three years, the paintings he created there and in Philadelphia at the very close of the Colonial period fall, because they are the result of European study, into the next great division of American art.[3]

As exemplified in the careers of Peale and West, gentlemen sometimes contributed to the education of artisan painters. They did not, however, encourage their own sons to follow so lowly a trade. The first well-born and college-educated artist known to American history was John Trumbull (1756-1843). His career began during the Revolution and thus falls outside the scope of this volume, yet it is relevant that his father, the governor of Connecticut, regarded painting as an unsuitable profession, and that

Trumbull himself became ashamed of his fascination with design. In 1789, he wrote Jefferson that he only continued to paint because of a patriotic desire to commemorate the events of the war. 'I am fully sensible that the profession, as it is generally practiced, is frivolous, little useful to society, and unworthy of a man who has talents for more serious pursuits. . . . I flattered myself that by devoting a few years of life to this object, I did not make an absolute waste of time, or squander uselessly talents from which my country might justly demand more valuable services.'

Trumbull's attitude reflected English as well as American snob-

PATROON PAINTER: *Unknown Lady* *Courtesy of the Harry Shaw Newman Gallery*

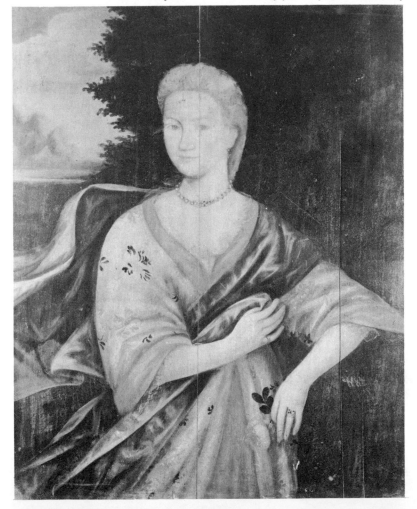

bery. It was correct for British gentlemen to be connoisseurs and even to paint a little on an amateur basis. Making the grand tour to Italy much as a modern young lady goes to finishing school, they brought back with them yellowed canvases which their high-born taste had enabled them to recognize at a glance as authentic works of Guido, or Claude, or whomever. But they considered contemporary native artists their social inferiors. Although a few very fashionable portraitists moved in society and had blue-blooded mistresses, English painters were just beginning to escape as a group from the rank of upper servants. Not till 1760 did they dare insist that their own taste was as valid as that of the amateurs. They organized the Society of Artists where a painter's work was judged and exhibited by a jury of his peers. America had to wait another generation for the successful founding of a similar organization. During the Colonial period, people commissioned paintings much as they would have ordered a silver teapot or a highboy.

Before we mourn that painting had so low a social standing in America let us compare it with arts which were considered more refined and thus within the province of gentlemen. At the other end of the scale was literature, an activity to which, according to age-old English tradition, members of the leisure classes might give their serious attention. American gentlemen were anxious to shine in prose and verse, as did their betters across the ocean, but they lacked the time and wealth to support the Muses in the manner to which those expensive ladies were accustomed. They called on Euterpe and Clio at off hours, and behind the backs of their legal spouses, commerce, religion, or law. Fifty years after the Colonial period ended, Jefferson wrote, 'Literature is not yet a profession with us. Now and then a strong mind arises and at intervals of leisure emits a flash of light.' As long as men absorbed in other pursuits gave writing only their superflux of energy, books were most valid when they also were by-products. Thus Colonial literature was at its liveliest in controversial tracts, first religious and then, as the intellectual climate changed, political.

Architecture occupied a middle position in the class scale. During the early years, craftsmen builders, the equivalent of the early craftsmen painters, designed most American structures, and they continued all through the Colonial period to plan the simple dwellings of the farmers and the *petit bourgeoisie*. However, as

[257]

painting approached its peak in the mid-eighteenth century, the best architectural opportunities — public edifices and elaborate dwellings — became increasingly the province of gentlemen-amateurs. In America as in England, a familiarity with architecture was regarded as one of the many accomplishments suitable to the well-born. The more elaborate Colonial structures were usually conceived by amateurs, very often individuals just arrived from abroad. Usually not troubling to work out details, they left these to the builders. The result was a collaboration, but the gentlemen kept the upper hand, regarding the structures as their brain children and the craftsmen as semi-automatic tools.

Although ladies laid out needlework designs and even painted on glass, although gentlemen drew an occasional landscape in water color, they rarely if ever attempted the intricate task of painting professional portraits in oil. This then was the only art where the craftsmen functioned autonomously. A society belle could describe in words the effects she desired, and even pull from her reticule an engraving after Kneller to serve as a model, but when the artist actually got to work he entered a world where she could not follow him.

That painting was a craftsman-art increased its isolation from European thought and models. Since an American artisan enjoyed greater opportunities, he had no desire to assume the servile position of his English cousins. But the Colonial aristocrat, as he clung uneasily to the temporal saddle into which he had just leaped, longed passionately to be mistaken for a lord. Thus one class dreamed of London splendors and the other preferred to keep its dreams at home.

As dreams went, so went bodies. The richer Colonials were drawn across the ocean by the tides of trade or government. In the gilded drawingrooms of their London agents, they sipped the wine of Old World culture, and even put a bottle or two in their pockets. The craftsmen, however, were confined to the American landscape. While most upper-class writers or architects had walked down Piccadilly, no American-born painter before the seventeen-sixties is known to have done so. The class cleavage in architecture was indicative. As Fiske Kimball points out, the elaborate structures designed by gentlemen were more derivative than the back-country dwellings created by artisan-builders.

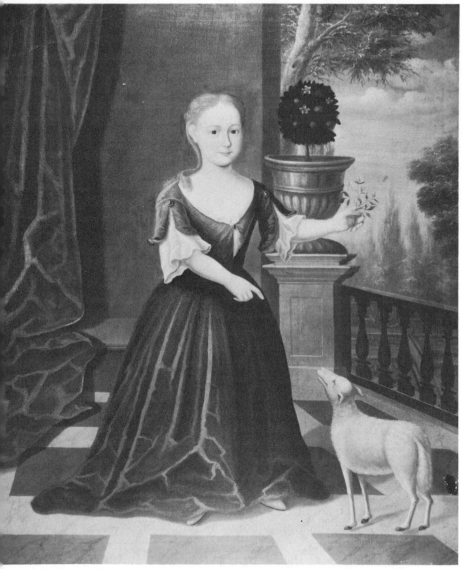

DE PEYSTER MANNER: *De Peyster Girl with Lamb* Courtesy of the New-York Historical Society

Painting's semi-independence was strengthened by a technological matter, the state of printing. Art books were full of words and almost completely devoid of illustration. As Copley complained, little technical lore could be gleaned from them. Large engravings of pictures existed, of course, but they were expensive and rare, and even when you could get your hands on them their hints were confined to one aspect of the painter's art, composition. They gave no idea of brushwork or color.

Literary works, on the other hand, could be reproduced endlessly by the printing press; they were seen by Americans and Englishmen in identical form. A Colonial in search of reading matter had merely to turn to his shelves of transatlantic books; and a poetaster, burning to hymn his lady's eyes, could find a model in the same place. Architectural patterns were almost as readily available, since line drawings were easily engraved. Every new building fashion was codified so exactly and expertly that a Colonial had merely to point to a page and say, 'Build this.' As long as the richer Americans felt no needs different from their English counterparts, it was unnecessary for them to do any literary or architectural thinking on their own, or to pay others to do it for them. A similar lack of demand barred the appearance in Colonial America of professional sculptors or composers.[4]

The aristocrats would have been delighted to import paintings as they imported all other luxuries. Overmantels that could be made to measure, wall decorations purchasable by the square yard, these often rocked across the ocean in the holds of ships. But unless a person was abroad at the very moment he wanted his likeness taken, he was forced to employ a local limner. That portraiture was the principal artistic interest of Englishmen on both sides of the ocean was not, as is so often stated, a misfortune for Colonial esthetic achievement. It enabled painting to become a profession before any other American art.

Colonial conditions raised the demand for likenesses to a high level. Not only did the rapidly churning society throw off, like a centrifuge, a perpetual skim of self-made aristocrats tremendously conscious of their own importance, but the geography of the New World separated families so completely that painted images had often to take the place of reality. Sons, building a new life in America, had themselves depicted in their new magnificence

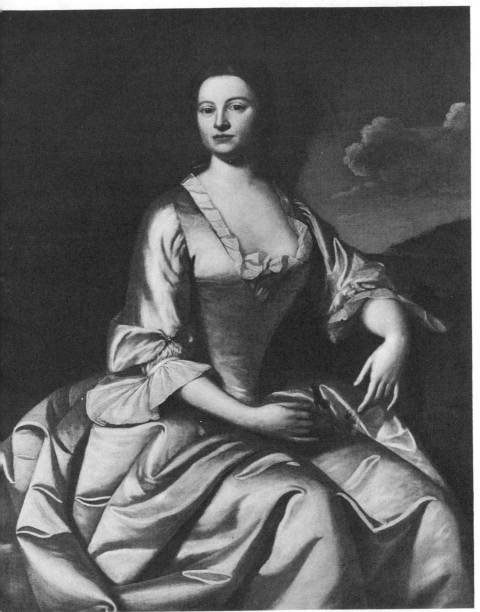

ROBERT FEKE: *Mrs. Josiah Martin*

Courtesy of the Detroit Institute of Art

for their mothers in England; grandparents made the acquaintance of their grandchildren through the medium of paint. Although we have been concerned primarily with oil portraits, they were only one method — the most expensive — of recording features. Pastels were cheaper than oils; miniatures than pastels; and silhouettes, either drawn or cut from black paper, than miniatures.

ROBERT FEKE: *Reverend John Callender* Courtesy of the Rhode Island Historical Society

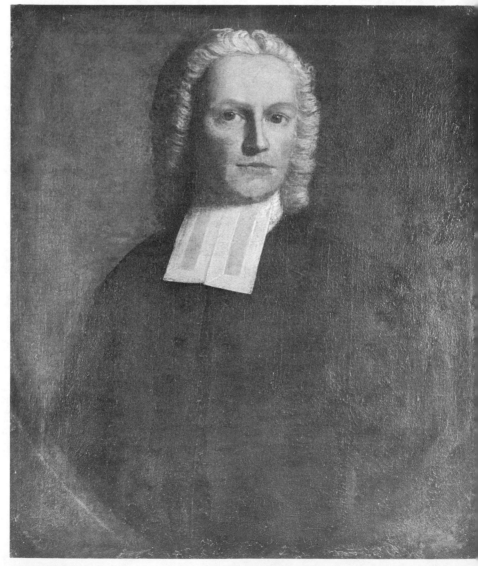

Unlike Hesselius when he staged a very proper *Bacchic Revel,* or West when he tried to imagine *The Death of Socrates,* the painter of a portrait had to subordinate his mind's eye to physical vision. Theory, however soul-satisfying and conned from however impressive a book, was forced to give way to direct study of nature. Since the faces he limned were American faces, the artist was bound to his immediate environment. Indeed, although writers have usually reserved this distinction for the Hudson River School, the early portraitists were the first explorers of the American scene.

Thus the pragmatic rôle of Colonial painting not only contributed to its economic position but also to its esthetic success. Our forefathers were as self-conscious and giggly in the presence of the Muses as a farm boy in the dressing-room of an actress. Put an axe in the same boy's hand and he is a different person. The early American genius was at its best in making things of use, be they a Kentucky rifle or a new nation. Undoubtedly, it was a great asset to our painters that the major demands made of them by society were matter-of-fact.

In Colonial America, the word 'art' did not have its present restricted meaning. Concerning Rittenhouse's model of the planetary system, Jefferson wrote, 'As an artist he has exhibited as great a proof of mechanical genius as the world has ever produced.' Science was included in the term, and also what we now consider the crafts, provided they were carried out with unusual excellence. A painter would turn his brushes from a wall decoration to a sign to a portrait to a panel for a coach with little sense of change of occupation. Thus, from the point of view of their period, American painters were from the first professionals. In the beginning, they gave more time to signs and cannon mountings than to portraits and landscapes, but as the years advanced the balance changed until many of the artists did not spend more energy on what we now consider crafts than our contemporary painters do on such pot-boiling activities as teaching or commercial design.[5] Before the Colonial period ended we find Copley, and to a slightly lesser degree West, concentrating all their energies on the higher branches of their calling.

The close interrelation of portraiture with the crafts raises an interesting stylistic question. How far were the typical American variations of the baroque tradition the result of another tradition

[263]

equally venerable: the lore of the house and sign painter handed down through a long succession of master and apprentice? To give a dogmatic answer is impossible at the present state of knowledge. European historians have been exclusively concerned with great names and self-conscious art movements. We can cast a romantic glow over the humbler styles by calling them 'folk art,' and yearn to see them growing, a democratic crop, from the ordinary soil, but specific facts were lacking. Were we to state, as is sometimes done, that such and such a picture reflects the ancient manner of the English sign painter, we would be, I fear, talking through our hats.

The difficulty is that the very stylistic elements about which this is said are also found in the work of children who have no art training whatsoever. Broad environmental influences combine with innate tendencies toward design to create a type of expression that wells up naturally in the genus *homo sapiens*, habitat Europe and European America. I have seen drawn in chalk on the sidewalks of New York pictures which contain some of the basic characteristics of American Colonial art.

Foreign sign painters who graduated themselves to portraitists moved in the same directions as the self-graduated sign painters of New York or Boston. There was considerable overlapping between the least elegant of known English work and the more elegant American. We cannot postulate that because a picture reflects academic conditions only palely it was painted in America by an American-trained artist. This theory proved a gold mine to the crooked art dealers of the last generation who imported provincial English canvases, signed them with names found in American records, and sold them for large sums as the first monuments of American art.

Whether the more primitive Colonial work also had its equivalents in the mother country is another question that must be left open pending further knowledge. Studies of paintings by English artisans should be the next labor of those who wish to define exactly the sources of the American style. For it cannot be overemphasized that the type of foreign canvases which the American limners imitated cannot be found in histories of art. The relevant pictures have only been examined by the bats and spiders who frequent attics and junk-shops.

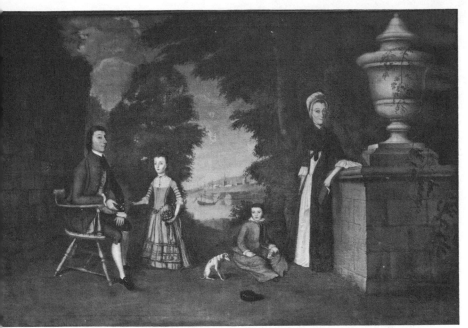

WILLIAM WILLIAMS: *The William Denning Family* *Courtesy of Miss Ettie Shippen*

Although we are unable to make an all-inclusive comparison between Colonial painting and the humbler art of the Old World, one important conclusion is indicated by known pictures and supported by general historical considerations. Since what had been in England the middle and lower classes became the leaders of American society, American life in all its aspects was characterized by a lopping-off of those forms that were highest on the European social and cultural scale. This raised to the status of national institutions conceptions that remained in the Old World the abberations of the lesser orders. To give an example: for numberless generations, the English farmers had celebrated the harvest. In America, this folk festival became a national holiday, Thanksgiving. But to find a harvest observance in contemporary England we must, like Frazer, penetrate the densest hedgerows.

In the same way, the lower-class art of the Old World became in America the expression of the whole society. A European sign painter who limned his inconspicuous neighbors knew he would never be another Raphael; that distinction would, of course, be

reserved for his betters who kept carriages and recorded the faces of kings. But no periwigged figure, complete with sword and ruffles, stood between the American artisan and the laurel-studded slopes of Parnassus. Indeed, the genius of social change, the angel of democracy, who scudded over the American fields whispered in the workman's ear that he, too, might set his feet on that promised land.[6]

Although Colonial painting was deeply rooted in the crafts, the artists were not allowed to walk tranquilly beside silversmiths and cabinetmakers down the restricted pathways of trade. Whenever they could, they got their hands on books about painting, and the words there written seemed aimed directly at them. Feke poring over Shaftesbury, West over Du Fresnoy, Copley over De Piles, Peale over Dossie, all received the gratifying intelligence that painting was one of the greatest and most immortal expressions of the human spirit. A picture was not really the equivalent of a tankard, so the magic legend ran; if you stared hard at nature and dreamed hard of truth, the generations of the future would know your name when the fame of merchant and aristocrat had rotted with their money-bags. West, the poor innkeeper's son, snubbed the son of a tailor now that he recognized his glorious destiny. Copley spent many a sleepless night trying to reconcile the leather apron of his upbringing with the wreathes the Muses proffered for his brow.

The very expansiveness of the North American continent — its limitless reaches, its wild storms, its endless opportunities — made a man stand up on his feet and strut like Adam that first day in Eden. As soon as written documents appear, we find the painters feeling profound responsibility as the pioneer artists of a civilization. Although West spent most of his career in England, he manifested an almost messianic sense of his mission to create an American art. As a young man Copley had written the famous pastelist Liotard, 'I assure you, sir, however feeble our efforts may be, it is not for want of inclination that they are not better, but the want of opportunity to improve ourselves. However, America, which has been the seat of war and desolation, I fain would hope would one day become the school of fine arts.' A few years later he wrote Peale, welcoming him as an ally in the 'great' work of making America rival 'the continent of Europe in those refined arts that

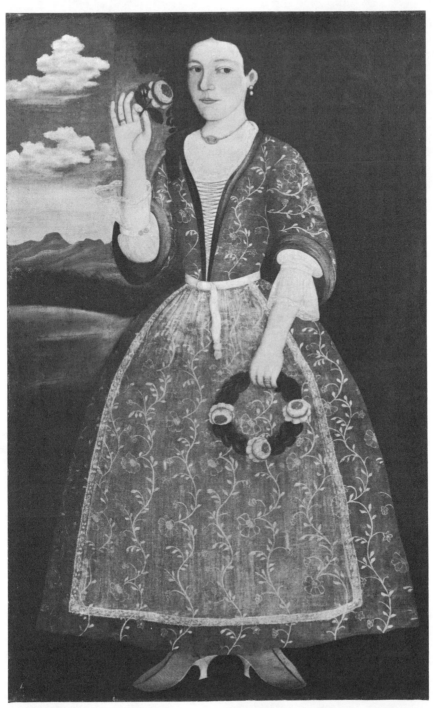

PATROON PAINTER: *Deborah Glen*　　*Courtesy of the Abby Aldrich Rockefeller Folk Art Collection*

have justly been esteemed the greatest glory of ancient Greece and Rome.' Even the English emigré Smibert dreamed that the center of painting would move to the New World. If this were to happen, the artisan-painters had to lift themselves by their boot-straps.

Similar ambitions moved the merchant aristocracy. Although they refused to become themselves professional painters, they honored the ideal that gentlemen should be patrons of the fine arts. Most of them were sure, of course, that the great workmen were dead, or, if alive, not their neighbors in provincial cities. As long as they adhered to this attitude they were on consistent ground, but once they recognized genius in the artisans around them, social confusion resulted. Although a Virginia governor felt it beneath his dignity to lend his coach to a painter, an artist in Maryland frequented the best drawing rooms. Smibert and Copley became the sons-in-law of men who would not have permitted their sons to become painters. Gentlemen hardly considered West and Peale their social equals, yet they felt it their patriotic duty to further a national art by sending these promising limners abroad for study.

Before the Colonial period ended, Americans had become extremely proud of their painters. West was known as 'the American Raphael.' And, Copley, that purely home-grown product, was compared to the old masters, not to his disadvantage. He wrote his half-brother from New York, 'As I am visited by vast numbers of people of the first rank, who have seen Europe and are admirers of the art, I am glad to have a picture [a lost portrait of Captain Richards] so well finished. Most of them say it is the best picture they ever saw, and all agree in its being an admirable picture.' The Philadelphia connoisseur, Doctor John Morgan, dared to write a Roman esthete that Copley was superior in natural ability to some of the great names of the past. 'Perhaps,' he added, 'history cannot afford a single instance of any person who, with so little assistance from others and so few opportunities of seeing anything worth studying, has by the force of his genius and by close application to the study of nature arrived at such pre-eminence as Mr. Copley.'

Thus the utilitarian approach to painting that was basic to Colonial society was shot through with contrasting threads. This strangely interwoven tapestry became in the youth of our culture

a magic carpet. That painting was a craft made possible its existence as a profession and knotted the artist firmly to the needs and preconceptions of his environment. That when the craft fabric became strong it rose from the ground and soared over the high mountains of art lifted the painters' eyes from their feet and gave them the prestige to fight their necessary battles.

When the artisan painters emerged from the snug valleys of craft, they found there was a strong wind blowing. The Colonies, themselves the products of new forces, came into being at a time of great social, religious, and economic transition. Institutions, many of them rooted in feudal times, were bending under the force of the hurricane, and those too rigid to bend crashed over, revealing strange patches of sky. Caught in the tempest, the painters were swept off, they knew not whither.

Even had they wished to do so, they could not have ridden out the storm in some stratosphere of the imagination, for as portraitists they were forced to concern themselves with the individual and his place in society. No aspect of life was more torn by the whirlwinds. The aristocratic emphasis on the class into which a man was born was warring with the bourgeois belief that since all men were born equal, the important considerations were virtue, ability, character.

Had American thought held a consistent place in the battle-line, the artists' task would have been easier, but consistency does not flourish at a time of transition. How contradictory attitudes toward art became tangled together in a single mind is revealed by the writings of John Adams. Sometimes he liked to think of himself as a gentleman-amateur. 'I wish,' he wrote, 'I had the leisure and tranquility to amuse myself with the elegant and ingenious arts of painting, sculpture, architecture, and music. But I have not. A taste in all of them is an agreeable accomplishment.' On another occasion, he denounced art as a luxury, a tool of the upper classes in the promulgation of despotism. But when Copley and his successors used their ripening realism to paint Adams not as a majestic ruler but as the stocky pouter-pigeon he was, the president was furious: 'The age of painting and sculpture has not yet arrived in this country, and I hope it will not arrive very soon. Artists have done what they could with my face and eyes, head and shoulders, stature and figure, and they have made them monsters fit for

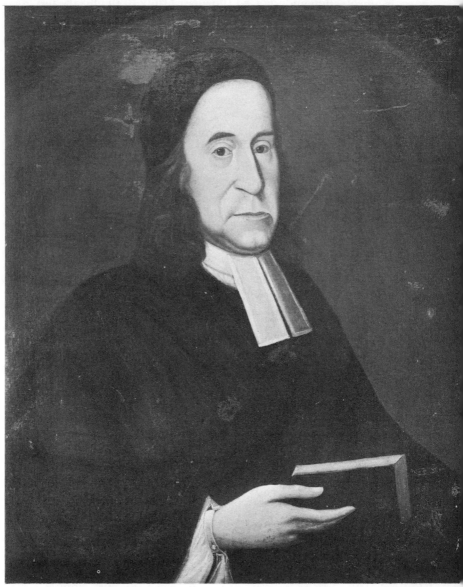

POLLARD LIMNER: *Thomas Thacher, so-called* *Courtesy of the Old South Association*

exhibition as harlequin or clown . . . I would not give sixpence for a picture of Raphael or a statue of Phidias.' He was so condescending to painters that Gilbert Stuart refused to finish his portrait, but later the two men became friends. Then Adams wrote, 'I should like to sit for Stuart from the first of January to the last of December, for he lets me do just as I please and keeps me constantly amused by his conversation.' In a final contradiction of his democratic ideas, the second president of the United States stated that since the common people could have no taste, great art could not rise in a republic.

The thinking of all men is a mixture of superstitions as old as mankind and ideals as new as utopia. In making a chemical analysis of a culture, we must expect to find not an indivisible element, but a compound whose peculiar properties are determined less by the nature of the ingredients present than by their proportions.

Although the aristocratic ideal existed in every Colonial mind, in its pure form that conception of humanity could have no indigenous life in America. Thus it could inspire no valid art. Not only did the experience of the artisan-painter keep him from a wholehearted admiration of rank, but the gentleman-sitter, even as he struck his noble pose, knew in his heart that he had reached his worldly eminence not because of birth but by his own activity in pursuits on which the true aristocracy frowned. When the courtly vision triumphed completely, as in the work of the Russell Limner or Kühn or John Hesselius, the result was empty parody. Telling a story that was theirs mostly by adoption, the artists had little reason to think for themselves. Slavishly, they attempted to duplicate the effects achieved by the true aristocratic masters. Mere imitation is never the springboard for vital art.

The other extreme, unadorned realism that strove to show a face exactly as it was, manifested itself only occasionally during the first century of American painting. Before the seventeen-fifties, such portraits were socially unacceptable to the upper classes, and the artisan-painters themselves would probably have felt rude had they shown a girl as plain or a minister as chinless. We find a downright approach only in a special category of pictures, those that were thought of as historical or scientific records. That the likeness of the centenarian *Ann Pollard,* or of the Indian chiefs

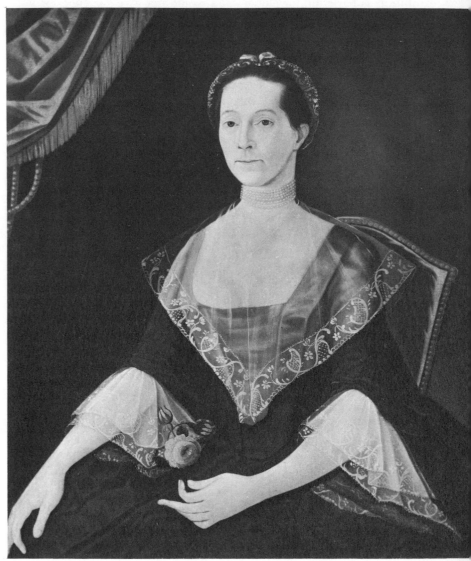

JOHN DURAND: *Mrs. Adriaan Bancker* *Courtesy of the New-York Historical Society*

Lapowinsa and *Tishcohan* are among the most interesting canvases that have come down to us shows that the compounds which were the painter's minds contained more lower-class than aristocratic elements. Indeed, the artists were inclined to make their self-portraits less flattering than the portraits of their paymasters. That this tendency would have gone further had the artistic influences sweeping in from abroad been suitable to bourgeois painting is indicated by the brief period during which the Dutch manner reigned in New York. Yet an examination of other aspects of Colonial existence makes it clear that America was not yet ready for a purely individualistic approach to human character.

Before 1750, the dominant painting style reflected its environment by being an unconscious modification of aristocratic forms in the directions of the future. Foreshadowed by the Freake Limner, the early American manner was exemplified by the Patroon Painters, William Williams, and the Philadelphia work of West. It reached its epitome in Feke.

The kinship of the pictures with European court portraiture is clear. Painters and sitters alike repeat Old World gestures, but in neither case do they come out quite right. The trappings are here, the lace and the elegantly flexed fingers holding flowers, yet the spirit of luxury which, like a sensuous perfume, hangs over the Lely-Kneller pictures, has been blown off by an American breeze. A middle-aged Circe, so wise, so expertly gowned and tinted, so sure in every gesture made accomplished by use, has given way to a fresh young girl, who allows the wind to tumble her hair and the sun to freckle her forehead. In the American portraits a society belle, far from seeming an habitué of courts, is a startled deer, ready to flee into the forest at any sound. The great merchant, there in his counting-house, stands awkwardly, like a backwoodsman. Not the placid, self-confident orbs of a London gentleman, his eyes, between their tight lids, seem to have known the bright American sun and the strange sights of a partially inhabited land.

The earliest American art tradition is light and lyrical. Profound comment on life, even the personalities of the sitters are often lost in the over-all elation. Wonder, excitement, joy of living are expressed, and also innocence, the innocence of a civilization that is itself a child. That lady, so fine in her party dress, is really a little

[273]

girl delighted on Hallowe'en to be wearing her mother's finery. Often we feel the painting before us is a new and shiny toy. The artist was as delighted with it as the sitter; both were amazed to see how agreeably the pigment went on to make an exciting image.

These pictures are less a new beginning than a modification of Old World techniques and Old World ideas. Since they reflect aristocratic thinking as well as democratic aspiration they have been denounced as un-American by our chauvinistic critics. We gather that the artists, out of a villainous desire to be traitors, deliberately painted in an unpatriotic and subversive manner. Actually, if we refuse to accept this painting as part of our heritage, we must also cast overboard the whole beginning of our national development. For one was an accurate representation of the other.

So sensitive a barometer was American painting that the needle shifted at the approach of the thunder-clouds of the Revolution. After 1750, the realistic ideas of the artisan-painters became so acceptable to the upper classes that they dominated art. Copley married the daughter of a great Tory merchant; he was generally considered the greatest painter America had ever produced; yet his emotional kinship was less with the international court tradition than with that other revolutionary art long dead: the bourgeois painting of democratic Holland. He showed people as they actually were, and his delighted sitters clamored for more realism. With his work emphasis on individual character became the touchstone of American painting.

During the long semi-isolation of the Colonial period, America produced a succession of artists devoted to recording the men and women of the New World. The instrument they forged was crude in many ways, yet it grew naturally from the forests and the forest cities. It suited the ways of life they knew. Generations before America produced a professional writer, professional painters were expressing our civilization with a growing maturity and a beauty that becomes increasingly manifest as we focus our eyes on the nature and the meaning of these first esthetic flowers that grew in the American wilderness.

Appendix

Notes

1. The chronology here given for Feke does not accord with generally accepted theories. See Chapter Six.

2. Since artistic movements, like all subdivisions of history, overlap, a book dealing with Colonial painting cannot include all the artists whose activity began before the Revolution. Thus, I shall leave to the next volume discussion of Benjamin West's European work, as well as that done by such artists as Charles Willson Peale and Matthew Pratt when, after having studied with West, they brought back to this continent, during the last decade of Colonial life, the results of European study. They were harbingers of new forces whose full impact was not to be felt until the period was over.

3. I acknowledge my profound indebtedness to the group of devoted scholars who, persevering despite a myriad obstacles, have extended our knowledge of early American painting. Although I must take responsibility for every conclusion I have drawn, many of my ideas have been suggested by the labors of my colleagues, and the basic facts that form the hard skeleton of this work have been amassed from the publications of many men. In questions of attribution in particular, I have relied whenever possible on the findings of specialists, such as William Sawitzky, who have given years to the basic labor of classifying the canvases of individual artists.

4. A whole bibliographical work could be written on the neglect of American painting by social historians. I shall cite here three examples, selecting books which have made major contributions to our cultural history.

Samuel Eliot Morison studied 'the intellectual life of New

[277]

England in the seventeenth century' in his profound and highly original *The Puritan Pronaos* (New York, 1936). He included chapters on religion, higher education, schools, publishing, libraries, theology and the sermon, literature, verse, and 'scientific strivings.' Neither painting nor the highly significant New England tradition of gravestone carving were mentioned.

Merle Curti's Pulitzer prize-winning *The Growth of American Thought* (New York, 1943), is another landmark in the study of our cultural history. Yet it summarizes Colonial painting in seventy words, as follows: 'Well-to-do merchants and their ladies had their portraits painted while on visits to England; others patronized such local portrait painters as Robert Feke of Newport and a half-dozen [!] others. A Philadelphia merchant, William Allen, made it possible for young Benjamin West to study in Italy; John Singleton Copley's portraits of the merchants of Boston and other cities bear witness to the patronage of this subsequently [!] distinguished artist.' Twice, on pages 40 and 64, West is referred to as 'the first Colonial American to achieve distinction in painting.' Feke is called the center of a group in Newport that 'read and discussed deistic writings' (p. 110). Copley is not mentioned again, and there are no other references to the artists of the Colonial period.

Among the most amazing summaries of Colonial painting is the brief account in Charles and Mary Beard's epoch-making *The Rise of American Civilization* (New York, 1927). The two paragraphs contain nine major errors of fact, the most startling being the statements that West was famous for his portraits and that Copley had enjoyed a period of European study before his Boston period (I, pp. 165-66).

Among the causes for the inadequate treatment of American painting by general historians is the lack of adequate sources on which they could rely. Students of our early art have published their findings mostly in specialized monographs which have never received wide circulation, while the writers who have attempted to generalize on American painting have usually been anything but scholars. No serious attempts have been made to relate known facts about Colonial painting to the broader aspects of history.

5. A gentle, unassuming Quaker lady of my acquaintance went for her likeness to one of New York's most admired artistic photog-

raphers, a man whose portraits are often shown at the Museum of Modern Art. He made her look like a nouveau-riche hostess scratching from her visiting list a person suspected of voting for Roosevelt.

It might be added that during the period when photography was not yet able to create such social miracles, the humbler portrait painters, the so-called American primitives, were occasionally lured into a realism as merciless as that of the early camera. My wife found in a junk shop an oil of a sea captain which showed his seamed, raddled, disagreeable, and imperious face without the least glossing over or pity. The dealer laughed as he accepted my wife's two dollars, and the picture created nothing but shocked mirth as it hung on our parlor wall. This aspect of American painting will be discussed in more detail in a later volume.

6. The dragon of nationalist criticism has demonstrated his reptile nature by changing his skin; a generation ago his scales were of an opposite color. Far from being worried lest American art seem derivative, nineteenth-century writers wished it to adhere to the European norm and were distressed by any deviations. Those were the days when our professors hoped against hope they would be mistaken for Englishmen; it was equally awful to wear a hat or paint a picture that would be out of place in London.

This attitude has been made old-fashioned not only by the appearance of a more self-confident spirit within our own borders, but by a change in artistic taste which, amusingly enough, originated abroad. Early American painting was usually more naïve than its English counterparts; this was hard to forgive as long as old ideas of connoisseurship reigned supreme. But revolutionary artists in Paris were battering at the fortress of Renaissance taste. Consciously, out of an excess of sophistication, they tried to recapture the virtues of the primitive. Thus, centuries after they were painted, the earliest American pictures came at last into accord with knowing canons. American attics became diamond mines that yielded gems of art. Keeping themselves blissfully ignorant of the fact that primitive pictures have been produced abroad, our writers began to scrawl across a simple directness of style those magic words: 'Invented in America.'

CHAPTER ONE

1. Many of the earliest surviving American canvases seem to be unique examples of the work of one man, while groups which have many resemblances may well be the output of several persons working at about the same time in about the same manner. On the other hand, portraits that vary greatly may be the early and late productions of a single artist; our chronology is not exact enough to enable us to evaluate progression.

When settlements, separated by miles of forest, were likely each to produce their own painters; when any artisan who owned a brush might use it to create a portrait; when foreign workmen of unknown origin appear and disappear; when portraits brought over from England became tangled with those done by Englishmen in America; when the identification of sitters must be accepted on the basis of that most unreliable source, family tradition; when dating by costume is precarious because of provincial lags and oddities of style; when many more pictures have been lost than have been preserved, and those remaining are often in terrible condition or largely repainted: then a whirlpool is a millpond compared with the confusion in which we find ourselves, if we attempt to group pictures as the work of a single individual. Yet if we stand on the banks of the pool and chart the currents that flow by us, we may establish general principles.

2. This is all the more remarkable because settlers often made their log forts double as dwelling houses. The suitability of logs to Colonial conditions should have been manifest, yet the New Englanders adhered to frame construction except when defense was the prime objective.

3. It is commentary on some scholarship in American art that even today we read in weighty books that the first group portrait painted in America was Smibert's *Berkeley Group* executed more than a half-century after the *Mason Children.*

4. According to conventional historians of British art, the American settlers should have brought with them no portrait tradition whatsoever; writers continually state that pictures were only painted for the court circle. This conclusion is reached by a roundabout

piece of thinking. The critics, absorbed in old-fashioned esthetic considerations, refuse to regard provincial painting as art. The pictures are thus ignored in books and refused when offered to museums. Then, because they are not available, critics insist that they do not exist.

A concern only with artifacts which the writer considers beautiful may be a tenable position for someone whose only interest is in 'appreciation'; it is disastrous for an historian of art. Much of our criticism today is at the point that archeology was some generations ago when diggers preserved a few obviously beautiful monuments and threw everything else away. As the archeologists discovered, this may fill museums with fine pieces, but it is no way to evaluate a culture. For the study of American art in particular, it is a tragedy that Old World critics have not examined the provincial paintings of their nations, for it is from such work rather than the productions of the masters that American painting sprang.

Amusingly enough, a pioneer in the modern approach to English art was an Indian prince, Frederick Dunleep Singh, representative of a land England considered too backward for freedom. In the county of Norfolk alone, he found eleven hundred seventeenth-century portraits, only a handful of them by the court practitioners who were supposed to have been the only painters in England. His book, and a similar study of the western part of Suffolk, show that the illuminators' tradition did not die in the back country till well after 1670. True, the portraits illustrated show a greater admixture of Renaissance elements and a less naïve approach than the Freake and Mason Limners, but only a small percentage of the pictures listed were reproduced, and all came from the seats of county families. It is safe to assume that the more innocent style was also practiced. However, assumption is not proof. A detailed study of English rural painting and its relation to American art is urgently needed.

5. It is certain that Foster was known to his contemporaries as a painter. That he included portraits in his repertoire has not been proved to the hilt, but seems probable since he executed a portrait engraving, and since a man of his education and adventurous temperament would be likely to try his hand at the most remunerative branch of a craft he practiced. That he painted *John*

[281]

Davenport is merely hinted at by the evidence; it is frankly a conjecture.

6. To substantiate the contention that the Puritans were opposed on principle to portrait painting, use has been made of the following passage written by Cotton Mather about the Reverend John Wilson: 'But from the like humility it was that a good kinsman of his, who deserves to live in the same story as he now lives in the same heaven with him, namely Mr. Edward Rawson, the honored secretary of the Massachusetts Colony, could not by his entreaties persuade him to let his picture be drawn; but still refusing it, he would reply: "What! Such a poor, vile creature as I am! Shall my picture be drawn? I say no; it never shall!"'

Mather clearly regarded Wilson's unwillingness to be painted as a personal idiosyncrasy, and had equal respect for Rawson, who trafficked with portraitists. Indeed, the passage goes on to say that it was the desire of Wilson's friends, all of them good Puritans, that Wilson's 'effigy' be taken.

7. Scholarship has not yet demonstrated that any important influence was exerted on the painting of the English Colonists by the richer traditions that were brought to their Indian converts by the Catholic missionaries to the north and south of them. The serene altarpieces, the bloody depictions of martyrdoms which the English settlers happened on sometimes in wilderness chapels, seemed to them as reeking of superstition as any Indian design scratched on bark. Not till after the Revolution was the United States ready to accept religious pictures in any quantity, and by that time its painters normally studied abroad. They turned for inspiration, not to the provincial Catholic art of their continental neighbors and enemies, but to the well-springs of that tradition in the Old World.

8. Thomas Child, the son of a ship's carpenter in Middlesex County, England, became, after his apprenticeship, a member of the Honourable Company of Painter-Stainers of London in 1679. Eleven years later we find him in Boston, where he was referred to in a record as 'painter.' In addition to mortuary art, he practiced all branches of house painting; he colored everything from window frames to cannon.

In 1930, a picture appeared in the art market bearing the in-

scription: 'Ye [?]Child pictur of William Phips Knight Govr of ye Province.' For reasons detailed in Dresser (*op. cit.*, pp. 111-15), the authenticity of this inscription is open to considerable question. Yet Child may well have painted portraits.

9. Other pieces of evidence demonstrating the prevalence of mortuary painting in early New England are as follows:

Thomas Francis Waters, in his *History of Ipswich,* brings out that in connection with the funeral of Colonel Francis Wainwright, August 7, 1711, Henry Sharpe was paid for 'hatchements and scutcheons' the sum of £10. 9. 0., itemized as follows:

One hatchment of arms	3. 10. 0.
To frame and cloth	1. 8. 0.
26 escutcheons 3/6	4. 11. 0.
10 yards of buckram 3/-	1. 10. 0.

The hatchment clearly depicted a coat of arms, but the cheaper and smaller escutcheons, which each used about a third of a yard of cloth, probably carried other designs. The *English Dictionary on Historical Principles* defines an escutcheon as anything shaped like a shield. Waters adds that a hatchment was a square of canvas stretched on a black frame and carried with a corner uppermost, while the escutcheon was attached to the livery of the horses or perhaps to the pall.

In describing the funeral of Colonel Samuel Shrimpton, February 8, 1797/8, Judge Sewell noted in his *Diary*: 'Mourning coach and also horses in mourning: scutcheon on their sides and death's heads on their foreheads.' Coburn states that the 'hatchments and badges' were painted by Thomas Child.

On September 3, 1752, James Turner was paid by the executors of William Lynde for eight escutcheons the sum of six pounds, plus eleven shillings, for adding a crescent to each of them. Turner was a well-known engraver in Boston and Philadelphia.

Mrs. Forbes kindly called my attention to the following passage from the Reverend Daniel Wadsworth's *Diary* (1728), concerning the funeral of Mrs. Eunice Talbot: 'The coffin was covered with black cloth and four escutcheons upon it.'

Going through her notes at my request, Mrs. Forbes found the names of five individuals, usually described as 'painter' or 'artist,'

who were paid during the eighteenth century for painting done at New England funerals:

(1) Edward Peel received the following sums: 1714, funeral of Peter Sergeant, £12. 0. 0 for escutcheons. 1726, funeral of Jonathan Tyng, £9. 12. 0 for escutcheons. 1730, funeral of Mrs. Gurdon Saltonstall, £24. 0. 0 for twelve escutcheons and a hatchment. (Peel is said to have been the architect of a brick church dedicated at Boston in 1721.)

(2) James Wright.

(3) John Gibbs. (Gibbs died January 22, 1725. In his will he was called 'painter-stainer,' but Jeremiah Bumstead referred to him in his *Diary* as 'the painter.')

(4) Thomas Johnston. In 1742, he drew a coat of arms to be used as a model by the cutter of William Clark's tombstone; for this, as well as an escutcheon and stockings for the funeral horses, he was paid £57. 0. 0. (Johnston was a well-known engraver, who depicted scenes and topographical views. At his death he was described as 'jappaner, painter, and engraver'; the inventory of his estate lists two portraits of Boston worthies — Dr. Mayhew and Mr. Gee — probably painted by himself. The portrait of Joshua Gee at the Massachusetts Historical Society, which has been so completely repainted that its original condition can only be guessed at, might possibly be one of these. It is interesting to note that Johnston, who practiced mortuary art, was the master of John Greenwood who, in turn, exerted an important influence on Copley.)

(5) John Gore. (A 'coach and carpet painter' who kept a paint shop. Gore advertised in the Boston newspapers between 1751 and 1769.)

Mrs. Forbes found further that the executor of Thomas Barrett noted in 1781: 'To cash for painting a coat of arms for a pattern for the stonecutter to work it by on the gravestone, £58. 10. 0.'

The evidence here presented demonstrates, I think, that mortuary painting was practiced to a considerable extent in early New England. Further research in old records would undoubtedly cast more light on the exact forms that painting took. It is to be hoped that scholars engaged in examining wills and executors' statements will keep their eyes open.

CHAPTER TWO

1. There was a marked variation in the development of intellectual life and of the crafts. After the passing of the immigrant generation, a narrow provincialism encased the minds of the New Englanders, but their artisans rose to their greatest heights. At the very moment when the hysterical Cotton Mather was considered our leading man of letters, the silversmiths were creating pieces so fine that even English writers consider them superior to those of the mother country. In furniture, this was the period of the Ipswich scratch designs and the Connecticut Valley sunflower chests. Carvers made their finest gravestones. Significantly, painting, despite its craft origin, declined with the intellectual life of the community.

2. Although there is a tendency to call any American amateur art 'folk art,' folk art in the European sense died out at an early date in most parts of America. Amateur painters tended to slough off patterns inherited by European peasants and to imitate the fine arts traditions of their own or their parents' times. The most conspicuous exception, of course, is the work of the Pennsylvania Germans, who, isolating themselves from the rest of the population, practiced until the mid-nineteenth century traditional Old World crafts. We have only to compare the work of the amateur painters of New York or Massachusetts with that of the Pennsylvania Dutch to realize how far American thinking had strayed from the old forms.

3. Lorenz Kielbrunn, who changed his name to Lawrence Kilburn, was born in Denmark in 1720. He reached New York from London during 1754. One of the least inspired of the foreign-trained painters, he painted portraits, sold paints, and offered to instruct 'gentlemen in the art or drawing landscapes, faces, flowers, etc.' He speculated in land, and when he drew up his will in 1770, he wrote himself down as 'merchant.' He died on June 29, 1775.

4. In 1921 there appeared on the art market four portraits signed with the name of Jeremiah Dummer (1645-1718), the distinguished

[285]

Boston silversmith. No independent evidence exists that Dummer ever painted. Although a technical examination failed to prove the inscriptions of modern origin, the pedigrees supplied with the pictures arouse suspicion. The so-called self-portrait of Dummer and portrait of his wife are said to have descended from Dummer's son to a Daniel Rogers Witcombe, whose signed statement, dated 1921, was given as evidence. Research had failed to establish that this Mr. Witcombe ever existed. From a stylistic point of view, the pictures signed with Dummer's name might easily fall into the group of English provincial portraits which were imported some years back for sale on the American market as examples of our earliest art.

In the book on Dummer he wrote, with Hermann Frederick Clarke, Henry Wilder Foote sums up the evidence on both sides of the controversy, coming to no definite conclusions as to whether the silversmith was also a painter. He then attributed thirty-eight pictures to the artist who created the so-called *Dummer Self-Portrait.* He includes the Pierpont pictures, as well as the portrait of *Elisha Cooke.* This writer believes that Mr. Foote's list contains the work of several painters.

5. William Sawitzky has attributed to the Pierpont Limner the portrait of *Caleb Heathcote* in the New York Historical Society, as well as several other canvases. Since the pictures come from Massachusetts, Connecticut, and New York, the artist must have been an itinerant.

6. By making use of the biographical data we have on mid-eighteenth-century artists, we may break down the origins of American painters into the following categories, which probably have validity for the entire Colonial period:

(1) Foreign-trained professionals who made brief painting trips to America. Example: Wollaston.

(2) Foreign-trained professionals who, after practicing their art abroad for some years, moved permanently to America. Example: Smibert.

(3) Foreign-trained professionals who moved to America as young men and conducted almost their entire career in this country. Example: Gustavus Hesselius.

(4) Foreign-born individuals who came to America as adults

and became professional painters here. This category can be further divided:

(a) Men trained in the humbler branches of the painter's trade: sign or house painters. Example: Watson.

(b) Men who had never received any professional training as painters, but who had used their eyes and were thus familiar with Old-World styles. Example: Williams.

(c) Men who were born abroad but reveal scant familiarity with foreign art. Example: Guy.

(5) American-born artists who received instruction abroad. Example: C. W. Peale.

(6) American-born artists who had contact in this country with foreign models or masters. Example: Copley.

(7) American-born artists who had no contacts with traditional sources. It is interesting that we have not a single name to write down here as an example.

Anyone who reads these categories carefully will see at once the dangers of trying to place an artist on the basis of his style alone. Type one represents from a biographical point of view the extreme of foreign influence, yet, if a man were professionally trained in a highly provincial European style, his work might be more primitive than that of an American-born artist in type six.

7. Emmons was born in Boston in 1703; he married a Boston girl. In his will he referred to himself as a 'painter stainer.' The inventory amounted to £634. Among the items were: eight mezzotint pictures, 64s; two pictures, 20s; sundry picture frames, 10s; one hundred brushes, £8.10; sundry colors ground, £5; the Honorable Judge Sewall's picture, £20.

Although two small print-like likenesses of Samuel Sewall by Emmons are known, the picture appraised at this tremendous sum must have been a large oil. However, it is almost certainly not the three-quarter length of Sewall at the Massachusetts Historical Society. Detailed stylistic analysis indicates that this canvas is the one exhibited by Smibert in 1730. (See Chapter Five.)

Emmons' known and identified pictures, all small portraits in black and white, are: (1) *Andrew Oliver*, here illustrated. (2) *Rev. John Lowell* (Coll. John Lowell, Westwood, Mass.). (3) *Rev. John Lowell* (Coll. A. Lawrence Lowell, Cam-

bridge, Mass.). (4) *Judge Sewall* (Coll. A. Mackay Smith, White Post, Va.). (5) Judge Sewall (burned, but reproduced as frontispiece in Chamberlain, N. H., *Samuel Sewall and the World He Lived In,* 1897).

Emmons' obituary shows that he also painted landscapes and scenes. This phase of his career will be discussed in Chapter Seven.

8. J. Cooper's name and dates have been established by inscriptions on some of the nine canvases attributed to him. Bartlett Cowdry, who discovered this interesting early artist, believes that the majority of his pictures are actual portraits of Colonials. This seems highly problematical, since not one has come down through the years associated with a specific person, and the pictures differ iconographically from any known Colonial likeness. In this writer's opinion, three of Cooper's known paintings might conceivably be portraits, but the other six probably represent historical or legendary figures. It is barely possible, however, that Cooper's fancy figure pieces fall into the class of mythological portraits that had been popular in France, where a countess temporarily awed her lovers by being painted as Diana.

9. I tentatively attribute to the Pollard Limner the following portraits: (1) *Mrs. Jethro Coffin* (Mary Gardner) in the Nantucket Historical Society. (2) and (3) *Mr. John Dolbeare and his wife (Sarah Comer)* in the collection of Thomas S. McLane, New York City. (4) and (5) *Mr. Richard Checkley and his wife (Sarah Walley)* in the Essex Institute, Salem. (6) *Stephen Greenleaf,* in the collection of Lewis Stone Greenleaf, Loudonville, New York. (7) *Ann Pollard* in the Massachusetts Historical Society. (8) *Thomas Thacher,* so-called but probably a likeness of a later minister, in the Old South Association, Boston. (9) Perhaps *Elisha Cooke* in the collection of Leverett Saltonstall, Chestnut Hill, Massachusetts, should be added to this list.

CHAPTER THREE

1. As Professor George A. Kubler of Yale has pointed out to the writer in conversation, research would probably reveal considerable East Indian influence on American architecture, painting, etc. Trade bound the Colonies with the Indies almost as much as with the mother country, and it is a well-known fact that several of our influential painters worked also in those islands, which were at that time more prosperous than any part of North America.

2. Stuart was actually describing a portrait of Napoleon by David.

3. We have no biographical information about Laurens Block. Probably he was a minor Dutch artist who made a brief visit to the New World.

It cannot be proved that *Christ at Emmaus* was painted in America. As we shall have occasion to point out again and again, to draw a sharp line between the work of the Old World and the New is impossible. Individuals shuttled back and forth across the ocean; painting did the same. *Christ at Emmaus* is so crude that it falls out of all known Dutch traditions, yet every land and time has had its amateur painters. However, the picture, even if made abroad, certainly represents the type of work that was done in America, where men tried with inadequate means to reproduce European art. Probably it was based on an engraving.

4. William Sawitzky has attributed to a single painter the two Stuyvesant portraits and a likeness of Cornelius Steenwyck, suggesting that 'all three portraits were painted at New York during the 1660's by an as yet unidentified artist.' Although the presumption is strong that the pictures were made in this country, such a conclusion cannot be proved to the hilt. In any case, the portraits are important to our study, since they reveal the taste of the great men of New Amsterdam.

Some writers have attributed the pictures to one Henri Couturier, a man known to art history only because during 1663 he received a burgher right in New Amsterdam in return for pictures of Peter Stuyvesant and his sons which had already been painted

at that time. Since the portrait of Nicholas William Stuyvesant is dated 1666, it cannot be one of the pictures referred to, and thus the Couturier attribution remains dubious.

My explanation of the peculiar proportions of the younger Stuyvesant's portrait is frankly a theory evolved to explain the facts. It might be added that the painters of America were, as far as panels to be painted on is concerned, in the position of the Ancient Mariner when he cried, 'Water, water everywhere, and not a drop to drink!' You cannot use green wood.

5. The Metropolitan Museum owns a conventional and uninspired Dutch portrait that has been called a self-portrait of Jacobus Strycker. Recent researches made by Margaret Jeffries of the museum staff have shown, however, that the attribution rests entirely on a 'family tradition' not written down until 1887. Early records refer to Strycker as a tailor, but never as a painter. Other pictures attributed to this artist no longer receive the credence of scholars.

Perhaps this is as good a place as any to attack a conception that has been responsible for much shoddy scholarship in American art. So few authentic facts are known about early painters that writers, grasping at any straw, have been inclined to accept as an authentic source that peculiar type of rumor known as 'family tradition.' Family tradition is made up of what Great-aunt Fanny remembered during her eighty-second year that her mother had told her when she was a child. Any of us who have had an Aunt Fanny know how much scholarly accuracy there is likely to be in her dynastic legends. And when we consider that to cover more than a century family tradition must pass through more than one such source, we can only be amazed that anyone can take the result seriously.

Evidence is presented to us again and again of the unreliability of family tradition. Very often, the subjects of portraits are identified as individuals whose dates make it impossible for them to have worn the costumes shown in the pictures. Furthermore, great-great-grandfather's picture is automatically attributed to a great name; anything is a Copley that Aunt Fanny's senile brain can imagine was painted during Copley's lifetime.

One faulty link in a long chain of word-of-mouth is all that is

necessary to create error. So many unscholarly motivations are mixed up with the inflation of dynastic pride, that family tradition is at best a dubious hint, useful only as a clue in our search for knowledge.

6. That two of the three portraits attributed to Gerret Duyckinck show the artist and his wife has been accepted on the basis of family tradition. That they were actually the work of Gerret was first suggested by John Hill Morgan 'on the assumption that a New Netherlander would not pay another for these portraits in view of the fact that he was a painter himself.' *The Catalogue of American Portraits in the New-York Historical Society* adds: 'While the evidence is only circumstantial, this tentative attribution has been generally accepted as one that is justified in the absence of documentary proof.' *Mrs. Augustus Jay*, also in the collection of the New York Historical Society, has been attributed to the artist on a basis of similarity of style.

7. The important rôle played by Watson in many histories of American art is a parable of incompetent scholarship. William Dunlap, whose *History of the Arts of Design in the United States* was for three quarters of a century the only important source on early American art, had been born in Perth Amboy. Thus, as a child, he had been familiar with Watson's reputation; he wrote that the Scot was the first American painter concerning whom 'we have any knowledge.' Subsequent writers ignored Dunlap's qualifying phrase, and hailed Watson as America's first artist. Forgers took advantage of this to create for Watson a considerable *oeuvre*.

8. Mrs. Vas was the painter's step-mother-in-law. Although many students of American art question Pieter Vanderlyn's authorship of her picture, the evidence seems to me convincing. The key document is a life of Pieter's grandson John, written shortly after John's death in 1852 by his neighbor and friend, Robert Gossman. Gossman states that during 1849 he accompanied John Vanderlyn to the Dumond house near Kingston to see the portrait of Mrs. Vas which was stated to be by John's grandfather, Pieter. The picture is described quite accurately, although the inscription is carelessly copied (1723 becomes 1728). John, himself a painter and the son of a painter, would certainly have been correct when

he said that his grandfather, whom he had known as a small child, practiced the same trade. Since the three generations of Vanderlyn artists all worked in Kingston, John would have known his grandfather's style. The biographical details about Pieter which I have repeated from Gossman must be taken with a little more salt, yet they too come from John Vanderlyn.

An attitude of skepticism toward Pieter Vanderlyn and all his works was built up by an article in which Frank X. Harris indiscriminately attributed all the Patroon Paintings he could find to Pieter Vanderlyn. We must start anew, working carefully outward from *Mrs. Vas*, to determine which canvases Pieter painted. The matter is so complicated that a definite conclusion will probably have to wait until an opportunity arises to bring the many pictures together for detailed comparison.

9. A word-of-mouth tradition states that six pictures belonging to the Beekman family were painted by a Duyckinck. A modern scholar fixed on Evert III, since Evert was related by marriage to the Beekmans. The circus clowns who balance on a seemingly haphazard pile of tables and chairs would, I am sure, not trust their necks to so flimsy a structure.

10. The variations in the *Aetatis Sue* paintings are very confusing because they follow no chronological order. Since even the most diverse pictures are identical in many details, the most logical explanation is to attribute them all to a single artist who was an enthusiastic experimenter, but we must not forget that this is conjecture. It is conceivable, for instance, that we have here a partnership in which two men worked closely together, both of them painting sometimes on the same canvas.

CHAPTER FOUR

1. This statement will, I fear, annoy patriotic Virginians. I hope that they, and their colleagues from other Southern states, will refute my conclusions by unearthing from attics or dark walls early paintings with real inner validity. Indeed, I write of Southern art with some misgivings, since, despite the pioneering efforts of such admirable scholars as Dr. J. Hall Pleasants, research on the pictures

of that region is far behind research on the art of the Middle and Northern states. In a highly publicized exhibition, *The Lees of Virginia*, held during 1946, five of the six canvases said to represent seventeenth-century Virginians showed individuals in eighteenth-century clothes. Weddell's book, *Virginia Historical Portraiture*, is full of such mistakes.

2. Because of the nature of her work, Henrietta Johnston is assumed to have been trained in England. Homer Martin Keyes found in Surrey pastels either by the artist herself or in a style close to hers. Perhaps she studied under Edward Ashfield (active 1675-1700).

3. Whether Hesselius actually painted in Virginia is open to question. Dr. Pleasants has attributed to Gustavus Hesselius a group of Virginia portraits of which *John Baylor* is typical. The pictures are characterized by a somewhat anemic grace. They seem to express a different approach to painting and a different philosophy of man than even Hesselius' most fashionable work, being pale reflections of the manner brought to Virginia by the English master, Charles Bridges. However, any conclusion reached by Dr. Pleasants should be given serious consideration. If he is right, it shows that Hesselius, in order to succeed in the real South, had to rebuild his style on a basis of greatly increased artificiality.

4. John Penn's *Journals and Cash Books*, under the date of June 12, 1735, contain the entry 'The Propr[ietor] J. Penn Dr. to cash £16 paid on his order to Hesselius, the Swedish painter.' Since the Indian portraits came down in the Penn family, and since on May 9, 1735, Tishcohan and Lapowinsa took part in a parley with the Penns, it is assumed that the entry represents payment for the two portraits we are discussing.

5. When Saint Barnabas' Church was rebuilt in 1773, *The Last Supper* vanished. The picture here discussed, which turned up during 1848 in an auction room at Georgetown, D.C., was not attributed to Hesselius until 1914. Scholars, on the whole, are inclined to agree with the attribution for stylistic reasons. That this is the very canvas that hung in Saint Barnabas' Church cannot be certain unless we assume that Hesselius painted only one *Last Supper*. However, the point is of little importance.

6. For further information on Wollaston, see Chapter Eight.

[293]

7. Bridges reached Virginia in May, 1735, and our last record of his activity there is dated 1740. According to the manuscript of a descendant, written about 1825-30, he married Alice Flower in London in 1683, came to Virginia 'as a very old man,' and 'around 1740 or so he returned to London to die' at the age of about eighty-eight. Concerning his English career our only hint is an engraving after his painting of *Thomas Baker* (1656-1740) in the British Museum.

Since William Byrd II wrote that Bridges 'has drawn my children,' it is generally agreed that the portraits of Evelyn and Wilhelmina (sometimes also called Lucy) Byrd are by his hand. Many other pictures exist in Virginia that are related to these two, but there are differences as well as similarities, and the whole situation is so confused that it is a rash man who would attempt dogmatic attribution. William Sawitzky writes that the 'Bridges problem . . . calls for a considerable amount of study and research.' To this Dr. J. Hall Pleasants enthusiastically agrees.

The Byrd portraits, and those canvases most closely related to them, are the masterpieces of the Bridges group of pictures. If the English painter was responsible for any of the others, his style deteriorated during his American stay. Some canvases are clearly the work of imitators. *Mrs. Mann Page II and Baby John* is considered one of these since John was not born until 1744, and Bridges is said to have disappeared about 1740. But we must remember that we cannot be absolutely certain about either the identity of the baby or the date of Bridges' departure.

8. Unfortunately, no pictures have been preserved in the South which were certainly painted there before the advent of the slave economy.

9. *The Boston News-Letter,* January 7, 1773, carried an advertisement seeking business for 'a Negro man whose extraordinary genius has been assisted by the best masters in London; he takes faces at the lowest rates.'

A colored painter, Joshua Johnston, was active in Baltimore between 1796 and 1824. His work will be discussed in a later volume of this study.

CHAPTER FIVE

1. Concerning Smibert's trip to Italy, as well as other aspects of the painter's biography, Oskar Hagen has evolved elaborate theories. I have not followed him into his speculations, since they seem to me to be based on the most tenuous of presumptive evidence.

2. In making this remark, Kneller showed a profound knowledge of a type of art criticism which, alas, is not altogether extinct. Its battle cry is: 'This picture is not good enough to be a Copley.' Devotees attribute the worst work of first-rate artists to second-rate painters and the best work of second-rate painters to first-rate artists. Thus, the Great Man Theory of Art is encouraged by creating a fallacious gap between the achievements of accepted masters and of their less publicized contemporaries.

3. In 1735, Smibert advertised for sale prints after 'the finest pictures in Italy, France, Holland, and England, done by Raphael, Michel Angelo, Poussin, Rubens and other great masters, containing a variety of subjects, as history, etc., . . . being what Mr. Smibert collected in the above-mentioned countries, for his own private use and improvement. . . . At the same time, there will be sold a collection of pictures in oil.'

However, Smibert kept enough of the results of his European trip to make his studio America's first important art school. In addition to the pieces already mentioned, there were busts and statues 'done in clay and paste,' a *Holy Family* after a Raphael in Florence, and a *Naked Venus and Cupid* after a Titian belonging to the Grand Duke of Tuscany. When Charles Willson Peale visited Smibert's studio in 1765, he saw 'an appropriate apartment lined with green cloth of baize, where there were a number of pictures unfinished. He had begun a picture — several heads painted — of ancient philosophers, and some groups of figures.'

In the 1770's, Copley, having reached the fabulous shores of Europe, tried to describe to his half-brother, Henry Pelham, the paintings he saw there. As an example of sophisticated coloring, he referred several times to Smibert's copy of Van Dyke's *Cardinal*

Bentivoglio. The copy of Poussin's *Scipio,* Copley remembered, 'had one general tint running over the whole picture, as if the painter when it was done had immersed it in brown varnish'; but he thought the real works of Poussin were even darker. Smibert's copy after Titian he judged 'by no means equal' to the original. And the *Holy Family* was 'very different' from the original Raphael, which had 'nothing of the olive tint you see in the copy, the red not so bricky in the faces, the whole picture finished in a more rich and correct manner. You remem[ber] the hands of the Virgin and of the St. John. They are very incorrect in the one you have seen, but in the original they are correctly finished, and the whole picture has the softness and general hue of crayons, with a pearly tint throughout.' Thus the Colonials saw European art through a glass darkly.

The inventory of Smibert's estate, dated February, 1752, contained the following items: Colors and oils, £307. 16. 5. Thirty-five portraits, £60. 5. 4. Forty-one history pieces and pictures in that taste, £16. 0. 0. Thirteen landskips, £2. 13. 2. Two conversation pictures, £23. 6. 8. Busts and figures in Paris plaster and models, £4. 4. 8. Prints and books of prints, £11. 12. 8. Drawings, £4. 16. 0. Most of the pictures were probably engravings, the stock of his store.

4. The interior of Faneuil Hall had been gutted by fire and rebuilt before Revolutionary days, but the outside remained, until a later date, much as Smibert had designed it.

5. Nathaniel Smibert (1734-56) spent his entire recorded life in Boston. When he died at the age of twenty-two, the three long obituaries that were published in the Boston newspapers concentrated their praise on his moral virtues, and spoke of his art as being promising. His contemporaries clearly regarded him as a beginner rather than a professional painter.

It is hard to think of anything very specific to say about his paintings, of which *Ezra Stiles* at Yale and *John Lovell* at Harvard are typical. Nathaniel Smibert was, as Colonial artists go, quite proficient and quite correct; his colors are agreeable; he achieved a certain amount of plasticity. Yet his portraits are profoundly dull, perhaps because he was unable to put any personality, either his own or his sitters', down on canvas. Old men and young men,

women, and even the Indian priest that hangs at Bowdoin, all are brightly colored vacuums.

6. In his later American years, Smibert alternated between pictures that leaned toward realism and others that were fashionable confections. Exactly how far he went in the two directions is at the present state of knowledge difficult to say. Although *Byfield* and *Mrs. Smibert* are definitely from his hand, many of the pictures linked to his name are not. For a full century, he was the only artist known to have worked in Massachusetts before Copley; floods of pictures were attributed to him. Scholarship has already given numbers of them to other hands, but the labor is not yet finished. On the conventional side, we have still ascribed to him English pictures which were imported during the last half-century and then embellished with his signature. On the crude side, we have pictures authentically of the period in New England which, however, are probably the work of such Colonial painter-stainers as Joshua Johnston or Nathaniel Emmons.

7. Gray's 'village Hampden who with dauntless breast the little tyrant of the fields withstood' was buried in a neglected graveyard and forgotten. In America, he would have signed the Declaration of Independence.

8. Anything inhibiting force in the way of an American Hogarth would have been the difficulty of achieving a large sale for engravings when the population was so scattered.

CHAPTER SIX

1. The biography of Robert Feke has become so confused with legendary elements that before we can analyze either his life or his work we must make an attempt to win back through theory to fact. Everything we know for certain about his career can be detailed in less than a thousand words:

1741. The Harvard University Law School possesses a group portrait showing one man, three women, and a child, the back of which bears the following inscription: 'Drawn for Mr. Isaac Royall whose Portrait is on the foreside Age 22 years 13th instant His lady

in blue Aged 19 years 13th instant His sister Mary Palmer in [one word illegible] Aged 18 years 2nd of August His sister Penelope Royall in Green Aged 17 years 25 of April The [illegible] daughter Elizabeth Aged 8 months 7th instant Finisht Sept. 15th, 1741 by Robert Feke.' It is extremely important to remember that this is the first certain evidence we have that the painter Robert Feke ever existed.

1742. The town record of Newport, Rhode Island, notes on September 23, 1742, that the Reverend John Callender of the First Baptist Church married Robert Feke to Eleanor Cozzens. The bride and groom were described as 'both of Newport.'

1744. Dr. Alexander Hamilton, a Scotch physician domiciled in Annapolis, recorded his arrival in Newport under the date July 16, 1744. The revelant quotation from his diary is included in the text of the chapter.

1745. Two portraits of divines, both of which were probably commissioned by Henry Collins of Newport, are signed 'R. Feake' and dated 1745. The misspelling of the artist's name, which is not repeated in any other signatures, makes us wonder whether the inscriptions could have been added by a later hand, yet they are probably genuine. One of the portraits is authenticated by an engraving inscribed: 'The Rev^d Tho^s Hiscox, late pastor of the Baptist Church in Westerly, taken from an Original Picture painted by Mr. Feke Published by Reak and Okey, Printers and Stationers on the Parade, Newport, Rhode Island, October 22, 1775.' The other picture is said to represent the Reverend John Callender who presided at Feke's marriage.

1746. Three portraits of Philadelphia people are signed with the name 'R. Feke' and this date. That of Williamina Moore is regarded by William Sawitzky as clearly not by Feke. Another, that of Mrs. Charles Willing, was mentioned with a slight misspelling by Dunlap in 1834 as being signed by Feke. This signature, and that on the portrait of Tench Francis, are generally accepted as genuine.

1748. Many paintings of Bostonians are signed either 'R. Feke' or 'R.F.,' followed with this date. Enough of the signatures are undoubtedly authentic to demonstrate that Feke was painting in Boston during that year. The four signed portraits of members of

the Bowdoin family at the Bowdoin Museum of Fine Arts, Brunswick, Maine, may be regarded as key pictures for this period.

1749. A portrait of Mrs. Oxenbridge Thatcher is signed 'R.F. Pinx 1749.' Mr. Sawitzky is convinced that the picture is by another hand.

1750. In his diary for April 7, 1750, John Smith of Philadelphia notes that he and his brother-in-law William Logan 'went to Fewke's the painter's & viewed several pieces & faces of his painting.'

1767. On October 15, 1767, Feke's daughters Phila and Sarah were both married in Friends' Meeting House, Newport. Each bride is described as 'daughter of Robert Feke, late of said Newport in said country and Colony, Mariner, deceased, and Eleanor his wife, now widow.'

This completes the contemporary documentary evidence certainly referring to Robert Feke, the painter, which has been brought to light by Poland, Foote, and other scholars. In addition, of course, there are many canvases which can with confidence be ascribed to his brush. The pictures give us little more information about his life; they show he painted in Newport, Boston, and Philadelphia, and perhaps one pair of pictures on Long Island.

The few facts that comprise Feke's entire authenticated biography have been greatly expanded by the use of material first published during 1859-60, more than a century after our last indication that the painter was living. In the November, 1859, issue of *Dawson's Historical Magazine,* Joshua Francis Fisher brought out a request for information about 'R.Feke, the Artist.' In January, 1860, one 'S. F.' replied that 'Robert Feke . . . was supposed to be a descendent of a Dutch family that settled at the head of Oyster Bay.' His father was a Quaker, but the artist became a Baptist. 'He then left the house of his youth,' S. F. continues, 'and was several years absent on voyages abroad, in one of which he was taken prisoner and carried into Spain, where, in the solitude of his prison, he succeeded in procuring paints and brushes, and employed himself in rude paintings which, on his release, he sold, and thus availed himself of the means of returning to his own country. He soon after settled and married in Newport, cultivated his talents, and painted portraits. . . . He followed his profession

[299]

for twenty years, and is said to have several times visited Philadelphia, where it is supposed others of his paintings may be found. His health declining, he sought the milder climate of Bermuda, where he died at about the age of 44.' S. F. closes with genealogical information gleaned from a book.

This letter seems to have been based on information gathered in Newport. However, despite the F. in S. F.'s initials he cannot be thought of as a descendant of the painter, since the male line had completely died out. Indeed, the one member of the Feke family S. F. mentions by name, the painter's son Charles, had died without issue thirty-two years before. S. F.'s cautious wording makes it clear that he was repeating a rumor which did not come from a source he considered unimpeachable.

S. F.'s letter stirred up the antiquarians of Oyster Bay. In a letter which appeared some months later in the same publication, one J. G. S. makes use of standard genealogical works to trace the history of the Oyster Bay Feke family. He points out that the Robert Feke referred to by S. F., the man who changed from the Quaker to the Baptist faiths, was a well-documented Baptist minister, who lived and died in Oyster Bay. However, J. G. S. now brings forward for the first time another Robert Feke, a son of the minister, whom he identifies as the painter. 'For information not derived from printed works,' J. G. S. writes, 'I am indebted to Mr. J. D. Feeks.' Mr. Feeks, not a descendant of the presumptive painter but of his brother, was the source of the statement: 'The house at Meadowside formerly contained a number of family portraits executed by Robert Feke, but they all perished when the house was destroyed by fire, *about ninety-two years since* [italics mine], prior to the revolution.' Mention is then made of a portrait of Levinah Cock, which we shall discuss in a moment.

Writers have without exception accepted the younger Robert Feke, introduced to history by J. G. S. in 1860, as the painter; I feel they have been too trusting. Only an unscholarly act of faith can make us regard S. F.'s cautious original statement as the result of an unbroken tradition coming down from the painter or his children. It is highly suspicious that the rumor he repeated seems to have identified the Oyster Bay father rather than his son as the painter. The elder Robert Feke, whose life-span (1683-1773) in-

cludes the years in which the portraits were painted, had been mentioned in books. It is quite possible that some Newport genealogist, anxious to identify the author of a family portrait, picked this man out of a book, thus giving rise to the report which S. F. repeated without any conviction.

When his letter was read in Oyster Bay, it was manifest there that the minister and the painter could not have been the same man. Enter another Robert, the son of the minister. As for Mr. J. D. Feeks, who represents 'family tradition' on the Oyster Bay side, it is significant that his only contribution about the painter — in addition to mentioning the existing portrait of Levinah Cock — was that some pictures by him had been burnt in the family homestead almost a century before. If a man suddenly discovered that there had been an artist in his family, he would naturally attribute any long-destroyed family portraits to that painter.

This explanation of the *Dawson's Historical Magazine* information is, of course, hypothesis. I merely wish to show how easily error could have crept in. The reader, if he wishes to amuse himself, can think of many other, equally plausible ways in which a false rumor could have got started during the century which intervened between Feke's disappearance and the publication of the letters. To regard Feke's connection with Oyster Bay as proved is, to put it mildly, naïve.

It is very difficult to trace the younger Oyster Bay Robert Feke, who was supposed to be the painter, back before that moment in 1860 when he burst into history. That he actually existed is implied by two contemporary notations, neither of which is altogether conclusive. On a deed made out in 1728, Robert Feke, the preacher, is referred to as 'Senr.,' which suggests the existence of a 'junior'; yet this is the only time among the many references to him in the town records of Oyster Bay that the preacher was so designated. A land survey made on December 12, 1730, is signed by 'Robart Feke Jur.,' but a later paper on the same survey refers simply to 'Robart feake.' I have been unable to find in any historical dictionary that 'junior' was ever abbreviated 'jur.' Could the reference be to 'juror'; i.e., 'swearer'? The earliest printed list of the children of Robert, the preacher, was published without birth and death dates, and with no source given, during 1895 in a book

famous for its inaccuracies: Mary Powell Bunker, *Long Island Genealogies* (Albany, 1895), pp. 202-03.

The date universally given for the painter's birth, *c.* 1705, was achieved by combining S. F.'s statement that the painter died 'at about the age of forty-four,' with an unwritten 'family tradition' that he died in 1750. In other words, it has no validity whatsoever.

The most tangible piece of evidence linking the painter with Oyster Bay is the portrait of Levinah Cock mentioned by Mr. Feeks. Said to represent a niece of the man identified as the painter, this picture of a baby has come down in the right family. On the back is written, 'To Robert Feke at Mr. Judea Hayes in Newyork.' This inscription is at best hard to interpret. Carefully and decoratively lettered in dark paint, it does not seem to be a direction jotted down for a carrier. We gather rather that the writer wished to have the phrase permanently connected with the picture.

If the portrait can be shown to be the work of Feke, the painter, it would certainly associate him with the Oyster Bay Fekes, but if the picture is by another hand, it proves nothing except that the family possessed a picture of a child which was inscribed to one of the Oyster Bay Roberts. This line of evidence, then, rests on stylistic attribution. The painting is a crude work, which would have to date many years before any established picture by Feke. It is dangerous business to try to reason back from an artist's mature style to his early daubs. Furthermore, the panel is in poor condition and has been somewhat repainted. Thus we are led to an impasse. *Levinah Cock* may or may not have been limned by Feke, and if she was not, the picture contributes nothing to the identification of the Oyster Bay Robert with the painter.

All that can be said with certainty about the origin of Robert Feke, the painter, is that more than a century after his disappearance he was linked, on equivocal evidence, with a Robert Feke who probably existed, and, if so, was born in Oyster Bay at some unspecified date in the early eighteenth century. Actually, the painter may have been the Robert Feke who, as Henry Wilder Foote demonstrates, was born in the Barbados in 1713. Or he may

have come from any place where we find the name Feke or its variants, Feak, Feeks, Freake, etc.

Other biographical details put in their first appearance with the *Dawson's Magazine* correspondence. Of course, none of this hearsay evidence, written down by anonymous individuals more than a century after the event, can be accepted without corroboration from sounder sources. Yet Oskar Hagen has taken the story of Feke's Spanish captivity with pompous seriousness. It was historically possible for an American sailor to be imprisoned in Spain during the 1720's or 1730's; beyond that we cannot be sure of anything.

Scholars who have been overreceptive to the *Dawson's Magazine* information about the beginning of Feke's life have been more healthily skeptical about the story that sickness drove him to Bermuda where he died. They note that later writers have changed Bermuda to the Barbados, but that it cannot be shown that this was anything more than careless copying. A search of the Bermuda records has shown them innocent of the name of Feke. John Hill Morgan and Mr. Foote have found traces of a Feke family in the Barbados, but no Robert was buried there between 1750 and 1757, although a Richard Feke was interred in 1752. The suggestion that Richard may have been a scribe's error for Robert is frankly speculation.

Thus, we are thrown back on the realization that we know nothing about the artist's life before 1741 or after 1750. But what about his pictures — does any of his work necessarily fall outside this period? Concerning the end of his career, there is general agreement; no attempt has been made to date any of his pictures after 1750. Ten canvases, however, have been assigned by important writers to the period before 1741. They are:

(1) *Levinah Cock*, which was discussed earlier in this article.

(2) *Early self-portrait*. Foote achieved his date for this portrait, c. 1725, by adding the supposed age of the sitter, twenty years, to his supposed birth date, c. 1705. Since, as we have shown, there is no certain evidence for this birth date, the whole argument collapses. Burroughs, and also Bolton and Binsse, noting many similarities between this picture and the *Royall Family* of 1741, moved the self-portrait along to 1735, not daring to go fur-

ther, perhaps, because they accepted Feke's spurious birth date and were unable to believe that the sitter was older than thirty. William Sawitzky has cut clearly through the tangle by stating that the picture could not be earlier than the Royall Family and was probably later. This writer's conclusion, for which he presents evidence in the main text, is in agreement with Mr. Sawitzky's.

(3) and (4) *Mr. and Mrs. Gershom Flagg IV.* These companion pictures came down in the same collection as the early self-portrait. With considerable cogency, Bolton and Binsse argue that they were painted at about the same time. This, as we have seen, does not necessarily date them before 1741. Foote gives the date as 1748. This writer dates them *c.* 1741-*c.* 1745.

(5) The so-called *Pamela Andrews.* Bolton and Binsse feel that this was painted at about the same time as the self-portrait. Foote considers the picture later than the *Royall Family,* a verdict with which this writer agrees.

(6) and (7) *Mr. and Mrs. Josiah Martin.* Because they consider the style crude and because the sitters were from Long Island, where they assume Feke spent his younger years, Bolton and Binsse date these portraits shortly after 1735. The Long Island argument, of course, holds no water, and the stylistic evidence is not clear. In this writer's opinion, the pictures are typical of Feke's mature style. Foote dates the pictures 1746.

(8) and (9) *Mr. and Mrs. Tench Francis.* Foote dates these portraits 'before 1740' on the grounds that they represent the same sitters as another pair of portraits, one signed and dated 1746, which make the subjects seem six or eight years older. When we recall how often sitters are wrongly identified by family tradition and how much alike Feke tended to make his people look, this evidence seems weak beside the fact that the portraits are linked stylistically to Feke's more mature work. Indeed, Mrs. Francis is almost identical in pose with *Mrs. William Peters,* dated by Foote 1750, and by this writer, *c.* 1746. Bolton and Binsse seem to have regarded the pictures under discussion as copies of the dated Francis portraits, a conclusion which comparison does not bear out.

(10) *Mrs. George McCall.* This portrait, which has been lost, was attributed to Feke by Foote on the basis of a photograph.

Estimating the sitter's age from her appearance, and thinking it likely she was painted before her husband's death in 1740, Foote dates the picture at the beginning of that year. Without considering the question whether the picture is actually by Feke, we may state that the arguments given for the date are hardly conclusive.

Perhaps a word should be said about the *Fanciful Landscape* which was bought in England by Mrs. L. K. George of Nottingham about twenty years ago as a Morland. She found on it the initials 'R.F.' and also, so she stated, the signature 'R.Feke.' Examining the picture in 1932, Foote was able to read the initials but not the signature. The history of the painting goes no farther back than the dealer from whom it was purchased. It is quite out of line in subject and, as far as can be told from a photograph, in treatment from all known works by Feke. Only the most careful stylistic study or the discovery of new evidence can authenticate this landscape with figures.

It is possible, of course, that some of the pictures that are similar in style to the *Royall Family* may have been painted slightly before September 15, 1741, when that canvas was completed. And, although this has never been suggested, some of Feke's mature pictures could conceivably have been executed shortly after our information about him fails in 1750. However, a year or so at either end of his career would be the greatest latitude that could be given for any of his known pictures (unless we accept *Levinah Cock*). New canvases that would change the verdict may yet be found. But until further evidence is presented, it seems safest to write Feke's dates as 'active *c.* 1741 to *c.* 1750.'

2. The baby in the *Royall Family* is painted in an entirely different style from the other figures. Pointing out that the infant specified in the inscription on the back of the picture died shortly after he was limned, Burroughs suggests that at some later date John Greenwood was commissioned to substitute the portrait of another child, then among the living.

3. At first glance, the *Self-Portrait*, which seems to have been painted flatly, appears to be quite different from the *Flagg* pictures which show much of Feke's typical preoccupation with three-dimensional shapes. The resulting simplicity has delighted critics

[305]

who pontificate about primitives, and also has inspired the very early date to which some writers have assigned the picture. If we examine closely, however, we will realize that this flatness was not created by Feke, but by some incompetent restorer who, in attempting to clean the picture, took off the top paint surface which included the highlights and shadows that give an impression of depth. That this accident, by reducing detail and exaggerating the basic design, may well have increased the picture's appeal to modern writers reveals again the quicksands through which students of art are forced to walk.

4. *The Judgment of Hercules,* an illustration for an essay on esthetics of the same name, was published with the essay in numerous editions of Shaftesbury's *Characteristicks.* That Feke copied a print from a book that also contained deist philosophy is the basis of Carl Bridenbaugh's statement that 'Feke, widely read, became interested in deism.' To this Merle Curti adds, 'At Newport the painter Robert Feke was the center of a group that read and discussed deistic writings.' Both authors seem to have allowed their generalizations to outrun their facts.

5. The Whitney Museum of American Art, New York City, opened in October, 1946, the first one-man show of Feke's work ever held. Since roughly half of the artist's known pictures were gathered under a single roof, the exhibition offered an unrivaled opportunity to make a chronological analysis of his work. Using his dated canvases as starting-points, I have tried to divide his portraits into groups that were painted at about the same time. No attempt has been made to determine the sequence of pictures that fall into a single group. The major criteria considered were stylistic similarity and the over-all evolution of his technique and approach; that portraits of sitters who lived close together often fell into the same group was a helpful sign. When some doubt as to the date of the picture remained in my mind, I added after the name of the sitter a question mark in brackets. Canvases that were not in the exhibition and thus unavailable for detailed comparison are not included. In making up this list, I have profited from discussions with Lloyd Goodrich, of the Whitney Museum, who is in substantial agreement with my conclusions.

The following classifications are not put forward as conclusive,

but rather as a preliminary effort to bring order into a chaotic situation.

BEFORE 1741

Levinah Cock, so-called, of Long Island. (?) Coll. Robert Feeks Cox. (If actually by Feke.)

1741

The Royall Family, of Boston. Coll. Harvard University. (Signed and dated 1741.)

Ca. 1741 to *Ca.* 1745

Pamela Andrews, so-called. (?) Coll. Museum of Art, Rhode Island School of Design. (Considerably repainted.)

Rev. John Callender, of Newport. Coll. Rhode Island Historical Society. (Signed and dated 1745.)

Robert Feke. Coll. Henry Wilder Foote.

Gershom Flagg IV, of Boston. Coll. Henry Wilder Foote.

Mrs. Gershom Flagg IV, of Boston. Coll. Henry Wilder Foote.

Rev. Thomas Hiscox, of Newport. Coll. Countess Lâszlo Széchényi. (Signed and dated 1745.)

Mrs. Joseph Wanton, of Newport. (?) Coll. Redwood Library and Athenaeum.

Ca. 1746

Dr. Phineas Bond, of Philadelphia. Coll. Miss Fanny Travis Cochran.

Tench Francis, of Philadelphia. Coll. Metropolitan Museum. (Signed and dated 1746.)

Miss Mary McCall, so-called, of Philadelphia. Coll. Pennsylvania Academy of Fine Arts.

Mrs. William Peters, of Philadelphia. Coll. Historical Society of Pennsylvania.

Edward Shippen, Jr., of Philadelphia. Coll. Edward Shippen Willing.

Mrs. Charles Willing, of Philadelphia. Coll. Edward Shippen Willing. (Signed and dated 1746.)

Ca. 1747

Ebenezer Flagg, of Newport. (?) Coll. Countess Lâszlo Széchényi.

[307]

Mrs. Ebenezer Flagg, of Newport. (?) Coll. Countess Lâszlo Széchényi.

Gershom Flagg III, of Newport. (?) Coll. Countess Lâszlo Széchényi.

Simon Pease, of Newport. (?) Coll. Mr. and Mrs. Myron Taylor.

Ca. 1748 to Ca. 1750

Charles Apthorp, of Boston. Coll. Cleveland Museum of Art. (Signed and dated 1748.)

Mrs. Charles Apthorp, of Boston. Coll. Mr. and Mrs. Ben P. P. Moseley. (Signed and dated 1748.)

Ralph Inman, of Cambridge, Mass. Coll. William Amory.

Mrs. Ralph Inman, of Cambridge, Mass. Coll. William Amory.

Josiah Martin, of Long Island and Antigua. Coll. Toledo Museum of Art. (There is no reason to believe that the landscape background of this picture is intended to represent the Long Island shore, since similar conventionalized views of bays and hills are found in several other Fekes, notably *Isaac Winslow.*)

Mrs. Josiah Martin, of Long Island and Antigua. Coll. Detroit Institute of Arts.

John Rowe, of Boston. (?) Coll. J. Webster Rowe. (If actually by Feke.)

Richard Saltonstall, of Haverhill, Mass. Coll. Mrs. Richard Middlecot Saltonstall.

Mrs. Barlow Trecothick. Coll. Mr. and Mrs. Ben P. P. Moseley.

Unknown Lady. Coll. Brooklyn Museum.

Isaac Winslow, of Boston. Coll. Museum of Fine Arts, Boston.

6. The bust portraits of Hiscox and Callender, typical of Feke's early style, were dated by the artist 1745; *Tench Francis* and *Mrs. Willing,* exemplifying the new mode, 1746. At the very outside, they could have been painted a year and three quarters apart. How may we explain the great change that had taken place?

Feke, who earned his living at times as a sailor, may have made a brief visit abroad — perhaps to London — in the interim, yet we do not have to postulate such a quick trip to explain his new style. He had brought the rudiments of it to Smibert's studio; he was now

getting back on his own track. His mature work is closest to English practice in composition, a matter that could be conned from engravings. Those other skills which he would have had to learn from actual contact with English pictures are less conspicuous. His methods of putting on paint, of coloring, of achieving the round were still primitive according to European standards.

CHAPTER SEVEN

1. Whenever we have documents expressing appreciation of the work of Colonial painters, we find the artists being admired because their achievements were less the result of training than of natural genius. This point of view, of course, made a virtue out of necessity; it reflected the actual plight of the American artists. Did it also reflect the romantic theory which glorified children of nature unspoiled by man-made conventions, that theory which is behind so much of our present love for 'American primitives'? The documents are not full enough to give us an answer. Historically, such a point of view would have been possible in the middle eighteenth century, for the conception of the 'noble savage' was one of the many manifestations of the bourgeois revolt against the institutions of the aristocrats. Indeed, it was a necessary corollary of the Low-Church doctrine of 'the priesthood of all believers.' When Rousseau published it in 1749, he was expressing a widespread emotional attitude.

2. Even today, Colonial portraits are often valued by their owners primarily for their dynastic associations. When this writer communicated with the possessors of the early monuments of our art, their courteous answers were sometimes interlarded with uncomplimentary comments on the pictures. One gentleman replied to my request that I be allowed to examine a portrait, 'I cannot assure you that the picture is worth the journey.' Another gentleman confided, 'An Italian who saw this picture once said to me, "I wish your American artist had taken a few lessons in painting in Italy and under those circumstances would have done much better work."'

3. Emmons' portraits were discussed in Chapter Two.

[309]

4. Since this chapter deals with the subject and landscape painting of the entire Colonial period, artists are mentioned who have not yet been discussed in detail. We shall meet again West, Copley, Badger, Greenwood, and the Pelhams.

5. The following alphabetical list of the more important Colonial painters specifies the subject matter which we know each one to have depicted. The reader will observe that those who left full autobiographical statements (Peale, West) or who advertised in the newspapers (G. Duyckinck; G. Hesselius; P. Pelham; Remick; Roberts; Theus; Williams) can be shown to have engaged in many more kinds of painting than artists for whom we have no such sources of information. We are forced to rely, for facts about many painters, on the chance discovery of some letter or entry in an account book. The identity of Joseph Blackburn, for instance, is an almost complete mystery; thus we can only prove him to have been a portraitist. It may be laid down as a general rule that the more written information we have about an artist, the more various is the subject matter in which we can show him to have been engaged. Further discoveries about American art must strengthen my case, because when no documents exist the argument automatically goes against the contention that pictures other than portraits were common.

Badger, Joseph. Portraits and figure pieces.
Blackburn, Joseph. Portraits.
Bridges, Charles. Portraits and heraldry.
Cooper, J. Pictures of historical and allegorical personages, and perhaps portraits.
Copley, John Singleton. Portraits; religious, historical, and allegorical subjects; figure piece (*Nun by Candlelight*); anatomical and other drawings.
Duyckinck, Evert I. Referred to in records as limner, painter, glazier, and burner of glass. Engraved arms on windows and painted them on fire buckets.
Duyckinck, Gerardus. Advertised 'all manner of painting work done.' His business consisted of 'limning, painting, varnishing, japanning, gilding, glazing, and silvering of looking glasses.' His sign showed two cupids.

Emmons, Nathaniel. 'Faces, rivers, banks, rural scenes, and imitations of works of art.'

Feke, Robert. Portraits. Copied *The Judgment of Hercules* from a print. A Philadelphia diarist saw 'several pieces and faces of his painting.' Possibly painted a scene of pirates on a rocky seacoast found in England.

Foster, John. Known as a painter, but his only certain works are engravings. His prints include a portrait, a map, coats of arms, decorative designs, and perhaps a view of Boston.

Greenwood, John. Apprenticed to Thomas Johnston, engraver, printer, designer of gravestones, painter of houses, fire buckets, ships, and almost certainly portraits. Greenwood made portraits, a view of Yale with genre elements, a genre figure piece, and, in the West Indies, a painting of sea captains at a party.

Hesselius, Gustavus. Portraits, religious and allegorical compositions. Advertised with John Winter 'painting done in the best manner, . . . viz. coats of arms drawn on coaches, chaises, etc., or any kind of ornaments; landskips, signs, show-boards, ship and house painting, gilding of all sorts, writing in gold and color, old pictures cleaned and mended, etc.' Made musical instruments.

Hesselius, John. Portraits.

Johnston, Henrietta. Pastel portraits. (No documents of any sort refer to her work.)

Kühn, Justis Englehardt. Portraits are known. His inventory mentions 'seventeen pictures and landskips' and a coat of arms.

Peale, Charles Willson. We shall deal here only with Peale's activities during the years before he sailed to England in 1766. He painted portraits, landscapes, signs, coaches, political banners, likenesses of towns and ships, miniatures, copies of paintings and prints, figure pieces. He also engaged in such trades as saddling, watch-making, brass-founding, silversmithing, and coach-making. He probably worked in watercolors as well as oil.

Pelham, Peter. Painted portraits. Engraved portraits and a map. Advertised that he taught, along with dancing and arithmetic, etc., 'painting upon glass and all sorts of needle work.'

Remick, Christian. Advertised 'he performs all sorts of drawing

in water colors, such as sea pieces, perspective views, geographical plans of harbors, seacoasts, etc. — Also colors pictures to the life, and draws coats of arms.' Made landscapes with genre elements.

Roberts, Bishop. Advertised portraits, engraving, heraldry, house painting, landscapes, drawings of houses in colors and India ink.

Smibert, John. Portraits, copies of Old-World materpieces, landscapes, satirical genre, ruins and neo-classical subjects, plans for architecture.

Smith, Thomas. Portraits. His self-portrait has a sea battle in the background. (There is only one brief documentary mention of this painter.)

Theus, Jeremiah. Advertised portraits, 'landskips of all sizes, crests and coats of arms for coaches and chaises.' Kept a drawing school where 'every branch of the art will be taught with great exactness.'

Watson, John. Portraits and imaginative figures in oil. Drawings of such subjects as Hercules, Homer, long-dead kings, saints, duchesses, etc.

West, Benjamin. During his American period he made portraits, landscapes, a seascape, *The Death of Socrates,* caricatures, pictures of birds and flowers, various subject pictures, and signs.

Williams, William. Portraits, conversation pieces, history, sign painting, lettering, landscapes, 'cow pieces,' caricatures, theatrical scenery. Taught 'the different branches of drawing and to sound the Hautboy, German, and common flutes.' Novelist, poet, and biographer.

Wollaston, John. Portraits.

6. When discovered quite recently by a Philadelphia dealer, the landscape was attributed to West on the basis of a description published by his biographer, Galt, of his second oil painting: 'The artist composed a landscape, which comprehended a picturesque view of a river, with vessels on the water, cattle pasturing on the banks.' If the picture is rightly identified, it was painted directly after the *Landscape with Cow* we have just discussed, a phenom-

enon difficult to explain, since it is much more sophisticated. Stylistically the pictures seem to have little relationship. Indeed, it may be questioned whether Galt's description really fits this picture; there is only one boat, for instance, and it is relatively inconspicuous. That a good proportion of the landscapes of the Colonial period showed river scenes seems likely, since such pictures were specifically mentioned in Emmons' obituary and rivers were a stock device in portrait backgrounds.

7. That landscape views, as opposed to representations of cities, were only engraved at the end of the Colonial period does not mean that they were not painted at an earlier date. A representation of a familiar valley, or one of the 'perspective views of gentlemen's estates' so often advertised, would find a local purchaser, but would not interest a large number of people. Before American scenery could become popular, good roads were necessary. That great natural wonder, Niagara Falls, was, it is true, engraved when only a few people had seen it, but less flamboyant subjects had to be familiar before they could achieve a large sale. During most of the Colonial period people normally traveled from city to city by sea. Perhaps it is not a coincidence that many Colonial views show the land as it appeared from the water.

8. In 1735 and 1737, Bishop Roberts advertised many kinds of painting in the *South Carolina Gazette*. The *View of Charleston* is his only known picture. After his death in about 1740, his wife, Mary Roberts, carried on his business.

9. Christian Remick was born at Eastham, Massachusetts, in 1726. A sailor, who became a master mariner, he served on privateers during the Revolution. He was alive in 1783, when his father died, but that is our last reference to him. It is an interesting comment on nationalism at the time of the Revolution that when Remick advertised his depictions of the landing of the British troops, he wrote himself down, not as an American, but as 'late of Spain.' He clearly thought that a foreign address would contribute to his prestige as an artist. Let us remember that even if an artist boasted in his advertisements of a European connection, he might really be native born.

10. The drinking scenes, amusingly enough, have survived in some quantity because they took on the nature of portraits.

[313]

Usually, each tippler is identified, either on the picture or by 'family tradition.'

CHAPTER EIGHT

1. As will be pointed out in Chapter Eleven, West's development was exceptional in many particulars. Thus we may not assume that his biography was typical of Colonial painters.

2. The date at which *The Journal of Llewellyn Penrose* was written, as well as the question whether it was finished in England or America, has been discussed by this writer in his article *The Amazing William Williams* (see reference notes).

3. In his novel, Williams wrote: 'There were here two sorts of lizards, with which I was at times greatly amused. One of these frequented the rocks above high water mark, and contrary to all others I have seen, had their tails in curls on their backs. They were of a yellow brown, beautifully mottled with dark spots, and carried their heads quite erect, like little dogs; and they were seldom above five inches in length. Being acquainted with their manners, many times have I seated myself to watch them. First, three or four of them would come round me, look me in the face, and if I began to whistle, would first turn their heads to one side, and then to other, and listen very attentively; yet if I offered to stir, they were so alert as to be off in a moment. I could never, by any contrivance, catch one of them alive.'

4. See Chapter Seven.

CHAPTER NINE

1. Although it is clear that Copley's birthday was July 3, some writers give the year as 1737, some as 1738. In using the later date, I am following what seems to be the most authentic evidence, a letter from the artist himself, dated September 12, 1766, in which he states that he was then twenty-eight years old. All the evidence pointing to the year 1737 is based on documents written after

Copley's death. For a complete discussion of this matter, as well as the fate of Copley's father, see Foote's article, 'When was Copley Born?' in the *New England Quarterly*, 1937. That he was born in America is implied in all known documents, including the artist's own letters.

2. While a portrait of a famous Londoner could be sold all over England, a famous Bostonian would hardly be known in Philadelphia. Similarly, few Colonial scenes or events had much meaning outside of their immediate geographic region. More unity of interest, more effective lines of communication, were needed before the Colonies could support engravers.

3. *L'Affaire Welsteed* is one of the most heated controversies in the field of early American painting; over it friendships have been lost and reputations dangled in the balance. No one denies the authenticity of the engraving with its inscription: 'J. S. Copley Pint et fecit.' The trouble is caused by a painting in the Massachusetts Historical Society which, although not identical, is so close to the print that it might well be the canvas from which it was taken. In their book on Copley, which has made so many important contributions to scholarship, Barbara Neville Parker and Anne Bolling Wheeler point out that there are records of another early portrait of Welsteed which has been lost. This, they argue, must have been the original for the engraving, because X-rays of the existing painting show that 'the brush-strokes are not Copley's. Secondly, the engraving and the oil are not the same.' Since Welsteed died two years before Copley's engraving was published, the authors suggest that Copley, unable to draw from life, used the existing portrait as a source for his own painting from which he then made his print.

By postulating that the painting Copley made as a model for his engraving was a somewhat slavish copy of a painting by another hand, the authors attempt to explain the differences in composition between the Welsteed print and such oil paintings as the *Manns*. Yet we cannot escape the fact that Copley was willing to publish as his own work a product sharply at variance with what we now regard as his early manner. Whether in his search for a personal style, the youngster might not have varied his brush strokes as well, and thus be the author of the Massachusetts Historical

Society portrait, is a question that is extremely difficult to answer with any finality. Until further evidence is unearthed, the line of caution is perhaps to follow Parker and Wheeler in questioning the painting. I am not convinced that we can altogether rule it out as a work by Copley. The authors have been unable to attribute it to any other Boston painter.

4. Burroughs and Hagen both state that after a little while Copley became the teacher and Blackburn the pupil. In support of this theory, they state that Blackburn's later American work shows a greater plasticity than his earlier. Thus Copley, so Hagen writes, 'was the first artist in America who molded the style of an English painter in the American tradition.'

It seems to me that the point can only be demonstrated by making a selection from Blackburn's pictures, fixing on the least plastic of his early work and the most plastic of his later. An over-all summary of Blackburn's output, such as is made possible by the file of photographs at the Frick Library, indicates that Blackburn varied in plasticity from picture to picture, moving through the same range during all his American years. I can see no certain progression. And never did the English artist take the problem as seriously as Copley was already beginning to do before Blackburn reached Boston. Such portraits as *Mrs. Jonathan Simpson,* which is cited as Blackburn's high point in plasticity, have depth from the near shoulder to the far side of the neck. The rest of the bodies are lost, giving them a curious on-the-half-shell effect. Till the end of his American career, Blackburn was an artist of formula who studied nature only at second hand.

We have no certain evidence about Blackburn's life before he turned up in Bermuda during 1752, although a word-of-mouth 'family tradition' states that he had come from England. Such gaps in knowledge open the way for speculation. In a history of Connecticut art published in 1879, H. W. French suggested most tentatively that Jonathan (*sic*) Blackburn might have been son and pupil to Christopher Blackburn, described as an itinerant Connecticut face-painter. This theory, long considered discredited, has recently been revived by that outstanding expert on English art, C. H. Collins Baker. His argument runs that since Blackburn was a more primitive artist than the leading London practitioners, it is logical

to regard him as an indigenous American product. But when Mr. Baker asks whether Blackburn's earliest known work is 'more in line with primitive American portraiture, or more consistent with the actual London tradition of Jonathan Richardson and Thomas Hudson,' he is leaving out a third alternative which is probably the right one. Indeed, Mr. Baker seems to have fallen into the age-old pitfall of English art scholarship, the assumption that there was no place in England but London, and no place in London but the court. He has not considered the possibility that Blackburn was a provincial English workman. There can be no doubt that the painter's style had little if any relationship to the Connecticut work of the previous generation. We must, however, thank Mr. Baker for correcting the tendency of American scholars to make Blackburn a pupil of Hudson's, and for cogent comments on the work of other New England artists of the time.

5. Research into early American pastel work has been almost completely ignored. Major discoveries may lie in wait for the scholar who will undertake the necessary explorations.

6. Copley was to write Benjamin West in 1766, 'I shall be glad [if] when you write me next you will be more explicit on the article of crayons, and why you disapprove the use of them, for I think my best portraits [are] done in that way.' It is hard to agree with this evaluation. Copley's pastels are agreeably colored and decorative; they show virtuosity in the depiction of textures; yet they lack the rock-ribbed strength that makes his oil paintings really great. Probably they were a pleasure to make, because they allowed the artist to escape from the convolutions of his temperament into something that approached facility. But this was not really an advantage. As Copley wrote on another occasion, his pictures were almost always good in proportion to the amount of time he spent on them.

CHAPTER TEN

1. From Copley's correspondence we infer that he had access during his American years to the following books on art (no editions are specified; page numbers refer to the *Copley-Pelham Letters*):

(a) Du Fresnoy, Charles Alphonse, *De Arte Graphica*, almost certainly in translation (p. 170). (b) De Piles, Roger, *The Art of Painting* (p. 170). (c) Walpole, Horace, *Anecdotes of Painting in England* (p. 171). (d) Webb, Daniel, *An Inquiry into the Beauties of Painting* (p. 303). (e) A book of engravings of antique statues accompanied by their measurements (p. 338). (f) A volume of engravings after Italian masters (p. 245).

Copley's own art collection contained: (a) A painted figure of Diana (pp. 240-41). (b) Some drawings by Albonius in bister (p. 246). (c) A group of 'Academy figures' on paper. Two of these, one showing a man pulling on a rope, were much in Poussin's manner (pp. 246, 339). (d) A picture representing 'a lady in car of shepherd or nymph' (p. 299). (e) Raphael's cartoons (p. 299). (f) A small head of Saint John. Copley was to write from Parma in 1775 that it was a detail from a *Holy Family* by Titian in the palace of the Grand Duke of Tuscany. 'Its general effect [is] just what Titiano is. Perhaps it may have been an original sketch by Titian for the picture' (pp. 340-41). (g) In 1771, Copley sold a 'Dutch picture' for half a guinea (p. 125).

In trying to describe European art in his letters from abroad to Henry Pelham, Copley mentioned the following paintings or engravings that were available in Boston: (a) Smibert's copies of Van Dyck's *Cardinal Bentivoglio*; Poussin's *Scipio*; Raphael's *Holy Family*; and Titian's *Venus and Cupid*. (See Chapter Five, note 3.) (b) 'Mrs. Sidley's picture at Captain Phillips', which, by the way, I believe the face to be painted by Van Dyck's hand by what I have seen here' (p. 240). (c) Some prints after paintings by Rubens at the Luxembourg Gallery (pp. 249-50). (d) A painting of 'Pan and Sirinks at Mr. Chardon's.' Related to Rubens (p. 250). (e) A head of (or by) Van Dyck at Mrs. Hancock's, which gave an idea of Rubens's flesh tones but was too raw in color (pp. 250-51). (f) Prints after Raphael belonging to Mr. Greenleaf (p. 299). (g) 'A little Jesus in the Madonna's lap' at Mr. Chardon's. Painting (p. 334). (h) An engraving of a Titian *Venus* at Florence. Copley also mentions a copy of this picture by West, but, since he is not sure Pelham has seen it, it may have been sent to Boston after Copley's departure (p. 333).

In 1771, Copley made a trip to New York, where he saw: (a)

Statues of the King and Pitt. 'I thought them both good statues' (p. 117). (*b*) Two portraits by West (p. 126). (*c*) A miniature of Governor Martin by Miers (p. 134).

Traveling on to Philadelphia, he saw at William Allen's 'a fine copy of the Titiano *Venus*; and [a] *Holy Family* as large as life from Correggio; and four other half-lengths of single figures as large as life: one a *Saint Cecilia*, an *Herodias with John Baptist's Head, Venus Lamenting over the Body of Adonis,* and I think a *Niobe,* I cannot be certain.' The copies after Titian and Correggio were a revelation to him in their use of color. 'On our return we saw several pictures at Brunswick. I have no doubt they are by Van Dyck. The date is 1628 on one of them. They were painted in Holland.' Copley's willingness to venture attribution is amusing when we recall that his familiarity with Van Dyck's work was based on written descriptions. Connoisseurship was easy in those days!

2. There is evidence that toward the end of Copley's American career, Henry Pelham helped him with his pictures, probably painting in the backgrounds.

3. That the social position of silversmiths was much less high in England than in America is shown by Fanny Burney's best-selling novel *Evelina* (1778) in which she casts her vulgar, bourgeois upstart as a silversmith.

4. In the 1770's, Joseph Wright of Derby exhibited at the Society of Artists (but not at the Royal Academy which had then been founded) paintings of blacksmiths' shops and iron forges.

5. Copley, of course, was a much more skillful painter than West had been when he left Philadelphia. However, this does not destroy our argument, since even Copley could have worked in a style more in keeping with fashionable British canons.

6. Copley's analysis of the attitude of the Bostonians refers, of course, to that part of society from which his clients came. This did not include the burly apprentices and stevedores who made up Sam Adams' 'trained mob,' but it did include Sam Adams. A statistical analysis of Copley's sitters shows that they were divided about evenly between Whigs and Tories. Although, as we look back through the mist of years, it seems that the Loyalists and the Revolutionaries were sharply divided, at the time the lines of

[319]

division were neither clear nor rigid. Many a man agreed in part with both groups, and took his eventual position behind the barricades only after long soul-searching, and perhaps because of the expediency of the moment. Copley's own position was, as we shall see, non-partisan. Henry Pelham objected to the early invasions of the rights of the General Assembly; he made an engraving of *The Boston Masacre*; but in the end he sided with the Tories.

7. The case of Benjamin West, who had remained in London to become world-famous, undoubtedly influenced this point of view.

CHAPTER ELEVEN

1. It is true that after an artist achieved a local reputation, some owners of pictures sometimes invited him to admire their possessions, or even sent him old paintings to restore. This haphazard method was, of course, no substitute for an art museum or an annual exhibition which artists could visit at will. Even today, when windows are large and electricity gives a thousand times the radiance of candles, it is usually very difficult to get enough light to study a picture hung on a private wall. Paintings have to be taken down if they are to be examined to any purpose, a maneuver which rarely finds favor with the housewife.

2. If writers are correct in identifying him with the Robert Feke who was born in Oyster Bay, Feke, the painter, was the son of a landowner who was a semi-professional preacher. He would thus have been born into the gentry, and be an exception to the rule I have just propounded. However, the painter's Oyster Bay origin has not been proved.

3. Several painters, in addition to Peale, returned from European studies before the Colonial period ended. They include: Matthew Pratt (1734-1805, returned 1768); Henry Benbridge (1744-1812, returned 1770); and Abraham Delanoy (*c*. 1740-*c*. 1786, returned 1767). Since in every case their most interesting work was done after their foreign excursions, I shall not discuss them in this volume.

4. Whatever may have been the situation in regard to folk tunes,

printed European compositions filled the Colonials' self-conscious
musical needs so well that when Francis Hopkinson (1737-91), who
was also an amateur poet and painter, published his *Seven Songs
for the Harpsicord* in 1788, he was able to claim that he was 'the
first native of the United States who has produced a musical com-
position.'

The sculpture of Colonial America is a field wide open for study,
yet the major outlines seem clear. Although early gravestone-cut-
ters created majestic monuments, the style deteriorated in the
eighteenth century as a growing worldliness made death less an
apotheosis than an unfortunate fact to be ignored. Wood-carvers
fashioned figureheads and other ship decorations in the early
eighteenth century, but no examples have been identified that pre-
date the Revolution, and the first carver known to have extended
his trade to the making of statues was William Rush (1756-1833),
whose preserved work falls in the Federal period. The architec-
tural carving that became increasingly popular throughout the
eighteenth century does not seem to have fostered independent
monuments.

Sculpture was not in these days an intimate art. No Englishman
or American would have commissioned his daughter's head in
marble for the mantelpiece. (Miniatures were made in wax, but
that is another story.) The order of the day was heroic statues of
the temporal great to be used as public monuments. Up until the
Revolution, the persons considered grand enough for such depic-
tion were not the little Colonial governors who came and went, nor
yet rich merchants whose battlefield was the counting-house. Even
American generals, like the victors of Louisburg, never aspired to
anything more impressive than full-length portraits. American
statues represented English kings or English statesmen. Since
these towering figures never set foot on American soil, it was only
logical to have their likenesses made abroad. The statues of
George III and Pitt that Copley admired in New York were by
the official royal fashioner of monuments, Joseph Wilton (1722-
1803). The rise of American sculpture had to await the rise of
indigenous heroes.

5. It is, of course, impossible to state accurately what part of
the earnings of such artists as Badger or Blackburn came from

painting pictures. However, the proportion would not have to be very high to put them in the same economic position as many of our best contemporary painters. During 1944, America's leading artists made only twenty-seven per cent of their income from the sale of art.

6. In my 'New Bottles for Old Wine; American Artisan, Amateur, and Folk Painting,' in *Antiques* (New York, XLI, 1942, pp. 246-49), I pointed out that a major difference between the Colonial portrait painters and the so-called 'primitive' portraitists of the nineteenth century was that the former were the leading artists of their place and time, while the latter worked for the poorer classes in the same environment which supported artists both more prosperous and more conventionally skilled.

Bibliography of General Sources

THIS BIBLIOGRAPHY lists important publications that deal with American Colonial painting in general. I have followed each reference with a few sentences in which I have attempted to characterize the book in a manner that will increase its usefulness to non-specialists.

Monographs on individual artists will be cited in the *Source References*. I have not attempted to annotate such references, since the task would require a volume in itself, and since I assume that these specialized studies will primarily be used by scholars who are familiar enough with the field to make their own evaluations.

Art in America from 1600 to 1865; An Illustrated Guide for a National Radio Broadcast. Chicago, 1934. An excellent brief summary.

Balch, Edwin Swift, *Art in America Before the Revolution; Address before the Society of Colonial Wars in the Commonwealth of Pennsylvania.* N.p. 1908. This brief account amazingly well-informed for its date, and contains odd bits of information (or misinformation).

Barker, Virgil, *A Critical Introduction to American Painting.* New York, 1931. The short section on Colonial painting in this pamphlet is full of interesting ideas and conclusions, although somewhat marred by the acceptance as key pictures of canvases no longer considered valid.

Bayley, Frank W., *Five Colonial Artists of New England.* Boston, 1929. A picture book dealing with Badger, Blackburn, Copley, Feke, and Smibert. Useful, but all the attributions may not be accepted without question.

Bayley, Frank W., *Little Known Early American Portrait Painters,* nos. 1-4. Boston, n.d. These little pamphlets, although brief and out of date, sometimes contain bits of information about obscure painters that cannot be found in more obvious sources.

Bolton, Charles Knowles, *Portraits of the Founders,* 3 vols. Boston, 1919-26. This valuable reference book lists portraits of individuals who came to America before 1701. The illustrations are often cut down to show only the face, while little attempt is made to identify artists or check traditional attributions.

[323]

Burroughs, Alan, *Limners and Likenesses*. Cambridge, Massachusetts, 1936. Giving more space to Colonial painting than any other general history, this volume is detailed and provocative, yet many of its judgments are open to question. In later publications, Mr. Burroughs has revised some of them.

Dow, George Francis, *The Arts and Crafts in New England, 1704-1775*. Topsfield, Massachusetts, 1927. An invaluable compendium of advertisements and articles published in early newspapers.

Dunlap, William, *History of the Rise and Progress of the Arts of Design in the United States*, 2 vols. New York, 1834. This is the basic source for American art between 1760 and 1830. Dunlap collected much material about West and Copley; he was familiar with the reputation of John Watson; he discussed Smibert. Concerning other Colonial painters he secured little, if any, information. The limitations of his monumental work remained the limitations of all histories of American art until well into the twentieth century, when at last scholars undertook independent investigations into the beginnings of our painting. A new edition, edited with additions by Frank W. Bayley and Charles E. Goodspeed, was published in three volumes (Boston, 1918). The book was slightly cut and the editors' additions, although often of great value, are sometimes inaccurate. Unless otherwise stated, the page references I give are to the original edition.

Fielding, Mantle, *Dictionary of American Painters, Sculptors, and Engravers*. Philadelphia, 1926. A useful biographical dictionary, in need of revision.

Flexner, James Thomas, *America's Old Masters*. New York, 1939. Accounts of West, Copley, Stuart, and Charles Willson Peale.

Frick Art Reference Library. The files of this institution constitute the most important single source on American Colonial painting. Photographs of almost all early portraits and of many early subject pictures may be found there, glued to mounts on the back of which is epitomized what is known about the pictures. Often the opinions of experts like William Sawitzky are given. The Frick Library also possesses a full collection of books dealing directly with American painting.

Gottesman, Rita Susswein, *The Arts and Crafts in New York, 1726-1776*. New York, 1938. An invaluable compendium of advertisements and articles in newspapers.

Hagen, Oskar, *The Birth of the American Tradition of Art*. New York and London, 1940. A student of European art, Mr. Hagen discusses the beginnings of American painting on a basis of theory; he tends to ignore factual scholarship. Unfortunately, the field is not well enough cultivated to permit of this approach. Only in the few cases when the

[324]

material available to him was both voluminous and sound are his conclusions valid. His tendency to break with historical reality was further encouraged by his desire to prove a thesis, namely, that American art, in contradistinction to British, was downright, direct, democratic. Documents and pictures were accepted or rejected in relation to their value in proving this assumption. There are some good passages in this book, but it cannot be recommended to readers who are not familiar enough with the field to separate Mr. Hagen's sheep from his goats.

Isham, Samuel, *The History of American Painting*. New York, 1905. Although a generation old, this book remains the best one-volume history of American painting. It is, however, quite inadequate on the Colonial period, since the author made use of few other sources than Dunlap.

La Follette, Suzanne, *Art in America*. New York and London, 1929. Miss La Follette's account of the Colonial period is interesting and closely reasoned, although in need of revision and expansion to bring it up to date.

Lee, Cuthbert, *Early American Portrait Painters; The Fourteen Principal Earliest Native-Born Painters*. New Haven, 1929. Agreeable essays on painters active during the three quarters of a century after 1740. The illustrations are of very high quality.

Mather, Frank Jewett, Jr., 'Colonial Portraiture,' in *The Pageant of America*, XII, pp. 4-15. New Haven, 1927. This brief introductory account contains interesting comment and many illustrations, but is marred by the reliance on the dubious attributions so rife in the 1920's.

Morgan, John Hill, *Early American Painters, Illustrated by Examples in the Collection of the New-York Historical Society*. New York, 1921. This useful book refers specifically, but not exclusively, to New York painters.

New Jersey Historical Records Project, Works Progress Administration, *1440 Early American Portrait Artists*. Newark, 1940. Compiled under the direction of George C. Groce, Jr., this mimeographed biographical dictionary is of the greatest value, although readers must be warned to look out for misprints. The New-York Historical Society is engaged in enlarging and correcting this work for eventual publication in ordinary book form.

Philadelphia Museum of Art, *Catalogue of Exhibition of Portraits by Early American Artists . . . Collected by Thomas B. Clarke*. Philadelphia, 1928. Although the Clarke Collection contained many fine pictures, others of dubious authenticity have been the most fertile

[325]

single source of error in the field of early American painting. As William Sawitzky and others have pointed out, pictures which have passed through this collection, especially if they are signed and dated, should be carefully checked before they are accepted at face value.

Prime, Alfred Cox, *The Arts and Crafts in Philadelphia, Maryland, and South Carolina, 1721-1785.* The Walpole Society, 1929. An invaluable compendium of gleanings from newspapers.

Saint Gaudens, Homer, *The American Artist and his Times.* New York, 1941. A pot-pourri of information, misinformation, theory, and dogmatism that makes amusing reading, but has little scholarly value.

Sawitzky, William, *Lectures Delivered at the New York University School of Fine Arts, 1940-1941.* Unpublished. Mr. Sawitzky is the most distinguished student of early American painting. I had the privilege of attending his lectures, which did much to guide me through the confusions surrounding our earliest art. Should Mr. Sawitzky decide to publish the lectures, they would instantly take first rank among basic studies. He is the author of many monographs on individual artists which are referred to in the *Source References.*

Sherman, Frederic Fairchild, *Early American Painting.* New York, 1932. This work is largely based on paintings whose authenticity is now questioned.

Wehle, Harry B., *American Miniatures, 1730-1850, with a Biographical Dictionary of the Artists by Theodore Bolton.* New York, 1927. A useful reference work.

Source References

THE SOURCE REFERENCES to the body of the book are placed in the order in which the material is discussed. Among them are distributed references to the statements in the *Notes* placed in a position equivalent to the position where the note elucidates the main text. Every reference is identified by a brief phrase in capitals.

Publications listed in the *Bibliography of General Sources* are referred to thus: 'La Follette, *op. cit.*, general, p. 62.'

CHAPTER ONE

JACQUES LE MOYNE AND JOHN WHITE: Le Moyne, Jacques, *Brevis Narrato; De Bry's Large Voyages, Part II* (Frankfort, 1591). Le Moyne, Jacques, *Narrative of Le Moyne* (Boston, 1875). Hariot, Thomas, *Admando Narration . . . Virginae; De Bry's Large Voyages, Part I. Illustrated by John White* (Frankfort, 1590). Camus, A. G., *Mémoire sur la Collection des Grandes et Petites Voyages* (Paris, 1802). Binyon, Lawrence, 'The Drawings of John White,' in *Thirteenth Volume of the Walpole Society* (1925). Many of White's original drawings are in the British Museum.

SEVENTEENTH-CENTURY NEW ENGLAND PAINTING IN GENERAL: The basic source is Dresser, Louisa, editor, *Seventeenth-Century Painting in New England* (Worcester, Massachusetts, 1935). See also Burroughs, *Limners and Likenesses, op. cit.*, general, pp. 8-18; Hagen, *op. cit.*, general, pp. 14-24.

EARLY NEW ENGLAND HOUSES, FURNITURE, DECORATION: There is a flood of books on this subject. I have found most useful: Dresser, *op. cit.*, pp. 14-16. La Follette, Suzanne, *op. cit.*, general, pp. 2-36. Lockwood, Luke Vincent, *Colonial Furniture in America* (New York, 1901). Singleton, Esther, *The Furniture of Our Forefathers* (New York, 1901).

EARLY NEW ENGLAND ECONOMY: Weedon, William Babcock, *Economic and Social History of New England, 1620-1789* (Boston, 1890), 2 vols.

[327]

FREAKE LIMNER: Dresser, *op. cit.*, see index. Burroughs, *op. cit.*, pp. 10-11. Hagen, *op. cit.*, pp. 15-16, 18-19, 24.

MASON LIMNER: Dresser, *op. cit.*, see index. Burroughs, *op. cit.*, pp. 9-10, 18.

ENGLISH PROVINCIAL PAINTING: Singh, Frederick Dunleep, *Portraits in Norfolk Houses* (Norwich, n.d.) 2 vols. Farrer, Rev. Edmund, *Portraits in Suffolk Houses (west)* (London, 1908).

JOHN FOSTER: Dresser, *op. cit.*, see index. Green, Samuel Abbott, *The Earliest American Engraver and First Boston Printer* (Boston, 1909).

THOMAS SMITH: Dresser, *op. cit.*, see index. Burroughs, *op. cit.*, pp. 12-16, 24. Dexter, Orrando Perry, *Dexter Genealogy* (New York, 1904), pp. 36-37, 63-65. Account book of treasurer of Harvard University, June 2, 1680.

PURITAN CULTURE: Morison, Samuel Eliot, *The Puritan Pronaos* (New York, 1936). For the opposite point of view see La Follette, *op. cit.*, pp. 4-6.

MATHER QUOTATION: Mather, Cotton, *Magnalia Christi Americana* (Boston, 1855), I, p. 320.

LAMBS IN A LARGE PLACE: Quoted Weedon, *op. cit.*, I, p. 71.

WIGGLESWORTH QUOTATION: Morison, *op. cit.*, p. 159.

COTTON QUOTATION: Weedon, *op. cit.*, I, p. 70.

MORTUARY ART IN GENERAL: Forbes, Harriette Merrifield, *Gravestones of Early New England* (Boston, 1927). Forbes, Harriette Merrifield, letter to author, Worcester, Massachusetts, September 2, 1945. Sewall, Samuel, *Diary* (Boston, 1878-82), I, pp. 203, 470-71; III, pp. 43-44, 249. Waters, Thomas Franklin, *Ipswich in the Massachusetts Bay Colony* (Ipswich, 1917), pp. 59-60. Clark, Hermann Frederick, and Foote, Henry Wilder, *Jeremiah Dummer* (Boston, 1935), p. 105.

THOMAS CHILD: Dresser, *op. cit.*, see index. Coburn, Frederick W., 'Thomas Child, Limner,' in *Magazine of Art*, XXI, 1930, pp. 326-28. Sewall, *op. cit.*, I, p. 204; II, p. 170.

JAMES TURNER: Stauffer, David McNeely, *American Engravers upon Copper and Steel* (New York, 1907), I, pp. 278-79; II, p. 289. Whitmore, William H., *Notes Concerning Peter Pelham . . . and his Successors Prior to the Revolution* (Cambridge, Massachusetts, 1867), pp. 24-25.

EDWARD PEEL: Porter, Edward Griffin, *Rambles in Old Boston* (Boston, 1887), p. 327.

JOHN GIBBS: Dresser, *op. cit.*, p. 19.

THOMAS JOHNSTON: *Dictionary of American Biography.* Dow, *op. cit.*

[328]

general, pp. xix, 8-9, 28-31, 298. Whitmore, *op. cit.*, pp. 25-26.
Stauffer, *op. cit.*, I, p. 144; II, pp. 251-53.
JOHN GORE: Dow, *op. cit.*, pp. 239-43.

CHAPTER TWO

THEORY OF INTERNATIONAL ARISTOCRATIC PORTRAITS: Nisser, Wilhelm, *Michael Dahl and the Contemporary Swedish School of Painting in England* (Uppsala, 1927), pp. iv-li.

KILBRUN: Advertisement from *The New-York Gazette and Weekly Post-Boy*, May 13, 1754; quoted in Gottesman, *op. cit.*, general, p. 3. Hastings, Mrs. Russel, 'Note on Kilbrun,' in *New York Genealogical and Biographical Record*, LXXII (1941), p. 285.

ENGLISH COURT PAINTERS: Baker, Charles Henry Collins, *Lely and Kneller* (New York, 1922). Baker, Charles Henry Collins, *Lely and the Stuart Portrait Painters* (London, 1912), 2 vols. Whitley, William T., *Artists and Their Friends in England, 1700-1799* (London and Boston, 1928), vol. 1.

EARLY EIGHTEENTH-CENTURY NEW ENGLAND PORTRAITS IN GENERAL: Dresser, Louisa, editor, *Seventeenth-Century Painting in New England* (Worcester, Massachusetts, 1935). Clarke, Hermann Frederick, and Foote, Henry Wilder, *Jeremiah Dummer* (Boston, 1935). Burroughs, *op. cit.*, general, pp. 20-26.

JOSEPH ALLEN: Dresser, *op. cit.*, pp. 18-19.

DUMMER: Clarke and Foote, *op. cit.* Dresser, *op. cit.*, pp. 70-73, 75, 175-76, 178-80.

LAWRENCE BROWN: Dresser, *op. cit.*, p. 19.

PIERPONT LIMNER: Dresser, *op. cit.*, p. 115. *Catalogue of American Portraits in the New York Historical Society* (New York, 1941), p. 133. Clarke and Foote, *op. cit.*, pp. 193-94.

EMMONS: Obituary in *New England Journal*, May 27, 1740, quoted in Dow, *op. cit.*, general, pp. 1-2. Sewall, Samuel, *Diary* (Boston, 1878-1882), II, p. 120. Bayley, *Little Known*, *op. cit.*, general, no. 2.

J. COOPER: Cowdrey, Bartlett, 'J. Cooper — An Early New England Portrait Painter,' in *Panorama* (Harry Shaw Newman Gallery, New York, 1945), I, pp. 15-19.

ELISHA COOKE: Clarke and Foote, *op. cit.*, pp. 167-68.

WILLIAM STOUGHTON: Dresser, *op. cit.*, pp. 141, 144-47, 176.

POLLARD, LIMNER: Bolton, Charles Knowles, *Portraits of the Founders* (Boston, 1919-1926), II, pp. 447-48; III, p. 1058. Forbes, Esther, 'Americans at Worcester,' in *Magazine of Art*, XXXVI (1943), pp. 82-

89. Flexner, James Thomas, 'The Americanism of New England Painting,' in *Magazine of Art*, XXXVIII (1945), pp. 122-27.

CHAPTER THREE

BIRDS QUOTATION: Singleton, Esther, *Dutch New York* (New York, 1909), p. 18.

CLEANLINESS QUOTATIONS: Singleton, *op. cit.*, pp. 136-37.

ART COLLECTIONS: Singleton, *op. cit.*, pp. 102-06.

STUART QUOTATION: Flexner, *op. cit.*, general, p. 301.

BLOCK VIEW OF NEW AMSTERDAM: Stokes, I. N. Phelps, *The Iconography of Manhattan Island* (New York, 1915), I, pp. 138-39.

STUYVESANT LIMNER: *Catalogue of American Portraits in the New York Historical Society* (New York, 1941), pp. 228-29, 298, 301. (This book was edited by Donald Shelley with the advice of William Sawitzky.) Morgan, *op. cit.*, general, pp. 24-27.

HENRI COUTURIER: Morgan, *op. cit.*, p. 16.

STRYCKER: Information supplied by the Metropolitan Museum of Art.

EVERT DUYCKINCK I: Morgan, *op. cit.*, pp. 17-18.

GERRET DUYCKINCK: Morgan, *op. cit.*, pp. 28-31. *New York Historical Society*, *op. cit.*, pp. 93, 154, 247, 262. Hagen, *op. cit.*, general, pp. 35-38.

GERARDUS DUYCKINCK, SENIOR AND JUNIOR: Gottesman, *op. cit.*, general, pp. 15, 21, 24-25, 97, 102, 104, 129-30, 349, 354, 367. Morgan, *op. cit.*, pp. 18-19.

DUYCKINCK, EVERT III: Morgan, *op. cit.*, pp. 18-20, 34, 38. *New York Historical Society*, *op. cit.*, pp. 336, 644, 660, 764.

PROVOOST LIMNER: *New York Historical Society*, *op. cit.*, pp. 246-47. Bolton, *op. cit.*, general, III, pp. 805-06.

DU SIMITIERE QUOTATION: From the notes of Marshall Davidson, Metropolitan Museum.

NEHEMIAH PARTRIDGE: Dow, *op. cit.*, general, pp. 237, 302. Morgan, *op. cit.*, p. 21.

WATSON: Morgan, John Hill, *John Watson, Painter, Merchant, and Capitalist of New Jersey* (Worcester, Massachusetts, 1941). Morgan, John Hill, *Further Notes on John Watson* (Worcester, Massachusetts, 1943). Dunlap, *op. cit.*, general, pp. 18-21.

DE PEYSTER MANNER: Comstock, Helen, 'Some Hudson Valley Portraits,' in *Antiques*, XLVI (1944), pp. 138-40. *New York Historical Society*, *op. cit.*, pp. 78-79, 315-16.

PIETER VANDERLYN: Harris, Charles X., 'Pieter Vanderlyn, Portrait

Painter from 1719 to 1732,' in *New-York Historical Society Quarterly Bulletin*, V (1921), pp. 59-73. Hastings, Mrs. Russel, 'Pieter Vanderlyn: A Hudson River Portrait Painter (1687-1778),' in *Antiques*, XLII (1942), pp. 296-99. Gosman, Robert, *Life of John Vanderlyn*, manuscript in Collections of New York Historical Society.

PIETER SCHUYLER: I wish to thank John Davis Hatch, Jr., for calling this portrait to my attention.

VAN ALSTYNE PORTRAITS: *New York Historical Society, op. cit.*, p. 314. Hagen, *op. cit.*, p. 38.

CHAPTER FOUR

VIRGINIA PAINTING: Weddell, Alexander Wilbourne, *Virginia Historical Portraiture* (Richmond, Virginia, 1930).

LEE EXHIBITION: *Stratford: The Lees of Virginia and Their Contemporaries*, Catalogue of an exhibition, Knoedler Galleries, New York, April 29 to May 18, 1946.

WRITTEN DESCRIPTIONS OF SITTERS: Barker, *op. cit.*, general, p. 13.

HENRIETTA JOHNSTON: Keyes, Homer Martin, 'Coincidence and Henrietta Johnston,' in *Antiques*, XVI (1929), pp. 478, 490-94. Willis, Eola, 'The First Woman Painter in America,' in *International Studio*, LXXXVII (1927), pp. 13-20, 84. Willis, Eola, 'Henrietta Johnston, South Carolina Pastellist,' in *Antiquarian* (September, 1928), pp. 46-48. Wilson, Rev. Robert, 'Art and Artists in Provincial South Carolina,' in *Year Book of Charleston, 1899* (Charleston, n.d.), pp. 137-47.

KUHN: Pleasants, J. Hall, *Justus Englehardt Kühn, an Early Eighteenth-Century Maryland Portrait Painter* (Worcester, Massachusetts, 1937).

GUSTAVUS HESSELIUS: Brinton, Christian, *Catalogue of Gustavus Hesselius Exhibition at the Philadelphia Museum of Art* (Philadelphia, 1938). Hart, C. H., 'The Earliest Painter in America,' in *Harper's New Monthly Magazine*, XCIV (1898), pp. 565-70. Keyes, Homer Eaton, 'Doubts Regarding Hesselius,' in *Antiques*, XXXIV (1938), pp. 144-46.

SWEDISH PAINTING: Nisser, Wilhelm, *Michael Dahl and the Contemporary Swedish School of Painting* (Uppsala, 1927).

JOHN HESSELIUS: Bolton, Theodore, and Groce, George C., Jr., 'John Hesselius: An Account of his Life and the First Catalogue of his Portraits,' in *Art Quarterly*, II (1939), pp. 77-91. Sawitzky, William, 'Further Notes on John Hesselius,' in *Art Quarterly*, V (1942), pp. 340-41.

BRIDGES: Letter of William Byrd II to Colonel Alexander Spotswood, December, 1735, in *Virginia Magazine of History and Biography,* IX (1901-02), p. 235. Letter of William Gooch to his brother in England, May 6, 1725, in Coll. Colonial Williamsburg. Wehle, Harry B., 'A Portrait by Charles Bridges,' in *Bulletin Metropolitan Museum of Art,* XX (1925) pp. 197-200. Information from John Marshall Phillips, William Sawitzky, and J. Hall Pleasants. O'Donoghue, Freeman, *Catalogue of Engraved British Portraits Preserved in the Department of Prints and Drawings in the British Museum* (London, 1908), I, p. 106.

THEUS: Prime, *op. cit.,* general, pp. 10-11. Morgan, John Hill, 'Notes on Jeremiah Theus and his Portrait of Elizabeth Rothmahler,' in *Brooklyn Museum Quarterly,* XI (1924), pp. 46-54. Wilson, *op. cit.,* pp. 140-43.

SOCIAL ATTITUDE TOWARD ART: Curti, Merle, *The Growth of American Thought* (New York, 1943), pp. 80-81.

NEGRO PAINTERS: Dow, *op. cit.,* general, p. 6. Pleasants, J. Hall, *An Early Baltimore Negro Painter, Joshua Johnston* (Windham, Connecticut, 1940). Pleasants, J. Hall, *Joshua Johnston, the First American Negro Portrait Painter* (Baltimore, 1942).

CHAPTER FIVE

SMIBERT IN GENERAL: Bayley, Frank W., *Five Colonial Artists of New England* (Boston, 1929), pp. 335-437. Bolton, Theodore, 'John Smibert: Notes and a Catalogue,' in *Art in America,* XX (1933), pp. 11-15, 39-42. Burroughs, *op. cit.,* general, see index. Burroughs, Alan, 'Notes on Smibert's Development,' in *Art in America,* XXX (1942), pp. 109-21. Dunlap, *op. cit.,* general, I, pp. 21-31. Hagen, *op. cit.,* general, pp. 40-63. Isham, *op. cit.,* general, pp. 13-17. Perkins, Augustus J., 'Lists of Portraits by Smibert,' in *Proceedings, Massachusetts Historical Society,* XI (1878), pp. 392-99, 474-75; XII (1879), pp. 93-97. Walpole, Horace, *Works* (London, 1798), III, pp. 422-23. Walpole, Horace, *Anecdotes of Painting in England, 1760-95* (New Haven, 1937), V, pp. 58-60. Whitely, William T., *Artists and Their Friends in England, 1700-1799* (London and Boston, 1928), I, pp. 62-67.

STATE OF PAINTING IN ENGLAND: Rouquet, J. A., *L'Etat des Arts en Angleterre* (Paris, 1755), pp. 55-74.

BERKELEY'S POEM: Dunlap, *op. cit.,* I, p. 23.

POEM ON SMIBERT'S EXHIBITION: Foote, Henry Wilder, 'Mr. Smibert

[332]

Shows his Pictures,' in *New England Quarterly*, VIII (1935), pp. 14-28.

HAMILTON QUOTATION: Hamilton, Alexander, *Itinerarium* (St. Louis, 1907), pp. 139, 164.

SMIBERT'S COLLECTION OF PICTURES: Advertisements in *Boston News Letter*, May 15/22, June 5/12, 1735, quoted in Dow, *op. cit.*, general, p. 3. Flexner, *op. cit.*, general, pp. 182-83. Whitmore, William H., 'The Early Painters and Engravers of New England,' in *Proceedings, Massachusetts Historical Society* (1866), pp. 208-09. *Letters and Papers of John Singleton Copley and Henry Pelham* (Boston, 1914), pp. 240-41, 245, 250-51, 304, 340.

SMIBERT LETTERS: Smibert to Arthur Pond, Boston, July 1, 1743, and March 24, 1743/4, in 'Smibert-Moffat Letters,' in *Proceedings, Massachusetts Historical Society*, XLIX (1915), pp. 28-32.

ADVERTISEMENT RE SLAVE: *Boston Gazette*, October 3/10, 1737, in Dow, *op. cit.*, pp. 3-4.

NEPHEW'S LETTER: John Moffat to Arthur Pond, Boston, December 28, 1752, in 'Smibert-Moffat Letters,' *op. cit.*, pp. 32-33.

FANEUIL HALL: Brown, Frank C., 'John Smibert, Artist, and the First Faneuil Hall,' in *Old Time New England*, XXXVI (1946) pp. 61-63.

1749 SMIBERT LETTER: Whitely, *op. cit.*, p. 65.

NATHANIEL SMIBERT: Burroughs, Alan, 'Paintings by Nathaniel Smibert,' in *Art in America*, XXXI (1943), pp. 88-97. Obituary notices in: *Boston Gazette*, November 8, 1756, and May 2, 1757; *Boston News-Letter*, November 11, 1756; photostats in Frick Art Reference Library. Dunlap, *op. cit.*, I, p. 31.

VERTUE QUOTATION: Whitely, *op. cit.*, p. 63.

PATRICIAN ON SMIBERT: *Diary* of Edward Waldo (Boston, 1747), quoted in Robie, Virginia, 'Waldo Portraits by Smibert and Blackburn,' manuscript to be published in *The American Society Legion of Honor Magazine*.

CHAPTER SIX

FEKE IN GENERAL: The basic sources for both fact and theory concerning Feke are: (1) Poland, William C., 'Robert Feke, the Early Newport Portrait Painter,' in *Proceedings, Rhode Island Historical Society* (1904-05), pp. 73-96. This was the first attempt to collect material on Feke. (2) Foote, Henry Wilder, *Robert Feke, Colonial Portrait Painter* (Cambridge, Massachusetts, 1930). This book summarizes all known information about Feke. Mr. Foote has given the evidence

for all his statements so conscientiously and clearly that this writer, who disagrees with him on many details, has often based his disagreements on the documents Mr. Foote cites. (3) Bolton, Theodore, and Binsse, Harry L., 'Robert Feke, First Painter of the Colonial Aristocracy,' in *Antiquarian*, XV (October, 1930), pp. 33-37, 74, 76, 78, 80, 82. (4) Hagen, Oskar, *op. cit.*, general. In this book, the Feke legend loses all contact with reality, and floats off into a stratosphere of unrestrained theory.

HAMILTON QUOTATION: Hamilton, Alexander, *Itinerarium* (St. Louis, 1907), pp. 123-24.

ROYALL FAMILY INSCRIPTION: Quoted from back of mount, Frick Art Reference Library.

FEKE'S MARRIAGE: Foote, *op. cit.*, p. 48.

SAWITZKY ON WILLIAMINA MOORE: Statement on back of mount, Frick Art Reference Library, used here with the kind permission of Mr. Sawitzky.

DUNLAP ON MRS. CHARLES WILLING: Dunlap, *op. cit.*, general, I, p. 32.

SAWITZKY ON MRS. THATCHER: Quoted from back of mount, Frick Art Reference Library, with the kind permission of Mr. Sawitzky.

SMITH DIARY QUOTATION: Myers, Albert Cook, editor, *Hannah Logan's Courtship* (Philadelphia, 1904), p. 290.

DAUGHTERS' MARRIAGE: Foote, *op. cit.*, pp. 52-53.

DAWSON'S MAGAZINE CORRESPONDENCE: Quoted in full in Foote, *op. cit.*, pp. 111-13.

ROBERT, THE PREACHER, MENTIONED IN BOOKS: Flexner, *Robert Feke*, *op. cit.*, note 15.

CONTEMPORARY RECORDS OF OYSTER BAY ROBERT: Bolton and Binsse, *op. cit.*, p. 36.

HOW DATE OF FEKE'S BIRTH WAS DETERMINED: Foote, *op. cit.*, p. 30.

A ROBERT FEKE BORN IN BARBADOS: Foote, *op. cit.*, p. 116.

END OF FEKE'S LIFE: Foote, *op. cit.*, pp. 97-100, 114-17.

EARLY SELF-PORTRAIT: Foote, *op. cit.*, p. 33. Burroughs, *op. cit.*, general, p. 43. Bolton and Binsse, *op. cit.*, p. 76. Statement on back of mount, Frick Art Reference Library, quoted with permission of Mr. Sawitzky.

FLAGG PORTRAITS: Foote, *op. cit.*, pp. 146-47. Bolton and Binsse, *op. cit.*, p. 121.

PAMELA ANDREWS: Foote, *op. cit.*, p. 121. Bolton and Binsse, *op. cit.* p. 76.

MR. AND MRS. MARTIN: Foote, *op. cit.*, p. 164. Bolton and Binsse, *op. cit.*, p. 76.

FRANCIS PORTRAITS: Foote, *op. cit.*, pp. 38-39, 66, 69, 88, 90, 147-51. Bolton and Binsse, *op. cit.*, p. 82.

Mrs. McCall: Foote, *op. cit.*, pp. 39-40, 91, 165-66.

Fanciful Landscape: Statement on back of mount, Frick Art Reference Library, quoted with the kind permission of Mr. Foote.

Baby in Royall Family: Burroughs, Alan, *John Greenwood in America, 1743-1752* (Andover, Massachusetts, 1943), pp. 37, 60, 70.

Judgment of Hercules: Bridenbaugh, Carl, *Cities of the Wilderness* (New York, 1939), p. 460. Curti, Merle, *The Growth of American Thought* (New York, 1943), p. 110.

Smibert's Illnesses: See preceding chapter.

CHAPTER SEVEN

Emmons Obituary: *New England Journal,* May 27, 1740; quoted in Dow, *op. cit.*, general, pp. 1-2. See also Chapter Two of this book.

Fox and Spotswood Inventories: Stanard, Mary Newton, *Colonial Virginia, Its People and Customs* (Philadelphia and London, 1917), pp. 316, 318.

Checkley Pictures: *Boston Gazette,* October 24, 1754; quoted in Dow, *op. cit.*, p. 6.

Pictures of Game: Advertisement in *Boston News-Letter,* May 15, 1760; quoted in Dow, *op. cit.*, p. 6.

Advertisements in General: Dow, *op. cit.*, Gottesman, *op. cit.*, general. Prime, *op. cit.*, general.

Shores Advertisement: *Boston Gazette,* April 4/11, 1720; quoted in Dow, *op. cit.*, p. 14.

Winter Advertisement: *Pennsylvania Chronicle,* June 1, 1771; quoted in Prime, *op. cit.*, pp. 13-14.

Stevenson Curriculum: *South Carolina and American General Gazette,* November 18, 1774; quoted in Prime, *op. cit.*, pp. 9-10.

Badger Pictures: Dresser, Louisa, 'Attribution and Authenticity in American Painting,' in *Art in America,* XIII (1945), p. 196.

Nun by Copley: *Letters and Papers of John Singleton Copley and Henry Pelham* (Boston, 1914), pp. 71-72.

Rouquet Quotations: Rouquet, J. A., *L'Etat des Arts en Angleterre* (Paris, 1755), pp. 33, 92-93.

Early English Landscapes: Grant, Maurice Harold, *A Chronological History of Old English Landscape Painters in Oil from the XVIth Century to the XIXth Century* (London, n.d.), 2 vols.

West's Landscape: Sawitzky, William, 'The American Work of Benjamin West,' in *Pennsylvania Magazine of History and Biography,* LXII (1938), pp. 445-46. Dunlap, *op. cit.*, general, p. 40. Flexner,

James Thomas, 'The Amazing William Williams,' in *Magazine of Art*, XXXVII (1944), pp. 242-46, 276-78.

LANDSCAPE ATTRIBUTED TO WEST: Sawitzky, *op. cit.*, p. 446. Galt, John, *The Life, Studies, and Works of Benjamin West* (London, 1820), I, p. 26.

VAN DER DUNK QUOTATION: Singleton, Esther, *Dutch New York* (New York, 1909), p. 10.

WALPOLE QUOTATION: Dunlap, *op. cit.*, p. 28.

BISHOP ROBERTS: Prime, *op. cit.*, p. 8. Bowes, Frederick P., *The Culture of Early Charleston* (Chapel Hill, 1942), p. 109.

CHRISTIAN REMICK: Cunningham, Henry Winchester, *Christian Remick, an Early Boston Artist* (Boston, 1904).

PELHAM AND BOSTON MASSACRE: *Copley-Pelham Letters, op. cit.*, p. 83.

ROUPEL PICTURE: Owned by Dr. Hawkins Jenkins, Conway, South Carolina. I wish to thank Marshall Davidson for calling my attention to this picture.

GREENWOOD SEA CAPTAINS: Burroughs, Alan, *John Greenwood in America, 1745-1752* (Andover, Massachusetts, 1943), pp. 45, 47, 53, 61, 71.

PHILADELPHIA ADVERTISEMENT: Advertisement of Alexander Stewart in *Pennsylvania Journal*, July 13, 1769; quoted in Prime, *op. cit.*, p. 9.

HIGHMORE ON VANDERSTRAETEN: Whitely, William T., *Artists and Their Friends in England, 1700-1799* (London and Boston, 1928), I, p. 23.

WARWELL: Advertisement in *South Carolina Gazette and Country Journal*, January 21, 1766; quoted in Prime, *op. cit.*, p. 13.

WESTON ADVERTISEMENT: *Philadelphia Chronicle*, June 20, 1768; quoted in Prime, *op. cit.*, pp. 308-09.

WARNER HOUSE MURALS: Allen, Edward B., *Early American Wall Paintings, 1710-1850* (New Haven, 1926), pp. 21-25.

INVENTORY WITH EVALUATIONS: Quotation from notes of Marshall Davidson.

COPLEY PRICES: *Copley-Pelham Letters, op. cit.*, pp. 71, 112.

CHAPTER EIGHT

WEST'S CHILDHOOD: Galt, John, *The Life, Studies, and Works of Benjamin West . . . Composed from Materials Furnished by Himself* (London, 1820), I, pp. 1-25. Flexner, *op. cit.*, general, pp. 22-29; bibliography, pp. 318-20.

WILLIAM WILLIAMS: Williams, William, *The Journal of Llewellin Penrose, a Seaman* (London and Edinburgh, 1815), 4 vols.; new edition,

London, 1825. Sawitzky, William, 'William Williams, the First Instructor of Benjamin West,' in *Antiques,* XXXI (1937), pp. 240-42. Sawitzky, William, 'Further Light on the Work of William Williams,' in *New-York Historical Society Quarterly Bulletin,* XXV (1941), pp. 240-42. Flexner, James Thomas, 'The Amazing William Williams: Painter, Author, Teacher, Musician, Stage Designer, Castaway,' in *Magazine of Art,* XXXVII (1944), pp. 242-46, 276-78; bibliography of further sources, pp. 277-78.

WILLIAMS ON ART: *Penrose Journal* (1825 edition), *op. cit.,* p. 2.

WEST ON WILLIAMS: *Penrose Journal* (1825 edition), *op. cit.,* pp. vii-x. Galt, *op. cit.,* pp. 27-29. Flexner, *Old Masters, op. cit.,* pp. 30-32, 35-36. Flexner, *Williams, op. cit.*

WILLIAMS AND EAGLES: Eagles, John, 'The Beggar's Legacy,' in *Blackwood's Magazine,* LXVII (1855), pp. 251-72.

BYRON QUOTATION: Hutton, Stanley, *Bath and Bristol* (London, 1915), p. 178.

WILLIAMS ADVERTISEMENTS: *Pennsylvania Journal and Weekly Advertiser,* January 13, 1763; quoted in Prime, *op. cit.,* general, p. 13. *The New York Gazette and the Weekly Mercury,* May 8, 1769; quoted in Gottesman, *op. cit.,* general, p. 7.

WEST'S EARLY PROFESSIONAL CAREER: Sawitzky, William, 'The American Works of Benjamin West,' in *Pennsylvania Magazine of History and Biography,* LXII (1938), pp. 433-62. Sketch book in Coll. Historical Society of Pennsylvania. Flexner, *Old Masters, op. cit.,* pp. 29-41. Galt, *op. cit.,* pp. 27-90.

DEATH OF SOCRATES: Jordan, Francis, *The Life of William Henry of Lancaster, Pennsylvania* (Lancaster, 1910), pp. 26-33.

JOHN WOLLASTON: Bolton, Theodore, and Binsse, Harry Lorin, 'Wollaston, an Early American Portrait Manufacturer,' in *Antiquarian,* XVI (1931), pp. 30-33, 50, 52. Morgan, John Hill, 'Notes on John Wollaston and his Portrait of Sir Charles Hardy,' in *Brooklyn Museum Quarterly,* X (1923), pp. 2-11.

HOPKINSON POEM: *American Magazine,* I (1758), pp. 607-08.

PATRON'S LETTER: John Allen to D. Barclay & Sons, August 10, 1761, in Flexner, *Old Masters, op. cit.,* p. 48.

CHAPTER NINE

COPLEY'S AMERICAN CAREER, PRINCIPAL SOURCES: *Letters and Papers of John Singleton Copley and Henry Pelham, 1739-1776* (Boston, 1914).

[337]

Parker, Barbara Neville, and Wheeler, Anne Bolling, *John Singleton Copley, American Portraits in Oil, Pastel, and Miniature* (Boston, 1938). Flexner, *op. cit.*, general, pp. 101-42; bibliography, pp. 321-23. Important publications since this bibliography was made in 1939 are: Burroughs, Alan, 'Young Copley,' in *Art in America*, XXXI (1943), pp. 161-71. Hagen, *op. cit.*, general, pp. 85-107. Morgan, John Hill, *John Singleton Copley* (The Walpole Society, 1939). Parker, Barbara Neville, 'Problems of Attribution in Early Copley Portraits,' in *Bulletin Museum of Fine Arts, Boston*, XL (1942), pp. 54-57.

WIDOW COPLEY QUOTATION: Advertisement in *Boston Gazette*, July 12, 1748; quoted in Dow, *op. cit.*, general, p. 286.

DATE OF COPLEY'S BIRTH: *Copley-Pelham Letters, op. cit.*, p. 48. Foote, Henry Wilder, 'When Was John Singleton Copley Born?' in *New England Quarterly*, X (1937), pp. 111-20.

PETER PELHAM: Information from Miss Anne Allison. Whitmore, William H., *Notes Concerning Peter Pelham* (Cambridge, Massachusetts, 1867). Stauffer, David McNeely, *American Engravers upon Copper and Steel* (New York, 1907), I, pp. 206-08; II, pp. 406-10. Fielding, Mantle, *American Engravers upon Copper and Steel*, a supplement to Stauffer (Philadelphia, 1917), p. 212.

JOSEPH BADGER: Park, Lawrence, *Joseph Badger* (Boston, 1918). Park, Lawrence, 'Joseph Badger of Boston, and his Portraits of Children,' in *Old-Time New England*, XIII (1923), pp. 99-109. Bayley, Frank W., *Five Colonial Artists of New England* (Boston, 1929), pp. 5-49.

JOHN GREENWOOD: Burroughs, Alan, *John Greenwood in America, 1745-1752* (Andover, Massachusetts, 1943). Weitenkampf, Frank, *John Greenwood . . . with a List of his Etchings and Mezzotints* (New York, 1927). Burroughs, Alan, 'The Other Side of Colonial Painting,' in *Magazine of Art*, XXXV (1942), pp. 234-37.

L'AFFAIRE WELSTEED: Parker and Wheeler, *op. cit.*, pp. 237-38.

SUPPOSED PORTRAIT OF PETER PELHAM: Parker and Wheeler, *op. cit.*, pp. 151-52.

JOSEPH BLACKBURN: Park, Lawrence, *Joseph Blackburn . . . with a Descriptive List of His Works* (Worcester, Massachusetts, 1923). Morgan, John Hill, and Foote, Henry Wilder, *An Extension of Lawrence Park's Descriptive List of the Works of Joseph Blackburn* (Worcester, Massachusetts, 1937). Baker, C. H. Collins, 'Notes on Joseph Blackburn and Nathaniel Dance,' in *Huntington Library Quarterly*, IX (1945), pp. 33-47. Bolton, Theodore, and Binsse, Harry Lorin, 'An American Artist of Formula: Joseph Blackburn,' in *Antiquarian*, XV (November, 1930), pp. 50-53, 88, 90, 92. Perkins, Augustus T., 'Checklist of Portraits,' in *Proceedings, Massachusetts Historical Society*, XVI

(1878), pp. 385-92, 474-75; XVII (1879), pp. 93-94. French, Henry Willard, *Arts and Artists in Connecticut* (Boston, 1879), pp. 29-31.

LUXURY IN SEEING: Quoted in Hagen, *op. cit.*, p. 91.

COPLEY'S CHARACTER: Flexner, *op. cit.*, pp. 116-17, 121-22, 125.

NO EXAMPLES OF ART IN AMERICA: Copley to West, Boston, November 12, 1766, in *Copley-Pelham Letters, op. cit.*, p. 51.

COPLEY'S PASTELS: Copley to Jean Etienne Liotard, Boston, September 30, 1762; Copley to West, Boston, November 12, 1766; Copley to R. G. Bruce, *circa* January 17, 1768; in *Copley-Pelham Letters, op. cit.*, pp. 26, 51, 70.

CHAPTER TEN

TRUMBULL ON COPLEY: Trumbull, John, *Autobiography* (New York, London, and New Haven, 1841), p. 11.

COPLEY'S STUDIO: Copley to Thomas Ainslie, Boston, February 25, 1765, in *Copley-Pelham Letters, op. cit.*, p. 33.

COPLEY'S METHOD OF PAINTING: Dunlap, *op. cit.*, general, pp. 125-26.

PICTURES GOOD IN PROPORTION TO AMOUNT OF TIME SPENT: Copley to Bruce, *c.* January 17, 1768, in *Copley-Pelham Letters, op. cit.*, p. 70.

CHILD'S CRITICISM: Thomas Ainslie to Copley, Quebec, November 12, 1764; Copley to Ainslie, Boston, February 25, 1765; in *Copley-Pelham Letters, op. cit.*, pp. 30, 33.

COPLEY ON ADVANTAGES OF EUROPEAN TRAINING: Copley to West, Boston, November 12, 1776, in *Copley-Pelham Letters, op. cit.*, p. 51.

COPLEY ON GLORIES OF ART: Copley to Charles Willson Peale, Boston, December 17, 1770; Copley to John Greenwood, Boston, January 25, 1771; in *Copley-Pelham Letters, op. cit.*, pp. 100-01, 106.

COPLEY'S COLOR: Hagen, *op. cit.*, general, pp. 92-93.

ADAMS QUOTATION: Parker and Wheeler, *op. cit.*, p. 18.

COPLEY LACKS ASSISTANCE AND MUST HIMSELF IMPORT FASHIONABLE COSTUMES: Copley to West, Boston, January 17, 1768, in *Copley-Pelham Letters, op. cit.*, pp. 67-68.

PELHAM PAINTS BACKGROUNDS ON COPLEY'S PICTURES: Benjamin Andrews to Henry Pelham, March ?, 1773, in *Copley-Pelham Letters, op. cit.*, p. 197.

COPLEY WISHES TO AVOID POLITICS: Copley to West, Boston, November 24, 1770, in *Copley-Pelham Letters, op. cit.*, p. 98.

DESIRE FOR IMPROVEMENT: Copley to Thomas Ainslie, Boston, February 25, 1765, in *Copley-Pelham Letters, op. cit.*, p. 33.

EXHIBITION OF BOY WITH SQUIRREL: Copley to Captain R. G. Bruce,

Boston, September 10, 1765; Bruce to Copley, London, August 4, 1766; West to Copley, London, August 4, 1766; Francis M. Newton to Copley, London [?], September 3, 1766; Copley to Peter Pelham, Jr., Boston, September 12, 1766; Copley to West, Boston, October 13, 1766; Copley to West, Boston, November 12, 1766; in *Copley-Pelham Letters, op. cit.,* pp. 35-36, 41-52.

COPLEY ON HIS IGNORANCE OF WORK OF ENGLISH COLLEAGUES: Copley to West, Boston, November 12, 1766, in *Copley-Pelham Letters, op. cit.,* p. 51.

ZOFFANY'S GENRE PORTRAIT: Sitwell, Sacheverell, *Conversation Pieces* (New York and London, 1937), p. 26.

WRIGHT OF DERBY'S GENRE PICTURES: Graves, Algernon, *The Society of Artists of Great Britain, 1760-1791; The Free Society of Artists, 1761-1783* (London, 1907), pp. 286-87.

EXHIBITION OF MARY WARNER: Bruce to Copley, London, June 11, 1767; West to Copley, London, June 20, 1767; Bruce to Copley, London, June 25, 1767; in *Copley-Pelham Letters, op. cit.,* pp. 52-60.

COPLEY'S UNFINISHED LETTERS OF DEFENSE: Two undated and unaddressed fragments in *Copley-Pelham Letters, op. cit.,* pp. 64-66.

COPLEY TO WEST RE. SETTLING IN ENGLAND: Letter, Boston, January 17, 1768, in *Copley-Pelham Letters, op. cit.,* p. 68.

COPLEY'S SITTERS EVENLY DIVIDED BETWEEN WHIGS AND TORIES: Flexner, *op. cit.,* p. 137.

COPLEY AND THE BOSTON MASSACRE: Flexner, *op. cit.,* pp. 135-42.

PELHAM ENGRAVES BOSTON MASSACRE: Henry Pelham to Paul Revere, Boston, March 29, 1770, in *Copley-Pelham Letters, op. cit.,* p. 83.

CHAPTER ELEVEN

PEALE'S VISIT TO BOSTON: Flexner, *op. cit.,* general, pp. 182-84.

HARDING IN PARIS, KENTUCKY: Harding, Chester, *A Sketch of Chester Harding, Artist, Drawn by his Own Hand* (Boston, 1890), pp. 42-45.

C. W. PEALE: The Peale Papers in Coll. American Philosophical Society. Sellers, Charles Coleman, *The Artist of the Revolution; the Early Life of Charles Willson Peale* (Hebron, Connecticut, 1939). Flexner, *op. cit.,* pp. 171-244; bibliography, pp. 323-24. The only important publication on Peale since this bibliography was prepared is Bolton, Theodore, 'Charles Willson Peale; An Account of his Life and Work,' in *Art Quarterly,* II (1939), pp. 354-85; also checklist in supplement to vol. II. Mr. Sellers has completed his account of

Peale in a second volume to be published by the American Philosophical Society.

TRUMBULL QUOTATION: Trumbull to Thomas Jefferson, London, June 11, 1789, in Trumbull, John, *Autobiography.* (New York, London, and New Haven, 1841), p. 158.

JEFFERSON ON LITERATURE: Quoted in Rourke, Constance, *The Roots of American Culture* (New York, 1942), pp. 6-7.

KIMBALL STATEMENT ON ARCHITECTURE: Kimball, Fiske, *American Architecture* (Indianapolis and New York, 1928), p. 57.

MUSIC: 'Early American Music,' in Rourke, *op. cit.,* pp. 161-94.

EARLY AMERICAN SCULPTURE: Forbes, Harriette Merrifield, *Gravestones of Early New England* (Boston, 1927). Pinckney, Pauline A., *American Figureheads and Their Carvers* (New York, 1940). An unannotated list of sculptors before 1800 appears in Gardner, Albert TenEyck, *Yankee Stonecutters* (New York, 1945).

JEFFERSON ON RITTENHOUSE: Quoted in Rourke, *op. cit.,* pp. 5-6.

ECONOMIC POSITION OF CONTEMPORARY PAINTERS: McCausland, Elizabeth, 'Why Can't America Afford Art,' in *Magazine of Art,* XXXIX (1946), pp. 18-21, 33-36.

WEST'S DESIRE TO ELEVATE AMERICAN ART: Flexner, *op. cit.,* pp. 77, 81.

COPLEY TO LIOTARD: Boston, September 20, 1762, in *Letters and Papers of John Singleton Copley and Henry Pelham, 1739-1776* (Boston, 1914), p. 26.

COPLEY TO C. W. PEALE: Boston, December 17, 1770; in *Copley-Pelham Letters, op. cit.,* p. 100-01.

COPLEY ON NEW YORK TRIP: Copley to Henry Pelham, New York, July 14, 1771, in *Copley-Pelham Letters, op. cit.,* p. 128.

MORGAN ON COPLEY: Dr. John Morgan to Peter Grant, Philadelphia, November 24, 1773; Dr. John Morgan to Isaac Jamineau, Philadelphia, November 24, 1773; in *Copley-Pelham Letters, op. cit.,* pp. 209-10.

ADAMS QUOTATIONS: Rourke, *op. cit.,* pp. 4-5. Flexner, *op. cit.,* pp. 194, 291, 309.

Catalogue of Illustrations

AETATIS SUE MANNER: *Thomas Van Alstyne;* oil on canvas; 39¼" x 30";
1721; owned by The New-York Historical Society; photograph
from owner; dated. Page 81

Mrs. Thomas Van Alstyne (Maria van Alen); oil on canvas; 39¼" x
30"; 1721; owned by The New-York Historical Society; photo-
graph from owner; dated. Page 82

Girl of the Van Rensselaer Family; oil on canvas; 45" x 34¾; owned by
Mrs. Joseph Ferris Simmons, New York; photograph from Frick Art
Reference Library. Page 83

AMERICAN SCHOOL: *British Privateers with French Prizes in New York
Harbor;* oil on canvas; 38" x 72½"; 1750's or 1760's; owned by
The New-York Historical Society; photograph from owner.
 Pages 168-69

Chimney Piece; oil on panel; 22½" x 58¼"; owned by Jean Lipman,
Cannondale, Conn.; photograph from *Magazine of Art.* Such
pictures as this are extremely difficult to date, since styles
changed very little; the chimney piece could easily have been
done in the eighteenth century. Pages 170-71

(Attributed to); *Christ at Emmaus;* oil on panel; 29" x 36"; owned
by Albany Institute of History and Art, Albany, N.Y.; photo-
graph from owner. Page 56

(Possibly JOHN FOSTER); *John Davenport;* oil on canvas; 27¼" x 23";
1670; owned by Yale University Art Gallery; photograph from
owner; dated. Page 16

The End of the Fox-Hunt; oil; 34½" x 53¾"; owned by Dr. Wynd-
ham B. Blanton, Richmond, Va.; photograph from The Metro-
politan Museum of Art, New York. Page 163

Flag Carried at the Seige of Louisburg; oil on linen; 25" x 29¼";
1745; owned by The New-York Historical Society; photograph
from owner. Page 174

Lady and Tramp; needlepoint worked with polychrome wools and

[343]

a little silk in tent stitch on linen, faces and hands painted; 19⅜" x 15⅞"; owned by Mrs. Philip L. Spalding, Milton, Mass.; photograph from Museum of Fine Arts, Boston. Page 167
(Sometimes attributed to BENJAMIN WEST); *Landscape;* oil on canvas; 23" x 36"; mid-eighteenth century; owned by Colonial Williamsburg, Incorporated, Williamsburg, Va.; photograph from Frick Art Reference Library. Pages 154-55
Mrs. Mann Page, II (Alice Grymes) and Son, John; oil on canvas; 46" x 36½"; after 1744; owned by William and Mary College, Williamsburg, Va.; photograph from Frick Art Reference Library. Page 107
Daniel Russell; oil on canvas; 30" x 25"; owned by Russell S. Codman, Boston; Photograph from Frick Art Reference Library. Page 39
William Stoughton; oil on canvas, 50¼" x 42"; c. 1701; owned by Harvard University; photograph from owner. Page 49
Mrs. John Wensley (Elizabeth Paddy); oil on canvas; 41⅝" x 33⅜"; owned by Pilgrim Hall, Plymouth, Mass.; photograph from owner. Page 23
See also: Aetatis Sue Manner; De Peyster Manner; Freake Limner; Gansevoort Limner; Mason Limner; Patroon Painters, School of; Pierpont Limner; Pollard Limner; Provoost Limner; Stuyvesant Limner.

BADGER, JOSEPH: *James Badger;* oil on canvas; 42" x 33"; c. 1760; owned by The Metropolitan Museum of Art, New York; photograph from owner; an old inscription on the back of the canvas reads, "July 8, 1760." Page 197
Mrs. John Edwards (Abigail Fowle); oil; 36½" x 25½"; owned by Museum of Fine Arts, Boston; photograph from owner. Page 196
BLACKBURN, JOSEPH: *Mrs. James Otis, Jr. (Ruth Cunningham);* oil on canvas; 28⅞" x 23½"; 1755; owned by Brooklyn Museum, Brooklyn, N.Y.; photograph from owner; signed and dated. Page 210
The Winslow Family; oil on canvas; 42" x 102"; owned by Museum of Fine Arts, Boston; photograph from owner. Pages 208-09
BLOCK, LAURENS: *New Amsterdam;* watercolor on paper; 5⅞" x 19 1/16"; 1650; owned by The New-York Historical Society; photograph from owner; signed and dated. Pages 60-61
BRIDGES, CHARLES: *Wilhelmina Byrd (Mrs. Thomas Chamberlayne)* (?) oil on canvas; 50" x 40"; owned by the Misses Stewart, Henrico County, Va.; photograph from Frick Art Reference Library. The owners of the picture do not agree with the attribution here

given. Miss A. C. Stewart writes that the portrait "is of the first Mrs. Byrd and was painted by Kneller or one of his pupils."
Page 104

BRITISH SCHOOL: *The Death of Socrates;* engraving used as frontispiece of Vol. IV, Rollin's *Ancient History,* 8th edition, London, 1788; 3½" x 4¼"; owned by New York Public Library; photograph from owner. This engraving, published June 20, 1749 by J. and P. Knapton, was used in many editions of the history. Page 186
Henry, Prince of Wales, and Lord Harrington; oil on canvas; 80" x 57¾"; 1603; owned by The Metropolitan Museum of Art, New York; photograph from owner; dated. Page 12
(Attributed to); *Pocahontas;* oil on canvas; 30⅝" x 25¼"; 1616; owned by National Gallery of Art, Washington, D.C. (Mellon Collection); photograph from owner; dated. Page 13

BURGESS, WILLIAM: View of New York *(detail);* owned by The New-York Historical Society; photograph from owner. Page 166

CONNECTICUT ARTISAN: *Painted Chest;* 33" x 48¾" x 20½"; 1705; owned by The Metropolitan Museum of Art, New York; photograph from owner; dated. Page 5

COOPER, J.: *Allegorical Figures;* oil on canvas; 21⅜" x 16⅞"; c. 1715; owned by Lyman Allyn Museum, New London, Conn.; photograph from Harry Shaw Newman Gallery, New York. Page 45

COPLEY, JOHN SINGLETON: *Samuel Adams;* oil on canvas; 50" x 40½"; c. 1771; on loan from City of Boston at Museum of Fine Arts, Boston; photograph from Museum of Fine Arts. Page 227
Mrs. John Amory (Katherine Greene); oil on canvas; 49½" x 40"; c. 1763; owned by Museum of Fine Arts, Boston; photograph from owner. Page 215
Mrs. Nathaniel Appleton (Margaret Gibbs); oil on canvas; 35½" x 29"; 1763; owned by Fogg Art Museum, Cambridge, Mass.; photograph from *Magazine of Art;* signed and dated.
Page 242
Mrs. Jerathmael Bowers (Mary Sherburne); oil on canvas; 49¾" x 39¾"; c. 1763-64; owned by The Metropolitan Museum of Art, New York; photograph from owner. Page 219
Boy with Squirrel (Henry Pelham); oil on canvas; 30¼" x 25"; c. 1765; owned anonymously; photograph from Museum of Fine Arts, Boston. Page 229
Mrs. Gawen Brown (Elizabeth Byles); pastel; 19¼" x 14½"; 1765; owned by Mr. and Mrs. Luke Vincent Lockwood, New York; photograph from Frick Art Reference Library; signed and dated.
Page 212

[345]

Rev. William Welsteed; engraving; 10" x 7"; 1753; owned by Yale University Art Gallery; photograph from owner; signed and dated. Page 199

Mr. and Mrs. Isaac Winslow (Jemima Debuke); oil on canvas; 54" x 60"; 1774; owned by Museum of Fine Arts, Boston; photograph from owner. Copley was paid twenty-eight guineas for this picture in 1774. Pages 232-33

Mrs. John Winthrop (Hannah Fayerweather); oil on canvas; 35½" x 28¾"; 1773; owned by The Metropolitan Museum of Art, New York; photograph from owner. Copley received ten guineas for this portrait on June 24, 1773. Page 237

DENNIS, THOMAS: (attributed to); *Carved Chest;* 29¾" x 48 x 21⅜"; c. 1675; owned by The Metropolitan Museum of Art, New York; photograph from owner. Page 4

DE PEYSTER MANNER: *De Peyster Boy with Deer;* oil on canvas; 50¼" x 41"; owned by The New-York Historical Society. Facing page 68

Eva and Catherine De Peyster; oil on canvas; 56" x 47"; c. 1728; owned by the Abby Aldrich Rockefeller Folk Art Collection, Williamsburg, Va.; photograph from The Metropolitan Museum of Art, New York. Page 70

De Peyster Girl and Lamb; oil on canvas; 50¼" x 41"; owned by The New-York Historical Society; photograph from owner.
Page 259

Phila Franks (Mrs. Oliver De Lancey) and David Franks; oil on canvas; 44" x 34¾"; owned by the American Jewish Historical Society, New York; photograph from the Frick Art Reference Library. Page 88

Moses Levy; oil on canvas; 43¼" x 34½"; owned by the Museum of the City of New York; photograph from Frick Art Reference Library. Page 72

Elizabeth Van Brugh (Mrs. Henry Van Rensselaer); oil on canvas; 45½" x 36⅜"; owned by The New-York Historical Society; photograph from owner. Page 71

DURAND, JOHN: *Mrs. Adriaan Bancker (Anna Boelen);* oil on canvas; 35½" x 30½"; owned by The New-York Historical Society; photograph from owner. Page 273

DUYCKINCK, GERRET: (attributed to); *Gerret Duyckinck;* oil on panel; 30" x 25"; c. 1700; owned by The New-York Historical Society; photograph from owner. Page 62

(Attributed to); *Mrs. Gerret Duyckinck (Maria Abeel);* oil on panel; 30¼" x 24⅞"; c. 1700; owned by The New-York Historical Society; photograph from owner. Page 63

[349]

owned by the City Art Museum, St. Louis, Mo.; photograph from owner. Pages 164-65

View of Yale College; engraved by Thomas Johnston; 17 1/5" x 23 2/5"; owned by Yale University Art Gallery; photograph from owner; signed. Page 173

HESSELIUS, GUSTAVUS: *A Bacchanalian Revel;* oil on canvas; 24½" x 32½"; owned by Pennsylvania Academy of the Fine Arts, Philadelphia; photograph from Frick Art Reference Library. Page 101

Self Portrait; oil on canvas; 36" x 28"; owned by Historical Society of Pennsylvania, Philadelphia; photograph from Frick Art Reference Library. Page 97

Lapowinsa; oil on canvas; 33" x 25"; 1735; owned by Historical Society of Pennsylvania, Philadelphia; photograph from owner. Page 99

The Last Supper; oil on canvas; 35" x 117½"; c. 1721; owned by Mrs. Rose N. Henderson, Fredericksburg, Va.; photograph from Philadelphia Museum of Art. Pages 102-03

Tishcohan; oil on canvas; 33" x 25"; 1735; owned by Historical Society of Pennsylvania, Philadelphia; photograph from owner. Page 98

HESSELIUS, JOHN: *Charles Calvert and Colored Slave;* oil on canvas; 50" x 40"; 1761; owned by Baltimore Museum of Art; photograph from Frick Art Reference Library; signed and dated. Page 106

HOGARTH, WILLIAM: *Simon, Lord Lovat;* engraved by Hogarth after his own drawing; 14¼" x 9¼"; 1746; owned by New York Public Library; photograph from owner; signed and dated. Page 123

The Rake's Progress, plate one; engraving; 14" x 16½"; 1735; owned by New York Public Library; photograph from owner; signed and dated. Page 122

HUDSON, THOMAS: *Mary, Duchess of Ancaster;* engraved after the painting by J. McArdell; 18¾" x 13¼"; 1757; owned by New York Public Library; photograph from owner; signed and dated. Page 115

JOHNSTON, HENRIETTA: *Anne Broughton;* pastel on paper; 11⅝" x 8¾"; owned by Yale University Art Gallery; photograph from owner. Page 93

Colonel William Rhett; pastel on paper; 12" x 9"; owned by Gibbes Art Gallery, Charleston, S.C.; photograph from Frick Art Reference Library. Page 92

[351]

Mrs. Jacobus Stoutenburgh (Margaret Teller); oil on panel; 39" x 30"; owned by the Museum of the City of New York; photograph from Frick Art Reference Library. Page 75

Unknown Lady; oil on panel; 41¼" x 32¾"; owned by Harry Shaw Newman Gallery, New York; photograph from owner. Page 256

PEALE, CHARLES WILLSON: *James Arbuckle*; oil on canvas; 47½" x 36"; owned by Mrs. Walter B. Guy, Washington, D.C.; photograph from Frick Art Reference Library. Page 252

Mrs. James Arbuckle (Tabitha Scarborough Custis) and son, Edward; oil on canvas; 48" x 36½"; owned by Mrs. Walter Guy, Washington, D.C.; photograph from Frick Art Reference Library. Page 253

PELHAM, PETER: *Rev. Mather Byles*; oil on canvas; 30" x 25"; owned by American Antiquarian Society, Worcester, Mass.; photograph from owner. Page 195

PIERPONT LIMNER: *Rev. James Pierpont*; oil on canvas; 31½" x 25"; 1711; on loan from Allen Evarts Foster to Yale University Art Gallery; photograph from Yale University; dated. Page 42

Mrs. James Pierpont (Mary Hooker); oil on canvas; 31" x 25"; 1711; on loan from Allen Evarts Foster to Yale University Art Gallery; photograph from Yale University; dated. Page 41

POLLARD LIMNER: (attributed to); *Elisha Cook*; oil on canvas, 29½" x 24½"; owned by Mrs. R. M. Saltonstall, Chestnut Hill, Mass.; photograph from Frick Art Reference Library. Page 47

Mrs. John Dolbeare (Sarah Comer); oil on canvas; 29½" x 24½"; owned by Thomas S. McLane, New York City; photograph from Frick Art Reference Library. Page 50

Anne Pollard; oil on canvas; 28¾" x 24" 1721; owned by Massachusetts Historical Society, Boston; photograph from Rhode Island School of Design; dated. Page 48

Thomas Thacher (so-called); oil on canvas; 29½" x 24⅞"; owned by Old South Association, Boston; photograph from Worcester Art Museum. Page 270

PROVOOST LIMNER: *Mrs. David Provoost (Tryntie Laurens)*; oil on panel; 30" x 25"; c. 1700; owned by The New-York Historical Society; photograph from owner. Page 65

REMBRANDT: *The Standard Bearer*; oil on canvas; 54½" x 45"; 1654; owned by The Metropolitan Museum of Art, New York; photograph from owner; signed and dated. Page 54

REMICK, CHRISTIAN: *View of the Blockade of Boston*; watercolor; 12⅞" x 61⅜"; owned by Essex Institute, Salem, Mass.; photograph

[353]

from Philadelphia Museum of Art. Page 188

Landscape with Cow; oil on panel; 26¾" x 50¼"; c. 1749-52; owned by Pennsylvania Hospital, Philadelphia; photograph from Philadelphia Museum of Art. Pages 150-51

Thomas Mifflin; oil on canvas; 47½" x 35½"; c. 1758-59; owned by Historical Society of Pennsylvania, Philadelphia.

Facing page 190

Elizabeth Peel; oil on canvas; 47¼" x 34⅜"; c. 1757-58; owned by Pennsylvania Academy of the Fine Arts, Philadelphia; photograph from owner. Page 191

Seascape; oil on panel; 13¼" x 43"; c. 1749-52; owned by Pennsylvania Hospital; photograph from Philadelphia Museum of Art.

Page 172

Self Portrait; miniature in watercolor on ivory; oval, 2 9/16" x 1 15/16"; c. 1756-57; owned by Yale University Art Gallery; photograph from owner. Page 187

See also American School: *Landscape.*

WHITE, JOHN: *Indian Runner;* watercolor on paper; 9⅝" x 6"; owned by British Museum; photograph from owner. Page 2

WILLIAMS, WILLIAM: *Conversation Piece;* oil on canvas; 30" x 40"; 1775; owned anonymously; photograph from Albert Duveen, New York City; signed and dated. Page 182

The William Denning Family; oil on canvas; 40¾" x 57¼"; 1774; owned by Mrs. Harold D. Harvey; photograph from Frick Art Reference Library; signed and dated. Page 265

David Hall; on canvas; 71" x 46"; 1766; owned by the Henry Francis Du Pont Winterthur Museum, Winterthur, Del.; photograph from Frick Art Reference Library; signed. Page 178

Deborah Hall; oil on canvas; 71½" x 46½"; 1776; owned by Brooklyn Museum, Brooklyn, N.Y.; signed and dated. Facing page 180

Benjamin Lay; engraving by Henry Dawkins after a lost original; 8 1/10" x 7 1/5"; after 1759; owned by Historical Society of Pennsylvania, Philadelphia; photograph from owner; signed.

Page 181

John Wiley, His Mother and Sisters; oil on canvas; 35½" x 46½"; 1771; owned by William Ogden Wiley, New York; photograph from Frick Art Reference Library; signed and dated.

Pages 184-85

WOLLASTON, JOHN: *Mrs. Daniel Blake of Newington (Eliza Izard);* oil on canvas; 30" x 25"; owned by Reginald Edmund Rutledge; photograph from Frick Art Reference Library. Page 192

[355]

Index

[357]

226, 234, 236-238, 266; read books on art, 317-318; saw imported pictures, 318-319; social conflict in his painting, 222, 224-226, 240-243, 268, 319-320; and Peale, 247, 254-255; pastels, 211-212, 317; miniatures, 211; scope of his art, 310; *John Adams,* 269; *Samuel Adams,* 224-225, 227; *Mrs. John Amory,* 215, 217, 220; *Mrs. Nathaniel Appleton,* 242; *Mrs. Jonathan Belcher,* 210; *Mrs. Jermathmael Bowers,* 217-218; *Boy with Squirrel,* 226, 228-230; *Mrs. Gawen Brown,* 212; *Jane Browne,* 207, 211; *An Engraver,* 204-205; *Mrs. Michael Gill,* 222-223; *Nathaniel Hurd,* 224, 228, 239; *Mrs. Samuel Livermore, see Jane Browne; Joseph Mann,* 203, 315; *Mrs. Joseph Mann,* 202-203, 315; *Mr. and Mrs. Thomas Mifflin,* 220, 222; *Nun by Candlelight,* 153, 175; *Paul Revere,* 222-226, 228; *Mrs. Paul Richard,* 235; *Captain Richards,* 268; *Joseph Sherburne,* 241; *Nathaniel Sparhawk,* 220-221; *Venus, Mars, and Vulcan,* 152, 204, 206; *Mary Warner,* 231, 234, 236, 238; *Rev. William Welsteed,* 199, 201, 315-316; *Mr. and Mrs. Isaac Winslow,* 232-233; *Mrs. John Winthrop,* 237
Copley, Mary, 194-195, 240
Correggio, 319
Cotton, John, 22
Couturier, Henri, 289
Cowdrey, Bartlett, 288
Cozzens, Eleanor, 297-298
Crafts: Copley's craft approach, 214, 222, 224-225, 236, 240; lack of craftsmen in South, 110-112; medieval crafts, 6-7, 14, 22, 30; painters also craftsmen, 38, 43, 45, 60-61, 102, 110, 112-113, 153, 172-175, 198, 201, 250-255, 257-258, 260, 263-266, 268-269, 282-285, 310-312; place of craftsmen in society, 224-225, 250, 254-255, 258, 319
Cromwell, Oliver, by Robert Walker, 36

Crucifixion, by Gustavus Hesselius, 101-102
Curti, Merle, 278, 306

Dahl, Michael, 77, 95-96
Danish Influence, 285
Darnall, Eleanor, by Justus Engelhardt Kühn, 91-92, 94
Davenport, John, possibly by John Foster, 16-17, 282
David, Jacques Louis, 129, 289
Dawson's Historical Magazine, 299-301
Death of Socrates, by West, 152, 183, 186; British School, 183, 186
Defoe, Daniel, 180
De Lange, Dr. Jacob, 52-53
Delanoy, Abraham, 320
Delaware, 95
Denning, William, Family, by William Williams, 265
Dennis, Thomas, 4
De Peyster Boy with Deer, De Peyster Manner, 68-69, 72
De Peyster, Eva and Katherine, De Peyster Manner, 69-70
De Peyster Girl with Lamb, De Peyster Manner, 259
De Peyster Manner, 68-72, 76, 80, 88, 131; *De Peyster Boy with Deer,* 68-69, 72; *Eva and Katharine De Peyster,* 67-70; *De Peyster Girl with Lamb,* 259; *Phila and David Franks,* 88; *Moses Levy,* 72; *Elizabeth Van Brugh,* 69, 71, 76
De Piles, Roger, 266, 318
De Wandelaer, Pau, by Gansevoort Limner, 80
Dickson, William, gravestone of, 249
Dolbeare, John, by Pollard Limner, 288
Dolbeare, Mrs. John, by Pollard Limner, 50-51, 288
Dossie, Robert, 254
Drawings, 112, 153, 176, 296, 310-312. *See also* Pastels, Watercolors
Dresser, Louisa, 283
Du Fresnoy, Charles Alphonse, 266, 318
Dummer, Jeremiah, 38, 285-286
Dunlap, William, 291, 298

[361]

Gooch, Gov. William, 105, 111
Goodrich, Lloyd, 306
Gore, John, 284
Gossman, Robert, 291-292
Gravelot, Hubert François, 176
Gravestone, *see* Tombstone
Gray, Thomas, 296
Great Man Theory of Art, 295
Great Queen Street Academy, 113
Greenleaf, Stephen, attrib. to Pollard Limner, 288
Greenwood and Lee Families, by John Greenwood, 200-201
Greenwood, John, 162, 164-166, 173, 198, 200-201, 203, 224, 250, 284, 305, 311; *Greenwood and Lee Families,* 200-201; *Jersey Nanny,* 162, 166-167; *Sea Captains Carousing at Surinam,* 164-165, 170; *View of Yale,* 173
Guy, Francis, 287

Hagen, Oskar, 295, 303, 316
Hair, pictures made from, 153
Hall, David, by William Williams, 178
Hall, Deborah, by William Williams, 180-181
Hamilton, Dr. Alexander, 116, 130, 136, 298
Hancock, Mrs., 318
Hancock, John, 240
Harding, Chester, 251, 254
Harris, Frank X., 292
Harvard University, 14, 17-18
Hatchments, 283
Hawkins, George, by Gustavus Hesselius, 96
Hayes, Judea, 302
Henry VIII, 24
Henry, Prince of Wales, and Sir John Harrington, British School, 12-13
Henry, William, 183; *Portrait* of, by West, 187-188
Heraldry, 60, 93, 102, 108, 110, 113, 152, 172, 174, 310-312
Hercules, by John Watson, 312
Hesselius, Andreas, 95
Hesselius, Gustavus, 95-103, 152, 156, 187, 251, 286, 293, 311; *Bacchanalian Revel,* 100-101, 263;

Crucifixion, 101-102; *George Hawkins,* 96; *Self-portrait,* 96-97; *Lapowinsa,* 96, 98-99, 271-292, 293; *Last Supper,* 100-103, 293; *George Ross,* 96; *Tishcohan,* 96-97, 99, 271-272, 293
Hesselius, John, 102-103, 106, 254-255, 271, 311; *Charles Calvert and Colored Slave,* 103, 106
Highmore, Joseph, 172
Hiscox, Rev. Thomas, by Feke, 137-138, 298, 307
History painting, 150-152, 156, 166, 172, 180, 295, 309, 311, 312
Hogarth, William, 122-124, 127, 152, 180, 182, 297; *Simon, Lord Lovat,* 123; *The Rake's Progress,* 122
Holbein, Hans, 13, 152
Holland, 53-54, 64; *see also* Dutch painting
Homer, bust of, 115; drawing of by John Watson, 312
Hopkinson, Francis, 190, 321
Hudson River School, 160, 263
Hudson, Thomas, 114-115, 204, 317; *Mary, Duchess of Ancaster,* 114-115
Hurd, Nathaniel, by Copley, 224, 228, 239
Hutchinson, Thomas, 224-225
Huxley, Aldous, 143

Indian Priest, by Nathaniel Smibert, 297
Indian Runner, by John White, 2
Inman, Ralph, by Feke, 308
Inman, Mrs. Ralph, by Feke, 308
International court tradition, 31-51, 55-57, 64, 67, 84, 90, 95-96, 105, 113-114, 118-129, 247, 269, 271, 273-274, 296. *See also* British painting
Irving, Washington, x, 60
Italian painting, influence of, 31, 57, 228, 245, 318

Jay, Mrs. Augustus, attrib. to Gerret Duyckinck, 291
Jefferson, Thomas, 256-257, 263
Jeffries, Margaret, 290
Jersey Nanny, by John Greenwood, 162, 166-167

[362]

[364]

[366]

Smith, Thomas, 17-20, 25, 38, 312; *Major Thomas Savage* (attrib. to), 20; *Maria Catherine Smith*, 18-19; *Self-portrait*, 18-19
Smith, Dr. William, 183
Society of Artists, London, 226, 228-230, 234-235, 257, 319
South, painting in, 3-4, 90-111, 150-151, 157-161, 166, 170, 172, 247, 252-255, 292-294
South Carolina, painting in, 91, 108, 157-161, 166, 170, 172
South Carolina Gazette, 108, 313
Spanish painting, influence of, 193, 245
Spanish-American painting, influence of, 24, 282
Sparhawk, Nathaniel, by Copley, 220-221
Spotswood, Alexander, 150-151
Standard Bearer, The, by Rembrandt, 54-56
Steenwyck, Cornelius, by Stuyvesant Limner, 298
Stelle, Isaac, by Feke, 144
Stevenson, Hamilton, 153
Stevenson, John, 153
Stiles, Ezra, by Nathaniel Smibert, 296
Still-lives, 53-54, 150, 176, 285, 310-312
Stoughton, William, American School, 46, 49
Stoutenburg, Jacobus, by Patroon Painter, 74, 76
Stoutenburg, Mrs. Jacobus, by Patroon Painter, 75-76
Strycker, Jacobus, 290
Stuart, Gilbert, 56, 271, 289; *John Adams*, 271
Stuyvesant Limner, 57-59, 289-290; *Cornelius Steenwyck*, 289; *Nicholas William Stuyvesant*, 57, 59, 290; *Peter Stuyvesant*, 57-58, 289-290
Stuyvesant, Nicholas William, by Stuyvesant Limner, 57, 59, 289-290
Stuyvesant, Peter, by Stuyvesant Limner, 57-58, 289
Surinam, 170
Swedenborg, Emanuel, 95

Swedish painting, influence of, 77, 95-96
Swiss painting, influence of, 66, 108, 245

Talbot, Mrs. Eunice, 283
Thacher, Thomas (so-called), attrib. to Pollard Limner, 270, 288
Thanksgiving, 265
Thatcher, Mrs. Oxenbridge, misattrib. to Feke, 299
Theatrical scenery, 153
Theus, Jeremiah, 108-110, 312; *Mrs. Gabriel Manigault*, 109
Thornhill, James, 113
Thrale, Mrs., 127
Tintoretto, 57
Tishcohan, by Gustavus Hesselius, 96-97, 99, 271, 273, 293
Titian, 234, 295, 318
Tombstones, 24-29, 153, 249, 284, 321; William Dickson, 249; John Foster, 26-28; Andrew Neal, 24
Trade Cards, 166
Travel conditions in seventeenth century, 52
Trecothick, Mrs. Barlow, by Feke, 308
Truman, Benjamin, by Gainsborough, 228
Trumbull, John, 113, 214, 255-256
Tuesday Club of Baltimore, 166
Turkey-work rugs, 6, 21
Turner, James, 283
Tuscany, Grand Duke of, 295, 317
Tyng, Jonathan, 284

Unknown Lady, by Patroon Painter, 76, 256

Van Alstyne, Thomas, Aetatis Sue Manner, 79-81, 84
Van Alstyne, Mrs. Thomas, Aetatis Sue Manner, 79-80, 82, 84
Van Brugh, Elizabeth, De Peyster Manner, 69, 71, 76
Van Der Donk, Adrien, 160
Vanderlyn, John, 76, 292
Vanderlyn, Nicholas, 76
Vanderlyn, Pieter, 73, 76, 292; *Mrs. Petrus Vas*, 73, 76, 291-292
Vanderstraeten, Mr., 172

[367]

Van Dyck, Anthony, 14, 31, 55-56, 113, 115, 220, 248, 295-296, 318; *Cardinal Bentivoglio*, 113; *Robert Rich, Earl of Warwick*, 55-56
Vas, Mrs. Petrus, by Pieter Vanderlyn, 73, 76, 291-292
Venus de Medici, 115
Venus, Mars, and Vulcan, by Copley, 152, 204, 206
Vertue, George, 113, 118
View of New York, by William Burgess, 166
Virginia, painting in, 3-4, 90, 95, 103-105, 107-111, 150-151, 292-294

Wadsworth, Rev. Daniel, 283
Wainwright, Col. Francis, 283
Waldo, Samuel, by Feke, 140-141
Walker, Robert, 35-36; *Oliver Cromwell*, 36
Walking purchase, 96
Wallpaper, 152
Walpole, Horace, 114, 117, 160, 230, 318
Wanton, Mrs. Joseph, by Feke, 307
Warner House, Portsmouth, N.H., 174-175
Warner, Mary, by Copley, 231, 234, 236, 238
Warren, Dr., 240
Warwell, Mr., 172
Washington, George, 108, 224
Watercolors, 161, 163, 258, 310-312
Waters, Thomas Francis, 283
Watson, John, 66-68, 153, 250, 287, 291, 312; *Hercules*, 312; *Homer*, 312; *Gov. William Burnet*, 67
Wax sculpture, 321
Webb, Daniel, 318
Weddell, Alexander Wilbourne, 293
Welsteed, Rev. William, by Copley, 199, 201, 315-316
Wensley, Elizabeth Paddy, American School, 19, 23
West, Benjamin, xi, 201, 266, 277-278; childhood, 176-177, 183, 250, 314; influenced by Williams, 177, 179-180, 183, 187; at Lancaster, 183; at Philadelphia, 150-151, 158-159, 177, 179-180, 183, 186-193, 263, 312-313; influenced by

Wollaston, 187-188, 190-191; in New York, 153, 193; sails for Europe, 193, 238, 255, 268, 318; in London, 177, 179; and Copley, 213, 234, 237, 240, 317-320; American landscape style, 150-151, 158-159, 312-313; American portrait style, 158-159, 187, 272; scope of American art, 312-313; later influence, 156, 193, 266, 268; *Stephen Carmick*, 187; *Death of Socrates*, 152, 183, 186, 263; *Jane Galloway*, 187, 189; *William Henry*, 187-188; *Landscape with Cow*, 150-151, 158-159, 183, 312-313; *Thomas Mifflin*, 190; *Elizabeth Peel*, 190-191, 355; *Seascape*, 172; *Self-portrait*, 187
Weston, Isaac, 172
Wheeler, Ann Bolling, 315-316
Wheelwright, John, possibly by John Foster, 17
White, John, 2-4; *Indian Runner*, 2
Whitney Museum of American Art, 306-307
Wigglesworth, Michael, 22
Wiley, John, his Mother and Sisters, by William Williams, 182, 184-185
Williams, Roger, 250
Williams, William, 273, 287; youth in England, 177, 250; author, 177, 179-180, 314; painter in America, 180-185, 187, 247; old age in England, 177, 179; scope of art, 312; *Conversation Piece*, 182; *William Denning Family*, 265; *David Hall*, 178, 355; *Deborah Hall*, 180-181; *Benjamin Lay*, 181, 347; *John Wiley, his Mother and Sisters*, 182, 184-185
Willing, Mrs. Charles, by Feke, 139-140, 298, 307
Wilson, Rev. John, 282
Wilson, Richard, 156, 158, 160
Wilton, Joseph; *George III*, 321; *William Pitt*, 319, 321
Winslow Family, by Joseph Blackburn, 204, 208-209
Winslow, Isaac, by Feke, 144-146, 308